The
Rise
of
S u r r e a l i s m

The
Rise
of
Surrealism

Cubism, Dada, and the
Pursuit of the Marvelous

Willard Bohn

State University of New York Press

PUBLISHED BY
STATE UNIVERSITY OF NEW YORK PRESS
ALBANY

© 2002 State University of New York

For information, address
State University of New York Press,
90 State Street, Suite 700, Albany, NY 12207

Production and book design, Laurie Searl
Marketing, Anne M. Valentine

Library of Congress Cataloging-in-Publication Data

Bohn, Willard, 1939–
 The rise of Surrealism : Cubism, Dada, and the pursuit of the marvelous / Willard Bohn.
 p. cm.
 Includes bibliographical references and index.
 ISBN 0-7914-5159-3 (alk. paper) — ISBN 0-7914-5160-7 (pbk. : alk. paper)
 1. Surrealism. 2. Arts, Modern—20th century. I. Title.

NX456.5.S8 B64 2001
709'.04'063–dc21
 2001049329
 10 9 8 7 6 5 4 3 2 1

For

Anita and Heather,

with all my love

CONTENTS

LIST OF ILLUSTRATIONS

ACKNOWLEDGMENTS

I would like to thank the late Georgia O'Keeffe, Rodrigo de Zayas, and Yale University for allowing me to examine and publish excerpts from letters in the Beinecke Rare Book and Manuscript Library. Thanks go as well to Dorothy Norman, who provided me with a key portion of a (then) unknown manuscript by Marius de Zayas entitled "How, When, and Why Modern Art Came to New York." I am also grateful to Gabrielle-Buffet Picabia for sharing her memories of Francis Picabia and Dada with me. Special thanks go to Professor William A. Camfield, who offered precious advice about Marius de Zayas and Francis Picabia at key junctures in this project. In addition, I am indebted to James Thrall Soby, with whom I was able to discuss Giorgio de Chirico on several occasions. Thanks are also due to François Chapon and the staff of the Bibliothèque littéraire Jacques Doucet in Paris, who helped me with various problems. Carol Ruyle and the Interlibrary Loan staff at Milner Library, Illinois State University, filled my extravagant requests promptly and efficiently. Joan Winters and the staff in the Circulation Department provided equally conscientious service and were consistently helpful.

I am also grateful to the Museum of Modern Art (New York), the Moderna Museet (Stockholm), the Musée Nationale d'Art Moderne (Paris), the Yale University Art Gallery (New Haven, Connecticut), and the Wadsworth Atheneum (Hartford, Connecticut) for permission to reproduce works by Giorgio de Chirico and Joan Miró in their collections. In addition, a generous grant from the College of Arts and Sciences at Illinois State University

allowed me to include many of the illustrations. Much of the original research was facilitated by three University Research Grants from the same institution.

Preliminary versions of several sections appeared in the following publications and are reprinted with their kind permission: "Giorgio de Chirico and the Solitude of the Sign," *Gazette des Beaux-Arts*, CXVII, 1467 (April 1991), pp. 169–87; "Giorgio de Chirico and the Paradigmatic Method," *Gazette des Beaux-Arts*, CVI, 1398–99 (July–August 1985), pp. 35–41; "Semiosis and Intertextuality in Breton's 'Femme et Oiseau,'" *Romanic Review*, LXXVI, 4 (November 1985), pp. 415–28, copyright by the Trustees of Columbia University in the City of New York; "Picabia's 'Mechanical Expression' and the Demise of the Object," *The Art Bulletin*, LXVII, 4 (December 1985), pp. 673–77; "The Abstract Vision of Marius de Zayas," *The Art Bulletin*, LXII, 3 (September 1980), pp. 434–52; "Mirroring Miró: J. V. Foix and the Surrealist Adventure," *The Surrealist Adventure in Spain*, ed. C. Brian Morris (Ottawa: Dovehouse, 1991), pp. 40–61; "At the Cross-Roads of Surrealism: Apollinaire and Breton," *Romance Quarterly* XXVII, 1 (1980), pp. 85–96 (Reprinted with permission of the Helen Dwight Reid Educational Foundation. Published by Heldref Publications, 1319 Eighteenth St. N.W. Washington, D.C. 20036-1802. Copyright © 2000); "From Surrealism to Surrealism: Apollinaire and Breton," *Journal of Aesthetics and Art Criticism*, XXXVI, 2 (Winter 1977), pp. 197–210.

1 INTRODUCTION

The present volume represents neither a history nor a theoretical study of Surrealism. It seeks neither to chronicle the successive phases of its evolution nor, for the most part, to analyze the principles that govern its expression. On the contrary, it examines certain developments that prepared the way for the Surrealist movement, considered in its international context, as well as the triumph of Surrealism itself. Had the movement been founded a mere twenty years earlier, before the Cubists and the Dadaists left their mark, it would never have assumed the form in which we know it today. As will become apparent, the Surrealists benefited both directly and indirectly from their avant-garde predecessors, who served as important models and influenced them in numerous ways. Although the book is concerned with historical schools to some extent, I have preferred to concentrate on some of the artists and writers who played a key role in the elaboration of Surrealism. Each chapter is devoted to one or two persons who deserve to be much better known, both in their own right and in the light of their contributions to modern aesthetics. Although a few of these figures have achieved a certain notoriety, most of the others have received little or no recognition. For every Marcel Duchamp or Salvador Dalí who has risen to prominence, dozens of equally talented individuals have been consigned to relative obscurity.

For better or worse (I hope the former), the study that follows is highly ambitious. Spanning the first two-thirds of the twentieth century, it surveys half a dozen countries situated on three different continents. Among the various movements that receive extended commentary, four are especially

prominent: Cubism (both literary and artistic), Metaphysical Art, Dada, and Surrealism. Within the framework constituted by these schools, the work examines a number of distinctive styles, such as machinism and abstraction, and encompasses a series of related topics. Much of the book is concerned with competing artistic models and with different strategies for creating Surrealist and proto-Surrealist works. Much is devoted to the dynamics of the imagery that artists and writers chose to employ and to the new roles it assumed in their compositions. Utilizing examples taken from a number of countries, including France, Italy, Germany, Spain, Argentina, Mexico, Chile, and the United States, the volume analyzes their aversion to mimesis and the solutions they devised to replace it. As much as anything, it considers how poets and painters sought to redefine their relationship to the modern world, which was fraught with paradox. For just as the discovery of a new reality demanded to be expressed by a new realism, the creation of a new realism disclosed a brand new reality.[1]

As the reader will discover, each chapter investigates one or more problems that, in many cases, have puzzled scholars for decades. Following the Introduction, the initial chapter examines Guillaume Apollinaire's treatment of the fourth dimension, which, like Max Weber's, has appeared to some observers to be inexplicable. At the same time, it explores the concept of the fourth dimension itself and discusses its implications for Surrealism and for the avant-garde in general. By appropriating this intriguing concept, which fired the popular imagination, the Fauvists and the Cubists succeeded in freeing themselves—and those who came after them—from the shackles of traditional realism. For the first time, artists and writers were able to enter into a new, imaginary dimension where they could do as they liked. Although the fourth dimension served primarily as a metaphor initially, the Surrealists conceived of it as an actual domain—that of the Freudian unconscious—whose boundaries could be determined via certain procedures. Embracing both literary and artistic invention, the fourth dimension serves as an overarching metaphor for the succeeding chapters, each of which examines a similar attempt to construct a brave new world.

Chapter 3 considers Dada portraiture as practiced by Marius de Zayas and Francis Picabia, two of the first artists to experiment with abstraction. As with Apollinaire and Weber, the interaction between a major French figure and an obscure artist living in America leads to a surprising finding, which the reader will discover in due course. The principal challenge that confronts the critic is

to understand how these portraits operate and to clarify their relation to each other. For in liberating objects from their ordinary functions, one discovers, Picabia and de Zayas endowed them with endless interpretive possibilities that the Surrealists would exploit in turn. In contrast to Duchamp, who emphasized the aesthetic value of ordinary objects, they focused on their symbolic value and explored their multiple associations. The relationship between Dada and Surrealism has been the subject of endless debates, as critics have sought to demonstrate that the former was subsumed in the latter or vice versa. What matters for our purposes is that Surrealism was born out of a certain disillusionment with Dada. Although the two movements differed radically in spirit, they were continuous historically and included many of the same members (see Chapter 5). Convinced that they had become trapped in a vicious circle, André Breton and his colleagues sought to redefine Dada's negativity "as a critique capable of opening the way to more constructive enterprises."[2]

The fourth chapter concentrates on the inventor of Metaphysical Art, Giorgio de Chirico, and investigates his revolutionary aesthetics. The father of Magic Realism, Neue Sachlichkeit, and Surrealist painting, de Chirico has been the last major modern artist to successfully defy interpretation. This chapter proposes the first systematic explanation of his enigmatic art, which it studies extensively. "It is a paradox of de Chirico's career," James Thrall Soby remarks, "that he first attained truly international fame during the 1920's, when his relationship with those chiefly responsible for his fame—the Dadaists, soon to become Surrealism's leaders—was slowly deteriorating."[3] Until they concluded (toward 1926) that his original inspiration had disappeared, they eagerly corresponded with de Chirico, visited him in Italy, wrote glowing accounts of his paintings and drawings—which they also purchased—and welcomed him into their group when he settled in Paris. Despite their eventual disillusionment with the man himself, they continued to draw inspiration from his early works, which so perfectly exemplified the Surrealist mission. "De Chirico a accompli dans sa jeunesse le voyage le plus extraordinaire qui soit pour nous" ("During his youth, de Chirico completed what was for us the most extraordinary journey ever undertaken"), Breton declared in 1928—a journey not only into the realm of dream but into the deepest recesses of the unconscious.[4]

The remaining chapters in the volume explore a series of topics associated with the Surrealist movement itself. Chapter 5 examines a persistent question that continues to intrigue modern scholars: the extent of André

Breton's debt to Apollinaire. Focusing on their respective poetics, which for both were subsumed under the heading of *surréalisme*, it attempts to elucidate the relations that existed between them. Concentrating on several crucial texts, the investigation discloses a number of differences but reveals that the two poetics (and the two poets) had a surprising amount in common. In particular, it sheds new light on Breton's theory of the image that, as he admitted himself, derived from experiments initially performed by the Cubists. Another example of the broad debt that Surrealism owed to Cubism, Breton's conception of Surrealist imagery turns out to exemplify his understanding of inspiration as well.

Extrapolating from the preceding discussion, Chapter 6 explores Surrealism's iconic dimension. Above all, it seeks to explain how the Surrealist image functions and proposes a new model based on Roman Jakobson's distinction between metaphor and metonymy. Drawing on both art and literature, it investigates the internal dynamics of Surrealist imagery, which, I argue, operate at multiple levels.

The final two chapters are devoted to the vexing problem of textual interpretation. What is the best way to interpret Surrealist poetry, which is so notoriously difficult to decipher? In response to this question, I propose two separate but complementary solutions. After many years of trying to unlock texts that seem hopelessly obscure, I have found these strategies to be especially rewarding. I hope others will find them equally useful and will experiment with them in turn. To some extent, since they adopt a generative approach to art and literature, both models recall Noam Chomsky's invention of transformational grammar. Although they generate somewhat different insights, they allow one to enter into the artist's or the writer's mind and to recreate the works in question. Chapter 7 employs a critical methodology of my own devising based on Jakobson's discussion of metaphor and metonymy. Chapter 8 favors an approach invented by Michael Riffaterre, a proponent of structural stylistics, who has contributed immeasurably to the study of Surrealist poetry. Each chapter concentrates on a single text reflecting an encounter between a poet and an artist. The former considers a poem by the Catalan Surrealist J. V. Foix that comments on the art of his compatriot Joan Miró. The latter analyzes a poem by Breton that embodies his response to a single painting, also by Miró. Although it presents the reader with a similar challenge, one discovers that it operates in an entirely different manner. In both instances, we

are confronted with a double task: to decipher works that are apparently impenetrable and to discover how they function as *poésie critique*.

Although this itinerary is far from exhaustive, it illustrates a series of Surrealist principles and focuses on a number of major figures. One is struck, finally, by the immense vitality of the Surrealist adventure and the various movements that preceded Surrealism, which infected even minor works with unexpected exuberance. The artists and writers examined in these pages were excited by the period in which they lived, by the numerous changes that were transforming modern life. This was especially true of the earlier decades, which experienced a rapid succession of technological advances. Understandably, as Marjorie Perloff notes, they "felt themselves to be on the verge of a new age that would be more exciting, more promising, more inspiring than any preceding one."[5] In keeping with their anti-bourgeois sentiments and the emphasis they placed on creativity, Surrealism and the movements that preceded it embraced the twin goals of revolution and revelation. Although the first goal encouraged numerous people to engage in provocation and subversion, these were not their only objectives. The individuals who subscribed to the Surrealist cause, and to its various antecedents, were committed above all to producing change—social as well as aesthetic. I hope the reader will experience some of the excitement that accompanied their experiments as poets and painters vied with each other to create a new vision, and a new version, of the world around them.

2 PROBING THE
FOURTH DIMENSION

Guillaume Apollinaire
and Max Weber

One of the first hints that there might be more to reality than meets the eye was furnished by the discovery of X rays toward the end of the nineteenth century.[1] Another influential hypothesis was that the universe was not restricted to the traditional three dimensions postulated by Euclid's geometry. In addition to height, width, and depth, certain individuals were beginning to explore a fourth dimension that existed independently of the other three. These discoveries and others spelled the downfall of traditional realism, which the invention of photography had in any case rendered obsolete. Here was scientific proof that other realms existed that our five senses were powerless to detect. Indeed, according to the evidence that was rapidly accumulating, our own world was far more complex than anyone had imagined. The cult of physical exactitude favored by the Realists, the Naturalists, and the Impressionists was barely able to scratch the surface. What was needed above all was a new way of looking at things. New tools (and new concepts) were required to explore these previously uncharted regions.

Not surprisingly, X rays and the fourth dimension were frequently discussed in vanguard circles, where they were associated with different aspects of the avant-garde program. From the beginning they served as metaphors for aesthetic exploration, as models to be emulated, and even as justification for the

program itself.[2] During the first three decades of the twentieth century, as Linda
Henderson has demonstrated, the fourth dimension was "a concern common to
artists in nearly every major modern movement."[3] We will discover in this chap-
ter that it appealed to numerous writers as well, who vied with their artistic
colleagues in devising ingenious applications. Although the Surrealists experi-
mented with the concept somewhat belatedly, during the 1930s and 1940s, they
were well aware of the theories and the models that preceded them. Drawing
on earlier discussions of the fourth dimension, artists such as Yves Tanguy, Max
Ernst, Oscar Dominguez, Matta Echaurren, and Salvador Dalí explored its plas-
tic potential in painting after painting.[4] Like the Surrealist writers, they were
attracted to the notion of a higher four-dimensional reality—a *surreality*—that
they alone could perceive.

GUILLAUME APOLLINAIRE

Like the X-ray machine, the fourth dimension may be viewed in retrospect
as a kind of invention. Perhaps it would be more accurate to say that it repre-
sented the discovery of new possibilities.[5] One of the earliest authors to
discuss this concept in print—at least insofar as it pertained to aesthetics—was
Guillaume Apollinaire, who devoted several paragraphs to the subject in *Les
Peintres cubistes* (*The Cubist Painters*) (1913).[6] Although scholars have cited his
discussion repeatedly over the years, primarily in connection with modern
art, to many readers these paragraphs have seemed problematic. If critics have
not always been able to reconcile Apollinaire's fourth dimension with con-
temporary painting, they have had even less success in relating it to the
theories of Albert Einstein, Hermann Minkowski, and other scientists. Al-
though the Cubists constantly stressed the importance of the temporal
dimension in their art, for example, little trace of this invention exists in Apol-
linaire's art criticism. And yet it is impossible to deny the role of time in
Cubist painting, for its intrusion into pictorial space was one of the move-
ment's greatest innovations.[7] Similarly, the fourth dimension is associated with
time in the scientific universe, where its interaction with the three dimensions
governing space modifies the nature of physical reality.

 To be sure, the role of the temporal element in Cubist painting was not
nearly as complicated as its role in modern physics. All artists had to do to in-
corporate time into their pictures was to follow two simple procedures. First,
they were supposed to circle the object to be portrayed in order to note its
three-dimensional shape. Next they expressed a total vision of that shape by

representing it from all sides at once, translating their circular movement (and the time it required) into two-dimensional space on the canvas.[8] This is essentially the process described by Mabel Dodge in an early text on Gertrude Stein:

> To her a portrait is a series of impressions that expresses a total unity. Of course this is a grave assumption for her to make, because it is possibly assuming control of the fourth dimension. If we have any reason to admit the existence of the fourth dimension, we may presume that it is present or will be in human beings. So for any work of art to completely depict a human being in his entirety, it would be necessary for it also to contain the fourth dimension.[9]

In June 1913, when her article appeared, Dodge had recently returned from Europe where she and Stein spent a great deal of time together. Although her explanation was admittedly speculative, she was attempting to summarize ideas acquired during her trip. Her immediate source was undoubtedly Stein herself, whose recent experiments with prose portraiture followed Picasso's example closely. Thus, the description of the fourth dimension previously quoted above applied not only to literature but to art. According to Dodge, poets and artists both sought to reproduce their total vision of a given subject. What distinguished their efforts from those of ordinary mortals was their ability to perceive, to tap, to participate in the fourth dimension. Access to this realm, she explained, required the creative artist to cultivate a heightened state of awareness.

The absence of time in Apollinaire's account of the fourth dimension, which has bothered generations of critics, is matched by another puzzling feature. Insisting that the term was seriously outmoded, he abruptly terminated his discussion and moved on to a new topic. Previously applied to painting inspired by primitive art, he declared, "On n'attache plus aujourd' hui à cette expression utopique, qu'il fallait noter et expliquer, qu'un intéret en quelque sorte historique" ("This utopian expression—which needed to be noted and explained—is only of historical interest today") (PC, p.12). However, Apollinaire's words contrasted with his behavior both before and after the publication of *Les Peintres cubistes*. The fourth dimension not only continued to be an important concept for the Cubist painters but was associated with Apollinaire's name in particular.

As Apollinaire reminded Tristan Derême during the war, he had defended this influential principle on a number of occasions. "Je suis bien content qu'en fait d'édition / vous ayez la quatrième," he wrote on a copy of *L'Hérésiarque et Cie*, "puisqu'en critique d'art j'ai défendu la même / dimension" ("I am

delighted to send you / the fourth edition / since I defended the same dimen-
sion / as an art critic").[10] Indeed sections III, IV, and V of *Les Peintres cubistes*,
which contain the passage in question, seem to have evolved from a public lec-
ture. On November 25, 1911, Apollinaire spoke about the fourth dimension at
the Exposition d'Art Contemporain (which was devoted to Cubism), where his
remarks were well received.[11] Shortly thereafter, in April 1912, his lecture was
published in *Les Soirées de Paris* as "La Peinture nouvelle: notes d'art."[12] This ar-
ticle was incorporated into *Les Peintres cubistes*, which appeared approximately
one year later. Apollinaire decided to add a disclaimer as he was revising the
previous text. Prior to that there was not the slightest hint that the fourth di-
mension posed a problem.

Apollinaire divided his treatment of the fourth dimension in *Les Peintres
cubistes* into two parts. Striving to summarize the discussions that had taken
place in various *ateliers*, he began with a scientific account and concluded with
a metaphoric version. Although he seems to have presented the former out
of a sense of duty, the latter interested him much more because of its poetic
possibilities. For our purposes the article that was published in *Les Soirées de
Paris* is more revealing than the final text. In the first section, which follows,
the poet addressed the question of the artist's scientific pretensions. The
phrases that appear in (my) italics were deleted when the article was revised
for *Les Peintres cubistes*.

The new painters have been strongly criticized for their preoccupation with
geometry. Nevertheless geometric figures are the very essence of drawing.
The science of space, its measurement, and its relations, geometry has always
regulated painting.

Until now, the three dimensions of Euclidean geometry sufficed to
quell the anxieties experienced by great artists who found themselves face to
face with the infinite, *anxieties which are not deliberately scientific since art and sci-
ence are two separate domains.*

The new painters have never intended to become geometers, any more
than their predecessors did. But it may be said that geometry is to the plas-
tic arts what grammar is to the art of the writer. Now today, scientists no
longer restrict themselves to the three dimensions of Euclidean geometry.
Thus the painters have naturally come to concentrate on these new methods
of measuring space which, in the language of the modern studios, are desig-
nated collectively by the term "fourth dimension."

*Without entering into mathematical explanations belonging to another domain
and limiting myself to plastic representation,* as I conceive of it, I would say that
in the plastic arts the fourth dimension is brought into existence through the
three known measurements.

Perhaps the most surprising discovery to emerge from this document, at least for later readers, is that Apollinaire associated the fourth dimension with mathematics rather than physics. The formal definition at the beginning, the negation of Euclidean geometry (twice), the "mathematical explanations" developed by several "scientists" who were never named—everything conspired to push physics into the background where it could safely be ignored. Whereas critics have marveled at Apollinaire's apparent perversity, we will see that he was alluding to an alternate source.

IN PURSUIT OF THE FOURTH DIMENSION

At this point it is necessary to examine the options that were at Apollinaire's disposal. As Henderson has shown, the fourth dimension was associated originally with several different principles.[13] In the first place, the dominant mathematical model during this period equated the concept not with time but with space. Dating from the early nineteenth century, this interpretation was developed by Georg Friedrich Bernhard Riemann and other mathematicians who wanted to overcome some of the limitations of traditional geometry. By devising strategies to increase the number of dimensions that were available for study, they sought to explore a higher geometric reality. These models appealed to a number of artists who were searching for a higher aesthetic reality. In particular they influenced the Cubist painters, who borrowed the concept of the fourth dimension.

Although Georges Braque and Pablo Picasso do not seem to have exhibited much interest in this principle, the artists belonging to the Puteaux school were openly enthusiastic. One of the reasons they were attracted to a spatial fourth dimension is that they were attempting to restructure space themselves. "This kind of space, less real than *suggested*," André Lhote later explained, "has called forth the term ' Fourth Dimension,' employed in a figurative sense by impatient theorists who have borrowed from the mathematician's vocabulary."[14] Another reason was suggested by the prolific Spanish writer Silverio Lanza, who discerned similarities between the Cubists' artistic techniques and those utilized by mathematicians. In his opinion, Cubism and four-dimensional geometry exhibited similar patterns of thought. As he told the painters themselves,

> You have discovered the fourth dimension because your brush-strokes and your ideas resemble the generatrixes of complex surfaces, which move from one projection to another without anyone being able to determine

how. It is as if they also referred to a fourth plane of projection that we know nothing about.[15]

In the second place, Henderson explains, a mathematical traditional also existed of the fourth dimension as time going back to the eighteenth century (D'Alembert and Lagrange). Like the spatial interpretation, it had its literary adherents who popularized the concept in various works. The best known example is H. G. Well's novel *The Time Machine* (1895), which was enormously influential, leading Alfred Jarry to publish an article four years later devoted to the construction of just such a machine.[16] Interestingly, Jarry also viewed the fourth dimension as a spatial phenomenon.

The competition between these two principles, and the confusion that occasionally resulted, is illustrated by Marcel Proust as well, who identified the fourth dimension both with time and space. Evoking his protagonist's childhood in the first volume of *A la recherche du temps perdu (In Search of Lost Time)*, published in 1913, he described the village church at Combray in terms that recall H. G. Wells' book. Above all, he wrote, this venerable structure provided an important link with the past: "[C'était] un édifice occupant, si l'on peut dire, un espace à quatre dimensions—la quatrième étant celle du Temps—déployant à travers les siècles son vaisseau qui . . . semblait vaincre et franchir . . . des époques successives" ("[It was] a building occupying a four-dimensional space—the fourth dimension being Time—deploying its nave across the centuries, which . . . seemed to conquer and to bridge . . . successive eras").[17] Constructed in the eleventh century, the church was portrayed as a primitive (but highly effective) time machine connecting the present with the past. This impression was reinforced by an implicit pun: *déployer un vaisseau*, which means both "to extend the nave of a church" and "to dispatch a ship"—in this case back through time. These two actions were depicted as operations that were not only interchangeable but structurally congruent.

In contrast to the foregoing interpretations of the fourth dimension, the last two were anything but scientific. Ironically, although they both owed their existence to scientific discoveries, although they called on science to support their claims, they belonged to a radically different domain. Both developments appear to have been generated by the considerable publicity that the fourth dimension received at the time. Whereas this led to the creation of a mystical tradition on the one hand, it gave rise to a popular tradition on the other. The first version does not really concern us here. Invented by Madame

Blavatsky toward the end of the nineteenth century, Theosophy held that there was another plane of existence besides the one people were familiar with. In order to perceive this fourth dimension it was necessary to develop a superior form of consciousness. Among other things this doctrine produced a number of books, such as M. Gifford Shine's *Little Journeys into the Invisible: A Woman's Actual Experiences in the Fourth Dimension* (1911), purporting to describe life as it existed on "the psychic plane." It also produced as series of paintings by Frantisek Kupka, who had ties to the Puteaux Cubists.[18]

By this time the fourth dimension had acquired an independent existence via the public media and was very much in vogue. According to the popular tradition that soon sprang up, the term described an unearthly sphere of existence, a sort of reality beyond reality. Where this tradition parted ways with Theosophy was with regard to the ontological status of the phenomena it described. In contrast to the former movement, it simply viewed the fourth dimension as an imaginary construct. At best it provided popular writers with another interesting metaphor to exploit. Gaston de Pawlawski's *Voyage au pays de la quatrième dimension* (*Voyage to the Land of the Fourth Dimension*) (1912) typifies the kind of work this tradition produced. A scientific fantasy novel in the tradition of *Alice in Wonderland*, it was intended as little more than entertainment. That the novel was serialized in *Comoedia* while Apollinaire was preparing *Les Peintres cubistes* suggests that his last-minute decision to add a disclaimer was motivated by this event. Pawlawski's book seems to have been the proverbial last straw. Concluding that the press had hopelessly distorted the original concept, Apollinaire apparently decided to banish the term from his vocabulary.

THE ROLE OF MATHEMATICS

In retrospect, Apollinaire's remarks in *Les Peintres cubistes* were clearly inspired not by contemporary physics but by four-dimensional geometry. The vision of the fourth dimension that emerges from the first section conforms to the dominant mathematical model.[19]

While Henderson has unearthed numerous mathematical texts the Cubists could have drawn on, Maurice Princet also served as an important intermediary. An amateur of painting and mathematics who frequented the Cubists, Princet loved to speculate on the connections between modern art and the fourth dimension. Jean Metzinger and Juan Gris even studied geometry under his tutelage for a while. And yet their interest in mathematical

principles was stimulated by Cubist experiments, not the other way around as critics have occasionally claimed. The same question of precedence emerged during contemporary discussions of other artists whose originality could scarcely be doubted. Whereas one writer claimed Cubism was "Pablo Picasso's ingenious adaptation of fourth-dimensional geometry,"[20] the process proceeded in the opposite direction. "Picasso . . . fonde une perspective libre, mobile," Metzinger wrote in 1910, "telle que le sagace mathématicien Maurice Princet en déduit toute une géométrie" ("Picasso . . . has invented a free, mobile perspective from which that wise mathematician Maurice Princet has derived a whole new geometry").[21] Interestingly, Apollinaire listed Princet as an exponent of Scientific Cubism and Orphic Cubism on the proofs of *Les Peintres cubistes* (later deleted).

Whether Apollinaire learned about four-dimensional geometry from Princet or from other sources, he was highly impressed by modern mathematics. "Les mathématiciens," he wrote in 1918, "ont le droit de dire que leurs rêves, leurs préoccupations dépassent souvent de cent coudées les imaginations rampantes des poètes" ("The mathematicians can rightly claim that their dreams, their preoccupations surpass the poets' sluggish imaginations by a hundred miles").[22] Apollinaire was almost certainly thinking of the fourth dimension. And yet, despite his admiration for recent mathematical achievements, he did not believe they played a significant role in the development of Cubism. "Les nouveaux peintres font bien de la mathématique," he insisted in 1912, "sans le ou la savoir" ("The new painters practice mathematics without being aware of it or knowing anything about it").[23] The same statement appears at the end of section II in *Les Peintres cubistes*, just before the passage on the fourth dimension (PC, p. 10).

The passage from "La Nouvelle Peinture" also contains several revealing phrases (in italics) that were subsequently omitted. For in insisting on the separation of art and science ("two separate domains"), he in effect denied the possibility of interpreting one with tools belonging to the other. In *Les Peintres cubistes* this dichotomy was reflected by the appearance of the text itself: the scientific section was separated from the metaphoric section by a large space. According to Apollinaire, the mathematical model had little to recommend it. Art could never be explained by science and vice versa. The painters had come to revise their traditional concept of space "tout naturellement" not by artificial (i.e., scientific) means. Wishing to emphasize the independent character of their experiments, he expanded this statement in *Les Peintres cub-*

istes: "Les peintres ont été amenés tout naturellement et, pour ainsi dire, *par intuition,* à se préoccuper de nouvelles mesures possibles de l'étendue." ("The painters have naturally and, so to speak, *intuitively* come to concentrate on these new methods of measuring space") (PC, p. 51) (emphasis added). In Apollinaire's view, the work of art was produced by creative processes that were diametrically opposed to the deductive/inductive logic of science.

APOLLINAIRE AND MAX WEBER

Having found fault with the mathematical model, Apollinaire hastened to explore the metaphoric value of the fourth dimension. In this section he was indebted not only to Friedrich Nietzsche but to the American painter Max Weber (who was born in Russia). From Nietzsche he borrowed a brief anecdote about Dionysos pulling Ariadne's ears, which was meant to illustrate the superiority of artistic vision over scientific description, of fantasy over mimesis.[24] From Weber he borrowed a number of observations about the fourth dimension. A talented painter, Weber resided in Paris from 1905 to 1908, where he briefly attended a Matisse class organized by Sarah and Michael Stein. Joining the Parisian avant-garde at a surprisingly early date, he included Apollinaire, Picasso, Robert Delaunay, and the Douanier Rousseau among his friends. As a document in the Bibliothèque littéraire Jacques Doucet confirms, Apollinaire drew heavily on an article Weber had published in *Camera Work* entitled "The Fourth Dimension from a Plastic Point of View."[25] Consisting of a translation of this article, the document comprises six pages entirely in Apollinaire's handwriting.

Apollinaire's translation can be dated fairly precisely. Judging from clues furnished by the manuscript itself, the poet received and translated the English text between July 1910, when it appeared in print, and December of the same year.[26] At that period Weber was living in New York, where he had joined the Alfred Stieglitz group centered around the "291" Gallery. From several unpublished texts and other documentation we know he spent much of his time publicizing avant-garde developments in France. Among other things, he lectured his associates on the importance of the fourth dimension, which he defined on one occasion as "the essence of life" and on another as "dynamic energy."[27] One member of the group, Marius de Zayas, found himself in Paris in October and had a chance to apply Weber's theories to the Salon d'Automne. Describing Metzinger's *Nu (Nude)* in a letter to Stieglitz, he remarked

that the artist "sees everything geometrically. . . . To him a head represents a certain geometrical figure, the chest another, and so forth. The fourth dimension was not enough for him so he applies the whole geometry."[28] The fact that de Zayas differentiated between the fourth dimension and traditional geometry indicates that, like the Cubist painters, he regarded the former as the province of mathematics. What made Metzinger's painting so remarkable was that it incorporated both traditional and nontraditional principles.

Because Apollinaire and Weber do not seem to have been especially close, the article in *Camera Work* was probably communicated to him by somebody else—perhaps by Gertrude or Leo Stein, whose residence on the Rue de Fleurus had provided them with a convenient meeting place. It is astonishing, in any case, how little time elapsed between the article's publication and its translation by Apollinaire. The poet seems to have had closer ties to the American avant-garde than anyone has imagined. By 1914, of course, he was actively collaborating with the Stieglitz group.[29] Why Apollinaire chose to translate Weber's article quickly becomes apparent. Although the fourth dimension had been discussed in artistic circles for years, no record of those conversations existed. Attempting to relate the concept to artistic practice, first in a lecture and then in printed form, Apollinaire supplemented his memories with generous borrowings from Weber's text. To facilitate the comparison of these two documents, which follow, the relevant sections have been italicized.

Les Peintres cubistes

Considered from a *plastic point of view*, the fourth dimension is *brought into existence through the three known measurements*: it represents the *immensity of space in all directions at one time. It is space itself, the dimension of infinity; it is what gives objects their plasticity. It gives them the proportions they deserve in a work of art*, whereas in Greek art for example a kind of mechanical rhythm continually destroys their proportions.

Greek art possessed a purely human conception of beauty. It took man as the measure of perfection. *The art of the new painters takes the infinite universe as its ideal*, and it is to this *ideal* that we owe a new measure of perfection allowing the artist to give the object proportions in accord with the degree of plasticity he wishes to achieve. . . .

"The Fourth Dimension from a Plastic Point of View"

In plastic art, I believe, there is a fourth dimension which may be described as the consciousness of a great and overwhelming sense of *space-magnitude in*

all directions at one time, and is *brought into existence through the three known measurements*. It is not a physical entity or a mathematical hypothesis, nor an optical illusion. It is real, and can be perceived and felt. *It* exists outside and in the presence of objects, and *is the space that envelopes* a tree, a tower, a mountain, or *any solid*; or the intervals between objects or volumes of matter if receptively beheld. It is somewhat similar to color and depth in musical sounds. It arouses imagination and stirs emotion. *It is the immensity of all things. It is the ideal measurement,* and is therefore as great as *the ideal*, perceptive or imaginative faculties of the creator, architect, sculptor or painter.

Two objects may be of like measurements, yet not appear to be of the same size, not because of some optical illusion, but because of a greater or lesser perception of this so-called fourth dimension, *the dimension of infinity*. Archaic and the best of Assyrian, Egyptian, or Greek sculpture, as well as paintings by El Greco and Cézanne and other masters, are splendid examples of plastic art possessing this rare quality. A Tanagra, Egyptian, or Congo statuette often gives the impression of a colossal statue, while a poor, mediocre piece appears to be of the size of a pin-head, for it is devoid of *this boundless sense of space or grandeur*. The same is true of painting and other flat-space arts. A form at its extremity still continues reaching out into space if it is imbued with intensity or energy. . . .

These texts coincide, or nearly, in at least eight places. The French version of Weber's article is even closer to Apollinaire's text. Although the two men do not always employ an expression in exactly the same way, their theories of the fourth dimension were obviously closely related. Apollinaire seems not only to have borrowed several concepts from the painter but to have appropriated a number of phrases. However, before concluding that he was guilty of plagiarism, one should remember that these notions did not originate with Weber. The latter was indebted to French artists and writers for most if not all of his ideas, which he acquired during his apprenticeship in Paris. It is even possible that portions of his discussion derived from previous conversations with Apollinaire. Thus, the poet was simply reasserting the right of the French avant-garde to this important discovery. The path of aesthetic exchange was circular rather than linear. Exported to the United States in 1908, where it prospered, the fourth dimension returned to its homeland a few years later basically unchanged.

Rather than analyze each borrowing in detail, it is more rewarding to consider the theories underlying these two texts. As noted previously, the role of time is extremely restricted in both documents. It is the notion of space that receives all our attention, that seems to govern the creation of modern

art. Apollinaire even declares that the fourth dimension "is space itself." And Weber proclaims that to apprehend it the observer must experience a sensation of boundless space. As the first author explains, the fourth dimension "represents the immensity of space in all directions at one time"—which echoes an identical statement by his American colleague.[30] And yet this sentence contrasts rather strangely with the theoretical stance it purports to describe. Despite Apollinaire's commitment to the spatial model, which is readily apparent, he appears to some scholars to associate the fourth dimension with a temporal dimension.[31] How else is one to interpret the words "at one time," they demand, which place the model within a temporal framework? The same situation prevails in Weber's text, which actually mentions the word "time."

At this point one begins to understand why previous critics have sought to link the fourth dimension in art to Minkowski's theories. For Apollinaire's description closely resembles the model of the space–time continuum proposed five years earlier.[32] However, Henderson has conclusively demonstrated that the avant-garde was unaware of Minkowski's theories until after World War I. Additional research reveals, moreover, that Apollinaire's statement was never intended to comment on the role of time. Through what was essentially a misunderstanding, the sentence wound up saying much more than it was originally supposed to. The real culprit was not Minkowski but Weber and Apollinaire, both of whom had an imperfect command of English. As it originally read, Weber's description of the fourth dimension was highly ambiguous. Whereas he declared that it radiated outward in every direction "at one time," a native speaker would have said "at the same time" or "simultaneously." Not realizing that this was what the painter meant, Apollinaire translated the expression literally: "at a given moment," leading to the confusion described previously. Because the fourth dimension was linked in his mind to spatial constructions, it never occurred to him that it could describe anything else.

As originally conceived, therefore, the Weber–Apollinaire definition portrayed the fourth dimension as a purely spatial phenomenon. However, it differed from that envisioned by modern artists in one respect. Both men associated the fourth dimension with what might be called centrifugal simultanism as opposed to the centripetal simultanism of the Cubist painters, who focused inward on the object they were portraying (and who circled around it). As such, the opposition is essentially between expansion and con-

traction, between an open form and a closed form. By contrast, the definition provides an excellent description of simultanism in poetry, a form that was to find its apotheosis in the concentric circles of Apollinaire's "Lettre-Océan" in 1914.[33] With the poet at its center, simultanist poetry radiated outward in every direction at once, encompassing first the life of the quarter, then of the town, the nation, the continent, and eventually the world.

In addition, the definition contains a fundamental theme pervading all of Apollinaire's work. Michel Décaudin describes this thematic element as "[le] rêve d'une éternité qui, abolissant le temps, permet une connaissance simultanée et universelle" ("[the] dream of an eternity which, having abolished time, will facilitate simultaneous and universal knowledge").[34] Apollinaire's yearning for an infinity characterized by omniscience and ubiquity, free from the constraints of time, can be seen in the definition given previously. Whoever knows how to activate the fourth dimension, where everything is immobilized before the creator's all-encompassing gaze, usurps a function formerly reserved for God. Given the structural and thematic importance of this dimension for Apollinaire, one would like to know more about Weber's role here. Although he published a book of *Cubist Poems* in 1914, his poetry betrayed little affinity with the artistic movement and no trace whatsoever of simultanism.

NEW PERSPECTIVES

For both Weber and Apollinaire the fourth dimension was dominated by two constants: the illusion of infinite space, examined previously, and subjective perspective. In this regard it mirrored the preoccupations of the painters themselves, who were exploring new ways of conceiving space and form. If anything the second notion was even more important than the first. It aimed to revolutionize traditional art by introducing new laws of composition as well as proportion. It was essential that objective reality be made to yield to a personal and arbitrary reality. This was the subject of Apollinaire's final paragraph, which stressed the mental operations that were involved in creating modern art. These remarks elicited some snide comments from Jacques Blanche one year later, in a preface to a catalogue of paintings at the Galerie Brunner. Appearing in the newspaper *Paris-Journal*, Apollinaire's rebuttal deserves to be quoted for the light it sheds on his earlier commentary. Once again he sought to distance Cubism from contemporary mathematics

and insisted on its cerebral foundation. In addition, the final clause, which evoked the abolition of traditional perspective, provided an excellent definition of the fourth dimension in art.

> M. Jacques Blanche, who is an intelligent man nevertheless, has adopted the shrill and pretentious tone which is so fashionable in order to inform us that there is an "increasing tendency to confuse the plastic arts with mathematics or metaphysics. We have become so cerebral the artists are trying to suggest the fourth dimension on a two-dimensional canvas." Well, the gentleman is obviously confusing sensibility with mathematics. Depicting the third dimension on a two-dimensional canvas is not supposed to be cerebral, according to M. Jacques Blanche, but trying to discover the composition and true proportions of objects is.[35]

In abolishing the traditional rules of perspective the Cubists discovered that they were free to combine multiple views of an object seen from different angles. They also discovered that the size of an object no longer depended on its distance from the viewer but on subjective criteria instead. In this context the *Petit Robert* dictionary provides the following definition: "*Proportion. Rapport de grandeur entre les parties d' une chose, entre une des parties et le tout, défini par référence à un idéal esthétique*" ("*Proportion.* Relation of size between the parts of one thing or between one of the parts and the whole, defined by reference to an aesthetic ideal"). Interestingly, although Weber and Apollinaire agreed that this ideal should be the universe rather than man, they focused on different aspects of the fourth dimension. At first glance, they appeared to disagree not only about the role of the universe with regard to the object but about the relation that existed between them. Whereas Apollinaire emphasized the importance of the creative act, Weber concentrated on the visual impression received by the viewer. For Apollinaire modern proportion was distinguished by a new sort of conception; for Weber it constituted a new kind of perception.

In Weber's scheme the fourth dimension, which represented the limitless size of the universe, was the source of physical size in general. The size of an object varied, in the viewer's eyes, to the extent that it partook of the fourth dimension. In acquiring the dimension of infinity the object succeeded in transcending its natural state, in overcoming the limitations imposed by its three-dimensional existence. Although Apollinaire was mostly interested in proportion's conceptual possibilities, as noted, he also subscribed to much of this theory. Ironically, while he rejected the fourth dimension early in *Les*

Peintres cubistes, he continued to make use of the concept as he progressed. However, since the term itself was now taboo, he was forced to resort to circumlocutions and synonyms to conduct his discussion. Apollinaire adopted this strategy in the section devoted to Albert Gleizes, for instance, whom he knew to have been influenced by four-dimensional geometry. Describing the impact of Gleizes's art on the viewer, he chose to speak of the paintings' majesty. "Cette majesté," he observed, "éveille l'imagination, provoque l'imagination et considerée du point de vue plastique elle est l'immensité des choses" (PC, p. 33). This statement was taken in turn from Weber's article, where it served to introduce the section on proportion. Seeking to define the fourth dimension "from a plastic point of view," Weber declared: "It arouses imagination and stirs emotion. It is the immensity of all things."

Apollinaire alluded to the role of the fourth dimension in Gleizes's work again in the next paragraph. This time he decided to depict it not as a majestic presence but as a monumental force. "Les tableaux d' Albert Gleizes," he proclaimed, "sont réalisés par une force de même sorte que celles qui ont réalisé les Pyramides et les cathédrales, qui réalisent les constructions métalliques, les ponts et les tunnels" ("Albert Gleizes's paintings are generated by the same kind of force that generated the Pyramids and the cathedrals, that generates steel structures, bridges, and tunnels today"). As before, the source of this statement was Weber's article, which cited the Acropolis and certain "Palatine structures" as examples of dreams realized through plastic means. Consistent with his earlier rejection of Classical beauty, Apollinaire eliminated the references to Greek and Roman architecture. In his opinion, Classical style suffered from a mechanical rhythm that interfered with a true sense of proportion. (Interestingly, he seems to have borrowed this idea from Picasso.)[36]

However, Apollinaire's initial discussion of the fourth dimension in *Les Peintres cubistes* was motivated by a different concern. If he still took the infinite as his aesthetic ideal, it was a question of artistic perspective rather than of viewer response. The problem with traditional perspective—"ce truc misérable" ("that miserable gimmick") as he called it elsewhere (PC, p. 44)—was that it restricted an object to a preordained size according to its position on the canvas. It represented a sort of "quatrième dimension à rebours" ("fourth dimension in reverse"), he explained, because it served as "un moyen de tout rapetisser inévitablement" ("an inevitable means of shrinking everything"). By contrast, modern perspective allowed artists to enlarge any detail whatsoever in their works. A painting's background suddenly became as important

as the foreground, since all objects were equal from the point of view of infinity. They differed from one another only in the amount of interest they generated among contemporary observers on earth. In the absence of absolute values, the artist strove to translate his or her subjective valuation by giving objects proportions corresponding to their importance. For Apollinaire, therefore, the fourth dimension coincided at this point with the personal vision of the painter.

Although it is tempting to speak of a "theory of relativity" here, the expression's inevitable association with Einstein makes it confusing and even misleading. It would be more accurate to say that Weber and Apollinaire both considered an object's size to be a permanent function of the fourth dimension. Although the two theories of proportion resembled each other to some extent, they were also quite different. On the one hand, the two men agreed that under certain circumstances the size of an object might appear to vary to an observer. This phenomenon seems to have especially interested the painter who viewed it as a sort of mystic union with the Infinite. On the other hand, Apollinaire insisted that artists were free to adjust an object's size in their paintings as they saw fit. For him the fourth dimension was conceived primarily as an aesthetic principle. Despite his remarks about the majestic impression conveyed by certain works, he identified with the creative artist rather than with the viewer. Although he earned his living as an art critic, he was first and foremost a practicing poet.

THE ROLE OF IMAGINATION

To some extent the differences between Apollinaire's and Weber's texts can be ascribed to differences in their authors' personalities. As the years passed, while the former continued to explore the metaphoric properties of poetry, the latter developed a mystic strain that became more and more pronounced. Toward 1920 it caused him to abandon the avant-garde and spend the rest of his life painting religious themes. In addition, chronological factors were even more decisive in determining the shape each document would assume. As Henderson points out, Weber's discussion of the fourth dimension was seriously out of date by the time Apollinaire began to write about this subject. Because the painter left Paris in 1908, before Cubism existed, his remarks reflect an earlier, less consciously developed philosophy. What makes his article so important is that it constitutes an aesthetic time capsule. In Weber's mind the fourth dimen-

sion was associated with Fauvist painting, not with the school that supplanted it. As such it was concerned with color and line rather than with overlapping planes. By contrast, Apollinaire's discussion displays his familiarity with Cubist doctrine, which adapted the earlier theory to its own ends.

Where the two theories coincided was in the importance they assigned to the creative imagination. Thus, Weber defined the fourth dimension in once place as the creative artist's "ideal perceptive or imaginative faculties." And Apollinaire reached approximately the same conclusion in *Les Peintres cubistes*. "Ajoutons," he interjected in passing, "que cette imagination: 'la quatrième dimension,' n'a été que la manifestation des aspirations, des inquiétudes d'un grand nombre de jeunes artistes" ("One should add that this imagination: 'the fourth dimension' merely reflected the hopes and anxieties of a large number of young artists"). This statement served more as an equation than as a declaration, for the colon established a fundamental equivalence between the two terms. Situated at the end of section III, it recapitulated the previous discussion and imposed the metaphoric definition for once and for all. If Apollinaire focused on other aspects of the fourth dimension previously, ultimately the concept was subsumed under the heading of imagination.

Encountering *Les Peintres cubistes* for the first time nine years later, William Carlos Williams grasped this fact immediately. During 1922 the *Little Review* published a translation by Mrs. Charles Knoblauch that attracted considerable attention. Following the first installment, which he eagerly devoured, Williams sent an enthusiastic letter to the editor. "I enjoyed thoroughly, absorbedly, Apollinaire's article," he wrote, which gave him a sense of having finally "arrived."[37] How much he benefited from the poet's discussion became evident the following year with the publication of *Spring and All*. As Marjorie Perloff observes, this experimental mixture of poetry and prose pays homage to *Les Peintres cubistes*.[38] Although the book contains a number of references to the latter volume, one passage stands out in particular:

> And what is the fourth dimension? It is the endlessness of knowledge—
> It is the imagination on which reality rides—It is the imagination—It is a cleavage through everything by a force that does not exist in the mass and therefore can never be discovered by its anatomization.[39]

Like Apollinaire, Williams equated the fourth dimension with the realm of the imagination. Because this domain was purely imaginary, it could never be apprehended by ordinary, three-dimensional methods. Writing in 1917,

the Mexican author Amado Nervo came to much the same conclusion. "Todas las contradicciones de la vida, sus ilogismos, sus antinomias," he asserted, "dependen sencillamente de que no vemos en el mundo más que tres dimensiones" ("All of life's contradictions, its illogicalities, its antinomies . . . simply stem from the fact that our perceptions of the world are limited to three dimensions").[40]

Returning to the texts by Weber and Apollinaire, one perceives that imagination constitutes a major theme in both instances. Although this theme is easier to detect in the 1910 article, where it is more pronounced, it is just as pervasive in the passage from *Les Peintres cubistes*. Linked initially to hypothetical creations ("cet idéal"), it is equated with cerebral processes in a later paragraph and lastly with metaphysical operations. Viewed from this angle, the fourth dimension can be seen to be identical to the creative impulse. Interestingly, Williams comes to the same conclusion in *Spring and All*, where the force that cleaves through everything is identified with poetic creation. The following pronouncement, which is taken from Weber's article, could also have served as Apollinaire's motto: "Only real dreams are built upon." As we will see in Chapter 5, the same idea recurs throughout Apollinaire's writings together with the same oxymoronic vocabulary.[41] Functioning as an important structural device, it engendered most if not all of his creative works.

Of course, Weber and Apollinaire were not the only ones to identify the fourth dimension with imaginative processes, since a similar tradition existed among the Cubist painters. If these artists sought to "completely depict a human being in his entirety," as Mabel Dodge asserted, they accomplished this exercise mentally without actually walking around their subject. In other words, they juxtaposed a series of mental pictures to form a composite image, which is how imagination is usually defined. Insofar as Cubism represented an art of conception rather than perception, therefore, it should also be regarded as an art of imagination. Among other things, the Dodge-Stein (-Picasso?) definition was shared by the critic Maurice Raynal, who perceived a link between Cubism and artists like the Douanier Rousseau. "The Primitives," he wrote in 1913, "instead of painting the objects as they saw them, painted them as they thought them, and it is precisely this law that the Cubists have readopted, amplified, and codified under the name of 'the Fourth Dimension.' "[42]

A somewhat different perspective was provided the same year by Francis Picabia, whose Dada portraits are the subject of the next chapter but who belonged to the Puteaux Cubists at the time. Arriving in New York for the

Armory Show, where he was exhibiting several pictures, Picabia quickly suc-cumbed to the spell of the metropolis. How this experience affected his painting, and what form it took, will be discussed in the next chapter. For the moment it suffices to note that it motivated him to paint a series of abstract pictures of New York. As a representative of the most "advanced" school of art, moreover, Picabia received a great deal of attention from the press. Dur-ing one interview, he explained to a reporter from the *New York Globe* that his paintings strove to reproduce "the 4th dimension of the soul, but not the 3rd dimension of actuality." His abstract studies of New York contained few traces of the city itself, he continued, but "only the results of the skyscrapers and the city upon my temperament."[43]

Although these remarks were rather vague, Picabia was attempting to de-scribe the role of imagination in his art. This was the subject of the first sentence, structured around a four-term homology, in which the word "soul" was opposed to "actuality." The fourth dimension was concerned not with ex-ternal reality, where Euclidean (and Cartesian) principles prevailed, but with inner reality that was governed by different principles. "For the Cubists," Hen-derson explains, "the most general usage of 'the fourth dimension' was to indicate a higher reality, a transcendental truth that was to be discovered indi-vidually by each artist."[44] Thus, Picabia was referring to a form of discovery associated with psychic activity. Similarly, Lhote relegated this experience to "a metaphysical dimension attached to the domain of the spirit."[45] Picabia's second sentence alluded to the initial stimulus that set the creative process in motion. The artist's impressions of the city triggered a series of thoughts that he attempted subsequently to express in his paintings. Once again, therefore, the fourth dimension was depicted as the realm of the imagination.

Since Apollinaire knew the fourth dimension played a role in Picabia's art, he adopted the same strategy in *Les Peintres cubistes* that he had used for Gleizes. As before, he resorted to circumlocutions and synonyms without actually nam-ing the principle in question. Instead of praising the "majesty" of Picabia's compositions, Apollinaire chose to identify the fourth dimension with the structural use of color. Because he had recently fallen under the spell of Robert Delaunay's paintings, he added a reference to this artist at the last moment. "[Pi-cabia] abordait ainsi un art où comme dans celui de Robert Delaunay, la dimension idéale, c' est la couleur. Elle a par conséquent toutes les autres di-mensions" ("Thus [Picabia] began to experiment with an art like Robert Delaunay's, in which color constitutes the ideal dimension. It encompasses all

the other dimensions as a consequence") (PC, p. 45). Like the expression "la dimension idéale," this idea was probably suggested by Weber's article, which drew an analogy between the fourth dimension and color and depth in music.

Whatever the explanation, it is easy to show that Apollinaire appropriated another section virtually wholesale. "La couleur dans cet art est saturée d'énergie," he declared, "et ses extrémités se continuent dans l'espace. La réalité est ici la matière. La couleur ne dépend plus des trois dimensions connues, c'est elle qui les crée." Despite several departures from the original text, this was a faithful rendition of a passage in Weber's article. "A form at its extremity," the painter proclaimed, "still continues reaching out into space if it is imbued with intensity or energy. The ideal dimension is dependent for its existence upon the three material dimensions . . . through matter." Like the artist, Apollinaire resorted to the standard mathematical metaphor to express the relation between the different dimensions. Whereas Weber portrayed the fourth dimension as the product of the other three, he preferred to reverse the process. Where color was concerned, the fourth dimension was the source of the other three. This much he had learned from Delaunay, who believed that height, width, and depth could be suggested by contrasting complementary colors.

LATER DEVELOPMENTS

The publication of Einstein's General Theory of Relativity in 1916 marked a crucial turning point in the history of the fourth dimension. The popularization of his theories in Europe and the Americas during the 1920s transformed this concept into a temporal principle by the end of the decade if not before. Except for occasional avant-garde groups, Alan Friedman and Carol Donley note, the general public remained unaware of Einstein's theories until after World War I.[46] Einstein emerged as a celebrity in November 1919, when photographs of a solar eclipse confirmed that light waves were bent by gravity, as he had predicted.

By 1930, the concept of a fourth spatial dimension was largely obsolete. During the next two decades only the Surrealists continued to explore some of its implications, which complemented their interest in Einstein's temporal theory.[47] Since existence was elsewhere, as the First Manifesto declared, they constantly searched for new domains in which to situate it. Discussing recent tendencies in Surrealist painting in 1939, Breton identified the need for "une représentation suggestive de l'univers quadridimensionnel" ("a suggestive rep-

resentation of the fourth-dimensional universe"). The young painters of today, he continued, are united in their desire to

> passer outre à l'univers à trois dimensions. Bien que ç'ait été là, à sa période héroïque, un des leitmotive du cubisme, il faut convenir qu'une telle question se pose d'une manière beaucoup plus aigüe à partir de l'introduction en physique de la conception de l'*espace-temps* par Einstein ("transcend the three-dimensional universe. Although this was one of Cubism's leitmotifs during its heroic period, the question has admittedly become much more urgent since Einstein introduced the concept of *space-time* into physics").[48]

As Henderson remarks, Breton considered four-dimensional geometry to be perfectly suited to his arguments for a new "surreality." "The advent of Einstein and Relativity," she declares, "did not negate for Breton the earlier significance of the new geometries. Instead, Relativity simply added a second, temporal definition to the fourth dimension and, in his view, further undermined accepted ideas about the nature of reality."[49] As we have seen, moreover, the spatial fourth dimension had certain mystical associations bordering on the irrational that dovetailed with the Surrealist agenda. For these and other reasons, many Surrealists continued to evoke a fourth dimension that owed more to mathematics than to physics. In contrast to other forms of modern art that were springing up around it, Surrealism continued to investigate the possibilities of space. "As a result," Henderson concludes, "it was through the Surrealists that the fourth dimension and non-Euclidean geometry had their last broad impact on early modern art."[50]

3 THE DEMISE
OF THE OBJECT

Francis Picabia
and Marius de Zayas

Like the Cubist painters and poets, the Dadaists also sought to transcend the three-dimensional universe. Although they appropriated several of Cubism's discoveries, which they exploited in various ways, they transformed them until they were virtually unrecognizable. Whereas the Cubists wished to demonstrate the complexities of modern reality, which was perceived as a mental and experiential construct, the Dadaists strove to destroy that reality altogether. They were opposed not only to realism itself, but to the world that it reflected, to the corrupt society that had embroiled Europe in the First World War. Determined to invent their own reality, the Dadaists insisted on wiping the slate clean so they could start from scratch. Having reduced artistic expression to its barest essentials—color and line—they began to experiment with brand new forms. As the movement gained momentum, Marius de Zayas and Francis Picabia focused their attention on objects, which had survived Cubism's insistent dissection relatively unscathed. What interested them was not the latter's material properties so much as the ways in which these could be manipulated. Working together over a period of several years, they succeeded not only in redefining the role of the object but in reconceptualizing it altogether.

MARIUS DE ZAYAS

"Il y avait des dadaïstes avant que n'existe pour Dada le nom Dada et que les dadaïstes ne soient Dada" ("There were Dadaists before the name Dada existed for Dada and before the Dadaists were Dada"), Jean (Hans) Arp once declared with a paradoxical flourish. Like Surrealism, as we will see in Chapter 5, Dada existed in spirit several years before it became an official movement. Well before Tristan Tzara and his friends invented the name, a number of individuals were experimenting with radical anti-art techniques. The Surrealist writer José Pierre is more specific: "Si l'appellation Dada vient indéniablement de Zurich, l'esprit Dada se manifeste tout d'abord à New York . . . Baptisé en Suisse en 1916, l'enfant—peut-être conçu à Paris?—était né à New York en 1915" ("If the term was invented in Zurich, the Dada spirit first became evident in New York . . . Baptized in Switzerland in 1916, the infant—conceived perhaps in Paris?—was born in New York in 1915").[1] Although Francis Picabia and Marcel Duchamp were important catalysts in New York, frequenting the Alfred Stieglitz and Walter Conrad Arensberg circles, numerous Americans made significant contributions as early as 1912.[2] One of these was Marius de Zayas who, as Stieglitz's closest associate, was responsible for many of the achievements often credited to his chief.

Born into a cultured and artistic family in Veracruz, Mexico, de Zayas became an illustrator and caricaturist for *El Diario* (*The Daily News*) in Mexico City. When the dictatorship of Porfirio Díaz forced his family to flee to the United States in 1907, he obtained a similar position on the New York *Evening World*.[3] Depicting personalities of the day with great verve and humor, de Zayas seems to have become something of a celebrity almost immediately.[4] Shortly after his arrival in New York, he made the acquaintance of Stieglitz, who admired his caricatures. His first one man show at "291" was in January 1909, followed by two others in 1910 and 1913. In the ensuing years, de Zayas wrote a number of articles for *Camera Work* and other magazines, acted as European agent for Stieglitz, edited the review *291*, and opened two galleries of his own: the Modern Gallery (1915–1918) and the De Zayas Gallery (1919–1921). His *A Study of the Modern Evolution of Plastic Form*, which he co-authored with Paul B. Haviland in 1913, was one of the earliest American attempts to understand modern art. His *African Negro Art: Its Influence on Modern Art* (1916) ranks as one of the first studies of primitive aesthetics. Catherine Turrill expresses the critical consensus when she remarks that "Marius de Zayas' chief importance for the avant-garde art movement in America lay not

in his work as a caricaturist but in his activities as an art dealer and in his asso-
ciation with several art-related publications."[5] On the contrary, we will discover
that his caricatures were at least as important as his other contributions.

The history of de Zayas's artistic accomplishments is inseparable from his
friendship with Picabia. Each artist was greatly stimulated by the other. As
William Agee observes, the exchange between them was "crucial to the em-
bryonic stage of New York Dada" (and thus to Dada in general).[6] Indeed, since
Picabia would collaborate with André Breton and his friends after the war, for
whom he represented "un des plus grands poètes du désir" ("one of the great-
est poets of desire"), the exchange was destined to have a considerable impact
on Surrealism as well.[7] De Zayas first met Picabia during the Armory Show,
which included four of the latter's iconoclastic paintings. Together with
Duchamp—whose contributions were equally scandalous—Picabia quickly
became the star of the show. During his lengthy stay in New York, Picabia de-
veloped close ties to Stieglitz and de Zayas (who spoke fluent French). The day
after Picabia's departure, in April, Stieglitz wrote to a friend:

> Picabia left yesterday. All at "291" will miss him. He and his wife were about
> the cleanest propositions I ever met in my whole career. They were one
> hundred percent purity . . . Picabia came to "291" virtually daily, and I know
> he will miss the little place quite as much as we miss him. . . . I don't know
> whether you know that an attempt is going to be made by him and Mabel
> Dodge to open a little place in Paris which is to resemble "291."
> Even Picabia was astonished at de Zayas' ability.[8]

Writing in the *American Art News* two weeks later, an anonymous reviewer
confirmed Stieglitz's words and noted: "Picabia says that [de Zayas] is greater
than any of the French producers of 'graphical and plastic synthesis of the analy-
sis of individuals,' and Picabia ought to know."[9] This testimony is rather
astonishing. Against all expectations, it reveals the considerable impact of a
provincial artist on a cosmopolitan colleague. Picabia's obvious delight with his
American friends testifies to the high quality of their accomplishments. Stressing
the mutual use of certain geometrical shapes by Picabia and de Zayas, William A.
Camfield concludes that the latter artist was influenced by the former.[10] How-
ever, Picabia's insistant praise of de Zayas suggests that the reverse may have been
true. One notes numerous parallels between them in any case. Each painter was
closely associated with the other, each was working with abstract form, and each
was seeking visual equivalents for moods and ideas. As if to stress their similari-
ties, Stieglitz decided to pair them on the "291" exhibition calendar: Picabia's
show ran from March 17 to April 5, de Zayas's from April 8 to May 20, 1913.

In Mexico and during his early years in New York, de Zayas had worked in a realistic, representational style. However much he might distort an individual's features, the portrait had to be recognizable to be effective. Struggling against the inherent limitations of caricature, de Zayas made a significant breakthrough in the period immediately preceding the Armory Show. Adopting invented forms punctuated by mathematical symbols, he developed an abstract portraiture that no longer exploited physical appearance. As Agee observes, this "new symbolic-associative language . . . was a forerunner both of the Dadaists formulae and numbers and of Picabia's object portraits of 1915–1917."[11] For many years, nothing was known about the origins of this abstract caricature, nor was it possible to decipher the hermetic drawings themselves. Although the scarcity of documentation continues to hamper investigations, a memoir published in 1973 provided the key piece to the puzzle. Recalling the genesis of his portrait of Stieglitz (Figure 3.1) nearly forty years later, de Zayas wrote:

> . . . studying the ethnographical collection at the British Museum, I was impressed by an object invented by an artist from Pukapuka or Danger Island in the Pacific [Figure 3.2]. It consisted of a wooden stick to which a few circles made of some vegetal material were fixed by pairs right and left of the stick. It impressed me particularly because it reminded me of the physical appearance of Stieglitz. I say "physical" because the resemblance was also spiritual. The object, said the catalogue, was built as a trap for catching souls. The portrait was complete, and it caught my soul, because from it I derived a theory of abstract caricature . . . which I exposed together with a few caricatures called "abstract," together with a few others which were of the "concrete" style . . . I had previously made a caricature of Stieglitz with the caption "l'Accoucheur d'idées." These two caricatures expressed my understanding of Stieglitz' mission: to catch souls and to be the midwife who brings out new ideas to the world.[12]

This account of the birth of abstract caricature provides precious insight into de Zayas's method and inspiration. Its implications are as exciting as they are far-reaching. It also explains what the artist meant when, in the preface to the exhibition of 1913, he stated: "my new procedure in caricature is inspired by the psychological reason of the existence of the art of the primitive races, which tried to represent what they thought to be supernatural elements, existing outside of the individual, elements however which science has proved to be natural and which exist within the individual."[13]

FIGURE 3.1 Marius de Zayas, *Alfred Stieglitz*

Before examining the caricatures, it is important to establish a chronology for de Zayas's invention. For while his description stressed the role of immediate inspiration, the actual outcome stemmed from his familiarity with modern art. And while his immediate source was anthropological, the principle itself

FIGURE 3.2 Soul-Catcher, Pukapuka (Danger Island)

was unmistakably artistic. Fortunately, the gestation of the abstract drawings can be reconstructed from correspondence preserved in the Alfred Stieglitz Archive at Yale University. This period corresponds to the twelve months that de Zayas spent in Paris between 1910 and 1911. Arriving on October 13, 1910, he immediately plunged into Parisian cultural life, attending the Salon

d'Automne repeatedly and mixing with the avant-garde crowd at the Café du Dôme. At this time de Zayas does not appear to have known much about modern art. In a letter to Stieglitz dated October 29, 1910, he demonstrated a familiarity with Matisse but was baffled by the Cubists, reporting with some astonishment that Metzinger "sees everything geometrically." According to his sources, he added, the latter was only an imitator: "the real article is a Spaniard whose name I don't recall." In a review of the Salon written at this time, de Zayas freely admitted his helplessness to understand the Parisian movements and wondered whether Cubism would ever amount to anything.[14]

By January 25, 1911, however, the situation had changed radically. In the interim de Zayas had met "the real article" (through Frank Burty Haviland, whose brother was one of the directors of "291"), had arranged to show eighty-three of his works at "291," and had obtained an interview to be included in the catalogue. Running from March 28 to April 25, 1911, the exhibition presented Picasso to the American public for the first time and was eventually extended. The interview was incorporated into a preface by de Zayas that was reprinted in *Camera Work*.[15] As this rapid series of events implies, de Zayas was very impressed by Picasso, and the two men quickly became close friends. Under Picasso's tutelage he gained an excellent knowledge of Cubism and became an ardent convert. De Zayas's interest in African sculpture probably dates from this encounter (in April he suggested an African show to Stieglitz), but it was the exposure to Cubism that had a lasting influence on his own art. Among other things, many of the subsequent caricatures employ geometric forms. More important, Cubism introduced him to a new concept of art and paved the way for his experiments with abstraction. If de Zayas devoted part of his preface to specific problems, such as the abolition of perspective and the absence of color, the bulk of the essay was concerned with Cubist theory in general.

At the heart of the essay lay the concept of what he called "the psychology of form," that is, the translation of intellectual and emotional responses into formal patterns on the canvas. "Instead of the physical manifestation" of an object or a scene, Picasso sought "the psychic one" in order to represent its "essence." Thus, the artist was no longer content to depict mere physical appearance. According to de Zayas,

> [Picasso] receives a direct impression from external nature, he analyzes, develops, and translates it . . . with the intention that the picture should be the pictorial equivalent of the emotion produced by nature. In presenting his

work he wants the spectator to look for the *emotion* or *idea* generated from
the spectacle and not the spectacle itself [emphasis added].

As will become apparent, the concept of essence versus appearance underlay
the invention of abstract caricature. Equally important was Picasso's theory of
pictorial equivalence from which de Zayas derived his own abstract method.
Notwithstanding their obvious stylistic differences, the two men shared a
common psychology of form. Nowhere is de Zayas's debt to the Spanish artist
more evident than in the preface to his 1913 exhibition in which he defined
abstract caricature as "the representation of feelings and ideas through mater-
ial equivalents."[16]

Written earlier, de Zayas's article on Picasso was not actually forwarded to
Stieglitz until March 7, 1911. In the accompanying letter, de Zayas remarked:
"I have started on a new idea and made some caricatures and drawings for the
philosophical collection." The correspondence breaks off after August 26, with
one important exception—a telegram. Containing an urgent request for
$150, which de Zayas said he would repay when he arrived in New York, it
bore the dateline "London, October 18, 1911." Not only does this allow us to
fix the date of his return, in early November, but it provides the only evidence
we have of a trip to London. It was doubtless at this time, pursuing the inter-
est in primitive art he had developed in Paris, that de Zayas encountered the
catalytic "soul-catcher" in the British Museum. This impression is strength-
ened by two separate bits of information. For one thing, Stieglitz wrote to
Sadakichi Hartmann on December 22, 1911: "De Zayas has developed most
remarkably and is a big fellow."[17] Coming from the leader of "291," this was
high praise and suggests a recent breakthrough. For another, external evidence
seems to limit the British Museum episode to October 1911.

After this date de Zayas did not venture abroad again until three years later.
Before this date, as far as can be determined, his caricatures were all realistic. Ad-
mittedly only a portion of his works remains, but the surviving photographs and
descriptions reveal a general pattern. According to the catalogue of de Zayas's
1913 show, entitled "Caricature: Abstract and Relative," eighteen drawings were
on display. Nine of these were published in *Camera Work* a year and a half later
with the original preface to the exhibition.[18] Interestingly, detailed analysis re-
veals that the drawings were evenly divided between de Zayas's new and old
styles.[19] In addition, it suggests that there was no sudden shift between the two
styles, as critics have assumed, which continued to exist side by side. Nor is

there any evidence that the second style was born in 1913, another frequent assumption. The most that can be said is that it was first made public in 1913.

Following his exhibition at "291," de Zayas returned to France in 1914 where he spent the summer on assignment for Stieglitz. In Paris, de Zayas quickly renewed his friendship with Picabia, who introduced him to Guillaume Apollinaire and the group centered around *Les Soirées de Paris* (*Paris Evenings*). Before long he and Apollinaire had become good friends and were collaborating on a Dadaist pantomime, together with Picabia and Alberto Savinio (Giorgio de Chirico's brother).[20] Interestingly, Apollinaire's reaction to the abstract caricatures was as enthusiastic as Picabia's had been the year before. Writing in *Paris-Journal* (*Paris Newspaper*) on July 8, he insisted that they equaled the accomplishments of the boldest contemporary painters.[21]

One week later Apollinaire published four of de Zayas's caricatures in *Les Soirées de Paris*. Besides the portraits of Stieglitz and Picabia exhibited at "291," they included drawings of Ambroise Vollard and Apollinaire himself.[22] Although de Zayas would experiment with visual poetry the following year, he seems to have published only two more caricatures before abandoning this form. Appearing in the December 1915 issue of *291*, the last example was devoted to Picasso, who resembled Ferdinand the Bull. At the center, seen in profile facing right, a triangular, horned figure gazes into the distance with beady eyes. The upper half of the drawing is dominated by a heavy structure resembling a canopy, which is balanced by the horned figure and a rectangular form at the lower right. Judging from the conjunction of the various forms, the figure (Picasso) seems to be seated before a desk or a table. To the left, behind this squat but powerful character, a rose pushes forth into the surrounding space, itself shaped like an arrowhead to indicate motion and direction. This strong diagonal, continued by other structures, adds a dynamic note to the otherwise static drawing. De Zayas has created a dialogue between beauty and power, a dialogue that he sees as central to Picasso's art. At one level, the horned figure and the rose refer to Picasso's Spanish origins, symbolized by the bullfight. At another level, they juxtapose the delicate sensibility of his Rose Period with the brutality of his Cubist phase.

THE ABSTRACT CARICATURES

To understand de Zayas's drawings fully one must go back to 1913 and the preface to his exhibition catalogue, in which he discussed his theory of abstract

caricature. Instead of depicting the physical appearance of an individual—a superficial process at best—de Zayas proposed to provide an "analysis." Art was no longer to be rendered as extrinsic impression but as "intrinsic expression." In this context, he outlined his method as follows:

1. The *spirit* of the individual was to be represented by algebraic formulae,
2. his *material self* by "geometrical equivalents," and
3. his *initial force* by "trajectories within the rectangle that encloses the plastic expression and represents life."

According to de Zayas, the spirit was composed of "[a] Memory (acquired knowledge), [b] Understanding (capability of learning, intelligence), and [c] Volition (the regulator of physical desires, vices and virtues)." By "material self" he meant the human body. Finally, he defined "initial force," which recalls Bergson's concept of *élan vital*, as that which "binds spirit and matter together." In the caricatures it is represented by a line or "trajectory" symbolizing the individual's passage through life, the quality of which is the product of his spiritual and material capabilities. De Zayas distinguished five classes of trajectory based on the Positivistic sequence: knowledge \longrightarrow progress \longrightarrow conclusion. Although these categories were meant to relate a person's life to the general "evolution of humanity," they were not judgmental so much as descriptive. De Zayas provided the following summary:

1. No beginning or end—individuals who have tacit knowledge, contribute to progress in general, but do not arrive at a conclusion.
2. An end but no beginning—same as 1 but with a definite conclusion.
3. A beginning but no end—acquisition of knowledge and contribution to progress without a conclusion.
4. A beginning and an end—acquisition of knowledge, contribution to progress, and a conclusion.
5. Inert or static individuals who do not move with the general progress. These have no trajectory whatsoever.

From this outline it is easy to see why Stieglitz, Picabia, and Apollinaire were so impressed with the abstract caricatures. Aside from de Zayas's technical mastery, his system was both sensitive and complex. Despite its obvious scientific bias, there was considerable leeway for artistic interpretation and expression. In trying to express his "feelings and ideas through material equivalents," de Zayas was aiming primarily at a "psychological representation" of his subject. Paul B. Haviland, who preferred the spelling *charachature*,

defined his goal as the "representation of character through form."[23] In actuality, de Zayas's ambition extended even further. Elsewhere in his article-preface he defined caricature as "the representation of the individual self and his relation to the whole"—a rather large order. In this light, the best assessment of his drawings was offered by Picabia who described them as "the psychological expression of man's plurality."[24]

Despite the startling originality of this system, de Zayas was heavily indebted to two schools of thought: Positivism and Cubism. His interest in the latter dated from 1910–1911, as we have seen, whereas the former seems to have captivated him at an early age. From 1911 (the date of his first article) to 1913 and beyond, these constituted the twin themes of his writings, which sought to apply the scientific method to modern aesthetics. Totally committed to the Positivist philosophy, de Zayas remarked in one place: "I believe in progress as a constant and ineludible law." Elsewhere he described himself as a "cause-and-effect speculator . . . for whom . . . all things . . . must be computed and accounted for."[25] An ardent admirer of Claude Bernard's *Introduction à l'étude de la médecine expérimentale* (1865), a cornerstone of scientific methodology, de Zayas adopted a similar approach in his 1913 preface. Envisaging a new mathematical humanism in the second paragraph, he claimed to be able to "represent psychological and metaphysical entities by algebraic signs and solve their problems through mathematics." Great as his admiration was for Picasso, de Zayas was troubled by one aspect of his work, which he interpreted as a shortcoming. In January 1913, he noted:

> Picasso is perhaps the only artist who in our time works in search of a new form. But Picasso is only an analyst; up to the present his productions reveal solely the plastic analysis of artistic forms without arriving at a definite synthesis.[26]

In inventing abstract caricature, de Zayas sought to correct what he considered a pernicious tendency in modern art—analytic fragmentation. This is why he spoke of "a graphical and plastic *synthesis*" in the preface. More than anything, the drawings were characterized by a synthetic approach to their subjects. If the artist divided his subject into three separate components, his ultimate goal was to provide a comprehensive picture of the total person. Viewing his subject from every possible perspective—subjective, objective,

and societal—he achieved synthesis in effect through multiple analysis. Although de Zayas appears to have been unaware of recent developments in Paris, this process paralleled the achievements of Synthetic Cubism since his last visit. In both cases the various parts were subordinated to the whole to produce an essential unity of vision.

Turning to the caricatures themselves, one notes a certain amount of technical variation over the years. According to *Camera Work,* the drawings in the 1913 show were done in charcoal, but the rest are in pen and ink—except *Pablo Picasso,* where the artist reverted to charcoal.[27] When de Zayas reprinted his Stieglitz and Picabia caricatures in *Les Soirées de Paris,* he made new pen and ink copies. These were remarkably faithful to the originals, but contained several minor variations. In a second portrait of Stieglitz (Figure 3.8), published in 1915, the main lines were accented with red watercolor, lending an unexpected dynamism to the composition. Although the dimensions of the later drawings are unknown, they appear to approximate the 25" × 20" format of the works exhibited in 1913.[28] In composition round forms predominate, but angular shapes are numerous and strong. The compositions are often arranged symmetrically around a vertical axis, and several include prominent diagonals. Black (mass) and white (space) occur in equal amounts, reflecting de Zayas's dichotomy between the spirit and the material self. In general, the caricatures' two-dimensionality emphasizes their schematic function, and the lack of perspective, like the absence of color and the geometric forms, is clearly Cubist-inspired. The only evidence of volume occurs in *Francis Picabia* (Figure 3.3), where it is not immediately recognizable. Here, just below the lowest "eye," the vertical edge intersects three parallel contours, suggesting a cylindrical object seen in cross section.

De Zayas's algebraic depiction of the spirit is both intriguing and frustrating. Although algebra permits a completely abstract symbolism, there is no evidence that he knew enough about mathematics to take advantage of it. Nevertheless, given his systematic, highly theoretical mind, one can scarcely doubt the existence of a complex system. Unfortunately, in the absence of any explanation by the artist, it remains resolutely personal and hermetic. The absence of algebraic devices in three of the later drawings seems to indicate that the system was eventually discontinued. For the present it suffices to note that only one of the drawings (*Theodore Roosevelt*) (Figure 3.4) contains a true equation. In all the others, the equals sign must be inferred. The equation for

FIGURE 3.3 Marius de Zayas, *Francis Picabia*

Stieglitz (Figure 3.1) is the most complex, followed by those for Agnes Ernst
Meyer and Haviland (both collaborators at "291"). This corresponds to what
we know of Stieglitz at least, who was quite a complicated person. At the
other end of the scale are Picabia and Teddy Roosevelt (Figures 3.3 and 3.4),
a rather unlikely pair. In Picabia's case the bare notation "a + b + c / a + b /
B" does not denote a mediocre spirit, but rather an inherent simplicity of

FIGURE 3.4 Marius de Zayas, *Theodore Roosevelt*

spirit. One of Picabia's most invigorating qualities was the childlike simplicity of his art and life. Both domains were governed by the principle of instant gratification (whim, fantasy, and so forth), which permitted him a refreshing directness of inspiration and execution.[29] Hence the caricature's simple arith-

metic progression corresponds to Picabia's basic thought processes. The capital B may emphasize his remarkable intelligence (Understanding), also one of his more salient characteristics.

In Roosevelt's case the lack of complexity is clearly derogatory. One suspects that the drawing was done in response to the ex-president's condescending review of the Armory Show in March 1913.[30] Described by a contemporary critic as "a sort of electric wired beartrap" with "shark teeth," this drawing is summarized by the equation $\infty/1 = 0$. As the same critic noted, what de Zayas meant to write was $1/\infty = 0$ ($\infty/1 = \infty$ not 0).[31] In either case his meaning is unmistakable: juxtaposed with the immensity of the universe, the self-important Roosevelt is insignificant. From a spiritual perspective he is a nonentity, a big fat zero. It is interesting that this is the only caricature lacking a trajectory line. Roosevelt is clearly an "inert" or "static" individual who has not contributed to real human progress. This impression is reinforced by his physical appearance, for he is mainly a mouth. A bulbous nose surmounts a wide-open mouth seen through a screen of zigzag lines. Anchored to the equation and extending in two directions, these represent his prominent moustache. The pattern at the top of the drawing repeats the vertical zigzag motif, resembling "a backgammon board or a row of dunce's caps" according to one critic.[32] Although the last suggestion has interesting possibilities, the white triangles probably represent Roosevelt's teeth. Displaced, flattened, and juxtaposed according to Cubist practice, they are partially screened by the black triangles of his moustache, which parts to reveal a flashing smile (a Roosevelt trademark). All in all, the portrait is quite humorous.

With the exception of *Theodore Roosevelt*, de Zayas's published abstract caricatures depict people he knew and admired. And since they were all successful avant-garde artists or critics, their portraits resemble each other in some respects. This is noticeable in the trajectories chosen to represent their passages through life. Although these are occasionally difficult to identify, their meanings are mostly self-evident. They should not be confused with the vertical axis in many of the drawings, which serves another function. Especially prominent in the Stieglitz, Meyer, and Haviland portraits, this device contributes to their general symmetry and introduces a note of stability. If these persons are more complex than their companions, as we have seen, they are also much more organized. In most instances the trajectory itself sweeps through the portrait in a graceful curve, intersecting the frame (symbolizing

life) initially and terminally. Since even the exceptions observe the rule of double intersection, these are all drawings of the fourth class of trajectory (having a beginning, middle, and end). Their subjects are all clearly achievers who have used their knowledge and skills to contribute to progress. Stieglitz (Figure 3.1) seems to have done this in two stages, for his trajectory contains the subtypes 3 and 2. De Zayas may have been thinking of his contribution via photography and "291." Finally, with one exception, the trajectories all follow rising curves, indicating prosperity and success. Either they arch toward the upper right corner like a bell curve, or they reverse this process, rising from right to left.

Interesting as these details are, they are overshadowed by de Zayas's theory of geometric equivalents. Although most of the drawings are highly resistant to interpretation, his experience with the Polynesian soul-catcher, described earlier, indicates the nature of their underlying inspiration. It also explains why de Zayas's visual symbolism is difficult to decipher. According to the method revealed to him at the British Museum, each of his subjects underwent a process of double abstraction. In practice this involved two steps: objectification and simplification. Once an object was chosen to represent a given person, its basic form was abstracted to produce a portrait twice removed from reality. In addition, the choice of the object depended on a double correspondence between subject and object. The resemblance had to be physical as well as "spiritual" (symbolic). The latter concept involved a search for functional equivalents in which the role of the object served as a metaphor for the role of the subject (Stieglitz the soul-catcher). If these intermediate objects are often impossible to identify, de Zayas makes it perfectly clear that objectification is at work in every instance. *Theodore Roosevelt*, for example, seems to have been constructed around the image of a common scrub brush—his moustache—perhaps symbolizing the ex-president's abrasiveness, his tendency to rub people the wrong way. Thus, in any caricature one can expect to find (1) visual reference to physical appearance, (2) visual symbolism, and (3) a certain amount of aesthetic adjustment (simplification, displacement, repetition, and so forth).

Returning to the very first abstract caricature (*Alfred Stieglitz*) (Figure 3.1), the source of all the others, one notes that it represents a significant advance over previous efforts. The earlier drawing *L'Accoucheur d'idées*, which juxtaposed a frontal, full-length view of Stieglitz with the halo of a full moon,

was entirely realistic. Despite the symbolism of the title (and the moon), the drawing was essentially allegorical and thus belonged to an established genre. If de Zayas combined an objective portrait and a metaphoric title in this work, he reversed the process in the abstract version. Here one finds a metaphoric portrait (the soul-catcher) coupled with an objective title: *Alfred Stieglitz*. In transferring his symbolism from the verbal to the visual plane, the artist gave it a central position in his aesthetic. In this particular instance the image is unusually apt. Not only does the soul-catcher symbolize Stieglitz's role as chief proselytizer for the American avant-garde, but it symbolizes his efforts as a photographer, whose task is to capture human images on film. De Zayas was undoubtedly thinking of the common primitive belief that a camera imprisons a person's soul.

Because the original soul-catcher (Figure 3.2) was already geometrical, artistic alterations of it were minimal in the caricature. De Zayas eliminated one pair of loops in the interest of symmetry, blackened the central pair for the same reason, and confined the configuration to a single plane. He then added the small, textured triangle at the lower left to evoke Stieglitz's physical appearance, which was dominated by his glasses and triangular moustache. The eyeglass motif is repeated above and below, to the right and to the left of the central pair of circles, stressing Stieglitz's all-encompassing vision. Alone of all the caricatures, this has forms that extend past the frame, which symbolizes life, and into the great Beyond. In this context, as Bailey remarks, the eyeglasses may be seen as infinity signs. A higher tribute to the leader of "291" would be hard to imagine.[33]

Although traces of physical characteristics may be seen in most, if not all, of the other caricatures, their symbolic objects are often obscured. Thus, Agnes Ernst Meyer's beauty is suggested by the long, flowing lines of her hair, a breast or two, and her eyes (Figure 3.5), but her objective symbolism escapes the viewer. If the object in the portrait looks suspiciously like an airplane soaring through the air, its upward course indicated by the same curves that represent her hair, this identification is far from certain. The portrait of Paul B. Haviland (Figure 3.6) is even more hermetic. The twin forms at the bottom, which recall Duchamp's malic molds, are totally unfamiliar, but may depict the halves of a teacup. Because he was the American representative for Haviland china, manufactured in Limoges, France, this symbol would certainly be appropriate. From the standpoint of physical appearance, the cup

FIGURE 3.5 Marius de Zayas, *Agnes Ernst Meyer*

handles undoubtedly depict his ears—his most prominent feature—that stood out at right angles from his head.[34] Similarly, the two halves of the cup, squeezing a fleshy object between them, evoke the high, stiff collar that Haviland liked to wear. Hyland suggests that they refer to the two halves of his jacket, parted to reveal a triangular necktie, and the handles to his arms, which are resting on his hips.[35] The key to interpreting the image in the middle lies in the series of parallel, M-shaped curves that give it the appearance

FIGURE 3.6 M a r i u s d e Z a y a s , *P a u l B .*
H a v i l a n d

of a fountain. Although they could represent Haviland's eyebrows, wrinkled
forehead, or hairline (or a combination of these), they probably allude to his
favorite hairstyle. His second-most prominent feature was his hair, which he
parted in the middle like H. L. Mencken. In keeping with the Cubist strat-
egy of displacement (e.g., the ears) and repetition, de Zayas abstracts and
repeats this characteristic frontal silhouette.

In like manner, the fun-loving Picabia is represented by three smiling eyes and the rounded contours of his head (Figure 3.3). Otherwise the portrait is impenetrable. The sharp corners and clean edges suggest a machine part of some sort, possibly connected with his passion for automobiles. Vaguely resembling a traffic light, the object has some of the characteristics of a (bisected) piston, seen from above. One can increase the resemblance by generating the other half according to the rules of symmetry, completing the circles (rings), and combining the black cutouts to form a single semicircle in the center (the shaft). Although these operations require a great deal of faith on the part of the viewer, we will discover in the final section that this interpretation is correct. The symbolic object in Ambroise Vollard's portrait is even more elusive. In terms of physical appearance the dealer is reduced to a pair of glasses and a pointed beard, but the role of objectification here is unclear.

Fortunately, the drawing of Apollinaire (Figure 3.7) is more accessible. Physically, the poet's bulk, his prominent eyes and eyebrows, and the smooth contour of his head are emphasized. Literally and figuratively he looms large over the picture, his enormous body crammed into the available space and overflowing the frame. If Apollinaire's physical presence is translated into heavy volumes, it is likewise evident in the bold strokes that slash through the work. Thus, despite his great size, his liveliness and love of adventure can be sensed. As in the portrait of Picabia, the sharp corners and clean lines suggest a mechanical object. Although the caricature of Agnes Ernst Meyer is fraught with ambiguity, no such problem exists here: there is little doubt that Apollinaire is represented as an airplane. For one thing, one can easily make out both wings of a biplane, extending from lower left to upper right, and connected by seven lines representing guy-wires. For another, Apollinaire's head is shaped exactly like the motor (without propeller). The two quotation-mark curves in the center probably delineate the cowl, just as the gigantic curve above his head indicates his flight path. In any case, the analogy between the soaring flight of the machine and that of the poet is unmistakable. Both symbolize the victory of mind over matter and glorify invention. The airplane is also the central image of Apollinaire's best known poem, "Zone" (1912), to which de Zayas was undoubtedly alluding.

If Apollinaire's portrait was easily the most dynamic of the series, it was rivaled by the 1915 caricature of Stieglitz as "291" (Figure 3.8). Appearing on the cover of the first issue of *291* (March 1915), with the legend "291 throws back its forelock," the drawing illustrated this gesture with broad di-

FIGURE 3.7 M a r i u s d e Z a y a s , *G u i l l a u m e*
A p o l l i n a i r e

agonal strokes. As such it announced the ambitious experimentalism of this
avant-garde publication and placed Stieglitz at its head. The original idea
was suggested by a previous anthropomorphic description of "291" by Pi-
cabia, beginning "291 arranges the locks on its forehead—but the flames
cannot scorch it, and its soul is full of life."[36] Like the earlier version, the

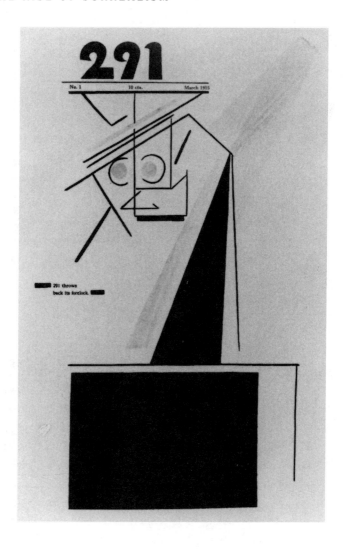

FIGURE 3.8 Marius de Zayas, *291 Throws Back Its Forelock*

Stieglitz portrait features the well known glasses and moustache. However, it is less abstract than its counterpart (Figure 3.1), and the algebraic equation has been replaced by a printed phrase. This time the key lies in the vigorous upward motion of the lines. The strong diagonals indicate that the small mass at the top (Stieglitz's head) has just popped out of the heavy, rectangu-

lar mass at the bottom. Because a jack-in-the-box is probably too irreverent an image for de Zayas's mentor, the inevitable conclusion is that Stieglitz represents a camera with extended bellows. Either object would be an apt choice. In portraying Stieglitz as a master of surprise, the artist would be stressing the avant-garde role of "291." In objectifying him as a camera, de Zayas would be focusing on his reputation as a photographer. "Stieglitz comprises the history of photography in the United States," he wrote a few months later, and in 1915 this was true.[37] The former interpretation empha- sizes Stieglitz's function as an innovator, the latter stresses his function as the eye of the avant-garde. From midwife to soul-catcher to camera or jack-in- the-box, there was a constant emphasis on revelation and personal vision in de Zayas's portraits.

FRANCIS PICABIA

Like de Zayas, Picabia developed a revolutionary style of painting in which objects played a central role. Like his friend, he was fascinated by the endless capability of mechanical forms to symbolize and/or comment on the human condition. As Camfield has demonstrated, Picabia's mechanomorphic style was born in New York during the summer of 1915.[38] Although the content and aesthetic preoccupations of his paintings remained much the same, the stylistic shift was radical. Despite the long list of European precursors cited by the same authority, little in Picabia's background suggests he was prepared to take such a step.[39] Little, that is, except his admiration for de Zayas, whose ex- periments with abstract caricature had long interested him. As we will see, these provided him with the model he was seeking and with a whole new theory of the object.

Although Picabia's art underwent a radical change in 1915, this devel- opment was not totally without precedent. Indeed, the fact that the mechanomorphic style emerged full-blown from the artist's mind, suddenly, without the slightest hesitation, points to a lengthy period of incubation. In order to trace the evolution of this idea it is necessary to examine an earlier work. The challenge to the official chronology does not come from Picabia's *Fille née sans mère* (*Girl Born Without a Mother*), which dates from either 1913 or 1915, since its mechanical shapes are far too rudimentary. It comes in- stead from an obscure watercolor entitled *Mechanical Expression Seen Through Our Own Mechanical Expression* (Figure 3.9), which the artist signed and dated 1913. If the main points of Picabia's (and de Zayas's) artistic evolution

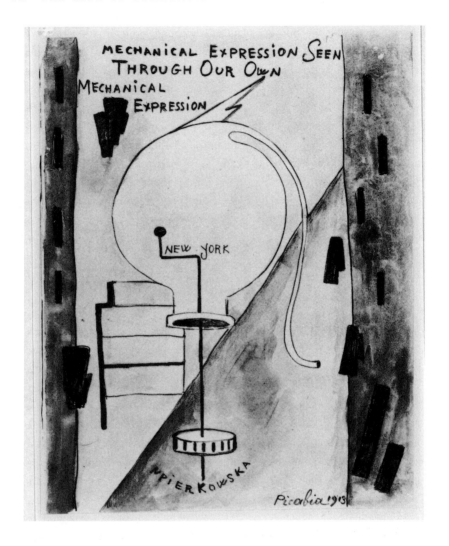

FIGURE 3.9 Francis Picabia, *Mechanical Expression Seen Through Our Own Mechanical Expression*

are clear, it is difficult to decide where this work belongs. Conceptually and stylistically, it is indistinguishable from the 1915 drawings. On the other hand, there is no reason to doubt the date of 1913, which is supported by

internal evidence. Thematically, *Mechanical Expression* is similar to to works done in New York in 1913 that, as Camfield observes, share some of the same rectangular shapes.[40] In addition, Picabia employed the term "mechanical representation" in the preface to the catalogue of his exhibition at "291" the very same year.[41] To decipher the picture requires focusing on the artist's symbolic language, that is, on his rhetorical approach to the object. A careful reading will shed light on Picabia's mechanomorphic method and will clarify his relation to de Zayas.

The viewer's first impression of the painting is one of utter confusion. Despite the presence of several labels, which are presumably meant to be helpful, it remains as inaccessible as the day it was created. If anything, the labels increase the viewer's frustration, since their promise of clarity is ultimately denied. The same is true of the title: *Mechanical Expression Seen Through Our Own Mechanical Expression,* which poses more questions than it answers. What does the artist mean by "mechanical expression," for example? How can it comment on itself? What is the identity of the mechanical object in question, which Virginia Spate has described as "an up-ended retort traversed by a bent rod"?[42] Adding to the confusion, Picabia has carelessly scrawled the title across the top of the picture as if neither one were of much importance. The fact that it is written in English is particularly surprising and tends to confirm the date of 1913. The only other work with an English title is *Catch as Catch Can,* which belongs to the same period. Above all, the viewer's attention is drawn to the mysterious object in the center of the picture that resembles an inverted fishbowl. Since a rod is visible in its interior, the object is evidently transparent. However, the triangular crest at the top provides little information, and the sinuous tube emerging from beneath it is equally puzzling.

At this point two observations are in order. Not only do the object's shape and orientation give it the appearance of a giant uterus, but it seems to be accompanied by a dangling Fallopian tube. Moreover, the rod inserted halfway inside it, which is labeled "New York," resembles a gigantic sperm. The knob at its upper end is its head, while the two right angles represent its thrashing tail. This suggests that we are dealing with a sexual metaphor involving penetration and/or fertilization. Certainly sexual metaphors are common in Picabia's art, whose erotic symbolism has often been remarked. This is especially true of the mechanomorphic works that revolve about the concept of functional analogy. The relation of this particular metaphor to the drawing's broader themes will become apparent in a moment.

At the lower end of the rod, which pierces a narrow disc, one finds the word "Npierkowska." Judging from its size and position, the disc serves as a stopper for the opening above it, which means that the object is not really a bowl but a bottle. Why Picabia has removed the bottle's stopper, allowing its contents to drain out, is not immediately evident. Fortunately, the reference to Npierkowska, who is the subject of several other paintings, presents fewer difficulties. Stacia Napierkowska was a popular dancer living in Paris whom Picabia met when he was voyaging to New York in January 1913. For the next two years aspects of this translatlantic encounter figured prominently in his work. Camfield reports that she starred in a Broadway variety show that opened at the Palace Theater on March 24 of the same year, which explains her juxtaposition with New York.[43] That Picabia has omitted the second letter of her name is initially puzzling. Recalling the latter's fondness for puns, however, which he shared with his friend Duchamp, one begins to suspect that some sort of wordplay is involved. In fact, the explanation is provided by French student slang in which *sensationnel* is abbreviated as *sensa* (or *sensas*).[44] Translating his admiration for Napierkowska's dancing into onomastic terms, Picabia indicates that she is a sensational performer (*elle est sensa*) by suppressing the letter "a" so that *elle est sans "a."*

On both sides of the bottle and stopper configuration are long narrow bands punctuated by small, dark rectangles. Spate's suggestion that these are meant to represent skyscrapers is undoubtedly correct. Indeed their shape is unmistakable. Prior to their appropriation by Picabia, skyscrapers played an important role in works by John Marin, who exhibited a series of New York studies at "291" in February 1913 that Picabia must have seen. Before long the skyscraper would be adopted by the Cubists, culminating in the French Manager's costume that Picasso designed for *Parade*.[45] As metonymic symbols of New York, the buildings provide a cosmopolitan setting here and confirm the location specified by the upper label. Because the two vertical forms are skyscrapers, the diagonal connecting them probably represents a city street. Descending from upper right to lower left, it marks the boundary between skyscraper (above) and pavement (below) and serves to unify the composition. To the left of the bottle is a rectangular object divided horizontally like a chest of drawers, which defies interpretation. It may be a schematic drawing of a skyscraper or perhaps a street sign of some sort.

Although the foregoing inventory of forms helps to situate the drawing and provides some idea of Picabia's intentions, its subject is far from clear. As in the later drawings, its symbolic meaning resides in the primary object that

until recently resisted all attempts at identification. At most, the uterine associations suggest the presence of a sexual metaphor. And while the secondary objects provide an interpretive context, they neither comment on nor explicate the central drama. To be sure, the title indicates that the stopper and bottle configuration must represent a mechanical object. But what kind of machine is housed in a glass bottle? And how does Stacia Napierkowska figure in the picture? To add to these problems, Picabia has distorted the original object in order to disguise his intentions. Despite his attempts to mislead the viewer, the fact that it represents a glass container narrows the field of inquiry to a few possibilities. Among other things, the object resembles a lightbulb or perhaps a cathode ray tube. Not only is its spherical shape promising, but it seems to possess a primitive filament and/or electrode.

Although the first interpretation is tempting, nothing about it specifically evokes the work in question. At best a lightbulb might suggest the luminary quality of Napierkowska's dancing or the bright lights of Broadway. The second interpretation, as Linda Henderson has argued at length, has more to recommend it.[46] Based on a careful analysis of the various forms, she deduces that the mysterious object is an X-ray tube. For one thing, veiled references to this invention occur in other watercolors painted at this time. For another, X rays were associated in Picabia's mind with the fourth dimension, which, as noted, preoccupied him during his visit to America. Both discoveries illustrated the concept of extrasensory perception. Thus, Henderson concludes that *Mechanical Expression* depicts a skeletal view of New York. It is an X-ray photograph taken by the apparatus positioned at its center.

However, this interpretation does not exhaust the symbolic possibilities inherent in the picture. For Picabia has also chosen to depict Napierkowska as a radiometer, which allows him to allude both to her profession and to a particular incident. For that matter, a photograph exists in which she actually looks like a radiometer.[47] Poised on one foot with her right leg extended, she raises both arms in a stylized gesture like an Egyptian hieroglyph. *Webster's Ninth New Collegiate Dictionary* provides the following definition:

> *Radiometer* . . . An instrument for measuring the intensity of radiant energy by the torsional twist of suspended vanes that are blackened on one side and exposed to a source of radiant energy.

Often seen in shop windows spinning around furiously, the radiometer is more a toy than a serious instrument. Picabia has modified the basic model considerably. Reducing the number of vanes from four to one, he has added

a (Fallopian) tube on the right and a crest on top. The latter, which resembles a bolt of lightning, recalls various signs associated with radio-telegraphy and connotes speed and energy. Perched on top the spherical container, the triangular crest gives the ensemble the appearance of a magic helmet like that worn by Buck Rogers. Picabia may be referring to the winged headgear traditionally associated with Mercury, which would reinforce the connotations noted previously and evoke the dancer's mercurial temperament. In any case, its connection with Napierkowska is self-evident. As a symbol of "radiant energy"—or rather its conversion into mechanical work—she personifies energetic activity. But the functional analogy at the heart of this work is more complex and more precise. Not only does Picabia's radiometer evoke her radiant personality, but it refers to her dancing. Like the radiometer that is fond of sunlight, Napierkowska loves to bathe in the limelight. Just as it revolves in response to solar radiation, she pirouettes furiously before the footlights. Among other things, the object portrait is a humorous commentary on her profession. Picabia posits a cause-and-effect relationship between the technical effects and her dance, as if the simple flick of a lightswitch were enough to set her in motion. Like most performers, he seems to say, she has a healthy dose of professional vanity.

So far the correspondences between radiometer and dancer seem to fit perfectly. Machine and performer obey the same laws and illustrate the same principles. For the radiometer to function, however, the vanes must be enclosed in a vacuum, which is hardly possible here. How can this requirement be reconciled with the fact that the artist has removed the stopper, allowing air to flow in and causing the mechanism to grind to a halt. The answer to this question is both humorous and unexpected. Shortly after she opened at the Palace, Stacia Napierkowska, who was fond of abbreviated costumes, had her performance closed down by the police. According to an article in the *New York Times* dated March 29, 1913, she was cited for the alleged indecency of her "Dance of the Bee."[48] This, then, is the incident that led Picabia to create his first mechanomorphic work. As *Mechanical Expression* makes clear, the authorities in effect succeeded in "pulling the plug" on Napierkowska's act. From this point of view, it makes little difference whether she is portrayed as a radiometer or as an X-ray tube, since the symbolism is identical. In addition, Henderson detects a similar functional analogy based on her identity as a dancer. Like a doctor X-raying a patient, Napierkowska strips away (her) external veils to expose (her) inner reality. On the one hand, the name of her

dance suggests that the "chest of drawers" in the background may be a stack of commercial beehives. On the other, as Henderson suggests, it may be an induction coil needed for the production of X rays.

It should be emphasized that the portrait of the hapless dancer as a radiometer (or X-ray tube) does not conflict with the sexual metaphor detected earlier. Each interpretation complements the other. A similar procedure characterizes Marius de Zayas's abstract caricatures in which a "realistic" portrait is superimposed on an object portrait. Thus, the fact the radiometer has stopped brings us to the realization that the sperm is powerless as well. Before it can enter the Fallopian tube at the upper right, it has been withdrawn by the unplugging of the vessel and rendered ineffective. The result of this act is to prevent conception from occurring. The Bee has not been able to reach the Flower. Napierkowska's attempt to fertilize New York culturally has likewise come to nothing.

Fortunately, *Mechanical Expression* can be dated fairly precisely. Since Picabia sailed for France on April 10, its composition was restricted to the period March 28–April 9, 1913. This explains why the picture was not included in his show at "291" that featured sixteen watercolors and drawings done in New York. It does not seem to have been finished in time for the exhibition, which ran from March 17 to April 5. There can be little doubt, in any case, that de Zayas's caricatures antedate this object portrait. Whereas the latter represented a single isolated experiment, the former constituted a whole new genre of expression. There is no need to invoke Gelett Burgess's *Picabia Neurasthenic Transformer*—a nonsense machine created during the Armory Show—as has been proposed.[49] Everything points to the abstract caricatures as the source of Picabia's inspiration.

As noted previously, the artist used the term "mechanical representation" in the preface to the catalogue of his "291" show. An ardent defense of the aesthetics of abstraction, the preface contrasted subjective experience with objective reality. Arguing that "the qualitative concept of reality [could] no longer be expressed in a purely visual or optical manner," it proposed a "new objectivity" in which subjective and objective impressions were combined. Although the preface was intended to justify Picabia's experiments with Cubist abstraction, it applies equally well to the drawing we have been discussing. Indeed, it provides the key to the theoretical program outlined in the title: *Mechanical Expression Seen Through Our Own Mechanical Expression.* Like the missing letter in "Npierkowska" the title involves a pun. The first reference to

mechanical expression refers to art that reproduces the external appearance of things. This art is "mechanical" in the sense that it does not require reflection but simply copies physical reality. The second reference concerns mechanomorphic art that represents reality by means of mechanical symbolism. In other words, Picabia has chosen to view traditional painting through a lens provided by machine art.

THE MECHANOMORPHIC STYLE

Mechanical Expression was thus an isolated experiment to which Picabia seems to have attached little importance. Intrigued by de Zayas's abstract caricatures, which offered interesting possibilities, he tried his hand at the genre and then let it drop. Although this style eventually led to a major breakthrough, he had neither the time nor the inclination to pursue it. In 1913, he was engaged in exploring various aspects of Cubism that demanded his full attention. When World War I broke out the following year, Picabia was living in Paris. Mobilized initially as a chauffeur, he found refuge in the United States following a series of picaresque adventures. Arriving in New York in June 1915, he resumed his friendship with de Zayas and threw himself into "291" activities with renewed vigor.[50] Already familiar with abstract caricature from his previous visit, he was moved to resume his experimentation by developments in his own art. Whereas all of Picabia's energy had previously gone into experiments with abstraction, which reached their zenith during 1913–1914, by 1915 he had tired of this form and was looking for new inspiration. Immediately contributing a drawing to *291*, edited by de Zayas, the artist collaborated on four of the remaining five issues. His mechanomorphic style did not appear (or reappear) until July, with the publication of five object portraits in *291*.[51] For viewers who had seen de Zayas's caricatures in *Camera Work*, the sense of *déjà vu* must have been overwhelming. Like the earlier works, Picabia's drawings depicted editors and collaborators on the magazine, beginning with Stieglitz, who headed both enterprises.

Picabia acknowledged his search for a new art form in an interview published in October. Speaking of his mechanomorphic drawings, he declared: "In seeking forms through which to interpret ideas or by which to expose human characteristics, I have come at length upon the form which appears most brilliantly plastic and fraught with symbolism. I have enlisted the machinery of the modern world and introduced it into my studio."[52] Although

there was no mention of de Zayas's role, Picabia's interest in "ideas" and "human characteristics" was identical to his friend's "representation of feelings and ideas through material equivalents." For each, portraiture was a psychological genre, focusing not so much on the artist's subject as on his reaction to his subject. Paradoxically, this response was expressed objectively. Both men created subjective portraits utilizing objective means—a reversal of the traditional artistic process. Whereas Duchamp's readymades began with the object (and often went no further), Picabia and de Zayas took the individual as their starting point. Whereas the Futurists sought to glorify the machine, Picabia and de Zayas were simply interested in its symbolism. Machines were the means to an end rather than the end itself. Their joint aesthetic was governed by the theory of *correspondance* linking psychological representation to a system of abstract pictorial equivalents. That various objects could be identified in the drawings did not make them any less abstract. Although Picabia's forms were easily recognizable, his works were not much easier to decipher than de Zayas's caricatures. Both artists employed a highly personal symbolism in which humor played an important part.

Picabia's humor is evident above all in his use of functional analogy in the object portraits, which inherited this device from the abstract caricatures. In general his comments are mischievous, decidedly irreverent, and even mocking at times. Although all five portraits present their subjects in a humorous light, some are more acerbic than others. This is true of Stieglitz's portrait (Figure 3.10), for instance, which appears initially to be rather flattering. Interestingly, it seems to have been modeled on the drawing of Stieglitz that de Zayas had published four months earlier (Figure 3.8). Both works appeared on the cover of *291*, both made Stieglitz the personification of "291," and both depicted him as a camera. They even utilized the same pose: a side view of the camera lying flat on its back with its bellows extended upward. Although Stieglitz was interested in many things, his main love was photography.

The portrait itself is accompanied by two phrases: "Ici, c'est ici Stieglitz" and "foi et amour." The first identifies the individual in question, while the second testifies to the "faith and love" that characterized his dealings with his friends. At the same time, however, Picabia and his associates were dissatisfied with Stieglitz's lack of leadership. He seemed to have lost sight of his original goals and to have sunk into a kind of lethargy. As Camfield and Homer have demonstrated, this situation led the artist to juxtapose three separate objects in the picture. Stieglitz is portrayed not only as a broken camera (which is

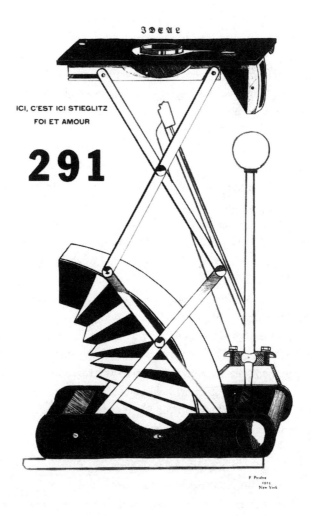

FIGURE 3.10 Francis Picabia, *Here, Here is Stieglitz*

incapable of attaining its "IDEAL") but as a gearshift stuck in neutral and as a handbrake that is still set. Even if he managed to put the vehicle in gear, it wouldn't budge. And even if he figured out how to get it moving, he wouldn't know where to go. Each of these analogies dramatizes the photographer's artis-

tic impotence, which is underlined by the flaccid condition of the camera's bel-
lows. While any one of them would have sufficed by itself, together they
constitute a devastating portrait.

By contrast the humor in *Voilà Haviland* (*Here Is Haviland*) (Figure 3.11)
is relatively subdued. Picabia was genuinely fond of his countryman, whose
views on a variety of subjects he respected. Camfield has discovered that the
drawing was based on an advertisement for the Wallace Portable Electric
Lamp, which the artist adapted to his own ends. Although Haviland is cer-
tainly depicted as a source of light, with all that this implies, the analogy is
more complicated. The fact that someone has amputated the lamp's plug
threatens to undermine the initial parallel between man and object. Without
a plug, how can either one continue to function? How can either one pos-
sibly be a source of illumination? Given the satirical bent of the other
portraits, this situation is surely not accidental. The precise reference is dif-
ficult to pinpoint, but Haviland is clearly cut off from an important source
of energy. While the absence of love, motivation, or even money are all pos-
sibilities, Picabia was probably alluding to his imminent departure for
Europe (he sailed soon after). The fact that the lamp is portable reinforces
this interpretation. Without the stimulus of "291," which we know he trea-
sured, Haviland would be deprived of his greatest source of vitality. The
inscription "La poésie est comme lui" ("Poetry is like him") may be inter-
preted to mean that neither poetry nor Haviland can flourish without vital
energy. Ultimately, the portrait is flattering since it implies that Haviland has
a poetic soul.

Entitled *Le Saint des saints* (*The Saint of Saints*) (Figure 3.12), the next
picture juxtaposes two different objects, which are framed by two phrases
and a single word: "Canter." As one quickly discovers, its subject is Picabia
himself ("C'est de moi qu'il s'agit dans ce portrait"). Because the artist had
chosen to depict the *291* editorial board, he had no choice but to include
himself. In addition to the meanings detected by Camfield, the title can be
translated variously as *The Holy of Holies, The Sacred Drawing*, and *The Sacred
Plan*. Compared to several of his colleagues Picabia gets off relatively easy,
representing himself as an automobile horn and as another automotive part.
In terms of composition the drawing resembles his portrait of Stieglitz. One
object occupies the foreground and the other the background. Thus, the
horn is not thrust into the second part, as critics have occasionally assumed,
but merely superimposed on it. The first functional analogy not only pokes

VOILÀ HAVILAND

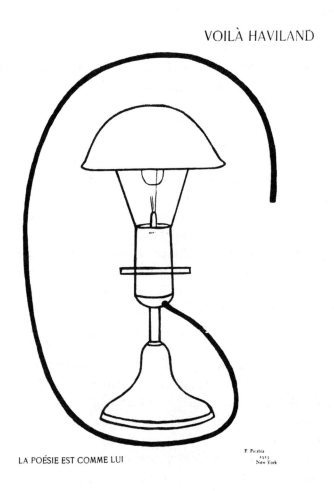

LA POÉSIE EST COMME LUI

F. Picabia
1915
New York

FIGURE 3.11 Francis Picabia, *Here is Haviland*

fun at Picabia's garrulousness, but suggests that he is basically a loudmouth. Like the sound of a klaxon, his voice is strident and insistent. Homer speaks more generally of his "noisy personality" and adds that the horn evokes his fondness for fast automobiles.

The object lurking in the background is harder to recognize and equally difficult to decipher. It requires a certain amount of experience to detect the

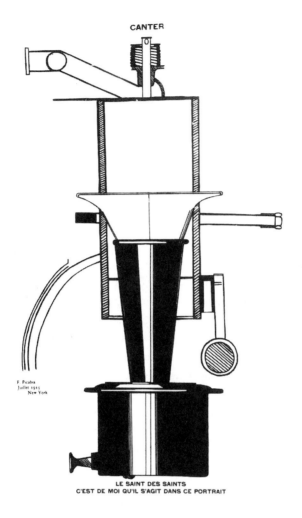

CANTER

F. Picabia
Juillet 1915
New York

LE SAINT DES SAINTS
C'EST DE MOI QU'IL S'AGIT DANS CE PORTRAIT

FIGURE 3.12 Francis Picabia, *The Saint of*
Saints

outline of a piston partially concealed by the horn. More precisely, the draw-
ing depicts a cutaway view like those found in automotive manuals. The
vertical rectangle represents the cylinder, while the horizontal line near the
bottom coincides with the piston's upper edge. Several other features can be
identified as well. The circle at the lower right, for example, appears to be a

cross section of the camshaft. And the device at the very top is part of the overhead valve assembly. The circle at the upper left represents the shaft (seen in cross section) about which the rocker arm pivots. Although the valve itself is not visible, one can make out the coil spring that closes it beneath the word "Canter." This term refers to the valve's regular up and down motion, which resembles that of a horse and rider moving at an easy gallop. Since Picabia has chosen an equestrian metaphor to describe part of a "horseless carriage," the comparison is probably meant to be humorous.

In terms of its symbolism, the second object turns out to be considerably more complex than its companion. Like the automobile horn, the piston clearly evokes some of Picabia's personal traits. In the first place, judging from his portrait of Stieglitz, it probably continues the analogy initiated by the klaxon. Since a piston also makes a lot of noise, it probably refers to his noisy personality. In the second place, it may represent the artist's forceful personality that many of his friends have commented on. Although he cultivated a relaxed manner, he usually seemed to get his way. Finally, there can be little doubt that the piston alludes to his sexual prowess, which was impressive. Throughout his life he engaged in one affair after another. Parenthetically, the fact that Picabia chose to depict himself as a piston confirms an earlier identification. In retrospect he obviously borrowed this idea from de Zayas's portrait of him (Figure 3.3), which featured the very same object. Whereas de Zayas focused exclusively on the piston itself, Picabia includes several devices that are not strictly necessary.

A review of the technical vocabulary employed by French mechanics discloses that it is surprisingly picturesque. Two of the drawing's features have interesting possibilities: the camshaft (*excentrique à cames*) and the rocker arm (*culbuteur* [literally "somersaulter" or "tumbler"]). On the one hand, Picabia may have been poking fun at his numerous eccentricities. On the other, he may have been laughing at the acrobatic existence he was forced to lead. Of course the two are not mutually exclusive. The most promising candidate, however, is the valve, whose presence is sensed as much as seen. Everything suggests that it is an exhaust valve (*soupape d'échappement*) rather than an intake valve. Like the automobile horn, this device enables the artist to satirize his talkativeness. Here is Picabia, he seems to be saying, emitting a constant stream of gas without letting anyone get a word in edgewise. In addition, Picabia is almost certainly punning on the term *soupape*, which finally permits us to explain the portrait's title. The reason he calls himself the "Saint of Saints" is because he has received an eccle-

siastical appointment. The artist has been appointed "Vice-Pope" (*sous-pape*) not because of his virtues but because of his language skills. He has been canonized through the intercession of the divine Word.

Picabia's portrait of de Zayas (Figure 3.13) turns out to be humorous as well. As Camfield has shown, part of the drawing reproduces a schematic diagram of an automotive electrical system. How this section is related to the other objects in the portrait, as well as its ultimate significance, has eluded scholars for years. Interestingly, the explanation is related to Picabia's fascination with erotic machines, which he shared with Duchamp. More precisely, the portrait belongs to the tradition of the automatic love machine, which generated a number of other works. In this instance, de Zayas is depicted not as a mechanical lover but as an automatic seducing machine. The act of seduction itself is portrayed as a two-step process. All that is necessary is to insert a coin into the slot at the top, which will start de Zayas's engine. In turn this will energize his headlights (bottom) and the sexual parts of the woman at the upper left (symbolized by a corset). The line connecting the tire valve (*valve de pneu* in French) at the upper right to the woman's nipple emphasizes the pneumatic bliss that awaits him. The comment "J'ai vu et c'est de toi qu'il s'agit" might best be translated as "I've seen you in action, and this is certainly you!" Picabia is obviously satirizing his friend's reputation as a lady-killer.

At the bottom of the picture, the exclamation "DE ZAYAS! DE ZAYAS!" is followed by the phrase "Je suis venu sur les rivages du Pont-Euxin" ("I have come to the shores of the Black Sea"). These two inscriptions are separated by a triangular view of the sea extending to the horizon. The allusion is not to Ovid, as Homer claims, but to another Classical source, Xenophon's *Anabasis* (IV.8.24). In fact, Ovid says exactly the opposite: "litore ab Euxino Nasonis epistula veni" ("I have come *from* the shores of the Black Sea") (*Tristia,* V.4.1). Glimpsing the shores of the Black Sea after their long, arduous retreat from Persia, Xenophon's soldiers burst into cries of "Thalassa! Thalassa!" "The Sea The Sea"). Picabia's exhuberant greeting, which echoes the Greek outburst, exhibits the same joy. For both parties salvation was at hand. Following a tortuous journey through war-torn France and across the ocean, Picabia had finally found refuge with his old friends in New York. Writing in the same issue of *291*, de Zayas declared: "Of all those who have come to conquer America, Picabia is the only one who has done as did Cortez. He has burned his ship behind him. . . . He has married America like a man who is not afraid of consequences."[53]

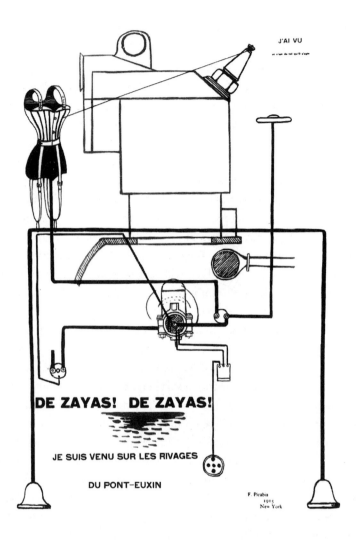

FIGURE 3.13 Francis Picabia, *De Zayas! De Zayas!*

The remaining portrait (Figure 3.14), like that of Paul B. Haviland, is concerned with a single object rather than with multiple forms. In contrast to many of the previous drawings, whose objects defy interpretation, Picabia has chosen to depict a common spark plug. Despite its lowly status, the plug's

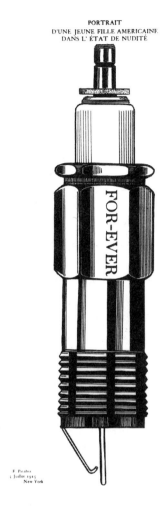

FIGURE 3.14 Francis Picabia, *Portrait of an American Girl in a State of Nudity*

clean, sleek lines give it an elegant appearance. While it could easily serve as an emblem of the machine age, its shape and pose are vaguely human. Although the portrait is nameless, Homer argues convincingly that it represents Agnes Ernst Meyer. Indeed, since the series was devoted to the *291* editorial

board, to which she belonged, it must be hers through process of elimination. At one level, the spark plug refers to her fondness for automobiles and motoring, which she shared with Picabia. One of her favorite pastimes, in which she constantly indulged, was driving her expensive limousine up and down Fifth Avenue. At another level, the object clearly refers to some of her personal qualities as well. Agnes Ernst Meyer, as Homer remarks, was a dynamic, attractive woman whose marriage to a prominent banker made her financially independent. Stressing her role as a patron of the arts, he concludes that Picabia portrayed her as "the spark that ignited the new energies within the Stieglitz group" in 1915.[54] In other words, it is meant to be a flattering portrait.

This interpretation is inconsistent, however, with the mischievous tone of the companion portraits. Here, as elsewhere in the series, Picabia plainly meant to be humorous. Fortunately, a visual poem published in *291* three months earlier provides an important clue as to how the picture should be interpreted. Entitled "Mental Reactions," with drawings by de Zayas and text by Meyer, it recorded her reactions to an attractive man at a gathering.[55] At the top, in the center of her caricature, de Zayas summarized her behavior with the notation "FLIRT." It appears that flirtation was another one of her favorite pastimes—one that irritated Picabia immensely. The artist decided to portray Meyer as a spark plug, therefore, because he regarded her as an *allumeuse* (*allumer* = "to light up"), an erotic tease who promised more than she was prepared to deliver.[56] The analogy is even closer in French since the word for "spark plug" (*bougie*) also means "candle." Picabia's personal frustration is revealed by his title: *Portrait d'une jeune fille américaine dans l'état de nudité* (*Portrait of an American Girl in a State of Nudity*). If this refers to "the inner personal characteristics of Mrs. Meyer, laid bare, as it were" (Homer), it also betrays the artist's desire to behold her in a naked state. In her capacity as a spark plug perpetually sparking men's passions, she prefigures a readymade Picabia reproduced two years later in *391* (July 1917). Consisting of a lightbulb with the inscriptions "Flirt" and "Divorce," it bore the title *Américaine*. For Picabia, then, Agnes Ernst Meyer personified American womanhood. Although she promised to be faithful "FOREVER," she and her sisters were basically fickle. Flirtation and divorce not only represented their favorite pastimes but were depicted as opposite sides of the same counterfeit coin.

From these examples it is apparent that Picabia's sense of humor differed radically from de Zayas's. It was much bolder, much bawdier than his friend's

and perfectly incarnated the Dada spirit. What made Picabia's humor so valuable, André Breton wrote in 1922, was that it sabotaged any attempt at military or artistic moblilization.[57] Not unexpectedly, the mechanomorphic drawings differ from the caricatures in several other respects. Instead of algebraic equivalents, for example, Picabia used titles and inscriptions. These were not only more accessible to the viewer but more expressive. More important, Picabia did not carry the process of abstraction as far as de Zayas. He preferred to stop after the first step, focusing on the machine itself instead of on its abstract reduction. What interested him was the concept of an illusionistic realism functioning within a symbolic framework. He delighted in toying with the viewer's expectations. The simple, clean lines of his machines implied that the correct interpretation lay at the same level. Already, however, there was a hint of Picabia's future development. By the end of the year the tendency toward further abstraction in the self-portrait and in *De Zayas! De Zayas!* led him to reject realism altogether. One of the first examples of his new style appeared in the December issue of *291*. As Camfield has demonstrated, *Fantaisie* is an extreme reduction of a nineteenth-century horizontal-beam steam engine.[58] Although Picabia was no longer interested in portraiture per se, in this and other works he returned to de Zayas's principle of double abstraction. This schematic mode, which would greatly appeal to the Surrealists, permitted him to comment on philosophical problems, personal relationships, and life in general.

Despite the object's problematic status in their pictures, De Zayas and Picabia maintained the fiction of an objective reality, at least momentarily. One title assumes a paradigmatic role in this respect: *Mechanical Expression Seen Through Our Own Mechanical Expression*. As the title indicates, Picabia, and to a lesser extent de Zayas, intended their works to serve as commentaries on realistic art. More precisely, they sought to expose the limitations of this genre by insisting on an objective paradox. Although the objects in their drawings are depicted in a realistic manner, they are devoid of meaning. Even after they have been identified, their role in the works remains unclear. Why has the artist chosen this particular object? What is its function here? These and other questions point to the inadequacy of physical appearance to interpret human experience and indicate the necessity of abstract expression. Only when one transcends the barrier of physical reality, passing from signifier to signified, does one succeed in conveying (and comprehending) the complexity of human experience. By combining abstract and realistic approaches to their subject, the two artists were able to express each in terms of the other. Not

only was a poet like an airplane, but an airplane was like a poet. Not only was a dancer like a radiometer, but a radiometer was like a dancer. While one may speak of primary and secondary metaphors here, a certain reciprocity exists between the first term and the second that ensures their basic identity.

Beginning with a concrete subject (Apollinaire, Napierkowska), the artists selected a symbolic object (the airplane, the radiometer) according to the principle of functional analogy. Utilizing an objective representation of this object, they added a symbolic dimension that referred back to the original subject. Thus, various details subvert the drawing's realistic premises and comment on the symbolic drama. Inscriptions often add another dimension by focusing the viewer's attention on an additional aspect. To the extent that the airplane or the radiometer is not immediately recognizable, the work depends on double abstraction. There are thus two barriers to be crossed before one can penetrate the artists' symbolic systems. In the last analysis, the drawings' objective character proves entirely illusory. In every instance the essential drama is enacted at the symbolic level. The same thing is true of various metaphors that are employed, which have nothing to do with the symbolic object but derive from the juxtaposition of certain forms. Far from glorifying the object, as has often been alleged, Picabia and de Zayas presided over its demise as a simulacrum of reality. Emptied of its representational content, devoid of its historical signification, the object would serve henceforth as a pretext for a variety of abstract experiments. More alibi than explanation, it would provide a familiar peg on which to hang a brand new hat.

The principal beneficiaries were the Surrealists, who combined the preceding insights with others provided by Marcel Duchamp. "Pour la première fois, une peinture devient source de mystère," Breton exclaimed a few years later in a preface to a catalogue of Picabia's paintings, "après n'avoir été longtemps que spéculation sur le mystère" ("For the first time, painting has become a source of mystery, having long been no more than speculation about mystery").[59] By demonstrating that the most mundane objects could produce a sense of awe in the viewer, by showing that objects could be manipulated to subvert (or expand) the concept of reality, de Zayas and Picabia paved the way for a series of related experiments by Breton and his colleagues. The Surrealists were even more intrigued by the possibilities of common objects than the Dadaists had been. In 1924, for example, Breton proposed to manufacture objects perceived in dreams.[60] In 1929, he exhibited the first *poème-objet*, in which objects were juxtaposed with each other to create a poetic dialogue.

By 1936, when an exhibition took place at the Galerie Charles Ratton, the Surrealists differentiated between mathematical objects, natural objects, primitive objects, found objects, irrational objects, readymade objects, interpreted objects, incorporated objects, and mobile objects.[61] "De même que la physique contemporaine tend à se constituer sur des schèmes non-euclidiens," Breton wrote the same year," "la création des 'objets surréalistes' répond à la nécessité de fonder, selon l'expression décisive de Paul Eluard, une véritable 'physique de la poésie'" ("Just as contemporary physics tends to be based on non-Euclidean systems, so the creation of 'surrealist objects' derives from the necessity to create, in Paul Eluard's masterful phrase, a genuine 'physics of poetry'").[62] Viewed in the light of the fourth dimension and non-Euclidean geometry, each object contained an infinite series of latent possibilities. To the extent that they attempt to shatter traditional reality, he concluded, "la pensée artistique et scientifique nous présente des structures identiques" ("modern scientific and artistic thought present us with identical structures").

4 GIORGIO DE CHIRICO
AND THE SOLITUDE OF THE SIGN

Although André Breton and his colleagues eventually came to despise Giorgio de Chirico, they never lost their admiration for his early works, which inspired several generations of Surrealist painters. For a period of nine or ten years, the artist created a series of brilliant paintings in which he explored the world of dreams, exploited unconscious impulses, and dramatized principles associated with the human condition. In addition, de Chirico was fascinated by the subjects examined in the preceding chapters: the fourth dimension and common objects. Like the Cubist painters and poets, he created a radical new mode of perception that thoroughly distorted the spatiotemporal universe. "La nature de cet esprit le disposait par excellence," Breton remarked in 1920, "à réviser les données sensibles du temps et de l'espace" ("His very nature led him to revise the physical coordinates of time and space").[1] Observing that traces of a modern mythology were discernible in the artist's obsession with statues and mannequins, he exhorted him to preserve its memory for future generations. Unlike the Cubists and the Dadaists, de Chirico did not reject mimesis outright but preferred to deconstruct it from within. Pretending to observe realistic conventions, he introduced visual discrepancies that undermined his claim to objectivity. Like de Zayas and Picabia, he found that objects could be manipulated to subvert the concept of reality. Like them as well, he discovered that ordinary objects could produce a sense of awe in the

viewer. Writing in 1940, Breton again linked the artist's works to modern mythology and proclaimed that they possessed

> a concrete, symbolic language that is universally intelligible, since it claims to render a highly accurate account of the specific reality of the period (the artist offering to be a victim of his time) and of the metaphysical questioning proper to that period (The relation between new objects that it happens to employ and old objects, abandoned or not, is totally overwhelming in that it exasperates one's impression of *fatality*).[2]

That de Chirico is one of the truly seminal figures of modern art is widely acknowledged, and yet, as Marianne W. Martin has remarked, it is astonishing how little is known about his work.[3] The reasons for this are many, including the lack of detailed commentary by the artist, the scarcity of intelligent criticism by his contemporaries, and the fact that many of the paintings have been inaccessible to scholars until fairly recently.[4] The principal reason, however, is that de Chirico's art is surprisingly resistant to interpretation. Toward the end of his metaphysical period the artist asserted that "ogni opera d'arte profonda contiene due solitudini" ("Every profound work of art contains two solitudes").[5] The first, he explained, could be called plastic solitude and corresponds to the picture's physical situation. Isolated inside its frame, cut off from the genius that created it, the finished work of art leads a lonely existence as a patch of color on an otherwise bare wall. As an object of contemplation it is excluded from the life around it. "La seconda solitudine," de Chirico added, "sarebbe quella dei segni; solitudine eminentemente metafisica e per la quale è esclusa a priori ogni possibilità logica di educazione visiva o psichica" ("The second solitude is that of signs, an eminently metaphysical solitude and one which excludes a priori every logical possibility of visual or psychic education").

A few years earlier, in his *Cours de linguistique générale*, Ferdinand de Saussure had noted the arbitrary nature of the linguistic sign that suffers from a similar solitude. Meaning—like language itself—is a product of social convention. There is no logical connection between a word and the concept it designates. In art the situation is somewhat different since an image is linked tautologically to the object it portrays. Outside the realm of denotative or "realistic" depiction, however, the visual sign begins to resemble its linguistic counterpart. The difficulty with symbolic art in general, as with symbolic language, is that every sign is opaque. The normal relation between signifier and signified is disrupted so that the sign depends on a larger context for its ulti-

mate meaning. By themselves signifiers—no matter how numerous—are of no use in deciphering a work unless one knows what they are supposed to signify. The viewer can only reiterate the realistic assumptions underlying its physical appearance.

This is precisely the problem with de Chirico's art whose "aspetto spettrale" ("spectral aspect"), as he calls it in the same essay, prevents the viewer from grasping his actual intentions. The problem with realistic interpretation is that the meaning of a work does not reside at the realistic level. Philosophically and artistically, true reality transcends the physical world. Among other things this explains why de Chirico called his art "metaphysical." His was an aesthetics of essence as opposed to physical appearance. Despite one's initial impression, his works are profoundly anti-realistic. Although their physical impact is important, as de Chirico himself specified, their meaning is relegated to a symbolic or allegorical plane. Unfortunately, there is very little in the paintings to indicate the nature of this ultimate meaning. On the surface they appear readily accessible, depicting familiar objects in recognizable settings whose careful execution is reassuring. In particular, buildings, statues, and objects are juxtaposed in various combinations to create a sense of mystery. The impression of intelligibility is heightened, moreover, by the artist's realistic style and his attention to detail. Not until the appearance of the mannequins in 1914 does one encounter a foreign element, and even then, startling as they may be, these characters are depicted realistically. When one attempts to analyze the paintings, however, de Chirico's realism quickly proves illusory. If it is easy enough to conduct stylistic analyses, studying the use of multiple perspective, for example, or the evolution of a particular motif, the actual meaning of the works continues to elude the viewer.

While the paintings' physical solitude is important from a plastic point of view, it masks a second, metaphysical solitude populated by mysterious characters engaged in tasks known only to the artist. Each apparent signified is a decoy designed to conceal a second signified and protect it from logical interpretation. This explains why de Chirico's symbolic system has defied interpretation since its inception. As James Beck observes, "his language came mostly out of himself, which is why his art appears to be so enigmatic to us (still, after nearly seventy years) and will always remain so."[6] Despite the presence of recurrent motifs, the artist's hermetic symbolism has succeeded in obscuring the ultimate drama of his art. This chapter attempts to get at the heart of that drama through the detailed examination of a large cross section

of his works. Covering the period 1910–1918, the latter consist of some 135 paintings and another fifty drawings. We will discover that de Chirico was fiercely logical, entirely consistent, and highly lucid as he explored the combinations and permutations of his unique aesthetics. Focusing on the human motifs in particular—silhouettes, statues, and mannequins—will allow us to identify his most persistent characters.[7] In the absence of any testimony by the artist himself, a somewhat circuitous route will be necessary. The following section, which concentrates on a single work, will demonstrate his fundamental method. Once we have defined de Chirico's approach to painting, these findings will be applied to his art in general in subsequent sections.

DECIPHERING DE CHIRICO

The year 1917 was an unusually productive one in de Chirico's life. Although he was stationed in Ferrara and nominally attached to the Italian army, he was able to spend much of his time painting and drawing. Surrounded by a number of other artists, including his brother Alberto Savinio, the former Futurist Carlo Carrà, and Filippo de Pisis, he was involved in a continual ferment of artistic activity. Indeed it was during this year that he founded the *scuola metafisica*, together with Carrà, which was destined to revolutionize Italian painting and influenced the development of European art in general. Among the various works that date from this period one finds a curious drawing entitled *The Phantom* (Figure 4.1).[8] Conceived as a preliminary study for a painting executed the following year, also called *The Phantom*, it exemplifies de Chirico's metaphysical manner and provides access to broader patterns in the artist's work. Belonging to a series devoted to metaphysical interiors, the work depicts two characters engaged in conversation in the middle of a room whose walls and floor are completely bare. In the background an open door beckons invitingly. In the foreground a strange mannequin is seated on an end-table—strange because its head consists of several drafting implements. Behind the mannequin and to the left stands a human figure, which in its own way is equally curious. Wearing what appears to be a toga and sporting a beard and moustache, the latter has his eyes closed as if in meditation. Apart from the T-shaped beard and moustache, the slightly balding figure is not remarkable. He appears to be a man in his late forties or early fifties.

Although the reasons for de Chirico's choice are not immediately apparent, from circumstantial and internal evidence this figure can be identified as

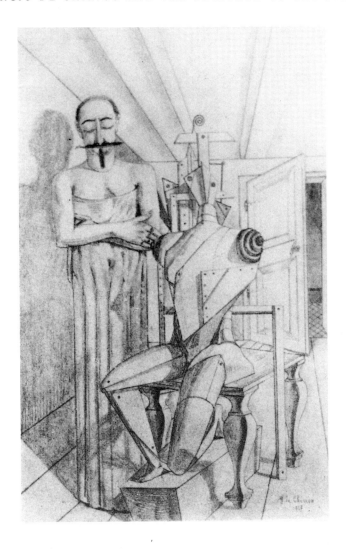

FIGURE 4.1 Giorgio de Chirico, *The Phantom*

Napoleon III, who governed France from 1852 to 1870. Indeed the peculiar configuration of his beard and moustache are enough to convince us by themselves. Very much the dandy, Napoleon III affected a long drawn-out moustache, which he waxed, and a small goatee. Among the various stars of de Chirico's metaphysical firmament, which include characters such as Ariadne, Apollo, and Zeus, the French emperor occupies one of the more

interesting roles. André Breton, long an admirer of the Italian painter, suggests that unconsciously Napoleon III represented de Chirico's father—which is certainly possible.[9] Judging from de Chirico's own writings, Napoleon III lends himself to several other interpretations that, if they do not disprove Breton's theory, suggest new paths to explore. These will take us, first, into the realm of mythology and then into the world of politics.

A mythological as well as a historical figure, Napoleon III possesses a metaphysical identity too—like all of de Chirico's characters. In his novel *Hebdomeros,* which appeared in 1929, the artist stressed the mythological aspect of Louis-Napoleon:

> And we know what it means, the demon who snickers constantly at our side; you are far from town . . . you are seated on a bench . . . you think you are free and at peace, and suddenly you notice that you are not alone; *someone* is sitting on your bench; yes, a gentleman dressed in old-fashioned elegance whose face vaguely recalls certain photos of Napoleon III and also Anatole France at the period of *Le Lys rouge,* a gentleman who is observing you and laughing up his sleeve, it is he again, the *tempter demon.*[10]

This *demon tentateur,* as will become clear in a moment, is in fact the god Dionysos. The key to his identity is to be found in a passage by Friedrich Nietzsche, de Chirico's favorite author, which describes the elegant bearing, seductive character, and supernatural power of this god:

> The genius of the heart, as it is embodied in the great and mysterious one, the tempter god and natural Pied Piper of souls, whose voice is able to descend to the underworld of each soul, who speaks nary a word, who casts nary a glance lacking in attraction, to whose perfection it seems that he is able to appear—not as he is but in a guise that acts as an additional constraint on his followers to crowd closer and closer to him, to follow him more cordially and more completely .[11]

Above all, the author of this passage, which is undoubtedly the source of the episode quoted previously from *Hebdomeros,* depicts Dionysos as a "tempter god" who possesses an irresistible attraction. The reason de Chirico speaks of a *démon* in *Hebdomeros*—which may be translated either as "demon" or as "daemon" (cf. the German *Genie)* is because Dionysos inhabits the underworld during the winter. This characteristic is also evoked by the German author. By contrast, Dionysos's return to the living world coincides with the birth and renewal of spring, and his visit culminates in the autumn harvest. These facts make it clear that Napoleon III and Dionysos were closely associ-

ated in de Chirico's mind. In addition they explain why the artist chose to title the drawing *Il ritornante* (*ritornare* = "to return") rather than, say, *Il spettro*. Not only are the human figure's features precisely those of the French emperor, whom he revered, but they also belong to the Greek god. This means that the figure is simultaneously Napoleon III and Dionysos, who has "returned" with the appearance of spring. The fact that he has his eyes closed indicates that the drawing represents a dream sequence, an encounter occurring in another (metaphysical) dimension.

Before attempting to identify the second character in the drawing, it is helpful to consider Breton's account of de Chirico's preoccupation with phantoms:

> The phantoms . . . Despite his current reticence regarding this subject, de Chirico still admits that he has not forgotten them . . . he has even named two of them for me: Napoleon III and Cavour, and has informed me that he had protracted dealings with them. . . . One of the most important dates for de Chirico is that of the secret talks between Napoleon III and Cavour at Plombières. To the best of his knowledge, he says, it is the only time that two phantoms have ever met *officially*, to such an effect that their inconceivable deliberations were followed by real, concrete, and perfectly objective results.[12]

Like Napoleon III, Vittorio Emanuele II, and Carlo Alberto, Count Camillo Cavour is featured in de Chirico's paintings. Like the former he belongs to a group of historical characters associated with the *Risorgimento*. In his capacity as prime minister to Vittorio Emanuele II, Cavour engaged in secret talks with the French emperor at Plombières in July 1858. Not only did they sign a treaty of alliance between their two countries, but they hatched a plot to create a kingdom of Northern Italy that eventually resulted in the country's unification. A sort of political *urszene* from which modern Italy was born, their encounter is the subject of a number of de Chirico's works. Indeed, one of the best examples of this obsessive theme is to be found in *The Phantom*. All the available evidence suggests therefore that the figure on the right is Cavour. Because the latter was associated with Napoleon III in de Chirico's mind, and since the French emperor is depicted in the drawing, the mannequin must represent his historical counterpart. Like the mannequins in general, it continues the symbolism of an earlier series of bald statues in his paintings, several of which have been identified as Cavour.[13]

It remains to discover what de Chirico meant by "phantoms." Now, according to his metaphysical philosophy, there existed certain elementary forces

in the universe that were embodied in rare individuals throughout the history of humanity. As he explained in "Zeusi l'esploratore" ("Zeuxis the Explorer"), published in 1918, these forces corresponded to what Heraclitus of Ephesus termed *daemons*—a concept encountered previously in the passage from *Hebdomeros*.[14] If, as Heraclitus said, "the world is full of daemons," it is the task of metaphysical art to reveal their presence, to dramatize their existence in everyday life. These forces were also to be found in literature and mythology, where they were personified by various characters. On the one hand, they were exemplified by the heroes of the *Risorgimento* who succeeded in unifying their country only because they embodied a superhuman power. On the other hand, one thinks of numerous characters taken from Greek mythology: either gods (Zeus, Dionysos, Apollo) or heroes from *The Iliad* and *The Odyssey* (Hector, Andromache, Odysseus, Ariadne).

In *The Phantom*, then, Napoleon III may be seen as a descendant of Dionysos in the sense that, like his predecessor, he personifies the spirit of creation. Like Dionysos he symbolizes rebirth and renewal—which is precisely the meaning of *risorgimento*. The two characters represent principles rather than persons. Their physical presence and their personal history are of little interest. De Chirico called them "phantoms" because their primary existence was confined to another (metaphysical) plane, the plane of the daemonic life force. Their appearance in our realm is illusory and gives no idea of their true nature. Indeed, most of the mannequins wear metaphysical emblems identifying them as phantoms, although this does not happen to be true of the characters in *The Phantom*. In "Zeusi l'Esploratore" we learn that the ancient Cretans symbolized the daemon by an enormous eye. In reviewing the evolution of the mannequin motif it quickly becomes apparent that their mysterious facial markings reproduce the Cretan symbol (see Figures 4.9, 4.10, and 4.12).

But if Napoleon III is a reincarnation of Dionysos, according to the method we have just discovered Cavour must also be the reincarnation of someone. From what mythological or historical figure is he descended? What principle does he personify in his role as metaphysical phantom? Although this problem is extraordinarily complex, fortunately it is not insoluble. One of the keys is to be found in a text by de Chirico's brother, Alberto Savinio, whose articles, plays, and poems share the artist's symbolism. The degree of coincidence between their symbolic systems is so marked that they may be said to share the very same inspiration. Evoking the bald-headed statue frequently

portrayed in his brother's paintings, Savinio remarked: "Désormais l'artiste créateur est homme politique, redingoté, statufié" ("Henceforth the creative artist is a statufied, frock-coated politician").[15] Another text by Savinio, which specified that the frock-coat belongs to a government minister, confirms that the politician in question (and the bald-headed statue) is none other than Cavour.[16] Not only is the creative artist equated with the prime minister, but the first text goes on to equate him with Dante Alighieri, sublime incarnation of the Poet. For that matter, de Chirico himself associated the statue with Dante in a whole series of paintings, beginning with *The Enigma of an Autumn Afternoon* (1910) (Figure 4.5). According to all appearances, then, Cavour is related to Dante. Like Napoleon III and Dionysos, both these characters are phantoms who personify the creative spirit. Thus, all four figures embody the principle of creation—the principle of life itself. This in the last analysis is the subject of *The Phantom*, which celebrates this elementary principle by depicting a series of illustrious representatives.

Although the symbolism of the individual characters in *The Phantom* presents relatively few problems, their relationship to each other is complicated. At this point in our analysis there appear to be two conversations that animate de Chirico's drawing. While Napoleon III and Cavour confer at one level, Dionysos and Dante seem to be engaged in conversation at another. In both cases the subject of their dialogue is the principle that governs them. Although the first conversation seems perfectly logical, the second leaves much to be desired. The main problem is that Dionysos and Dante belong to two entirely different contexts. In order to imagine a conversation between them, one is forced to abolish a number of important distinctions and to demolish several permanent obstacles. This is to say that the two characters are separated by insurmountable geographical, historical, and mythological barriers. It eventually becomes evident that they are not engaged in conversation with each other but rather with other phantoms whose presence has escaped detection. Thus, Dante belongs to another level than Dionysos and is probably paired with one of his contemporaries, possibly Petrarch. As we will see in the next section, Dionysos is paired with a much more suitable character: Apollo. This means that there are at least three conversations in *The Phantom*. The first, which is political, is followed by a second devoted to poetry and by a third that is clearly mythological. Interestingly, de Chirico's method recalls Dante's in several respects—described in his famous letter to Can Grande della Scala—that included four levels of exegesis. Like the author of *The Divine Comedy*, de

Chirico creates multiple dramas at several different levels. The resultant ladder structure, which can be extended indefinitely, looks as follows:

$$
\begin{array}{ccc}
\text{Napoleon III} & \leftrightarrow & \text{Cavour} \\
\updownarrow & & \updownarrow \\
\text{[Petrarch?]} & \leftrightarrow & \text{Dante} \\
\updownarrow & & \updownarrow \\
\text{Dionyosos} & \leftrightarrow & \text{Apollo}
\end{array}
$$

The mannequin figure in *The Phantom* also occurs in another 1917 drawing entitled *The Mathematicians* (Figure 4.2), which portrays two mannequins seated face to face. Sitting on a box, the figure representing Cavour faces a personage with a large, balloon-shaped head who is seated on the now-familiar end-table. Although there may be other conversations involved, from what we have already seen there can be little doubt that this scene is a metaphysical rendition of the conference at Plombières between Cavour and Napoleon III. The two men are "mathematicians" in the sense that they are calculating complex political strategies designed to attain several goals simultaneously. That they are the architects of modern Italy can be seen from the numerous triangles and T-squares adhering to their bodies. This explains the presence of drafting implements in the works discussed previously, especially in connection with Cavour. The fact that they replace his head in two of the drawings symbolizes Cavour's architectural mentality, his penchant for careful, meticulous planning.

Both characters in *The Mathematicians* reappear in the magnificent painting called *The Disquieting Muses* (1917) (Figure 4.3). In the background is the Castello Estense at Ferrara, flanked by a factory with tall chimneys on the left and receding arcades on the right. On the broad piazza fronting the castle, which seems to consist of wooden planking, one encounters an assortment of mannequins arranged like metaphysical chessmen. Among other things, *The Disquieting Muses* summarizes the mannequin theme since its inception in 1914. This is the last important statement of the theme in de Chirico's works, which become increasingly preoccupied with other subjects. With one exception, all the major mannequins are assembled on the square, allowing the viewer to trace their evolution from beginning to end. Only the mutilated mannequin of 1915 is missing, a tragic figure whose presence would be inappropriate.

For while the mannequins here are meant to be "disquieting," they do not share the anguish of their mutilated brother. On the contrary, the picture possesses a remarkable tranquility. The mannequin on the left is clearly

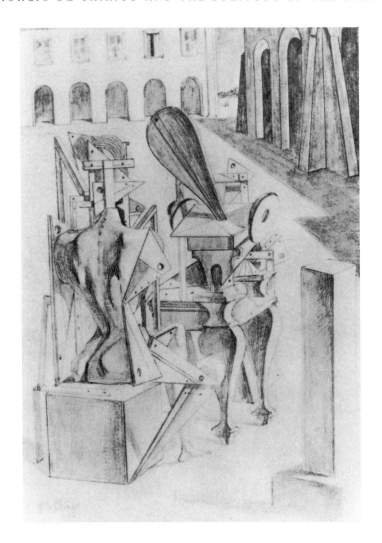

FIGURE 4.2 Giorgio de Chirico, *The Mathematicians*

Dionysos/Napoleon III. If his toga-clad body is taken from *The Phantom* (Figure 4.1), his bulbous head, which resembles a weather balloon, is borrowed from *The Mathematicians* (Figure 4.2). The two crosses on his face are a variation of the Cretan eye motif, as are the markings on the head next to the seated mannequin. The latter character is of course Cavour/Dante, whose

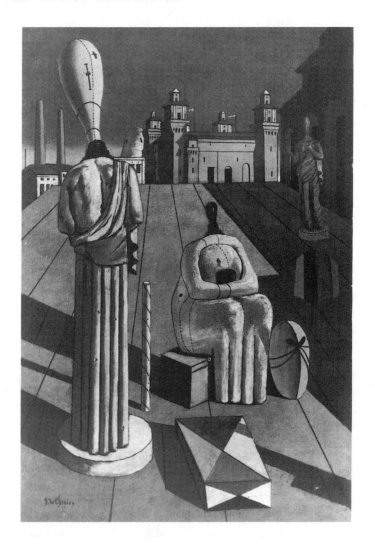

FIGURE 4.3 Giorgio de Chirico, *The Disquieting Muses*

pose recalls any number of previous works and whose head is taken from *The Faithful Spouse* (1917). That de Chirico juxtaposes this figure with the head of another species of mannequin may mean that they share the same symbolism. Although one can only guess at the dialogue between the various characters, the fact that they represent "muses" suggests that, once again, the subject is

creativity. Although the title specifically refers to poetry (the realm of Dionysos and Dante), taken as a metaphor it describes the creators of modern Italy. As in *The Phantom*, poetic inspiration combines with political inspiration to symbolize the creative impulse.

THE PARADIGMATIC METHOD

Before exploring some of the implications of the preceding discussion, it is necessary to dispel a misconception regarding the role of Apollo in de Chirico's work. In a lengthy article on the *Portrait of Guillaume Apollinaire* (1914) (Figure 4.8), for example, Maurizio Fagiolo dell'Arco denies that he figures in the paintings at all and relegates his role to Orpheus, "the clairvoyant musician and poet."[17] Although this is not the place to consider his argument in detail, the dismissal of Apollo has serious repercussions for the structure previously discerned in *The Phantom*. If he is correct, it will be necessary to eliminate the Greek god from our list of *dramatis personae*. The fact that Orpheus is absent from his early iconography is surely significant here. There simply is no Orphic tradition in de Chirico's art for the *Portrait* to exploit. More important, Fagiolo dell'Arco's denunciation of Apollo rests on rather flimsy evidence.

Remarking that the painter and his brother Alberto Savinio shared the same mythology (and aesthetics), he cites a derogatory passage by the latter as proof that Apollo could never have played a serious role in their art. What Fagiolo dell'Arco neglects to say is that it comes from an article published in the 1940s (later included in a satirical encyclopedia).[18] By this time the brothers had grown apart, and Savinio's own aesthetics had changed considerably. Not only is the quote of little value in understanding de Chirico, it does not accurately reflect Savinio's own stance. One of his best known paintings, dating from 1930–1931, is in fact entitled *Apollo*. Nothing indicates that either brother was contemptuous of this personage during the early metaphysical period. On the contrary, as I intend to show, they held him in high esteem. In de Chirico's case one can even speak of a *cult* of Apollo, for the painter seems to have been obsessed with this figure throughout his metaphysical phase. No other motif recurs so insistently. Spanning the period 1910–1918, it occurs in his earliest paintings, undergoes a series of startling transformations, and is brilliantly restated in his final works.

If Apollo's presence in *The Phantom* forms a prelude to his general rehabilitation in de Chirico's art, his structural role is even more important. For

while the ladder structure is useful in determining the picture's meaning, it is even more helpful in deciphering the artist's symbolic system. Not only does it determine the mode of signification in the drawing, on reflection it may be seen to govern de Chirico's entire artistic production. Although a particular painting may omit or transform some of these elements, the artist never loses sight of his basic paradigm. Each individual work reflects a broader artistic vision in which a character represents (1) a whole series of other characters and (2) a universal principle or impulse. With the aid of de Chirico's writings, most of these can be identified. In painting after painting, the artist's vision of the world takes the form of a series of dualisms arranged in paradigmatic fashion. If each of the figures is interchangeable with the others in a given column, the distinction between the two columns is absolute.

The Phantom illustrates his method perfectly. For one thing, the characters are taken from de Chirico's three favorite historical periods: classical antiquity, the Renaissance, and the modern era—which epitomized human achievement in his eyes. For another, they tend to revolve around Greece and Rome, which were privileged countries in his opinion and which represented the cradle of civilization. Moreover, they belong to the three main areas of human endeavor: mythology (religion), the arts, and politics. De Chirico evokes an extraordinary range of civilized accomplishment, identifies repetitive structures governing existence, and telescopes these into a fundamental visual statement. Despite its apparent simplicity The Phantom is incredibly dense. Above all, it celebrates the creative impulse as manifested throughout the ages. The same is true of de Chirico's work in general.

De Chirico integrated other characters into his aesthetic system besides those we have discussed. Some are relatively easy to identify, others remain to be discovered. Given the artist's hermetic method, many may never be identified. In the first group may be placed mythological figures such as Zeus (The Philosopher's Promenade, The Transformed Dream), Hector, Odysseus, Ariadne, Andromache, and Aphrodite (The Uncertainty of the Poet). Certain basic oppositions suggest themselves that parallel the structures in The Phantom. The most obvious is between Hector and Andromache, who are featured in a 1917 painting by the same name. Other oppositions include Zeus and Aphrodite, Odysseus and Circe, and Dionysos and Ariadne.[19] The second, more elusive group draws on the sciences and the humanities. Figures in this group include philosophers such as Schopenhauer and Nietzsche (who identified with Dionysos in Also Sprach Zarathustra and elsewhere); scientists like Galileo (in

The Astronomer?) and Leonardo; poets such as Homer and Vergil; and artists from diverse periods including Zeuxis (whom he calls "l'esploratore"), Phidias, Raphael, Andrea del Castagno, and de Chirico's master: Arnold Böcklin. The third group was composed of figures associated with the *Risorgimento* and the creation of modern Italy. A catalogue of the paradigmatic relations between the characters in de Chirico's art and criticism (and in his brother's) would answer a good many questions. In its absence the ladder structure in *The Phantom* remains our best guide to his intentions.

At the heart of de Chirico's aesthetic lies Nietzsche's distinction between Apollonian and Dionysian impulses in art—supplemented by large doses of Schopenhauer. What differentiates one paradigmatic column from the other in his works is whether it embodies the former principle or the latter. It is clear, for example, that Cavour and Dante are motivated by the Apollonian impulse, while Napoleon III and possibly Petrarch represent the Dionysian impulse. The following summary contains the gist of Nietzsche's theory:

> Perhaps the most influential of modern polarities is Nietzsche's in *The Birth of Tragedy* (1872), that between Apollo and Dionysos, the two art-deities of the Greeks, and the two kinds and processes of art which they represent: the arts of *sculpture* and *music*; the psychological states of the *dream* and of *ecstatic inebriation*. These correspond approximately to the classical "maker" and the romantic "possessed" (or *poeta vates*) (italics added).[20]

If "sculpture" is taken to refer to plastic art in general (as it is intended to), and if we remember that Savinio began as a musician, we begin to understand Nietzsche's appeal. To this should be added de Chirico's commitment to meditative vision and his predilection for effects associated with classical Greek sculpture: coolness, stillness, repose, clarity, sharp outlines, and so on. Although Marianne W. Martin has shown that his works possess an undeniable theatricality, his imagination was essentially sculptural.[21] This can be seen in his attentiveness to modeling and line and the importance of architectural volumes, not to mention the numerous statues and other objects. To complete the picture one has only to recall Savinio's frenzied pounding on the piano during his concerts, which is well documented, and his ecstatic demeanor.[22] Elsewhere he proclaimed that he was a "Dionysian artisan."

From this it is clear that de Chirico inscribed himself in the tradition of Apollo, while his brother preferred the cult of Dionysos. One suspects that their devotion to these gods was more than a simple artistic pose. According to all indications, the brothers saw themselves as exceptional beings who incarnated the

twin forces defined by Nietzsche. This is the lesson of de Chirico's ladder struc-
ture, which reiterates the Apollonian/Dionysian dichotomy and traces it
historically. This also explains the brothers' devotion to each other—often com-
mented on—and their close collaboration. Each saw himself as one-half of the
cosmic equation. *The Phantom* and other works probably dramatize the fruitful
interaction between them, which represents the most recent rung on Nietz-
sche's "ladder." Seen in this light, de Chirico's art becomes extremely personal,
its autobiographical component more pronounced.

These remarks allow us to refine our observations regarding de Chirico's
concept of creativity. Not only was this one of his major themes, but it lay at
the heart of his artistic mission. The latter, as he conceived it, was to celebrate
the twin creative forces previously described. Intertwined like strands of pro-
tein in a DNA molecule, art and music, dream and drunkenness spiraled
upward through the centuries, partners in the eternal dance of life. The very
concept of evolution, as Nietzsche explained, depended on the rules of
exchange governing their interaction. Above all, these impulses were
grounded in the world around us, in the change of seasons and other natural
phenomena. Thus, he proclaimed in one place: "Das Apollinische und seinen
Gegensatz, das Dionysische . . . Mächte . . . aus der Natur selbst, *ohne Vermitt-
lung des meinschlichen Künstlers*, hervorbrechen" ("The Apollonian and its
antithesis, the Dionysian . . . powers . . . burst forth from nature itself, *without
the mediation of the human artist*").[23] Although most of what Nietzsche had to
say concerned the manifestation of these powers in man, one comment was
especially revealing:

> It is by the powerful approach of spring penetrating all nature with joy, that
> those Dionysian emotions awake, in the intensification of which the subjec-
> tive gives way to complete obliviousness of itself. . . .
> Under the spell of the Dionysian the bond between man and man is
> not only re-established, but also alienated; hostile, or subjugated nature cel-
> ebrates its reconciliation with its lost son, man (GT, p. 24).

The joy and (re)union of Nietzsche's Dionysian spring suggest any num-
ber of works by de Chirico, from his 1913 drawing *Joy* to *The Joys and Enigmas
of a Strange Hour*, also from 1913, and *The Joy of Return* (1915). The last paint-
ing, in which a bald man and a locomotive are juxtaposed with several
buildings, is particularly interesting. De Chirico's subject is clearly the return
of spring, whose Dionysian virility is depicted by two phallic symbols poised
to impregnate numerous feminine openings. If further proof is needed, a

companion piece entitled *The Purity of a Dream* (1915) depicts a young tree thrusting vigorously into the space between two arcaded buildings, heralding the advent of spring. Both works were constructed around Nietzsche's penetration metaphor in the previous passage that de Chirico translated into concrete terms according to his own iconography. *The Double Dream of Spring* (1915) whose characters gaze out over a barren landscape, probably embodies a similar principle. Here the painting seems to represent the promise of spring rather than its actual arrival. In the first two works the reconciliation between nature and man, to borrow Nietzsche's terminology, follows a double "alienation": between nature and winter as well as between nature and the city. Both environments are hostile to vegetation. The importance of a Dionysian spring may also explain titles such as *Autumnal Meditation* (1910–1911), *The Autumnal Arrival* (1913), and *Autumnal Geometry* (1917). Since the first series celebrates the rebirth of Dionysos, the second series may commemorate his annual disappearance.

Nietzsche's image of nature celebrating "its reconciliation with its lost son, man" recalls another group of works on the theme of *The Return of the Prodigal Son*. Dating from 1917, these pictures feature a mannequin and a bald-headed statue embracing in the middle of an empty public square. Once again, de Chirico's symbolism appears to involve the return of spring in the guise of Dionysos (the mannequin), welcomed on this occasion by a joyful Apollo (the statue). This impression is strengthened by another passage from *Die Geburt der Tragödie* that bridges the gap between nature and man and extends the dichotomy into the realm of human endeavor:

> The constant development of art is linked to the duality of the *Apollonian* and the *Dionysian*: just as procreation depends on the duality of the sexes, with continual conflicts and only occasional reconciliations (GT, p. 21).

The operative word here is "reconciliation," which provides positive identification of the two characters, seen here during one of their periodic reunions. Ultimately, this series depicts a delightful spring day characterized by the conjunction of sunlight (Apollo) and vegetation (Dionysos). Its subject is the return of the prodigal *sun*, whose rays illuminate so many of de Chirico's canvases. A sun-worshipper *par excellence*, the latter often evokes his favorite deity by bathing a picture in sunlight. This explains why spring is so joyous and fall so sad. It is a question of *both* Apollo and Dionysos, whose return is cause for celebration and whose disappearance evokes the opposite

response. Reviewing *The Joy of Return* and *The Double Dream of Spring*, one can identify their protagonists with some degree of assurance. Since the second painting juxtaposes a bald frock-coated statue with a mysterious mannequin, like the prodigal series, these characters must represent Apollo and Dionysos. (On another level the frock-coat also identifies the statue as Cavour.) In the first painting de Chirico varies this formula slightly to include a person and an object. Here, judging from what we have just seen, the bald-headed man represents Apollo, while the phallic locomotive figures Dionysos. In *The Purity of Dream*, encountered previously, Apollo's presence is indicated not by a character but by a curved rod protruding from the easel in the background. The latter symbol will be discussed in more detail in connection with de Chirico's early iconography.

It remains to say a word about Nietzsche's concept of sexual duality, which de Chirico illustrates in almost every work. That this duality is embodied in nature itself is evident from the previously cited passage glorifying procreation as the ultimate dualistic act. Elsewhere Nietzsche speaks of the satyr whom the ancients saw as the "Sinnbild der geschlectlichen Allgewalt der Natur, die der Grieche gewöhnt ist mit ehr furchtigem Staunen zu betracten" ("the emblem of the sexual omnipotence of nature, which the Greek was wont to contemplate with reverential awe" (GT, p. 49). In addition to representing a natural phenomenon, the duality of the sexes serves as a metaphor in Nietzsche's writings. Procreation becomes a metaphor for the exchange between the Apollonian and the Dionysian impulses, which are "continually inciting each other to new and more powerful births" (GT, p. 21). In painting after painting, de Chirico pays homage to this universal principle (1) by juxtaposing Apollonian and Dionysian characters and (2) by juxtaposing phallic and vaginal symbols. At the architectural level these often take the form of towers and arcades. Elsewhere in the paintings they are associated with various objects, such as bananas and cannons.

Despite the blatantly sexual nature of de Chirico's symbolism, his art has little to do with sexuality. Its real subject is the dialogue between Apollo and Dionysos, which is responsible for the development of Western society and culture. Critics have often spoken of the static appearance of de Chirico's world, devoid of human inhabitants and ruled by geometric forms. To them the somnolent piazzas baking in the noonday sun suggest a timeless universe in which nothing happens, nothing matters. The universal character of de Chirico's art is undeniable, corresponding to a metaphysical world of essence as opposed to physical illusion. However, its static appear-

ance is deceiving. In reality his paintings are charged with nervous energy reflecting the tension between their Apollonian and Dionysian elements. Each canvas, with few exceptions, possesses a magnetic field emanating from its components. Like the spider in her web, the latter are simultaneously producers and prisoners of the network surrounding them. De Chirico's works are faithful renditions of reality as he perceived it. For ultimately the source of the Dionysian and Apollonian impulses traversing a given painting is the world around us.

THE EARLY PAINTINGS

Thus far the discussion has focused on the horizontal component of de Chirico's ladder structure, but much of the vertical structure derives from Nietzsche as well. In this connection it is useful to examine three concepts associated with de Chirico's aesthetics: metaphysical art, phantoms, and the Eternal Return. If, as Nietzsche announced in *Die Geburt der Tragödie*, art was the highest task and the properly metaphysical activity of this life, he defined the task of art as the creation of "gleichnisartigen Traumbilde" ("symbolic dream-pictures") (GT, pp. 20 and 26). An eminently Apollonian project, the cultivation of dream provided the key to a superior realm, to a domain of "höhere Wahrheit" ("higher truth") that contrasted with "der lückenhaft verständlichen Tageswirklichkeit" ("the partially intelligible everyday world") (GT, p. 23). Nietzsche described this metaphysical world, which was also the inner world of fantasy, as follows:

> Beneath this reality in which we live and exist, a second, completely different reality lies concealed. . . . Schopenhauer actually designates the gift of occasionally regarding men and things as mere phantoms and dream-pictures as the mark of philosophical competence. As the philosopher stands in relation to the reality of existence, therefore, so the man who is sensitive to art stands to the reality of dreams . . . from these pictures he derives his understanding of life (GT, p. 22).

The artist's task was thus to interpret the world of "dream," a vocation bordering on the ancient profession of oneiromancy. De Chirico echoed this passage in a manuscript written during his early years in Paris:

> I *believe*, and perhaps even have faith, that as the sight of someone in a dream is proof of his metaphysical reality, from a certain point of view, so a sense of revelation is proof of the metaphysical reality of certain chance occurrences.[24]

The concept of metaphysical reality is related to the notion of metaphysical beings, or "phantoms," many of whom populate de Chirico's paintings. Heraclitus, he tells us repeatedly, referred to them as "daemons," and the inhabitants of Crete utilized an enormous eye as their symbol.[25] As noted, the word "phantom," which the artist himself used to describe these beings, derived from Schopenhauer. One of de Chirico's favorite books, purchased in 1913, was a section of the latter's *Parerga und Paralipomena* entitled *Essay on Apparitions and Various Tracts*.[26] Schopenhauer employed the term "apparition" in two senses: to describe the visionary process and to refer to the subject of a particular vision. After discussing nine different causes of visions, such as somnambulism, dreams, and clairvoyance, he examined the mental pictures produced by this process. One passage seems to have greatly interested de Chirico:

> In the dream every object of intuitive perception has a truth, perfection, completeness, and consistent universality down to its most accidental properties. . . . For every object casts its shadow, every body falls with a heaviness that corresponds exactly to its specific weight.[27]

The importance of shadows in this passage, which emphasize an object's volume and weight, was to become one of the hallmarks of de Chirico's art. Their prominent role in his paintings guaranteed that the works were authentic dream-pictures. Equally important was Schopenhauer's insistence on the truth and precision of the dream image, which dovetailed with the sculptural vocation of Nietzsche's Apollonian artist, likewise devoted to the world of dream.

Although Schopenhauer's philosophy does not lend itself to ready summary, much of what he professed derived from an observation by Kant: "Was die Dinge an sich selbst sein mögen, wissen wir nicht, sondern erkennen nur ihre Erscheinungen" ("What things-in-themselves may be we know not, but we know only their phenomenal appearances") (PP, p. 361). Thus, the intellect was conceived as a superficial force, touching only the outer shell, never the inner core of things. This phenomenological approach to reality emphasized the similarities between the physical world and the dream world. In both instances the viewer was presented with an image whose ultimate source was obscured. The difference was that dream depended on intuitive, not rational, perception. As such it could only be understood metaphysically, representing "Eine [communication] unabhängig von der Erscheinung [the dream] . . . im Dinge an sich, welches als das innere Wesen der Dinge der Erscheinung der-

selben überall zum Grunde liegt" ("a [communication] that is independent of the phenomenon [the dream] . . . as something that occurs in the thing-in-itself and is afterwards perceivable in the phenomenon as the inner essence of things") (PP, p. 364).

From this it can be concluded that dreams are a better guide to reality than conscious perception. This is why de Chirico insisted that the appearance of someone in a dream was proof of his metaphysical existence. For Schopenhauer the thing-in-itself represented the objectification of the individual will, and dream represented the projection of this will. "Meiner Lehre zufolge," he added, "hat allein der *Wille* eine metaphysische Wesenheit, vermöge welcher er durch den Tod unzerstörbar ist" ("In consequence of my doctrine, the *will* alone has a metaphysical reality by virtue of which it is indestructible through death") (PP, p. 369). Although individuals died, therefore, they continued to transmit mental images of themselves and to communicate via dreams. The term "phantom" thus designated two sorts of being: (1) living persons who possessed a particular metaphysical essence and (2) dead persons whose spirit survived them and manifested itself in visions. De Chirico's phantoms, who derived from Schopenhauer's, could also be living or dead but had to incarnate one of the two metaphysical essences: the Apollonian or the Dionysian. The artist grafted Schopenhauer's theory onto his Nietzschean base to produce a whole series of characters—both fictional and actual—whose position on his symbolic ladder was determined by their historical moment.

According to Nietzsche, the evolution of art reflected the tension between his two polarities. In *Ecce Homo* he integrated his dichotomy into the historical sequence. "Der Gegensatz dionysisch und apollinisch," he remarked, "[ist] ins Metaphysische übersetz; die Geschichte selbst als die Entwicklung dieser Idee" ("The antagonism of the two concepts Dionysian and Apollonian [is] translated into metaphysics; history itself is depicted as the development of this idea").[28] To this dialectical view of history, which corresponds to the rungs of de Chirico's ladder, must be added another concept—the Eternal Return. The latter doctrine, which seems to have sprung from Heraclitus, was expounded in *Also Sprach Zarathustra,* whose protagonist sought to teach it to the multitude. Elsewhere Nietzsche devoted a lengthy philosophical essay to this concept.[29] In *Ecce Homo* he defined it as "[der] unbedingten und unendlich wiederholten Kreislauf aller Dinge" ("the absolute and endless repetition of all things in cycles").[30] This idea was also incorporated into de Chirico's structure. To the extent that the phantoms in a given column represent the same principle, each can be said to

be identical to the others. Seen in this perspective, each rung repeats the rungs below it and anticipates those to come. De Chirico's view of history, like Nietzsche's, was cyclical as well as dialectical. As noted, several works allude to the appearance of spring, including *The Phantom* (Figure 4.1), *The Return of the Prodigal Son*, and *The Joy of Return*. Although their immediate subject is the return of fair weather, personified by Dionysos and Apollo, the titles themselves evoke the general process described by Nietzsche—present here in the eternal alternation of the seasons.

One of de Chirico's most famous phantoms, who returned again and again, occurred in his very first metaphysical painting, which initiated the right side of his symbolic ladder. Entitled *The Enigma of the Oracle* (1910) (Figure 4.4), it features a black, hooded figure gazing out over the city below from a mountain sanctuary housing the statue of a god. As many critics have remarked, this figure is taken from Arnold Böcklin's *Odysseus and Calypso*, which portrays an episode from *The Odyssey*. Oblivious to the fleshy charms of his captor, Odysseus contemplates the sea from his rocky perch and yearns to rejoin his family. De Chirico adopted Böcklin's iconology, as well as his iconography, and superimposed at least three more characters on the original figure. One of these appears to be the philosopher Heraclitus whom he associated with this phantom on two separate occasions. The first reference was to his original source: "Strani ed inspegabili fenomeni che fecero già meditare Eraclito sott'i portici del tempio di Diana, nell'antica Efeso; e forse la sua figura idropica assumeva in quei momenti la solennità dolorosa dell'Ulisse che Böcklin rappresentò in riva al mare, ritto sopra gli scogli neri dell'isola di Calipso" ("These are strange and inexplicable phenomena that made Heraclitus meditate under the portico of the temple of Diana in ancient Ephesus; and perhaps in those moments his dropsical figure assumed the sorrowful solemnity of Odysseus as represented by Böcklin at the edge of the sea, standing above the black reefs of Calypso's island").[31] The second reference has a direct bearing on *The Enigma of the Oracle*:

> Thinking of these temples dedicated to the sea gods, constructed along the arid coasts of Greece and Asia Minor, I have often imagined those soothsayers attentive to the voice of the waves receding in the evening from that Adamic land: I imagined their head and body wrapped in a chlamys, awaiting the mysterious, revealing oracle. So also I once imagined the Ephesian [Heraclitus], meditating in the first light of dawn under the peristyle of the temple of Artemis of the hundred breasts.[32]

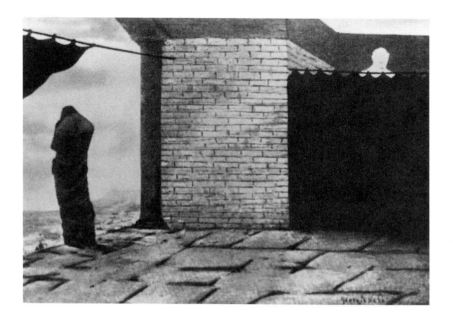

FIGURE 4.4 Giorgio de Chirico, *The Enigma*
of the Oracle

Not only does this passage confirm our identification of Heraclitus, but it designates de Chirico's figure as a soothsayer, clearly recognizable from his *chlamys*. At this point the multiple associations and the title begin to make sense. To complete the picture it is necessary to recognize that while the temple is situated on the coast, as de Chirico specified, it has nothing to do with sea gods. Located on the slopes of Mt. Parnassus overlooking Delphi and the Gulf of Corinth, it is devoted to Apollo. For one thing, the conjunction of temple, mountain, and water corresponds to the geographical facts. For another, because the title evokes an oracle the temple must be devoted either to Zeus or to Apollo. As one authority explains, these were the only gods of prophetic revelation in Greece (which explains Zeus' role in several other paintings).[33] And while only part of the god's statue can be seen behind the curtain, it is enough to disqualify Zeus. From these facts we can deduce that de Chirico's painting depicts the Delphic oracle—the greatest of all the Greek oracles. Nietzsche himself often referred to Apollo as "der wahrsagende Gott" ("the soothsaying god") and specifically connected him with Delphi (GT, p. 24

and passim). Finally, the fact that the hooded figure is a priest of Apollo explains his associations with Odysseus and, via Heraclitus, with the goddess he first calls Diana and then Artemis. In *Die Geburt der Tragödie*, for instance, Nietzsche proclaims that the Homeric world was Apollonian in contrast to the later school of Archilochus, which was Dionysian. In this context it is significant that Diana/Artemis was the twin sister of Apollo. In *The Enigma of the Oracle*, as elsewhere, de Chirico was amazingly consistent in his associations.

So far we have succeeded in pinpointing the phantom's various identities, but how is one to explain the painting itself? What is happening behind the black curtain and why has the artist chosen this subject? To answer these questions it is necessary to examine the oracular process as it was practiced in ancient Greece. Normally, the task of interpreting the Delphic oracle devolved on two persons. Questions were put to a priestess called the Pythia by a male prophet or soothsayer who also interpreted her answers, usually in hexameter verse.[34] Behind the curtain, then, seated on a tripod at the foot of an archaic statue of Apollo, the Pythia is preparing her response. After her possession by the god, she will fling back the curtain—whose drawn state symbolizes the hermetic process—and impart her wisdom to the priest. At still another level the latter symbolizes the creative artist, the Poet, who is waiting for the god to fill him with divine inspiration.

Marianne W. Martin observes that *The Astronomer* (1915) embodies the concept of the artist as Seeker-Priest, proposed by Otto Weininger, whom de Chirico admired.[35] The same may be said of *The Enigma of the Oracle*, which anticipates the later work. As a priest of Apollo, god of the plastic arts, the soothsayer must necessarily be an artist. Indeed, Nietzsche tell us that the Greeks did not distinguish between divine inspiration and poetic inspiration. Plato placed the creative faculty on a par with the gift of the soothsayer and dream-interpreter—as the author of *Die Geburt der Tragödie* was to do many years later.[36] Retracing the evolution of de Chirico's spectral figure, we are better able to appreciate his Apollonian heritage. Given to meditation like Heraclitus, the creative artist is both priest and explorer (Odysseus). Attentive to dream as he sets out on his eternal voyage, he directs his steps according to divine inspiration.

The next painting in the series, *The Enigma of an Autumn Afternoon* (1910) (Figure 4.5), introduces a new decor but enacts essentially the same drama. To be sure, as de Chirico declares in several places, the building and statue are modeled on the piazza Santa Croce in Florence, and the ship suggests a mar-

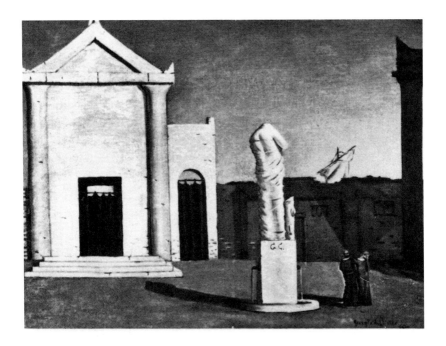

FIGURE 4.5 Giorgio de Chirico, *The Enigma of an Autumn Afternoon*

itime setting. Once again, however, he portrays a soothsayer—recognizable by his *chlamys*—waiting before a curtained temple to receive a divine message. The two human figures, who will recur in subsequent works, derive from the German Romantics (especially Caspar David Friedrich) and emphasize the monuments' immensity. The ship, which appears to be foundering, parallels the course of the sun. It is late afternoon, and Apollo's orb is sinking into the sea. Soon it will disappear altogether at the close of autumn until it reappears the following spring. This time the soothsayer has been transformed into a statue, but his clothing and pose show that he is the priest of Apollo encountered previously.

Since it is not immediately evident that the temple houses the god's oracle, de Chirico placed a naturalistic tree trunk on the pedestal beside the statue as a sign of Apollo's presence. This enigmatic artifact, which Soby interprets as a Victorian affectation, is a clue to the statue's identity.[37] For its

source is the famous statue of the Apollo Belvedere belonging to the Vatican, which includes a similar trunk in an identical position. That de Chirico's statue is closely associated with his original model can be seen from the object's location to the right of the figure. All but one of the countless descendants of this statue (*The Serenity of the Scholar*, 1914) place the trunk on the left side of the monument. In addition, we know that de Chirico's statue replaces Pazzi's nineteenth-century monument to Dante in the actual piazza. In this way the artist grafted another character onto his already impressive list of Apollonian phantoms. By incorporating the author of *The Divine Comedy* into his ladder structure, he extended it into the Italian Renaissance and broadened his motif accordingly.

In 1913, de Chirico ventured into the nineteenth century and identified the statue with Cavour.[38] Henceforth it depicts a bald, frock-coated man with his right arm extended and his left resting on a tree trunk. That he always has his back turned makes him more difficult to recognize and more enigmatic. During this period the artist experimented with a tower series and an Ariadne series in which the counterpoint between sunlight and shadow introduced the Dionysian/Apollonian dichotomy. The first series was devoted to huge individual towers thrusting upward in search of infinite bliss. Since the phallus was a symbol of Dionysos, this series may illustrate the Dionysian principle expounded by Nietzsche. The second series featured reclining statues of Ariadne juxtaposed with various objects, including a puffing locomotive. We have seen that the locomotive in *The Joy of Return* represents Dionysos, and one suspects that this is true of all of de Chirico's trains. Because Dionysos was the consort of Ariadne, whom he rescued from the island of Naxos, the second series must also be organized around the Dionysian principle. Taken together the two series counterbalanced the two Apollonian paintings and provided de Chirico with the left side of his ladder structure.

Dionysos did not assume a human form himself until 1914, but when he finally made his appearance it was unforgettable. The subject of *The Child's Brain* (Figure 4.6) is a nude young man, seen from the waist up, who is standing in back of a table with his eyes closed. On the table de Chirico placed a yellow book with a red bookmark, aligned in such a way as to symbolize genitals. The man himself is strangely seductive. Although he has little hair on his chest, he has curly black hair on his head, a generous moustache, a tiny goatee, and long feminine eyelashes. Curiously, his eyebrows are long and narrow as if he regularly plucked them. His body, which is soft and smooth, lacks any sign of muscular

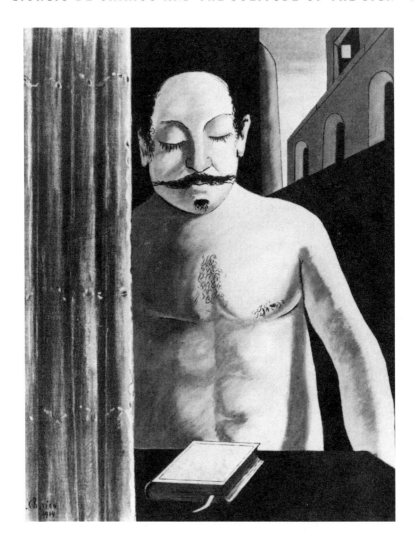

FIGURE 4.6 Giorgio de Chirico, *The Child's*
Brain

definition. To his right a Greek column, whose drums are plainly visible, blocks
his arm from view and symbolizes his connection with ancient Greece. The ac-
cepted interpretation of this painting, introduced by Breton following
conversations with de Chirico, is that it is an imaginary portrait of the artist's
father.[39] According to this interpretation, the scarlet bookmark inserted in the

yellow book symbolizes his parent's lovemaking, perhaps witnessed by him as a child. Although this assertion can neither be proved nor disproved, the existence of several precedents makes it a definite possibility. Exploring the various attributes of his projected Book, for example, Mallarmé described a similar scene: "Le reploiement vierge du livre, encore, prête à un sacrifice dont saigna la tranche rouge des anciens tomes; l'introduction d'une arme, ou coupe-papier, pour établir la prise de possession" ("The virgin folds of a book still lead to a sacrifice, from which the red edges of ancient volumes bled; the introduction of a weapon, or paper-knife, to establish the taking of possession").[40]

What is certain, in any case, is that the man in *The Child's Brain* closely resembles Dionysos in *The Phantom* (Figure 4.1). To be sure, he is younger and has a tuft of hair on his chin instead of a long, narrow beard. Nevertheless, the moustache and frontal pose are the same, and like the figure in *The Phantom* he keeps his eyes closed. Without a doubt he represents a younger, more virile version of Dionysos. This identification is supported by the list of feminine qualities previously noted, which complement his undoubted virility. An extensive review of the iconography of Dionysos reveals that his portrait in *The Child's Brain* agrees with Classical tradition. One author observes: "In works of art he appears as a youthful god. The form of his body is manly, but approaches the female form by its softness and roundness."[41] In addition, de Chirico told Breton that the portrait was a compromise between his father and Napoleon III, which clinches the matter. Since the portrait embodies the left side of the ladder structure, as this information attests, it represents several different individuals including Dionysos. Like the French emperor, de Chirico's father is simply an avatar of the Greek god.

This interpretation does not conflict with previous explanations, but merely adds a new dimension. Clearly the painting is concerned with sexual potency. If on one level it dramatizes the progenitive power of the Father, on another it depicts the (pro)creative spirit in general, symbolized by Dionysos. This principle, it will be recalled, differs markedly from the Apollonian. Unlike the latter, the Dionysian force is profoundly sexual, revolving about the concept of ecstasy and total oblivion. The ultimate goal of the Dionysian experience is complete self-forgetfulness—an orgasmic merging with the universe. Nietzsche also stressed the total receptivity of the Dionysian artist whose passions are intensified and who possesses the instinct of comprehension and divination in the highest degree. Although no outer sign of emotion escapes him, he is continually changing in response to external suggestion.[42] In *The Child's Brain* sexual

potency serves as a metaphor for artistic creation, which unlike its Apollonian counterpart is conceived as an orgasmic experience. For the first time the artist is presented as a Dionysian figure. Like the Apollonian artist, however, he is personified as a Poet. The fact that his eyes are closed indicates that he has transcended his personal consciousness and is communicating with cosmic forces. Following—or perhaps during—this process he will return to the book he is writing and translate his experience into words. Above all, the scarlet bookmark symbolizes the strength of the Poet's passion that he imposes on his work in a distinctly sexual manner. Impregnating, the blank page (a traditional symbol of woman) in the throes of ecstasy, he will eventually father a Text whose passionate vision corresponds to his own.

If *The Child's Brain* is devoted to Dionysos, *The Song of Love* (Figure 4.7), dating from 1914, glorifies his rival. There is no doubt about the identity of the protagonist, for he is represented by a plaster head of the Apollo Belvedere. Although Apollo played a prominent role from the beginning, this was the first overt reference to the god. Indeed, it, is one of the few visual statements in de Chirico's work that is clear and unambiguous. To be sure, the painting itself is not immediately decipherable. Juxtaposed with the plaster bust we see a child's ball, a shiny red rubber glove, and a locomotive puffing away in the background. The latter is trapped between a low brick wall and the wall bearing the head of Apollo. To the right a diagonal series of receding arcades focuses the viewer's attention on the protagonist, who is framed symmetrically by the three objects. The key to this work lies in a remark by Apollinaire, who joked: "Depuis quelque temps, M. de Chirico consacre son talent à peindre des enseignes, aussi bien pour les galeries de tableaux que pour les sages-femmes" ("M. de Chirico has been devoting his talent for some time to the painting of shop signs—for art galleries as well as for midwives").[43] This allows us to associate the glove with childbirth. Fixed to the wall by a thumbtack as if to dry out, the object recalls the rubber gloves used by obstetricians and midwives, while the fact that it is red suggests the blood of childbirth. Given this information and that de Chirico's father was a railroad engineer (a draftsman) who died at an early age, one can interpret the rest of the painting. Associated with each other metonymically, the glove, the ball, and the locomotive symbolize birth and childhood for the artist.

But the painting's symbolism is not autobiographical so much as universal. By now de Chirico's procedure has been well documented and his intentions have become familiar. Continuing in the vein of his previous

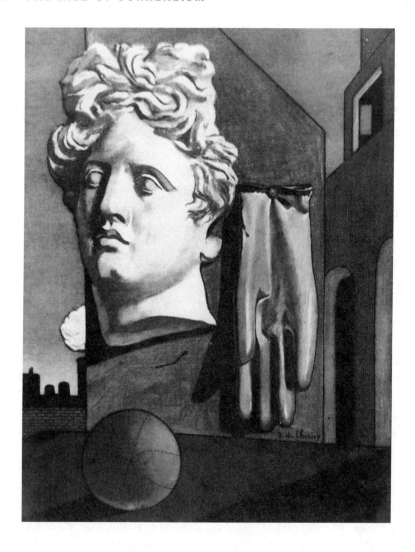

FIGURE 4.7 Giorgio de Chirico, *The Song of Love*

works, the canvas depicts the eternal drama of the Poet (Apollo) whose func-
tion is to give birth to art. More than anything, de Chirico's "song of love" is
the song of creation. This impression is confirmed by Salomon Reinach who
notes that the Apollo Belvedere depicts the god immediately after he has shot

his arrow—that is, following an act of artistic inspiration.[44] The epithet *bel vedere* derives from the statue's location in the Cortile del Belvedere, which is graced with a "beautiful view." Here, because of its associations with sight and seeing (*vedere* = "to see"), it stresses the visionary capacity of the Poet for whom insight and inspiration are the same. The Dionysian locomotive lurking in the background suggests Nietzsche's dichotomy, but the star of the painting is clearly Apollo. Conceived as a companion piece to *The Child's Brain*, *The Song of Love* is devoted to Apollonian inspiration. Although the two works dramatize the Poet in the midst of creation, they differ radically in their assessment of the person and the process. Of course both paintings exploit sexual metaphor, both stress the role of procreation. But the Dionysian artist is portrayed at the beginning of the creative act, while his Apollonian counterpart appears at the end. The apparent serenity of the latter, tired but victorious after a difficult "delivery," contrasts with the former's ecstasy as he engenders the artistic text.

THE MANNEQUINS

Following the success of *The Song of Love*, de Chirico used the bust of the Apollo Belvedere in another five paintings, including the *Portrait of Guillaume Apollinaire* (Figure 4.8). This procedure, it should be noted, was consistent with his general practice and was illustrated throughout his career. Typically the artist would become infatuated with an object, explore its plastic and symbolic possibilities, and then abandon it. The Apollo Belvedere in *The Song of Love* was apparently too transparent a reference for de Chirico, who decided to disguise his protagonist in at least three of the five works. That the bust in the *Portrait of Guillaume Apollinaire* continued to represent this figure can be seen from a comparison with *The Song of Love* (Figure 4.7). There is no need to postulate an intermediary, such as the Venus de Milo proposed by Fagiolo dell'Arco, to explain its appearance.[45] Not only are the left ears the same, for example, but the lips and nose are absolutely identical.

The fact that the artist portrayed a balding Apollo allowed him to graft this motif onto his preexisting bald statue motif, also connected with the Apollonian tradition. Since the motif also represented Cavour, he may be associated with the bust as well. Wieland Schmied's remarks recall de Chirico's obsession with the solitude of the sign: "Giorgio de Chirico a trouvé lui-même de nouveaux symboles aveugles pour la cécité des symboles: ses

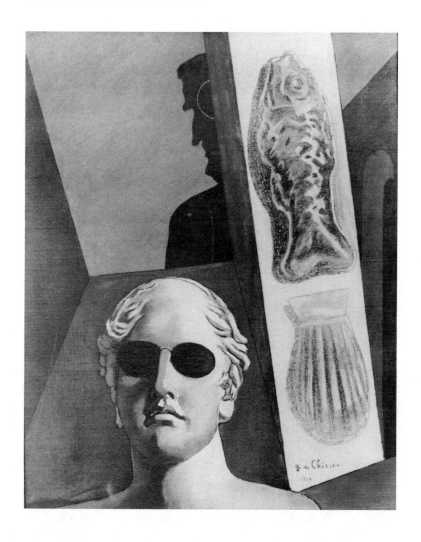

FIGURE 4.8 Giorgio de Chirico, *Portrait of Guillaume Apollinaire*

poupées de chiffon, ses figures en plâtre, ses statues nous regardent sans nous regarder, sans yeux, sans visage et souvent elles portent encore sur leurs orbites vides des lunettes noires, comme le portrait d'Apollinaire. Quadruple cécité" ("Giorgio de Chirico found new symbols of blindness for the blindness of symbols: his mannequins, his plaster figures, his statues look at us without see-

ing us, eyeless, faceless, and often their empty sockets are covered by dark glasses, as in the portrait of Apollinaire. Quadruple blindness").[46]

Paradoxically, their blindness conceals a superior sight, an inner gaze that probes both our motivations and their own. This impression is especially strong in the *Portrait of Guillaume Apollinaire* whose sightless bust seems to confront the viewer. Situated in the foreground in full frontal view, it dominates the spectator as it does the rest of the painting. De Chirico draws on an ancient tradition that viewed the poet's gift as compensatory. Homer is probably the most familiar example, but the tradition was widespread. In addition to a long list of poets, the blind soothsayer Tiresias received prophetic vision in return for his eyes. Traditionally, then, blindness was associated with poets and prophecy. The resulting portrait is clearly generic and has little to do with Apollinaire. Neither the bust in the foreground nor the silhouette in the background bears any resemblance to the French poet.[47] As before, the bust represents the (Apollonian) Poet who participates in the blindness of Homer or Milton and the clairvoyance of a Blake or Rimbaud. In his role as prophet and visionary he strives to interpret human experience, while the ominous figure in the background— probably associated with death—threatens to overwhelm him. The fish and the scallop fixed to the column are aspic molds that have been given monumental proportions. Once again one encounters the sexual dichotomy so prevalent in de Chirico's work. One of many traditional phallic symbols used by the artist, the fish represents the masculine principle. The shell itself is a vaginal symbol and recalls the scallop shell in Botticelli's *Birth of Venus*. Thus, potency is juxtaposed with fertility, fecundation with birth. If these principles are ordinarily opposed to each other, they are united here in the person of the artist who fulfills both functions in creating a work of art.

The Torment of the Poet (1914) (Figure 4.9) and *The Endless Voyage* (1914) (Figure 4.10) were among de Chirico's first mannequin paintings. Conceived as companion pieces, each depicts a faceless mannequin draped in Greek robes standing on a pedestal. Although at first glance these appear to represent de Chirico's favorite character the creative artist, the situation is actually quite different. For one thing, a brief survey of Greek costume reveals that both mannequins are female. Thus, the figure in *The Torment of the Poet*, whose breasts can just be seen, is dressed in a *peplos* and girdle, and the character in *The Endless Voyage* wears another typical feminine garment called a *diplax*. Eugenio La Rocca, in a generally unconvincing essay on de Chirico's archaeological sources, identifies the subject of the second painting as Kore

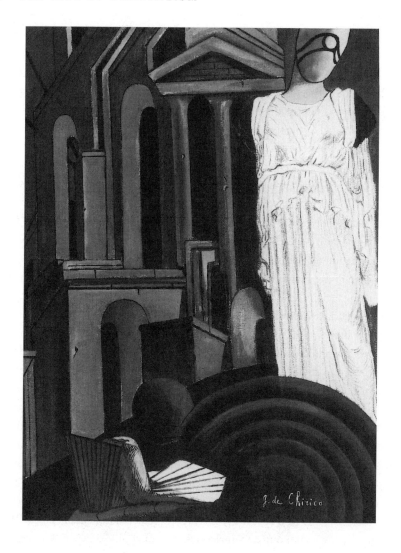

FIGURE 4.9　Giorgio de Chirico, *The Torment of the Poet*

(Persephone), based on a statue in the Capitoline Museum in Rome.[48] To be sure, the costumes match closely, but iconologically this identification is far from satisfactory. Not only is Persephone a stranger to the rest of de Chirico's art, she bears no relation to his normal stock of characters. A lengthy review of the major collections of Greek statuary indicates that the subject of both

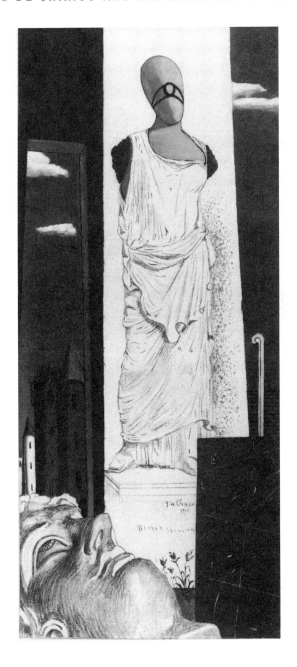

FIGURE 4.10 Giorgio de Chirico, *The Endless Voyage*

paintings is almost certainly Athena. This conclusion is based not only on her costume but on her position in de Chirico's metaphysical firmament.

In *The Torment of the Poet* the draped mannequin appears to be modeled on a statue of Athena by Myron—or rather a Roman copy—in the Frankfurt museum. Besides the characteristic *peplos* and girdle (Athena's normal uniform), de Chirico's figure reproduces her pose and one of her major attributes. Like the statue her head is turned to the left, her left leg slightly advanced. Like the statue she is armless, her stumps covered with metallic cones (taken from a play by Savinio). Against a background cluttered with architectural fragments, she looms over three enigmatic objects including a ball and a gigantic cone motif. The third object, which has been identified as a paper hat and a shuttlecock, is a fanciful rendering of her helmet. That she is not wearing the helmet indicates that we are meant to ignore her reputation as a goddess of war. Despite the imminence of the First World War, her presence in both paintings is due to other reasons. What these are is not immediately evident, but they appear to involve the Poet, who is mentioned by name in the first and is represented by the reclining bust in the second. All we know is that he is an Apollonian figure and that he is undergoing some kind of "torment" in the first work—from which he is conspicuously absent.

Part of the solution is to be found in Salomon Reinach's *Apollo: histoire générale des arts plastiques professée à l'école du Louvre*, published in 1904, which de Chirico and his brother read avidly.[49] Insisting on the expressiveness of Hellenistic art, for example, Reinach proclaims: "Les dieux . . . ne connaissent plus la sérénité olympienne; même victorieux et tout-puissants, ils sont tourmentés" ("The gods . . . no longer know Olympian serenity; even victorious and all-powerful they are tormented").[50] Not only is the Apollo Belvedere angry, passionate, and anxious, he added, but these emotions were even more apparent in a head of Apollo belonging to the British Museum, which he reproduced. Why, he asked, does this head seem to suffer so? What is the source of the pain and anguish that mar its handsome features? *The Torment of the Poet* not only reflects Reinach's observation but proposes an answer to his question. To understand Apollo's suffering it is necessary to examine his relationship with Athena, whom the Romans knew as Minerva. Indeed the titles of Reinach's two most popular books point to the answer. Whereas *Apollo* (1904) was concerned with the plastic arts, *Minerva* (1890) was devoted to the Greek and Roman classics (a third volume, *Orpheus*, considered the history of religion).

If Apollo is the god of art, therefore, Athena is the goddess of wisdom. However, Athena was also a virgin goddess who despised both love and marriage. Indeed, the Parthenon (parthenos = "virgin") is a monument to her chastity. *The Torment of the Poet* seems to embody both sets of associations. Viewers are free to imagine the goddess as simultaneously alluring and aloof, as receptive and reticent. On one level, the title evokes the pangs of unrequited love experienced by de Chirico's Apollo in his pursuit of the chaste Athena, obsessed with her eternal virginity. On another level it reflects the hopeless dichotomy between art and knowledge. Like the maiden, wisdom is impervious to creative attack; like the maiden, it remains inaccessible to the Poet. There is even a suggestion that wisdom has a deleterious effect on art. This recalls Nietzsche's thesis in *Die Geburt der Tragödie* that tragic drama was born from the fusion of the Apollonian and the Dionysian and that it was killed by Socratic rationalism. Seen in this light, the Poet becomes a victim of the rationalistic impulse; Apollo is devoured by Athena.

The situation in *The Endless Voyage* (Figure 4.10) resembles that of *The Torment of the Poet*. The mannequin itself seems to have been modeled on the Athena of Velletri—also a Roman copy—in the Louvre. One of the rare statues of Athena that does not wear the *peplos* and girdle, it corresponds to de Chirico's figure in every respect. All that is lacking is the helmet, which has been replaced by a head of Apollo. On the one hand, the perpetual voyage of the title recalls de Chirico's fascination with the Eternal Return. On the other, it serves as a metaphor for the creative spirit, which endlessly renews itself, a cerebral voyage in which the Poet continually searches for new domains to explore. This is why Apollo is lying on his back. That his eyes are rolled back in his head indicates that he is lost in poetic revery. De Chirico includes two additional objects that comment on the Poet's situation. At the lower right a curved rod protrudes from a blackboard covered with mysterious signs. In fact, as later paintings make clear, the blackboard is resting on an easel, and the rod is one of its supports. This device has been encountered previously in *The Purity of a Dream* in which de Chirico substituted a blank canvas for the blackboard.

Although the curved rod is a common sight in de Chirico's paintings, it has managed to escape critical attention until now. Relatively unobtrusive, it is often lost in the complex play of forms that characterizes de Chirico's art. This is especially true of the later metaphysical works, done in Ferrara, which possess a marked geometric appearance. The first clue to the object's

symbolism is furnished by Winckelmann's *History of Ancient Art*, which the artist certainly knew. In the course of compiling his monumental study, Winckelmann recalled a most unusual statue:

> In my opinion the most beautiful head of Apollo, besides that of the Belvedere, belongs to a seated statue of this god, larger than life, in the Villa Ludovisi. . . . This statue, which has attracted little notice, deserves to be singled out as the only one having a shepherd's crook, an emblem ascribed to Apollo. It lies on the stone on which the figure is sitting and signifies that Apollo is represented in his guise as the shepherd Nomius, referring to his service in this capacity with Admetus, the king of Thessaly.[51]

This statue, which was later acquired by the Museo Nazionale Romano, is certainly astonishing. What interests us, however, is not its great beauty, nor the rarity of the seated pose, but the fact that the shepherd's crook is an emblem of Apollo. Its presence in *The Endless Voyage* serves to identify the bust in the foreground and opposes the latter to Athena. In retrospect the emblem may be traced back to one of de Chirico's earliest paintings, *Autumnal Meditation* (1912) (Figure 4.11), where it is plainly visible. Framed by two converging porticos, a hunched statue stands with its back to us, clothed in a *chlamys*. Like many of de Chirico's statues, it has a tree trunk at its side. To the left, leaning against one of the porticos, is shepherd's crook seemingly abandoned by some unknown person. Although the statue continues the long line of symbolism from Odysseus to the soothsayer to Dante and perhaps Cavour, first and foremost it represents Apollo.

Although its association with the Greek god is indisputable, the curved rod's symbolism extends into other domains as well. In addition to its function as the emblem of Apollo, for example, it serves as a badge of the soothsayer. Once again a quote from Salomon Reinach illuminates the object's significance. In his *Manuel de la philologie classique*, the indefatigable scholar included a section on divination in which he discussed two important examples from ancient Rome. "Les augures," he reported, "portaient la prétexte et un *lituus* dans la main droite. Les aruspices interprétaient les signes celestes et lisaient l'avenir dans les entrailles des victimes" ("The augurs . . . wore the *praetexta* [a white robe with a purple border] and carried a *lituus* in their right hand. The *haruspices* interpreted celestial signs and read the future in the entrails of sacrificial animals").[52] To illustrate his remarks Reinach included a drawing of an augur holding a *lituus*, which looks remarkably like the curved staff in *The Endless Voyage*. The resemblance is especially marked in *The Phantom* (Figure

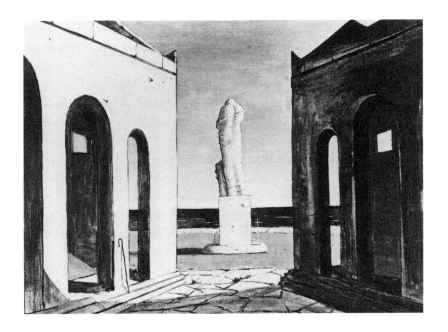

FIGURE 4.11 Giorgio de Chirico, *Autumnal Meditation*

4.1) in which an identical object, protrudes from the T-square at the top of the picture. In *The Endless Voyage*, then, de Chirico stresses the priestly role of the artist who, in addition to being an explorer, is preeminently a soothsayer. To be sure, we are talking about the Apollonian artist whose vocation coincides with that of the augur and the *haruspex*. If the curved staff is a sign of the former, the blackboard betrays the presence of the latter. Recalling the architectural blueprints that de Chirico's father used to pore over, the chalk-marks resemble (1) a star chart and (2) the heavens themselves. As "signes célestes" they exist on two levels for the soothsayer to interpret. Ultimately, the blackboard is a symbolic window on the universe whose starry traces are outlined against the night sky.

The artist explored this device in more detail the following year in paintings such as *The Astronomer* (1915)—whose name is symptomatic—and *The Philosopher and the Poet* (1915) (Figure 4.13). Both works feature a soothsayer mannequin gazing intently at a blackboard on which the secrets of the universe

are written. The best known example of this *topos* is found in *The Seer* (1915) (Figure 4.12), which summarizes the history of the Apollonian artist from his debut in 1910. "Un des tableaux les plus importants de cette époque" ("One of the most important paintings of that period"), de Chirico later recalled, it is a brilliant achievement by any standard.[53] As the title indicates, its subject is the Apollonian artist as visionary. "Der apollinische Rausch," Nietzsche explains in *Göten-Dämmerung*, "hält vor allem das Auge erregt, so dass es die Kraft der Vision bekannt. Der Maler, der Plastiker, der Epiker sind Visionäre par excellence" ("Apollonian ecstasy acts above all as a force stimulating the eye, so that it acquires the power of vision. The painter, the sculptor, the epic poet are essentially visionaries").[54] Artistic vision, poetic inspiration, prophecy, dream, even political foresight—these are all ways of seeing that transcend reality, that confer a privileged view of the world on the individual. Clothed in a metal jacket, the cloth mannequin in *The Seer* manages to participate in all these experiences. The star on his forehead, which represents the Cretan eye motif, allows the viewer to identify him as a *daemon* or phantom. Even without this information its general symbolism is clear. "As a star shining in the darkness," one authority explains, "the star is a symbol of the spirit . . . it stands for the force of the spirit struggling against the forces of darkness."[55]

In addition, de Chirico juxtaposed the mannequin with two of his alter egos, one of which was explicit, the other implicit. Both figures date from 1910 and demonstrate how far the Apollonian character had evolved. At the same time much of its underlying symbolism remained constant. The chalk figure on the blackboard, which mirrors the humanoid shadow beneath it, evokes the soothsayer in *The Enigma of the Oracle* (Figure 4.4) and his associations with Apollo, Odysseus, and Heraclitus. Once again the *lituus* forming part of the easel symbolizes the god's ascendancy, while the building in the background recalls his temple in *The Enigma of an Autumn Afternoon* (Figure 4.5). Not only does the mannequin share the earlier figure's associations with dream, meditation, and exploration, like his predecessor he is waiting for a divine message. Although the setting is obviously one of de Chirico's Italian piazzas, the wooden platform supporting the mannequin and easel suggests the floorboards of a house. The artist increases the confusion between interior and exterior, horizontal and vertical, by tilting the floorboards upward until they slope perilously toward the viewer.

The humanoid shadow projected onto the floorboards at the lower right repeats the soothsayer motif and adds another dimension. A glance at its base

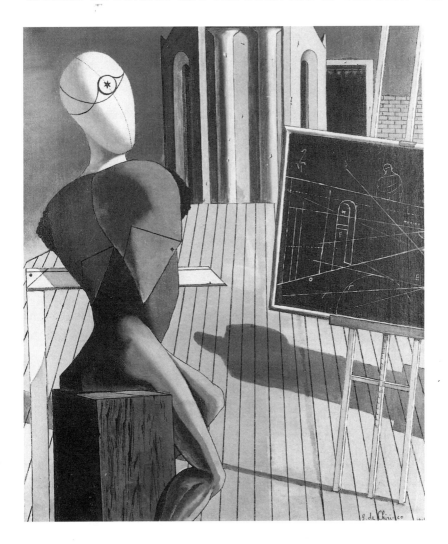

FIGURE 4.12 Giorgio de Chirico, *The Seer*

confirms that it belongs to a statue standing just outside the picture, like the monument in *The Enigma of an Autumn Afternoon*. As before, de Chirico juxtaposed Odysseus with Dante, whose epic voyage in *The Divine Comedy* echoes the former's adventures in the Homeric poem. As before, it is a question of visionary exploration. The theme of vision itself centers on the blackboard, which as the object of the mannequin's gaze corresponds to the

curtained enclosure in the background. Just as the mannequin yearns to question the Pythia hidden behind the black curtain, he yearns to solve the riddle of the universe by interrogating the blackboard before him. Both are the loci of his interest, both are sources of revelation. In addition to holding the key to existence, the latter principle played a major role in de Chirico's aesthetics, which depended in large part on surprise. Unlike the blackboards in *The Astronomer* (1915) and *The Philosopher and the Poet* (1915) (Figure 4.13), the present example contains a design resembling one of Leonardo's architectural drawings. From the foregoing discussion, however, there can be little doubt that it represents a window on the cosmos. De Chirico's symbolism is both implicit and analogical. Hidden behind the architect examining the drawing is an avid astronomer studying the blueprints of the universe.

The architectural metaphor in *The Seer* has other implications that extend into the realm of modern politics. Thus, the word "Torino" written in chalk evokes the first capital of United Italy and reminds us of de Chirico's love of the *Risorgimento*. This clue plus the fact that the mannequin is seated allow the viewer to identify the latter as Cavour, Vittorio Emanuele's prime minister and the "architect" of modern Italy. In work after work, including *The Phantom* (Figure 4.1), de Chirico portrayed him sitting on a box or table with the same flat buttocks that are evident here. The reason for this seems to be that the prime minister, who was fairly corpulent, was usually photographed in a sitting position. Indeed Cavour is the only one of de Chirico's mannequins who is ever seated. The others are inevitably depicted standing. The situation in *The Disquieting Muses* (Figure 4.3) is typical. As noted previously, the seated figure represents Cavour and the erect figure his companion Napoleon III. The only exception to this rule is *The Mathematicians* (Figure 4.2) in which the two mannequins sit opposite each other. To be sure, the prime minister is only one of many characters superimposed on the seated mannequin. Like the *chlamys*-clad silhouette, the bald statue, and the bust of Apollo, he summarizes the Apollonian tradition. As much as anything, de Chirico's ladder structure represents a family tree. If *The Seer* depicts the Astronomer contemplating the universe and the Architect consulting his plans, it also portrays the Artist seated before his canvas. All three professions demand exceptional vision of their practitioners and the ability to translate abstract ideas into reality. The painting's ultimate subject is de Chirico himself, the Artist incarnate, whose visionary activity marks him as a servant of Apollo. Ultimately *The Seer* is a self-portrait.

FIGURE 4.13 Giorgio de Chirico, *The Philoso-pher and the Poet*

The same observations about *The Seer* apply to many paintings with similar characters and themes. If the latter work concentrates on one-half of the cosmic/political equation, *The Philosopher and the Poet* (Figure 4.13) considers the whole picture. The situation in nearly both works is identical. Once again

de Chirico depicts a mannequin who is intently scrutinizing a blackboard. Once again this character represents Cavour—his seated position serves to identify him. To the right of the mannequin stands an equally impressive figure. Resting on a table or a desk, the bust of another mannequin gazes in the opposite direction from his companion. From the (evolved) Cretan eye motif that decorates his head it is evident that he is a *daemon*. But which one? And what is his relation to the first mannequin? Is it complementary or tautological? By now the viewer has seen enough of de Chirico's works to suspect that the bust portrays Napoleon III. Indeed, like its numerous predecessors, the bust represents Napoleon III and a host of other characters going back to Dionysos.

The proof of this statement is furnished by a recently discovered drawing entitled *The Seers* (Figure 4.14). In addition the drawing brings this chapter full circle, back to the drama enacted in *The Phantom* (Figure 4.1) with which we began. The first thing one notices is that *The Seers* closely resembles *The Philosopher and the Poet.* The resemblance is even more marked between it and the preparatory drawing for the painting.[56] On the right, however, occupying the space where the bust of the mannequin should be, is a bust of Napoleon III. His T-shaped beard and moustache make him immediately recognizable. This discovery not only enables us to identify the second mannequin in *The Philosopher and the Poet,* who clearly represents the French emperor, but confirms that the seated mannequin depicts Cavour. Consistent with the artist's inspiration since 1910, all three works restate his basic equation and reflect his belief in a dualistic universe.

Scholars have often commented on de Chirico's fascination with the story of Jason and the Argonauts, who sailed from the artist's hometown and whose Odyssey in many ways resembled his own. However tortuous de Chirico's voyage across Europe may have been, the best sign of his love of adventure is to be found in his art. An Argonaut of the Unknown, de Chirico was a greater explorer than any of the characters in his paintings. Resisting the inroads of influence, rejecting everything that failed to conform to his special vision, he developed a unique iconography that he reused obsessively from one work to the next. Thematically, he was even more obsessive, repeating and refining a few select themes in an attempt to define the forces that determine existence. Above all, one is struck by the quality of de Chirico's vision, which remains long after individual details have faded. Nietzsche best expressed what de Chirico was attempting to convey in a passage from *Ecce*

FIGURE 4.14 Giorgio de Chirico, *The Seers*

Homo. Including himself among the "Argonauten des Ideals, mutiger viel-
leicht als klug ist, und oft genug schiffbrüchig und zu Schaden gekommen"
("Argonauts of the ideal, whose courage is perhaps greater than their pru-
dence and who have often been shipwrecked and ruined"), Nietzsche
observed: "will es uns scheinen, als ob wir . . . vor uns haben . . . eine Welt so

überreich an Schönem, Fremdem, Fragwürdigem, Furchtbarem und Gött-
lichem, dass unsere Neugierde obwohl als unser Besitzdurst ausser sich
geraten sind" ("It would appear as if we had before us . . . a worl. so over-
flowing with beauty, strangeness, doubt, terror, and divinity that our curiosity
and our thirst for possession know no bounds").[57]

Reinterpreting the world according to Weininger's metaphysical geome-
try, de Chirico sought to (re)produce precisely these sensations. The operative
word is "Fremdem," that is, freshness of vision. Cultivating the solitude of the
sign as a passport to metaphysical reality, de Chirico deliberately subverted tra-
ditional signification. This explains why his pictures seem to possess an Edenic
innocence. Form and function exist side by side in a state of total bliss. Al-
though this chapter has focused on the symbolic aspect of de Chirico's art,
nothing could be further from his intentions (or mine) than to reduce each
picture to the sum of its Apollonian and Dionysian elements. Important as
these concepts are, they must be integrated into the total work of art. Visual
language always takes precedence over symbolic language. De Chirico out-
lined the best approach himself when he remarked:

> After any piece of music the listener has the right to say, and can say: What
> does this mean? In a profound painting, on the contrary, this is impossible:
> one must fall silent when one has penetrated it in all its profundity. Then light
> and shadows, lines and angles, the whole mystery of volume begin to speak.[58]

Since the Surrealist painters, and to a lesser extent the Surrealist writers,
were directly descended from de Chirico, this advice applies to their compo-
sitions as well. To recreate the sense of awe (le merveilleux) that they constantly
strove to evoke, one must learn to experience the work on its own terms. To
be sure, the Surrealists borrowed different things from de Chirico at different
times—including a number of motifs—that they modified to suit their own
aesthetic agendas. Salvador Dalí, for example, was struck by the manner in
which the artist revolutionized the treatment of the subject.[59] Among the
painters who practiced a similar brand of disquieting realism, René Magritte
and Paul Delvaux are his most obvious heirs. "Il n'y a que deux peintres que
j'estime," Magritte announced toward the end of his life: "Chirico et Max
Ernst!" ("There are only two painters whom I esteem: Chirico and Max
Ernst!").[60] Invoking a metaphor with a lengthy pedigree, he declared that the
individuals in question had taught him how to paint "visible poetry." Like
them, he explained in an article of the same name, he strove to depict the po-

etry of visible objects. In an earlier text, dating from 1938, Magritte described
de Chirico's art in terms that echo the artist's own words:

> It is a complete rupture with the mental habits of artists who are the pris-
> oners of talent, of virtuosity, and of all the little aesthetic specialties. It calls
> for a new vision in which the spectator rediscovers his isolation and hears
> the silence that fills the world.[61]

how Surrealists took some stuff off of Chirico and others

5 FROM SURREALISM TO
SURREALISM

Guillaume Apollinaire
and André Breton

The preceding chapters have examined efforts by several artists to transcend the three-dimensional universe, efforts that directly paved the way for Surrealism. Although Chapter 2 touched on modern literature from time to time, it focused on the role of the fourth dimension in art. At this point, it is time to turn our attention to the role literature played in facilitating the birth of Surrealism, which was at least as important as that played by art. Since Surrealism was first conceived as a literary movement, it is imperative to examine its literary antecedents. If Magritte and other artists practiced "visible poetry," the Cubist poets might be said to have practiced verbal painting. In both their works and those of the Dadaists, one encounters the same spatiotemporal distortion, the same attempts to subvert reality that characterize the painters. Like the latter, the writers sought to create a world that was no longer governed by height, width, and depth. We will now examine Surrealism's transitional phase as it traversed Cubism and Dada, gradually acquired momentum, and finally adopted a systematic program.

GUILLAUME APOLLINAIRE

For Apollinaire the period leading up to World War I was marked by a number of exciting literary experiments. Writing to his fiancée from the front in 1915, he confided: "J'aime beaucoup mes vers depus *Alcools*. . . . Ils ressortissent à une esthétique toute neuve dont je n'ai plus depuis retrouvé les ressorts" ("I am very fond of the poetry I wrote following *Alcools*. . . . It stemmed from a brand new aesthetic that I have not been able to recapture since").[1] And yet, although the war disrupted Apollinaire's aesthetic program for a time, his later works would draw much of their inspiration from his earlier experiments, which reached their climax in 1914. Whether he was discussing his own work or that of friends, one finds the same key ideas, the same aesthetic preoccupations in article after article in 1914. These can be loosely grouped under the twin headings of imagination and modernity.

The primacy of the imagination, encountered previously (see Chapter 2), is undoubtedly the most ubiquitous theme in Apollinaire's writings. Apollinaire valued imagination above all else because he identified it with the basic creative process. The artist's creative power, he believed, was directly dependent on the ability to imagine—like that of the scientist. It was the task of the imagination to create new realms to explore, realms leading to the discovery of new forms and concepts. This implied that creativity was dynamic in nature, involving the perpetual renewal of means and ends. Stasis was equivalent to stagnation and even death, in art as in life. In his dissatisfaction with the status quo, of course, Apollinaire mirrored the concerns of the avant-garde as a whole. At the heart of this aesthetics lay a fascination with newness, and more specifically with modernity, which tended to be equated with beauty.

The theme of modernity itself assumed two guises in Apollinaire's works. First, and more superficially, it took the form of references to modern means of communication (telephone, telegraph, cinema, phonograph) and transportation (automobiles, airplanes, oceanliners). These served as emblems of the new age and symbolized its spirit as much as its accomplishments. Second, and more important, Apollinaire's modernity assumed the form of a general attitude toward himself and the world around him—a modern perspective. As much as anything, this was reflected in his unshakable faith in the future. His optimistic belief in the notion of scientific progress was balanced by a similar faith in artistic progress. The spirit of invention, which was paramount in both domains, permeated his writings in 1914. It is evident above all in his critical vocabulary, where words such as *nouveau*, *moderne*, *imprévu*, *inattendu*, *audace*, *puissance*, *én-*

ergie, and *choc* ("new," "modern," "surprising," "unexpected," "audacity," "power," "energy," and "shock") recur with astonishing regularity. These terms tend to be used interchangeably and belong to a reflexive, self-validating critical system revolving about the central principle of invention. For Apollinaire, imagination, novelty (newness), and invention were essentially synonymous. With the adoption of surprise in 1914 as the governing principle of modern aesthetics, he created a unified field theory that applied to his own works, to those of his contemporaries, and to those that were destined to come after him.

Reviewing the Salon des Indépendants in March 1914, Apollinaire singled out Giorgio de Chirico's entries for praise:

> The strangeness of the plastic enigmas presented by M. de Chirico still escapes most observers. In order to depict the fatal character of modern things, this painter utilizes the most modern motive force of all: surprise.[2]

Identified as the mainspring ("ressort") of contemporary creative activity, surprise was not only equated with modernity, but was depicted as a universal principle and an aesthetic in its own right.[3]

Replying to a survey regarding his "ideal in art" three months later, Apollinaire employed the reflexive, self-referential technique seen previously. Among other things, surprise was defined as imagination, truth, novelty, and invention.

> My ideal in art: my senses and my imagination, no ideal but truth perpetually new. . . .
> Truth: authentic falsehoods, truthful illusions.
> . . . surprises, the beings they beget and the changes they produce.
> No ideal: surprise, invention, i.e., common sense that is continually surprising, continually unsuspected, i.e., truth.[4]

This text clarified the relationship of the various terms to each other for once and for all, grouping them together under the global principle of surprise.

For all practical purposes, therefore, Apollinaire's doctrine of surprise was fully developed by the middle of 1914. While he continued to elaborate on it in "L'Esprit nouveau et les poètes" (1917)—his critical last testament—it did not undergo any substantial changes.[5] The latter article was amazingly faithful to the original documents, to the point of even using the same language in several places. Thus, Apollinaire identified surprise as "l'inattendu" ("the unexpected") at one point and, recalling the definition in *La Vie*, as "la vérité toujours nouvelle" ("truth perpetually new"). Elsewhere he equated surprise with newness and the New Spirit in what proved to be the key passage of this essay-manifesto:

But newness certainly does exist, without constituting progress. It depends entirely on surprise. The New Spirit also depends on surprise. That is what makes it so new and so vital. *Surprise is the greatest new motive force of all.* It is by surprise, by the important position that it grants to surprise, that the New Spirit distinguishes itself from all the literary and artistic movements that have preceded it (EN, p. 949).

The principal development in Apollinaire's thinking since 1914 (but already evident at that time) was to shift the focus of his theory of surprise from the individual to the group, from himself to the avant-garde around him. In Apollinaire's terminology, "l'esprit nouveau" designated the entire modern movement in literature and the arts.[6] Surprise not only constituted the principal motive force of modern artistic endeavor, moreover, but served to differentiate the modern movement from others that had come before it. Elsewhere in the same essay Apollinaire gave it an explicit grounding in the modern age itself: "L'esprit nouveau est celui du temps même où nous vivons. Un temps fertile en surprises" ("The New Spirit belongs to the very time in which we are living, a time fertile in surprises") (EN, p. 954). If surprise was "one of the most important means of poetic effect since Homer," as T. S. Eliot was to proclaim some years later, it could not be separated from its social and psychological context.[7] If Apollinaire was thinking of the rash of technological innovations during this period, he was also referring to the precarious nature of everyday reality, as evinced in the works of Giorgio de Chirico. If he was alluding to recent cataclysmic political events, he was also referring to the modern distortion of the space-time nexus, as reflected in the works of the Cubist painters (see Chapter 2). The same uncertainty and discontinuity that characterized so much of modern life necessarily informed much of modern literature and art.

By isolating surprise as a key aesthetic principle of the new age, by grouping the innumerable schools and "-isms" under this single heading, Apollinaire supplied the flourishing avant-garde with a valuable way of looking at itself. As he himself stated in "L'Esprit nouveau et les poètes," the publication of this essay marked "la première fois qu'elle se présente consciente d'elle-même" ("the first time that [the modern movement] appeared fully conscious of itself") (EN, p. 943). As noted, surprise was a rather Protean concept that assumed a number of different guises depending on the particular context. In addition to the forms recorded previously, it occurred as deliberate provocation, conscious cultivation of the scandalous, and confrontation with the absurd. Although these characteristics were to surface

again in Existentialism, the New Novel, and the Theater of the Absurd, Apollinaire's immediate heirs were the Dadaists and the Surrealists, who built their movements in large part on his foundations. With the advent of these two schools, Apollinaire's surprise underwent new developments, bifurcating into the twin concepts of *le scandale* and *le merveilleux* ("the marvelous"), respectively. The latter notion, which is at the very core of Surrealism, will be discussed later. Despite the nonsense and nihilism that accompanied it, Dada was conceived primarily as a protest movement. Protesting bourgeois values in art and life, effecting a *tabula rasa* on all that preceded it, Dada both destroyed and reconstructed realty utilizing the "scandalous."[8] In their efforts to implement this program the Dadaists, like the Surrealists, abolished the distinction between art and life. The new reality was not something that could be turned on and off at will.

FROM SURNATURALISM TO SURREALISM

On May 15, 1914, Apollinaire published a brief text entitled "Surnaturalisme," which furnishes important insight into his aesthetics. Situated midway between his two articles on surprise, it provides an additional context in which to view his pronouncements.

> One would completely misunderstand [my] poetry, especially my current efforts, in refusing to see that it represents reality. . . . The aspects that seem the most fantastic are often the most true. It is a superior naturalism, more sensitive, more vital, and more varied than the former variety—a surnaturalism, entirely in accord with the surnaturalist achievements of the other arts . . . *Nothing is beautiful but Truth.*[9]

Contrasting his anti-realistic poetics with the photographic realism of the nineteenth-century Naturalists, Apollinaire asserted paradoxically that his works exemplified "un naturalisme supérieur."[10] Significantly, he would proclaim three years later that *Les Mamelles de Tirésias* (*The Breasts of Tiresias*) was conceived as a protest against the realistic conventions of the Naturalist theater.[11] Because its ambiguity eventually proved a problem, Apollinaire discarded the term *surnaturalisme* in 1917 in favor of *surréalisme*.[12] From surnaturalism to surrealism (with a small "s"), from 1914 to 1917, the basic principle remained the same. Ignoring the laws associated with the physical world, Apollinaire continued to concentrate on the internal, experiential nature of reality.

The term "sur-réalisme" (with a hyphen) first appeared in print in May 1917, in a preface written by Apollinaire for the program accompanying Jean

Cocteau's ballet *Parade*.[13] By the following month, when *Les Mamelles de Tirésias* was performed, it had assumed its present form. Apollinaire not only discussed the concept at considerable length in his preface to the play but proclaimed that the latter was a "drame surréaliste." At the same time, he never actually defined surrealism but described it in abstract terms or via a tautological system of synonyms. Before considering its relation to Breton's movement, therefore, we need to arrive at a working definition. Judging from empirical evidence and the author's own testimony, Apollinaire's surrealism was governed by two principles: surprise and analogical parallels, corresponding to the traditional opposition between form and content. In its simplest form, it can be defined as one or more surprising analogies based on reality. Typically, these are assigned an important structural role in the work in which they appear. This describes most of Apollinaire's science fiction, for example, in which a fabulous but (ana)logical invention determines the direction of the story. Similar circumstances obtain in *Les Mamelles de Tirésias,* whose plot revolves about a man who is able to give birth to children.

Significantly, Apollinaire identified this invention as the core of the play (MT, p. 866). But the situation is more complicated here and the surrealism more complex. The same observation may be made about *Le Poète assassiné* (1916). Both works contain an intricate network of analogical parallels and different types of surprise that finally question the nature of reality itself. In the best Dadaist fashion, Apollinaire destroyed the reality around him and simultaneously reconstructed it, erecting a delicate scaffolding to support his new ontology. His task, as he conceived of it in the preface to the play, was to create "des mondes nouveaux" ("new worlds") that would broaden the spectators' horizons by "procéd[ant] sans cesse aux découvertes les plus surprenantes" ("proceed[ing] ceaselessly toward the most surprising discoveries") (MT, p. 870). Although surprise covered a multitude of attitudes, one form predominates over the others. Time after time a situation or a statement that appears to be absurd turns out to be surprisingly valid. Viewed in this perspective, surrealism can also be defined as the structural use of paradox.

It is useful in this connection to consider Apollinaire's critical terminology. Writing in "L'Esprit nouveau et les poètes," he distinguished two sorts of surprising truths that lay at the heart of his surrealism (EN, p. 950). The first, which agrees with the preceding definition, falls under the heading of hidden truth: "Beaucoup de ces vérités n'[ont] pas été examinées. Il suffit de les dévoiler pour causer une surprise" ("Many of these truths [have] not been ex-

amined. One needs only to unveil them to cause a surprise"). The second stretches the concept of paradox to include the realm of the imaginary. The definition still seems to apply, however, for Apollinaire insisted on the validity (truth) underlying his imaginary projections: "On peut également exprimer une vérité supposée qui cause la surprise, parce qu'on n' [a] point encore osé la présenter" ("One may also express a hypothetical truth that causes surprise because no one [has] yet dared to suggest it").

As an example of hypothetical truth (elsewhere he called it "vérité lit-téraire" ["literary truth"]), he cited the husband in *Les Mamelles de Tirésias* who is able to bear children. Created by analogy with the childbearing function of women, his role possesses a certain perverse logic. Counterbalancing his wife's actions, one of which is to remove her breasts, it creates a symmetrical rever-sal of sex roles. Within the confines of the peculiar (ana)logic of the play, it is perfectly coherent. Now, it is clear from his earlier remarks in *La Vie* that Apollinaire believed truth was relative. And since we know he equated truth with beauty and reality (cf. "Surnaturalisme"), it followed that these were rel-ative as well. According to Apollinaire, each age, each culture, interpreted these concepts according to its own personal vision. "Reality" was what was "true" at a given moment for a given people and vice versa. The same applied to the notion "beauty." Thus, modern existence could no longer be rendered by the tired realism of the previous century but demanded a new mode espe-cially suited to its needs: a surrealism.

Seen from this angle, surrealism's "truth" resides essentially in its analogi-cal parallels to reality. In 1916, writing to a youthful admirer named André Breton, Apollinaire declared: "La vérité est, je crois, qu'en tout, pour attein-dre loin il faut d'abord retourner aux principes" ("The truth is, I think, that to make important breakthroughs one must first return to basic principles").[14] Despite their outrageous exaggerations, his inventions were "true" because they observed this fundamental rule. Despite its nonsensical demeanor, *Les Mamelles de Tirésias* was paradoxically true to life—as Apollinaire claimed at least twice (MT, pp. 865–66). "Cette fantaisie," he insisted, "est ma façon d'in-terpréter la nature" ("This fantasy is my way of interpreting nature"). In every respect it represented an "authentique fausseté" ("authentic falsehood") and a "fantôme véritable" ("truthful illusion"), reflecting surrealism's paradoxical structure.[15] The tension generated by the opposition between true and false, natural and artificial, constituted its motive force—that is, surprise. Compare Pierre Reverdy's definition: "L'Art, c'est l'amour du vrai et c'est aussi l'amour

du faux; du vrai en ce qu'il repose sur la recherche des justes rapports entre les choses, du faux en ce qu'il aboutit toujours à un résultat factice" ("Art is the love of truth and also the love of falsehood—of truth because it depends on the search for valid relationships between things, of falsehood because it always leads to an artificial result").[16]

This explains why Apollinaire often referred to his surrealist creations as "fables" (MT, p. 866; EN, p. 950). Like the latter genre, surrealism called for the juxtaposition of two representational systems. For Apollinaire, it was a question of translation, of shifting reality from one plane to another that, though removed from the first, remained analogically parallel to it. "Il s'agit avant tout de traduire la réalité" ("Above all, it is a matter of translating reality"), he wrote in 1917, equating surrealism with translation in the etymological sense of the word.[17] This process is well illustrated by the oft-quoted remarks in his preface to Les Mamelles de Tirésias. "J'ai pensé," he said, "qu'il fallait revenir à la nature même, mais sans l'imiter à la manière des photographes. Quand l'homme a voulu imiter la marche, il a créé la roue qui ne ressemble pas à une jambe. Il a fait ainsi du surréalisme sans le savoir" ("I thought it necessary to return to nature itself, but without imitating it in a photographic manner. When man wished to imitate walking, he created the wheel, which does not resemble a leg. In this way he committed an act of surrealism without knowing it") (MT, pp. 865–66).[18] Since, as he observed in a later passage, the theater was not the same thing as the life it sought to interpret, it was futile to employ trompe l'oeil techniques better suited to the cinema.[19] Life was represented more faithfully by interpretive techniques. Thus, Apollinaire's surrealism was depicted, finally, as an art that was to nature as the wheel was to the leg.

Ironically, Apollinaire's exaggerated realism (surrealism) was profoundly anti-realistic considered from the traditional point of view. It was this aspect of his work that relied heavily on the effects of surprise. As Anna Balakian remarks, Apollinaire "fabricated the word 'surreal' to designate the human ability to create the unnatural."[20] It described man's unique ability to invent something not existing in nature, be it a machine in the case of the sciences or a fantasy in the case of the arts. Both were inspired works of the imagination, the primacy of which was well established. Apollinaire's fascination with the myth of Icarus as it related to the invention of the airplane is well known. Like Les Mamelles de Tirésias, he classified it as a "vérité supposée" because of its prophetic role (EN, p. 950). Since modern science was out-

stripping the arts in the realm of imagination, he believed that poets should strive to imagine new fables in order to surpass (and spur on) the inventors. As much as anything, the function of Apollinaire's surrealism was to open new realms to the imagination, to suggest possibilities that for the moment exceeded humanity's capabilities.

APOLLINAIRE AND ANDRÉ BRETON

Although Apollinaire and Breton each practiced something they called *surréalisme*, a number of critics have insisted that the two doctrines were basically unrelated. At the same time, numerous critics have acknowledged Apollinaire's influence on the Surrealist (with a capital "S") movement.[21] Indeed, as the evidence continues to accumulate, it becomes increasingly apparent that he played a major role in the elaboration of Breton's aesthetics. To be sure, since the movements were far from identical, they differed in a number of respects. On the other hand, we will discover that they shared several key assumptions about the nature of the poetic act that tended to minimize these differences. Although the following discussion considers some of the personal factors that were involved, it focuses on theoretical pronouncements rather than personalities. What interests us is not the men themselves, but the nature of their respective poetics.

In contrast to Apollinaire's pronouncements, the tenets of the Surrealist movement are relatively well known. According to the *Manifeste du surréalisme*, Surrealism sought to liberate the unconscious, and to tap its powerful forces via automatic writing, automatic speech, and the analysis of dreams. The superior reality (or surreality) embodied by these forms of association was that of the unconscious itself, the exploration of which promised to expand our total awareness.[22] Looming over the entire project, *le merveilleux* ("the marvelous") embodied "l'irrémédiable inquiétude humaine" ("the incurable human malaise" (MS, p. 321). As such, it was recognizable by the revelatory shudder it evoked in those who experienced it. The single modern example cited by Breton was the mannequin, whose eerie presence would become one of the hallmarks of Surrealism.

Interestingly, although Apollinaire did not exploit this concept as systematically, one finds the same haunting irrationality in many of his works. Although Breton's definition ignored such crucial concepts as *l'amour fou* ("passionate love"), *le point suprême*, and even objective chance, which would

come later, it identified the core of Surrealist practice. The name "Surrealism" was chosen, Breton explained, in homage to Apollinaire whose tragic and premature death in 1918 had shocked the whole group (MS, p. 327). If the term itself survived unscathed, its semantics underwent a perceptible change. Whereas the prefix *sur-* had originally functioned as an intensifier, it now served to distance the new realism from objective reality. If *surréalisme* meant something like "hyperrealism" to Apollinaire, Breton and his friends came to regard it as a kind of "meta-realism." Among other things, this explains why Spanish critics had so much trouble translating the term.[23]

Like Breton, Apollinaire conceived of himself as an adventurer whose task was to discover and explore uncharted regions.[24] In addition, both men were conscious of the limitless nature of their quest. Having chosen to disregard traditional boundaries, they faced a frightening new realm in which anything was possible. Writing in "La Jolie Rousse" ("The Pretty Redhead"), Apollinaire implored: "Pitié pour nous qui combattons toujours aux frontières / De l'illimité et de l'avenir" ("Pity us who are locked in continual combat / On the future's boundless frontiers").[25] Similarly, describing the Surrealist mind at work, Breton wrote: "Il prend conscience des étendues illimitées où se manifestent ses désirs, où le pour et le contre se réduisent sans cesse" ("It becomes conscious of the boundless reaches where its desires are made manifest, where pros and cons are continually resolved") (MS, p. 338). In accordance with Freudian theory, Breton's task was to decipher the language of dream and probe the depths of the unconscious. By contrast, Apollinaire conceived of his mission in terms that were anything but programmatic. "Nous voulons vous donner de vastes et d'étranges domaines" ("We want to give you vast and strange domains"), he exclaimed in the same poem, leaving the choice of means to each individual practitioner.

More than anything, Apollinaire and Breton were fascinated by the imagination and its capabilities. Imaginative persons were the most highly regarded, imaginative works were the only ones worthy of praise. "L'Esprit nouveau et les poètes" and the *Manifeste du surréalisme* were first and foremost paeans to the workings of the imagination. The body of each text was devoted to exploring various ramifications of this central principle. In the course of pursuing what Breton called "l'aventure humaine," Apollinaire would have agreed with him that "l'imagination . . . fait à elle seule les choses réelles" ("only imagination . . . is capable of making things real").[26] Like Breton, he attempted to transform modern consciousness by resorting to imaginative means, by refusing to differ-

entiate between the imaginary and the real. Each poet in his own way strove to modify the way in which we view the world around us.

As Anna Balakian observes, neither Apollinaire nor Breton believed in the antinomy between life and art.[27] Rejecting the Symbolist model, both sought to ground their poetic practice in daily existence, in the interaction with others that constituted their lived experience. Like Apollinaire, who proclaimed: "Chacun de mes poèmes est la commémoration d'un événément de ma vie" ("Each of my poems commemorates an event in my life"), Breton conceived of each work as a personal document.[28] In addition, the concept of adventure that animated their poetry was often expressed in terms of personal risk. This serves as an index both of their commitment to avant-garde goals and their fear of the consequences of their actions. Devoted to systematic cultural sabotage, their experiments exposed the two men to a whole series of dangers. The risk was not limited to the aesthetic domain, but involved their personal existence as well. Breton and his colleagues even ran the risk of succumbing to mental disorders.[29] This is why he insisted the Surrealist adventure could only be undertaken "au péril de la vie" ("at the risk of ones life").[30]

Where the two men parted company, Balakian adds, was with regard not to aesthetics so much as to social issues. As a resident alien and later a naturalized citizen, Apollinaire was in no position to attack his country of adoption. It was left to Breton to cultivate the spirit of social subversion as he set about reconciling Marx with Freud. Like the younger poet, nevertheless, Apollinaire hoped to change society itself so it would be more in tune with modern consciousness. Writing in 1917, he declared that a global surrealist movement existed "qui a déjà si profondément modifié les arts et qui est en train de modifier brutalement les moeurs et les institutions" ("which has already modified the arts so profoundly and which is proceeding to brutally modify human behavior and institutions").[31] "Cette tâche surréaliste," he added emphatically, "je m'efforce de [l']accomplir dans les lettres et dans les âmes" ("I am striving to accomplish this surrealist task in literature and in peoples' souls").

AT THE CROSSROADS OF SURREALISM

During the years from 1918 to 1922, Breton's Surrealism gradually crystallized into a coherent doctrine. If its initial stirrings were evident in *Les Champs Magnétiques* (*Magnetic Fields*) (1919), it had largely assumed its definitive form four years later. Significantly, 1922 marked the culmination of a feud between

Tristan Tzara and Breton, and the open break between the Dadaists and the future Surrealists. In a very real sense, this period represented the crossroads of Surrealism. Not only did Apollinaire's death deprive surrealism of its most articulate spokesman, but it freed Breton to concentrate on his own ideas, following a period of deep involvement with his predecessor. Although biographical considerations have been excluded from the present study, it is worth noting that Breton looked to Apollinaire for poetic guidance from 1916 until the poet's death. As J. H. Matthews declares, "Breton . . . found . . . a mentor to whom he . . . remained grateful for the rest of his life."[32] Indeed, he was to acknowledge his debt to Apollinaire on numerous occasions. At one point he listed him among the ten top geniuses of the modern age, ahead of Sigmund Freud and Albert Einstein.[33] At this stage, the future Surrealists saw themselves as continuations of Apollinaire. Echoing Breton's own opinion, according to one critic, Jacques Rivière concluded in 1920 that: "Même quand ils n'osent pas franchement l'avouer, les Dadas continuent de tendre à ce *surréalisme*, qui fut l'ambition d'Apollinaire" ("Even if they are not eager to admit it, the Dadaists continue to tend toward that *surrealism* which was propounded by Apollinaire").[34] Similarly, in a companion piece to Rivière's article entitled "Pour Dada" ("For Dada"), Breton wrote:

> There has been some talk about the systematic exploration of the unconscious. Today poets are no longer willing to abandon themselves to the meanderings of their minds. The word "inspiration," which for some reason has fallen out of use, was formerly viewed with approval. Nearly every discovery of an image, for example, impresses me as being a spontaneous creation. Guillaume Apollinaire rightly believed that clichés like "lips of coral," whose popularity can be interpreted as an indication of their value, were the product of the activity he called *surrealist*. Language itself undoubtedly springs from these origins. He even advocated the principle that for scientific advancement and, so to speak, "progress" to occur one should never take a previous invention as one's point of departure. The principle behind the human leg, which was absorbed in the wheel, was only rediscovered by chance in the locomotive's connecting-rod.[35]

What makes this passage so interesting is its position as a bridge between the two surrealisms. Significantly, this was the first time the word "surrealist" appeared in Breton's writings. The last two sentences, which refer to the preface of *Les Mamelles de Tirésias*, reveal a perfect familiarity with Apollinaire's surrealism. The first sentence anticipates the First Manifesto (1924) and its preoccupation with psychic automatism. The possibility of a systematic ex-

ploration of the unconscious, mentioned in close proximity to the Apollinar-
ian adjective "surréaliste," leads Michel Sanouillet to conclude that by this date
Breton already intended to appropriate the term for his own ends.[36] The evo-
lutionary process is especially evident in the intermediate position of
"surréaliste" in the text. While it looks back to the analogical realism of *Les
Mamelles de Tirésias*, it also looks forward to the spontaneous creation of im-
ages. Moreover, surrealism is depicted as an independent "activité" of the
mind largely equivalent to artistic creativity (as opposed to artistic creation).

Even more strikingly, Breton seems already to have grafted onto Apolli-
naire's notion of surrealism the idea of tapping the forces of the unconscious.
More is involved than the mere physical association of the two concepts. If, on
the one hand, spontaneous creations spring from the unconscious, and if on
the other they are the product of surrealist activity, then surrealism must be in-
extricably tied up with the unconscious. Marguerite Bonnet suggests
Apollinaire may have made the connection with the unconscious himself
during conversations with Breton, which is quite likely.[37] Whatever the expla-
nation, Apollinaire was widely viewed as the father of automatic writing
during this period.[38] Breton himself would declare in the First Manifesto that
he occasionally functioned as an automatic poet (MS, p. 327). In addition,
Apollinaire's later writings contain a number of references to the increasing
artistic importance of the unconscious. In "Les Collines" ("The Hills"), for in-
stance, he made a very interesting prediction: "Profondeurs de la conscience /
On vous explorera demain / Et qui sait quels êtres vivants / Seront tirés de ces
abîmes / Avec des univers entiers" ("Depths of consciousness / You will be ex-
plored tomorrow / And who knows what living beings / Will emerge from
those abysses / With whole new universes").[39]

Although Apollinaire was not a poet of the unconscious to the extent that
Breton was to become, he had long been interested in psychic processes. As
one of the inventors of cubist poetry, he continued to privilege the mental
universe and subjective reality. In addition, both poets venerated inspiration
and imagination. In "Pour Dada," Breton equated inspiration with sponta-
neous creation, which was defined in turn as unconscious activity and as
surrealist activity. The four categories were identical; each could be replaced
by any of the others. Interestingly, this would continue to be the definition of
inspiration after Surrealism was codified in the *Manifeste*. In "Pour Dada,"
moreover, Breton claimed that he and Apollinaire shared the same concept of
inspiration and subscribed to the same four-part system. He supported this

implicit assertion by citing two examples: Apollinaire's theory of the image and his theory of surrealism, both of which exploited unconscious drives.

Apollinaire's most succinct discussion of creative activity occurred in "L'Esprit nouveau et les poètes," in which among other things, he refused to differentiate between artistic and scientific creativity. Although the creative impulse might express itself in different ways, the impulse was always the same:

> Poetry and creation are really the same thing; the only person who deserves to be called a poet is someone who invents, someone who creates, as much as it is given to mankind to create. The poet is someone who discovers new joys, no matter how painful they may be to bear. One can be a poet in any domain, provided that one is adventurous and willing to search for new discoveries (EN, p. 950).

Apollinaire continued with the observation that since creative discovery (invention) might result from an apparently insignificant fact, rules and regulations were counterproductive. The creative process was epitomized in his eyes by Isaac Newton, who was stimulated by a falling apple to create a whole new universe. To the best of my knowledge, no one has noted that Breton adopted an identical attitude in the First Manifesto. Although his aversion to the scientific method and to logic is evident throughout, he devoted two pages to what he called "la rêverie scientifique" toward the end. Speaking of scientific endeavor, he declared:

> In this domain as elsewhere, I believe in the pure Surrealist joy of the man who, informed of the repeated failures of his predecessors, refuses to believe he is beaten, chooses his own point of departure, and goes as far as he can by any path except a *reasonable* one (MS, p. 345).

Breton continued with several interesting remarks. For him, creative genius was epitomized not by Newton but by the "inventor"—the term is revealing—of the cutaneous plantar reflex, whom he was privileged to observe in action. We know from other documents that this individual was Dr. Joseph Babinsky, who had previously supervised his medical studies. As this scientist conducted his experiments, Breton recounted, "*il était clair qu'il ne s'en fiait plus à aucun plan*" ("*it was clear that he was no longer following any fixed plan*"). The italics were supplied by Breton, who was astonished to see the great man in the grip of "cette fièvre sacrée" ("that sacred fever") that he equated with inspiration. In utilizing an empirical approach, Babinsky was in effect hoping for an accidental discovery.

Without belaboring the point, it is clear that Breton was heavily indebted to "L'Esprit nouveau et les poètes." Both authors insisted on the unity of scientific and artistic creation. Both emphasized the privileged role of inspiration. Both chose a great scientist as a symbol of creative genius. Both equated discovery and invention. Both stressed the joy of creative discovery. Finally, both called this activity "surrealist." It remains to account for two ideas in Breton's text: nonlinear creativity and accidental discovery. To some extent these were combined in Isaac Newton's momentous apple. However, they were explicitly discussed in the preface to *Les Mamelles de Tirésias*, to which Breton alluded in "Pour Dada." This document provides the missing link (or intertext) we have been looking for. "Quand l'homme a voulu imiter la marche," Apollinaire declared, "il a créé la roue qui ne ressemble pas à une jambe. Il a fait ainsi du surréalisme sans le savoir" ("When man wished to imitate walking, he created the wheel, which does not resemble a leg. In this way, he committed an act of surrealism without knowing it") (MT, pp. 865–66). According to these lines, examined previously, conscious development plays no appreciable role in the creative process. Paradoxically, creative advancement requires one to move sideways rather than straight ahead.

Apollinaire's phrase "sans le savoir" was echoed not only in "Pour Dada," where it was rendered as "par hasard" ("by chance"), but in his reference to Babinsky in the manifesto. At first glance, Breton seems to insist that the invention of the connecting-rod—or rather the extension of the principle of walking by this invention—was purely accidental. And yet we know from the same passage that this event was associated with inspiration in his mind. In retrospect, it is clear that he viewed inspiration as a kind of creative accident that had its roots in the unconscious. Like Apollinaire's wheel, the connecting-rod represented an unconscious analogy to the human leg whose invention resulted from random processes. Although the discoverer of the cutaneous plantar reflex appeared to proceed in a random fashion, his movements were directed according to unconscious cues. As he observed the investigation, Breton was astonished to see that it was so "unscientific," that it followed no fixed plan. When he recalled the experience in 1924, he was amazed to discover that Babinsky's method was identical to his own approach. Like Apollinaire before him, Breton was forced to conclude that scientific revery was indistinguishable from poetic revery.

The preceding discussion provides a useful context in which to examine Apollinaire's and Breton's theory of the image. For one thing, as we will

discover, their concept of how images functioned was directly related to their theory of inspiration. For another thing, much of the following discussion revolves about "Pour Dada," which once again provides precious testimony. That Pierre Reverdy contributed to the development of the Surrealist image is common knowledge. Published in *Nord–Sud (North–South)* in March 1918, the following definition was reprinted in the First Manifesto word for word:

> The image is a pure creation of the mind. It results not from a comparison but from a juxtaposition of two realities that are more or less distant. The more the relations between the two juxtaposed realities are distant and valid, the stronger the image will be—the more emotive power and poetic reality it will have (MS, p. 324).[40]

Although he found this definition illuminating, Breton complained that it confused cause with effect (MS, pp. 324;337-38). It described the mechanics that were involved, yet it did not provide an adequate explanation of the image's origins. In particular, he could not accept Reverdy's assumption that the two distant realities could be juxtaposed voluntarily. In his experience, truly remarkable images could never be created consciously because they derived their effect from irrational associations. Because Reverdy's explanation was imposed after the fact, his theory needed to be modified. In order to understand how images were produced, it was necessary to incorporate the poet's viewpoint as well as the reader's. Eventually, of course, Breton concluded that the images with the greatest emotive power were generated by the unconscious.

How Breton came to this far-reaching conclusion was never made clear. The First Manifesto implies that it gradually dawned on him as he experimented with various possibilities. In retrospect, however, more and more evidence points to Apollinaire as the source of this discovery. In "Pour Dada," one will recall, Breton linked the production of striking imagery to inspiration and the exploration of the unconscious. "Presque toutes les trouvailles d'images," he declared, "me font l'effet de créations spontanées. Guillaume Apollinaire pensait avec raison que des clichés comme 'lèvres de corail' . . . étaient le produit de cette activité qu'il qualifiait de *surréaliste*" ("Nearly every discovery of an image impresses me as being a spontaneous creation. Guillaume Apollinaire rightly believed that clichés like 'lips of coral' . . . were the product of the activity he called *surrealist*"). A close reading of this document suggests that Breton valued Apollinaire's theory of the image because it complemented Reverdy's theory. It not only remedied the latter's deficiencies but

pinpointed the origin of the images in question. Associated with Apollinaire's discussion of clichés, the notion of spontaneous images spurting from the unconscious is remarkable to say the least. In every detail, it anticipates the description of the Surrealist image in the First Manifesto.

It is important to note that Breton's conversation with Apollinaire took place in 1918 at the latest (he died in November) and possibly during 1917. Thus, it occurred at the same time as, or slightly prior to, the publication of Reverdy's article. What makes this observation so interesting is that Breton's theory of the image dates from the same period. Writing in the *Manifeste*, he situated the development of his theory in the context of 1918–1919 (MS, pp. 323–26). He placed it initially in the chronological framework of Reverdy's article and his own poem "Forêt-Noire" ("Black Forest") (*Nord–Sud*, October 1918), which he condemned in retrospect as "pseudo-poésie cubiste." He then proceeded to describe his encounter with the first Surrealist image, the famous "homme coupé en deux par la fenêtre" ("man cut in two by the window"). This experience, which seems to have followed the experiments with cubist poetry, probably dated from early 1919. Breton linked it to the subsequent experiments with automatic writing that resulted in *Les Champs magnétiques*, portions of which appeared in *Littérature* in October 1919. By this date his theory of the image seems to have solidified. At least the versions in "Pour Dada" (1920) and "Max Ernst" (1921) do not differ substantially from that in the *Manifeste*.[41] The elaboration of Breton's theory was limited accordingly to the period from March 1918 to October 1919. Proposed at about the same time, Apollinaire's and Reverdy's theories were combined to produce a powerful synthesis. As much as anything, I believe, "Pour Dada" acknowledges Apollinaire's crucial contribution.

Ironically, Apollinaire's analysis of striking imagery, revolved about the concept of dead metaphor. Although clichés seem to represent an insipid, unimaginative use of language, he undoubtedly argued, this testifies to their former vitality. The emotive power of expressions such as "the heart of the matter" and "the head of the table" has simply become exhausted. This is what Breton meant when, paraphrasing Apollinaire, he spoke of "clichés . . . dont la fortune peut passer pour un criterium de valeur" ("clichés . . . whose popularity can be interpreted as an indication of their value"). The basic soundness of association (validity) between the two terms of a dead metaphor was originally quite marked. If one strips away the dulling veneer of cliché, therefore, the equation lips = coral juxtaposes two radically different realities.

The original, spontaneous image must have positively sparkled. Like clichés, the Surrealist image derives its startling effect from gratuitous association. "Les deux termes de l'image ne sont pas déduits l'un de l'autre par l'esprit en vue de l'étincelle à produire" Breton proclaimed; "ils sont les produits simultanés de l'activité que j'appelle surréaliste" ("The image's two terms are not deduced mentally, one from the other, in order to produce a spark. . . . They are the simultaneous products of the activity I call Surrealist") (MS, p. 338). Significantly, the second sentence was taken verbatim from "Pour Dada," where it referred to Apollinaire's discussion of clichés.

Once again the two surrealisms resemble each other in the importance they accorded to inspiration and to its synonym, spontaneous creation. One should also remember that Apollinaire was one of the first to enshrine surprise as an aesthetic principle and that this concept underlies the Surrealist notion of the marvelous. Breton confirmed this statement himself on several occasions.[42] The "spark" produced by a Surrealist image was simply a flash of recognition that its tenor and vehicle had something in common, as the next chapter demonstrates. The greater the validity of this relation, the greater the surprise. Like Breton's works, Apollinaire's poetry swarms with startling imagery, which assumed an important function from the beginning. Reviewing *Alcools* in 1913, Georges Duhamel accused him of indulging in countless arbitrary analogies and abortive images.[43] Anticipating Reverdy, he explained that the two terms of an image must always be connected by a secret thread. The trouble with Apollinaire, he complained, was that he often stretched that thread until it snapped. In retrospect, Duhamel's testimony confirms that Apollinaire was one of the first practitioners of the polar image.

Despite their obvious differences, Apollinaire's poetry often seems to spring from the same source as Breton's. Like surprise, the principle of spontaneity is particularly well illustrated by their imagery. Paraphrasing Baudelaire, Breton declared: "Il en va des images surréalistes comme de ces images de l'opium que l'homme n'évoque plus, mais qui s'offrent à lui, spontanément, despotiquement" ("Surrealist images resemble the images produced by opium, which the individual no longer evokes but which offer themselves to him spontaneously, despotically") (MS, p. 337). The same observation applies to many of Apollinaire's creations, which rival their Surrealist counterparts in intensity as well as in beauty. One thinks of the conclusion to "Zone," for instance, where the poet suddenly glimpses the decapitated sun. Previous drafts reveal that the image

haunted Apollinaire for months before the final version occurred to him in a burst of inspiration.[44]

In the last analysis, Breton learned a great deal from Apollinaire, who helped shape his future course. Although he sought to transcend Apollinaire's poetics, he chose not to reject it but to develop it along his own lines. In making the transition from surrealism to Surrealism, he focused on aspects that appealed to him and incorporated them into his evolving project. Although the commitment to the irrational varied from one man to the other, they found a common meeting ground in inspiration and imagination. Breton's indebtedness to Apollinaire's theory of creativity, verified by a corresponding debt to his theory of the image, stands out in particular. He adopted the name *surréalisme* not simply in deference to Apollinaire's memory, I would argue, but because he recognized the decisive role the poet played in his life. Although Breton's efforts tended in new directions, he was conscious of continuing experiments begun by Apollinaire and of belonging to the same tradition.

6 THE SURREALIST IMAGE IN LITERATURE AND ART

Now that we are fully embarked on the Surrealist voyage, it is time to examine the movement in more detail. Because we have some idea what Breton was trying to accomplish, it will be interesting to consider some specific examples. Like the remainder of the book, this chapter is devoted entirely to Surrealist poetry and art. In particular, it explores some of the preceding concepts more fully while proposing a working typology of Surrealist imagery. Although most of the examples are taken from authors, primarily those writing in French or Spanish, its conclusions are also applicable to Surrealist art. Since Surrealism was conceived as a series of principles, it was intended to extend into every possible domain. Encompassing a bold new aesthetic on the one hand, it developed a philosophy of life, on the other, that sought to redefine the nature of reality. In questioning the basic premises of existence, it promoted activities that transcended traditional boundaries, including generic and disciplinary conventions. In particular, as Anna Balakian notes, Surrealism established a closer bond between poetry and art than ever before.[1] Many, if not most, of the Surrealists refused to distinguish between these two modes of expression. Writing in 1935, Andre Breton observed that "la fusion des deux arts tend à s'opérer si étroitement de nos jours qu'il devient pour ainsi dire indifférent à des hommes comme Arp, comme Dalí de s'exprimer sous la forme poétique ou plastique" ("The fusion of the two arts tends to take place so completely today

that it becomes more or less a matter of indifference to men like Arp, like Dalí, whether they express themselves in poetic or plastic form").[2]

To be sure, Breton was referring to the phenomenon known as *Doppelbegabung* that was a prominent feature of the Surrealist movement. The *rapprochement* between literature and art was not limited to works by multiply talented individuals, however, but was characteristic of most Surrealist works. For one thing, Balakian explains, the Surrealist poets succeeded in appropriating several of the painters' techniques, which they adapted to their own needs.[3] For another, Surrealist poetry exhibited a marked pictorial bias, much of which can be attributed to the role of psychic automatism. Drawing on his own experience, Breton concluded in 1933: "L'écriture automatique, pratiquée avec quelque ferveur, mène tout droit à l'hallucination visuelle, j'en ai fait personnellement l'expérience" ("Practiced with some fervor, automatic writing leads directly to visual hallucination. I have experienced this personally").[4] Thus, the process of writing itself tended to evoke a visual *gestalt*.

Reflecting the same interest in interartistic principles as their literary colleagues, the Surrealist artists appropriated some of the poets' techniques. J. H. Matthews observes that many of the methods employed in Surrealist art were pictorial equivalents of automatic writing.[5] "The image-making process from which Surrealist objects result," he notes in particular, "accords perfectly with the one to which we owe certain verbal Surrealist images."[6] In a similar vein, Balakian emphasizes the role of verbal models in determining the Surrealists' predilection for collage and automatic drawing.[7] Even more important, she identifies a key rhetorical trope exploited by Surrealist artists and writers alike. The integrated vision on which Surrealism depends, she declares, "derives from the metaphor, which translated into art, means the possibilities of association between objects." Not only did the Surrealists manipulate words as if they were objects, therefore, but they manipulated objects as if they were words. On the one hand, they were fascinated by language's ability to transcend itself, to communicate what was essentially uncommunicable. On the other, they were obsessed with the image's ability to transcend physical reality, to portray what was essentially unimaginable.

The following discussion does not attempt to define the image so much as to describe how it functions. To proceed otherwise would have required a chapter by itself and would have involved endless speculations about what constitutes an image. Whether one chooses to identify imagery with sensuous particularity and figuration, like René Wellek and Austin Warren, or to

conceive of the image as structure, like Ezra Pound, makes little difference for our purposes.[8] If anything, one is tempted to adopt Gerald Mead's definition: "The capacity of language to refer to a perception or sensation," which allows us to focus on the dynamics of the image rather than on its reception.[9] Although this description dovetails nicely with the strategy informing this chapter, it still leaves much to be desired. As will quickly become apparent, the present study is concerned more with pairs of images than with individual examples. This is because the Surrealist image is first and foremost a hybrid genre. If in the first manifesto Breton identified *le merveilleux* with the modern mannequin, following Giorgio de Chirico's lead (see Chapter 4), the movement's first official image remains "un homme coupé en deux par la fenêtre" ("a man cut in half by the window").[10] One evening just before falling asleep, Breton recalled, the phrase occurred to him spontaneously, accompanied by a faint visual image of a man bisected at the waist by a window perpendicular to his body.

For every isolated, monolithic example there are dozens of Surrealist images produced by the intersection of two mutually exclusive planes. This is the sense of the definition adopted by Pierre Reverdy and Breton, encountered previously: "L'Image . . . ne peut naître d'une comparaison mais du rapprochement de deux réalités plus ou moins éloignées. Plus les rapports des deux réalités seront lointains et justes, plus l'image sera forte" ("The image . . . results not from a comparison but from a juxtaposition of two realities that are more or less distant. The more the relations between the two juxtaposed realities are distant and valid, the stronger the image will be") (MS, p. 324). Although Breton's concept of the image owed as much to Apollinaire as to Reverdy, as I argued in the last chapter, we may take this statement as our guide. Whether one speaks of two intersecting planes, two contradictory terms, or two conflicting images the dynamics are the same: intensity is a function of distance or, more precisely, of dissimilarity. "[L'Image] la plus forte," Breton remarked, "est celle qui présente le degré d'arbitraire le plus élevé . . . celle qu'on met le plus longtemps à traduire en langage pratique" ("The strongest [image] is that which offers the highest degree of arbitrariness . . . that which requires the longest time to translate into practical language") (MS, p. 338).

Despite its official place in the Surrealist canon, however, Reverdy's definition does not discriminate between traditional and nontraditional imagery—as Breton complained on more than one occasion.[11] To grasp how the Surrealists revolutionized the image, creating a visionary instrument in the

process, it is helpful to examine the role of conventional metaphor. Ironically, as Rudolf Arnheim argues at considerable length, while metaphor permits art to represent the contradictions of daily life, it is governed essentially by abstraction.[12] In order to explain how metaphor resolves the basic incompatibility between tenor and vehicle, he postulates the existence of two different levels.

> When heterogeneous segments of reality are forced into one grammatical whole, a structural conflict results, which must be resolved. Structural unity can be obtained on the basis of certain physiognomic qualities the components have in common. Therefore, the discordant aspects of the components will retreat, the common ones will come to the fore. . . . I suggest that, negatively, the reality-character of the components is toned down and that, positively, the physiognomic qualities common to the components are vigorously underscored in each. Thus, by their combination, the components are driven to become more abstract, but the abstracted qualities continue to draw life blood from the reality contexts in which they are presented—subdued as these contexts may be.
>
> In the whole-structure created by a metaphor, components that are and remain separate on the reality level unite on the level of physiognomic qualities.[13]

By its very nature, it would seem, metaphor depends on abstract processes. But how does this improve our understanding of Surrealism, one may ask, and what does it have to do with the Surrealist image? The response to these questions, which occupies the rest of this chapter, appears to be twofold. In the first place, as will become increasingly evident, the Surrealist image fulfills the second condition described by Arnheim: the two components are joined at the abstract level. To the extent that one may speak of Surrealist metaphor—the term is somewhat problematic—they can be shown to share common features. In the second place, the Surrealist image violates the initial condition specified previously, which insists on the components' individuality. Arnheim sheds important light on this process as well. "When . . . the grammatical construction merges the segments of reality into a strongly unified whole," he explains in the following paragraph, "these segments must lose concreteness. Otherwise, the construction would either split up into incompatible elements or give birth, on the reality level, to a *Surrealistic monster*" (emphasis added). As every critic has insisted from Aristotle onward, metaphors must not be interpreted literally.

Citing two examples taken from Shakespeare, Arnheim demonstrates the wisdom of this advice and the folly of proceeding otherwise. To test his hy-

pothesis, he proposes that the reader experiment with metaphors such as Romeo being stabbed with a white wench's black eye or Heaven stopping its nose at the crime attributed to Desdemona. Taken at face value, which common sense forbids, these images are clearly ridiculous. And yet the Surrealists were attracted to precisely this quality because it was associated with *le merveilleux*. In the Surrealist image, Breton declared, the different elements "se recommandent surtout par un très haut degré d'*absurdité immédiate*" ("are valuable especially for their very high degree of *immediate absurdity*") (MS, p. 327; the emphasis is Breton's). By the same token, the refusal of tenor and vehicle to efface themselves, to retreat from the demands of realistic representation, is typical of Surrealism. The fact that both terms are meant to be interpreted literally means that every Surrealist image is a two-headed monster. Each image is activated, Matthews explains, when mental representation is allowed to displace physical perception and, in some cases, to discredit it entirely.[14] As such it constitutes a new mode of cognition organized around the pleasure principle rather than the reality principle.

Viewed as a rhetorical device, the Surrealist image is related to Aristotle's fourth category of metaphor, which, as Umberto Eco demonstrates, involves a four-term homology.[15] Like an assassin's knife, Juliet's eye possesses the ability to "wound" Romeo—that is, to cause him pain and suffering. Compare the following lines by Baudelaire, which express a similar idea: "Toi qui, comme un coup de couteau, / Dans mon coeur plaintif es entrée" ("You who, like a knifeblade, / Have penetrated my plaintive heart").[16] Where two images are conflated and give birth to a visual (as well as conceptual) hybrid, Eco suggests that we are faced with "a kind of oneiric image." He goes on to add that this operation is similar to Freudian condensation in which two lines of development converge in a single word or concept. That he associates this type of metaphor with dreams and other unconscious processes indicates how ideally suited it is to the Surrealist enterprise. The fact that these similarities are not only thematic but structural explains why the Surrealist image makes an excellent tool for probing the unconscious.

One of Surrealism's greatest accomplishments was to expand the Aristotelian model until metaphoric distance exceeded the bounds of ordinary logic. In this perspective the movement appears to have been a relative, not an absolute, phenomenon, differing from its antecedents in degree more than in kind. There is thus little point in analyzing Surrealist imagery in terms of its individual elements, interesting as these may be. If it is tempting to classify

them as, say, animal, vegetable, or mineral, such exercises have limited application. What matters, as the Reverdy–Breton definition implies, is not the elements themselves so much as their relation to one another. A similar objection can be made to purely rhetorical approaches, which tend to emphasize formal relations while ignoring their semantic justification. For better or for worse, this describes the brief taxonomy advanced by Breton in the first manifesto (MS, pp. 338–39). In his own experience he had encountered images marked by contradictions, implicit structures, decrescendo effects, formal pretenses, hallucinatory effects, substitution of concrete for abstract, negation of physical properties, and humorous effects.[17] Plainly indebted to Classical rhetoric, as propounded by Quintillian and others, the list includes a few items related to reader response in an attempt to modernize the typology. Although these categories are helpful in identifying some common strategies, they are useful primarily in accounting for aesthetic effects.

DECIPHERING SURREALISM

To be sure, Surrealism employs a wide variety of devices besides startling imagery, many of which are quite ingenious. Complaining that "the rhetoric of the image entails a thorough disregard for syntax," recent critics have successfully focused on the semantics of narrativity in Surrealist literature.[18] Whereas these devices are unquestionably important in generating Surrealist texts, however, they are not as central to the Surrealist adventure. Like Proust's experience with the *petite madeleine*, which allowed him to reconstitute his past, the image holds the key to the whole endeavor. As Mary Ann Caws indicates, Surrealism is based on the contrast between "the will to link and the constant perception of contraries. It is the tension between these two elements which furnishes the energy and the basis for Surrealist poetry."[19] In a certain sense, as Breton's testimony in the First Manifesto bears witness, the entire movement grew out of his experience with the Surrealist image. Primed by Apollinaire, the project caught fire when it encountered Reverdy's definition, which provided the necessary spark.

In order to grasp Surrealism, therefore, we need to pursue the elusive relation between the two terms that constitute the image. Robert Champigny has devised a model, for example, based on the concept of "spatiotemporal distance" and on patterns of impossibility.[20] He proposes to divide Surrealist images into those that are spatially unlikely, those that are temporally unlikely,

those that feature a metamorphosis, and those that depict a monstrosity. While his model is useful in understanding how the polar image functions, it is less successful in describing the bonds that exist between the two poles. It explains what separates them but not what binds them. For Breton insists that "les rapports des deux réalités seront lointains et *justes*" (MS, p. 324; emphasis added). Despite their apparent unrelatedness, ultimately the poles must have something in common.

Champigny himself suggests that the image may be structured around a hidden analogy of some sort. What makes this conclusion particularly tempting is Breton's lifelong enthusiasm for what he called "la méthode analogique."[21] "Je n'ai jamais éprouvé le plaisir intellectuel," he admitted in 1947, "que sur le plan analogique" ("I have never experienced intellectual pleasure except on the analogical plane").[22] In fact, Breton's original definition specifically states that every Surrealist image must have an analogical component. This is what he means by "rapports justes." From this one can deduce that every successful image, no matter how illogical it may appear, is coherent at some level. The same thing is true of the text or work of art to which it belongs. To be effective the analogy must remain undetected on the surface but must trigger a response at a deeper level. This explains the reader/viewer's involuntary shudder on encountering one of the more powerful images.

At this point it is necessary to examine the phenomenon in greater detail. What happens when the reader or viewer is exposed to a Surrealist image? Assuming that the image is not rejected out of hand, what response do its obvious incongruities engender? How is it received and processed by the human mind? To judge from most accounts, the process is virtually automatic and requires little or no participation on the part of the observer. Some witnesses even imply that the latter's presence is superfluous. Thus, Breton declared in one place that words have their own emotional life, unrelated to their meaning, which permits them to respond to each other according to secret affinities.[23] Echoing this statement, many of his colleagues have testified to the strange ability of two words to find a common level, to create links between them where none existed before. "Dans le surréalisme," Louis Aragon noted in 1928, "le sens se forme en dehors de vous. Les mots groupés finissent par signifier quelque chose" ("In Surrealism . . . meaning is created without your participation. Words grouped together end up signifying something").[24] Reflecting the absence of conscious control, these statements emphasize the role of automatism in producing the Surrealist image. In theory, the image

takes form without deliberate intervention by either the artist, who merely records it, or the observer.

Although the latter's role is theoretically passive, it is far from negligible. As described by Breton, the process of apprehending the image involves two distinct phases. "La beauté exige qu'on jouisse le plus souvent avant de comprendre," he explains, "et . . . elle ne supporte [l']élucidation qu'*a posteriori* et comme en dehors d'elle" ("Beauty demands to be enjoyed usually before being understood and . . . tolerates elucidation only *a posteriori* and as though outside itself").[25] The spectator's first task is to perceive the literal image and register its emotional impact. To the extent that it conforms to the definition in the manifesto it will be received with astonishment. At this stage the image is primarily an aesthetic creation. The beauty of the spark obtained will reflect the difference in potential between the two terms (MS, pp. 337–38). As such, it will exert a revelatory power on the observer and will provide him or her with a momentary glimpse of the marvelous.

Not until these conditions have been fulfilled can the second stage begin. Only when the image has been experienced aesthetically can it be approached from an intellectual perspective. "La lucidité est la grande ennemie de la révélation," Breton adds. "Ce n'est que lorsque celle-ci s'est produite que celle-là peut être autorisée à faire valoir ses droits" ("Lucidity is the great enemy of revelation. Only when the latter has been produced can the former exercise its rights").[26] Once the initial shock has passed, therefore, the reader/viewer is free to interrogate the image. During the second phase, devoted to passive comprehension, the discrepancies between its two terms are resolved. To some extent the process of interpretation parallels the process of composition, at least in Breton's case, in which "the critical faculty kept in abeyance during the writing appeared in the editing that followed."[27] However, this procedure is relatively passive in the first instance and active in the second. For our purposes it is instructive to compare the interpretive process to the Freudian operation known as secondary revision.[28] Like this (unconscious) operation, which eliminates the initial absurdity and incoherence that characterize the dream work, passive interpretation transforms the original version into a logical scenario.

While this transformation seems miraculous at first, like turning water into wine, fortunately it is a good deal easier to explain. To understand how it actually occurs we need to return to Arnheim's discussion of traditional

metaphor. Like Breton, it may be recalled, Arnheim views metaphor as functioning on two distinct levels. Like Breton, he conceives of a progression from one level of apprehension to the next, activated by the image's impact on the retina (or the imagination). Like Breton, finally, he constructs a two-step model to explain how this process takes place in the viewer's mind. Whereas the former author describes a progression that leads from revelation to comprehension, the latter envisages a path extending from concreteness to abstraction. Despite obvious differences in terminology, each focuses on the interpretive link between perception and conception, seeing and understanding. Since Arnheim considers abstraction to be a necessary preliminary to comprehension, the two approaches are actually very similar.

The second task confronting the viewer, therefore, requires him or her to reduce the image to its abstract outlines. Since this does not require the viewer's active participation, in theory nothing could be easier. Conditioned by the initial stimulus, whether verbal or visual, the latter's response is largely automatic. As Breton remarked, "L'esprit est d'une merveilleuse promptitude à saisir le plus faible rapport qui peut exister entre deux objets" ("The mind is marvelously prompt in grasping the slightest relationship that can exist between two objects").[29] Without any prompting from the observer, Arnheim explains, it detects features that the tenor and vehicle have in common and concludes that a likeness exists. That Breton was perfectly aware of this process is easy to show. Discussing the Surrealist image in "Signe ascendant," which incidentally includes an example taken from Apollinaire, he insisted that the two terms did not form an equation but were linked instead by "similitudes partielles" ("partial similarities").[30] This expression recalls Arnheim's theory that they share certain "physiognomic qualities." Both expressions evoke the mind's uncanny ability to extract common semes (discrete semantic units) from apparently unrelated components.

As the foregoing discussion has, I hope, demonstrated, Arnheim's modified model describes the Surrealist image perfectly. More precisely, it describes how the latter is processed by the reader or viewer and eventually assimilated into a broader context. Additional proof is furnished by a passage in the first manifesto that describes the two-step process in detail. Although the first part, which stresses the image's absurdity, is often cited, the whole passage has received remarkably little attention. Viewed in retrospect, that is in the light of Arnheim's comments, it turns out to contain a theory of Surrealist reading (or

viewing). Drawing on Breton's experience in composing *Les Champs magné-tiques* (*Magnetic Fields*), it includes the following instructions for deciphering the Surrealist image:

> Poetically speaking, [the different elements] are valuable especially for their very high degree of *immediate absurdity*, the nature of that absurdity, upon closer examination, being to yield to everything that is admissible, that is le-gitimate, in the world: the disclosure of a certain number of properties and facts that are no less objective, finally, than any others (MS, p. 327).

ANALOGY AND SYMBOLISM

Breton's remarks leave no room for doubt: to qualify as Surrealist an image must contain a concealed analogical link. In the absence of such a link, an image may not bear the Surrealist label, even though it may stem from Surre-alist activity. In any case, we have seen that the effectiveness of the polar bond is directly proportional to its internal validity. Among other things, this allows one to reply to those critics who see no way to evaluate Surrealist composi-tions. If a work of art is the product of psychic automatism, they demand, how can the poet (or the artist) be considered its creator? If anyone can produce a Surrealist composition simply by tapping the unconscious, what happens to the concept of art? If the only criterion of excellence is unconscious activity, how can one tell a good automatic work from a bad one? Aren't the Surrealists in-different to the quality of their compositions so long as they contain a glimpse of the unknown? Although this is not the place to examine these questions in detail, the issues that they raise are certainly important. Since the present in-vestigation focuses on the Surrealist image, let us simply note that in theory evaluation poses no problem. Whether an image is successful or not can be de-termined according to well-established guidelines.

That not all Surrealist images are satisfactory comes as no surprise to any-one who has taken the trouble to look into the matter. The most candid assessment of Surrealism's shortcomings, at least in the literary arena, is offered by Balakian. "The Surrealists have written too much," she declares, "confused liberty with license at times, and probably made five unsatisfactory images for every successful one. There has been much trial and error, and unfortunately the Surrealists . . . have freely published their errors."[31] To be sure, it is neces-sary to distinguish the experimental compositions, which were more numerous

at the beginning, from those that were conceived as literary works. There is an enormous difference between a Surrealist text, resulting from psychic dictation, and a Surrealist poem. The same distinction exists between an automatic drawing and a finished painting. Whereas automatism's role was simply to express "le fonctionnement réel de la pensée" ("the true functioning of thought") (MS, p. 328), the work of art was concerned with aesthetic criteria as well. The whole purpose of Surrealism, as many passages attest, was to bridge the gap between conscious and unconscious worlds.

Since artists and writers were free to exercise their critical faculties following the initial burst of unconscious activity, the finished works are generally more successful than the experiments. Despite the increased attention given to aesthetics, however, many images fail to live up to their theoretical potential. One is repeatedly faced with the necessity of determining whether a particular image is authentic. To be successful, we recall, an image must juxtapose two realities that are apparently unrelated yet have something in common. This means that it may be disqualified on either one of two counts. By definition an image cannot be called Surrealist if the analogy is relatively obvious or if it is lacking altogether. Although the second criterion appears at first to eliminate compositions that are mechanically generated, this is not necessarily so. As long as an image can be demonstrated to contain a hidden analogy related to a broader context it source is irrelevant.

This situation describes many of the Surrealist games, such as the *cadavre exquis* ("exquisite cadaver"), in which a slip of paper was folded to combine random words (or images) supplied by several people. Despite its fragmentary origins, the initial example easily satisfies the analogical requirement: "le cadavre exquis boira le vin nouveau" ("the exquisite cadaver will drink the new wine").[32] Although the role of this device is clearly to set desire free, Matthews declares, "it still may be difficult . . . to say for sure who the exquisite corpse is."[33] And yet with a little imagination one can construct a satisfactory explanation, one that dovetails with its function as a cultural artifact. All that is necessary to bring the sentence to life is to posit a connection with the Catholic Church. Placed in a liturgical context, the wine can be seen to represent an infusion of Christ's blood during communion, its life-giving capacity reinforced by the adjective "nouveau." That the cadaver refers to Christ himself is indicated by the term "exquis," designating rare excellence

and beauty. Etymologically, it even emphasizes his role as the object of widespread veneration (*exquis* < *exquisitus* = "sought out"). Viewed in this perspective, therefore, the sentence reenacts the drama of Christ's resurrection and looks forward to the Second Coming. On a broader scale, it predicts the eventual triumph of life over death.

It should be added that this is far from an isolated example. Other Surrealist games based on objective chance are capable of giving excellent results as well, such as the *contrepet* ("spoonerism"). In some respects the following example by Robert Desnos, cited in the First Manifesto, resembles the previous sentence: "Dans le sommeil de Rrose Sélavy il y a un nain sorti d'un puits qui vient manger son pain, la nuit" ("In Rrose Sélavy's sleep, there is a dwarf who has emerged from a well who comes to eat her bread at night").[34] Both statements evoke a grotesque human figure whose task is to consume some form of food or drink. Both follow the same syntactic model: subject/modifier/transitive verb/object/modifier. Like the *cadavre exquis*, the *contrepet* is capable of functioning on several levels at once. The scene itself may be resolved analogically by imagining a mouse that comes out of its hole at night and eats the table scraps that are lying around. Thus, "son pain" refers to the mythical Rrose Sélavy rather than to the mouse. In addition, the fact that this particular dwarf lives in a well suggests a symbolic interpretation. If one takes the phrase "dans le sommeil de Rrose Sélavy" to mean not *while* she sleeps but *within her sleeping state*, the drama can be seen to take place in her mind. Recognizing the well as an archetypal symbol of the unconscious allows one to identify the dwarf with unconscious activity. However, the fact that he has emerged from his normal abode is of paramount importance. The sentence clearly describes the process of dreaming, during which secret impulses are released into more accessible areas of the brain.

At this point, the concept of a "hidden analogy" needs to be clarified, for it is open to several interpretations as it stands. If A represents the image's first term, B its second term, and A' and B' the two terms of the analogy, their relationship can be expressed mathematically as $A/B = A'/B'$. Expanding this equation to include the possibility of symbolism as well results in the expression $A/B = A'/B' = A''/B''$. Whereas these formulae create the impression that proportion is somehow involved, it is really a question of parallelism. The diagram below illustrates the dynamics of the Surrealist image that operates on several different levels.

Extending horizontally and vertically, the arrows retrace the major paths of interaction between the components as the image reverberates in the observer's mind. Meaningful connection does not exist between A and B but only between A' and B' and A'' and B''. In the brief period allotted the viewer, a certain amount of experimentation and verification is required before these connections can be established. To be effective, the image's impact must be almost instantaneous, in keeping with Breton's dictum about the value of surprise. The fact that much of the surprise is visual does not lessen the importance of these links. The line labeled "analogical plane" marks the border between the conscious and the preconscious, while the "symbolic plane" separates the latter from the unconscious. As Laplanche and Pontalis explain, the preconscious system lies between the conscious system and the unconscious, from which it is cut off by the censorship. "More generally, [it designates] what is implicitly present in mental activity without constituting an object of consciousness."[35] Thus, analogy is presented here as a preconscious process, at least as long as it remains concealed, and symbolism as the product of unconscious forces.

In theory, symbolism represents the more powerful mode of expression since it is closer to our psychic center. One would also expect an image containing a double bond, one that combines both symbolism and analogy, to be more resonant than an image with a single link. For that matter, there is no reason why additional symbols could not exist at the unconscious level structured around additional bonds. Not only do dreams frequently seem to have more than one meaning, Freud concluded, but "a succession of meanings or wish-fulfillments may be superimposed on one another."[36] This observation suggests that the ladder structure depicted previously, which recalls that employed by de Chirico (see Chapter 4), can be extended indefinitely. Based on these distinctions, in any case, one can divide the Surrealist image into three categories: analogical, symbolic, and analogo-symbolic. Although analogy and

symbolism differ from each other in their degree of psychic accessibility, they function identically in the context of the image. Both devices exploit similarity to produce parallel structures—by definition an analogical process. One should note nevertheless that this principle only governs the vertical structures. It explains the relation of A to A' but not that of A' to B' or A'' to B''.

It is useful at this juncture to introduce the concepts of metaphor and metonymy that, as Roman Jakobson has shown, govern all known symbolic systems.[37] Thus, the development of any discourse follows two different semantic lines. One topic may lead to another through their similarity ("the metaphoric way") or their contiguity ("the metonymic way"). In a given series, each topic/statement/image either resembles its neighbor or is somehow associated with it. Jakobson includes antonyms and other contrastive devices in the first category since dissimilarity cannot exist without presupposing the possibility of similarity. Because these principles govern cognition itself, they influence not only our worldview but the manner in which we view individual phenomena. As Henri Bergson pointed out earlier, there are two profoundly different ways of grasping something: either we turn about it or we enter into it.[38] The second (intuitive) approach, which is perfectly attuned to Surrealism, evokes Jakobson's metaphoric way. In contrast to the first approach, which would seem to be metonymic, it implies that a composition's structure engenders a parallel response in the observer's mind. In a similar vein, Jakobson concludes that metaphor plays a crucial role in Surrealist art. In contrast to "the manifestly metonymical orientation of Cubism, where the object is transformed into a set of synecdoches, the Surrealist painters responded with a patently metaphorical attitude."[39] The following remarks are not intended to be restrictive but simply to illustrate Jakobson's thesis. Since the Surrealist image offers itself to a variety of meanings, it would be futile to attempt to impose unilateral interpretations.

VERTICAL METAPHOR

Although a competition between metaphor and metonymy is manifest in any symbolic process, Jakobson declares, one mode usually predominates. Thus, Romanticism is closely linked to metaphor and Realism to metonymy. An analogous distinction exists between poetry, which exploits similarity, and prose, which is forwarded essentially by contiguity. As we will discover, metaphor does indeed have a crucial function in Surrealism, but metonymy

plays an important role as well. Although the vertical structures of the Surrealist image are largely metaphoric, for example, metonyms are also present in appreciable numbers. In general, the metaphoric bonds can be divided into three classes: those that depend on physical (formal) similarity, functional similarity, or similarity involving other characteristics. If the well and the mouse hole in Desnos' *contrepet* resemble each other physically, for instance, the well and the unconscious are linked by functional similarity. Both of the latter serve basically as reservoirs, as sources of one kind or another, whereas both of the former share the same circular shape. Although sexual symbolism is widespread in Surrealist works, it relies for the most part on physical similarity. More than anything, the shape of de Chirico's towers and arcades encourages the spectator to view them as sexual playthings. The same situation exists in various works by Salvador Dalí and Max Ernst that contain phallic shapes and vaginal outlines. By contrast, as we saw in Chapter 3, Picabia's sexual symbolism relies primarily on functional similarity.

Not surprisingly, since the Surrealists believed that existence was elsewhere, celestial images occur again and again in their works. Several of the poems that Federico García Lorca wrote in New York, for instance, evoke objects associated with the night sky. The following example is included in a catalogue of unrelated images: "nubes rasgadas por una mano de coral / que lleva en el dorso una almendra de fuego" ("clouds rent by a coral hand / that bears an almond of fire on its back").[40] In this case, the fact that the poem is shouted from the top of the Chrysler Building provides an interpretive context. The giant hand represents the building itself, which is portrayed not as a skyscraper (*rascacielos*) but rather as a sky-tearer (*rasgacielos*). Interestingly, the two objects appear to be linked by physical similarity. As Lorca must have noticed, the building's unusual silhouette resembles a vertical hand with its fingers held together. This means that the mysterious almond of fire functions on two levels simultaneously. In the first place it represents a ring with a brilliant jewel on one of the hand's fingers; in the second place it refers to the building's prominent beacon. All three images are related by physical similarity.

Yet another kind of metaphoric bond is illustrated by Desnos' *contrepet*. The link between the dwarf who lives in the well and his implicit counterpart the mouse depends on characteristic similarity, in this case their small size. This category is characterized by considerable diversity since any shared trait suffices to join two images together. It can involve general classes such as animal, vegetable, or mineral; concrete properties like size, color, or weight; or

less tangible qualities such as direction, provenance, or orientation. Like Desnos's *contrepet*, the sentence "Il y a un homme coupé en deux par la fenêtre" relies on concrete properties. On the one hand, as Breton remarks, it is easy to imagine a man whose upper torso is simply framed in the window. On the other hand, it is more rewarding to identify this individual with Breton who was experimenting with automatism at the time. Presented from this angle, the sentence would appear to describe his discovery of the Surrealist method, which provided him with a momentary glimpse into his unconscious. "Through a magic window," he seems to be saying, "I can see my innermost recesses as if a surgeon had opened me up (cut me in half)." In this case the attribute uniting the man and Breton is simply their common sex. However, the link between the window and psychic automatism involves functional similarity. Each device permits us to see into areas that would otherwise be sealed off.

Another Spanish poet, José María Hinojosa, provides an example of vertical metaphor associated with less tangible qualities. Writing in the first person, he describes a recent experience with a female companion: "Tu boca entreabierta por donde salían nubes blancas que humedecían con sus lluvias nuestros dos corazones" ("Your half-open mouth from which white clouds emerged that moistened our two hearts with their rain").[41] Since Hinojosa and the woman appear to have been making love, the phrase presents at least two possibilities. At first glance, the poet seems to be depicting his partner in the throes of passion. Like a tea kettle or even a locomotive, she seems to be emitting puffs of steam as her lover stokes her inner fires. However, this impression is undercut by the second half of the phrase, and the rest of the poem, in which the woman acquires a nurturing role. Above all she is associated with fertility. The key to what is actually happening is furnished by the realization that, at a deeper level, the clouds represent a string of words. The link that joins them is provided by their common provenance: the woman's mouth. She may still be making love, but her words are tender rather than passionate. Instead of lust, the rain that they shed (the emotional response they produce) fosters the growth of love in the lovers' hearts.

Examples of elements that belong to a common class are relatively plentiful as well. Indeed, many if not most of the personifications that occur in Surrealist compositions belong to this group. Thus, Octavio Paz evokes Nature's shocked response when an innocent bird is struck by the arrow of Fate: "vibró el cielo, / se movieron las hojas, / las yerbas despertaron" ("the sky vi-

brated, / the leaves stirred, / and the grass awoke").[42] Although these images express a universal wave of indignation, they function on the mimetic level as well. The bird's death coincides with a gust of wind that, paradoxically, brings the landscape to life. The clouds scudding across the sky are paralleled by leaves and grass blowing in the breeze. In other words, since the sky cannot feel cold nor the grass experience sleep, they resemble human beings only because they are capable of moving. Viewed in this perspective, the world turns out to be a very simple place. There is no need to invoke complicated distinctions when everything can be reduced to just two categories: animate and inanimate.

By contrast the Catalan Surrealist J. V. Foix exploits a tripartite distinction, that between animal, vegetable, and mineral, in another text. At one point the reader suddenly encounters some "cavalls negres que, en ésser nit, vaguen a milers i milers per la platja amb una estrella al front" ("black horses that, since it is night, roam the beach by the thousands with a star on their foreheads").[43] With a little effort one realizes that this incident must have been suggested by another nocturnal scene, one that is equally breathtaking. From time to time certain beaches are invaded at night by swarms of marine creatures, such as crabs or turtles, which come to mate and/or lay eggs. Because they all arrive at the same time, and because of their vast numbers, the phenomenon has received much publicity. In this case, therefore, Foix simply chose to substitute one kind of animal for another. What links the horses to the original crustaceans (or amphibians) is their common animality. Although the stars on the horses' brows can be explained at the mimetic level, these are not white patches presumably but actual celestial objects. The stars may enable the horses to see where they are going, like miners' lamps, yet they also serve to confirm their cosmic identity.

The mysterious horses reappear in another passage by Foix that demonstrates how flexibly different types of vertical metaphor can be combined. In addition, it reveals that more than one bond may exist between an image and its analogical or symbolic partner.

> The Man-Who-Sells-Coconuts has put on such a big false moustache that he has made me cry from fear. He has seized me by the hand and has made me go to the back of the stable where the black horses are sleeping. To make me keep quiet he has shown me, through a crack covered with cobwebs, the vague landscape where a thousand silver rivers die in the sea, and he has filled my hands with olives.[44]

C. B. Morris describes this episode, quite rightly, as "a short narrative of fear."[45] What makes the story so disturbing, one comes to realize, is that it recounts a thoroughly despicable act. More precisely, since nothing objectionable occurs on the surface, it conceals an unacceptable action whose broad outlines it enthusiastically reenacts. Although the reader is spared most of the unpleasant details, the act in question is clearly that of child molestation. Reflecting a form of paranoia commonly found in dreams, the narrator finds himself reduced to a helpless boy, while the Coconut Seller looms over him larger than life. Through a link based on physical similarity, the coconuts that the latter displays represent his testicles. Like his false moustache, they serve as emblems of his terrible virility. Once he has taken the boy to the back of the stable, where he intends to molest him, he shows him a landscape and fills his hands with olives. Both actions correspond to strategies commonly employed by child molesters, who show their victims pornographic pictures before they begin and who give them candy when they protest. As Morris notes, the olives are "an unspoken bribe." Because the purpose of both actions is to keep the boy quiet, as he tells us himself, they are related to their original models by functional similarity. In addition, each image can be shown to contain a second bond. Since the landscape is juxtaposed with an obvious vaginal symbol ("a crack covered with cobwebs"), it is linked to the pornographic pictures by physical similarity. And since olives are something one eats, they are related to the candy through characteristic similarity.

VERTICAL METONYMY

The role of vertical metonymy in Surrealism has already been illustrated by Foix's horses, whose prominent stars allow us to associate them with cosmic forces. The fact that the horses are black, parenthetically, suggests that they may represent unconscious forces as well. In any event, this dichotomy characterizes a similar image employed by the Chilean poet Rosamel del Valle in *Eva y la fuga* (*Eva the Fugitive*) (1930).[46] Consisting of a well with a star at its edge, the book's central image draws on physical similarity in the first instance and physical contiguity in the second. As Balakian points out in her introduction to the English translation, the image evokes a voyage into the unfathomable.[47] In spanning the distance between the well and the star, this voyage, like Eva herself, encompasses all of human experience. The image of the well, Balakian remarks, "seems to suggest simultaneously abysmal depth

and an ever replenishable source of water, conciliating thus the antithetical significations of life and death, of consciousness and oblivion." Like the well in Desnos's *contrepet*, therefore, it represents a source at one level and the unconscious at another. Recalling mottos such as *Ad astra per aspera,* the image of the star represents both a higher goal and a higher consciousness. The two images are thus associated with voyages of discovery, one internal the other external.

As one would expect, vertical metonymy can also be found in visual compositions. For that matter, as the next example demonstrates, it also occurs in dreams and visual hallucinations. "Une nuit de 1936," René Magritte later recounted, "je m'éveillai dans une chambre où l'on avait placé une cage et son oiseau endormi. Une magnifique erreur me fit voir dans la cage l'oiseau disparu et remplacé par un oeuf" ("One night in 1936, I awakened in a room where a cage and the bird sleeping in it had been placed. A magnificent visual aberration caused me to see an egg, instead of a bird, in the cage").[48] So impressed was he by this unexpected discovery, based on physical contiguity, that he placed additional objects next to the cage to see if he could duplicate the experience. This event undoubtedly contributed to Magritte's lifelong obsession with objects, which is documented by many of his paintings. Although many critics have tried to identify the principle linking various objects with each other, they have focused primarily on the level of mimesis. The experience previously described suggests that this principle is situated at the preconscious or the unconscious level instead. Like the substitution of the egg for the sleeping bird, it may involve some kind of psychic triangulation.

Other examples confirm the importance of physical contiguity in establishing vertical bonds. Luis Cernuda invokes this principle in "Cuerpo en pena" ("Body in Torment"), for instance, which describes a drowned man surveying his undersea domain.[49] Strange life-forms move to and fro, like trees and flowers in the world he has left, "Mas el viento no mueve sus alas irisadas" ("But the wind no longer moves its iridescent wings"). Despite the ease with which this image is introduced into the poem, and despite its obvious beauty, the metaphor is surprisingly tenuous. All that links the wind to a bird in flight is their momentary contact. Evoking the overwhelming silence a few lines later, the poet introduces an image that is even more delicately poised. "El silencio impasible sonríe en sus oídos" ("The impassive silence smiles in his ears"), he proclaims with a flourish. This personification stems not from any perceived similarity but from the ability of human beings to smile (and remain silent). By contrast, a human shadow in one of Rafael Alberti's poems is more securely anchored.

Despite its ethereal status, it manages to seem amazingly concrete. Appearing from out of nowhere, "una sombra se entrecoge las uñas en las bisagras de las puertas" ("a shadow catches its fingernails in the doors' hinges").[50] What could be more human than slamming one's finger in the door?

To these examples should be added the notorious *Poisson soluble* (*Soluble Fish*), a collection of automatic texts that accompanied the first manifesto. Breton explained that the paradoxical title described himself since he was born under the sign of Pisces (MS, p. 340). For that matter, he added, each one of us is soluble in his or her own thought. Interestingly, a recently published text reveals that Breton originally conceived of the "poisson soluble" as a goldfish. Although the editors of his collected works speculate that he was thinking of a Matisse painting, the actual source may have been Apollinaire's poem "Fusée-Signal" ("Signal Flare"), which we know he admired.[51] In any case, the bond between Breton and the soluble fish exploits what might best be called categorical contiguity, when two terms are linked by the logic of classes rather than properties. Unlike the metaphoric dwarf and mouse in Desnos's *contrepet*, the poet and the fish do not share a given characteristic but merely the same sign. The classification is completely abstract.

It is instructive in addition to consider an image taken from *Poisson soluble* itself. At one point a marvelous "lyre à gaz" ("gas lyre") appears that hovers over the protagonist, who is hunting in a desolate region, and "s'offr[e] à le conduire en un lieu où aucun homme n'avait jamais été" ("offer[s] to take him to a place where no man had ever been before").[52] Since the protagonist may be identified with Breton himself, following a common pattern in his work, the text invites us to relate the sequence of events to his innermost desires. The key to this passage is furnished by the mysterious lyre à gaz—a lyre-shaped fixture that was formerly used to hold gaslights.[53] Although this is undoubtedly how the poet wishes us to picture it, at the analogical level the name suggests a musical instrument powered by methane or perhaps butane gas. Or the instrument may be filled with helium like a balloon, which would explain why it is floating in the sky. On yet another level the mysterious fixture can be seen to refer to automatic poetry as well. This time the vertical metonymy is based on (double) functional contiguity. Just as the lyre serves to express poetry, the gas in question serves to power poetic discourse, to make it automatic. One wonders if a similar principle is not at work in Tristan Tzara's play *Le Coeur à gaz* (*The Gas Heart*). Be that as it may, the present text appears to recommend automatic poetry as an important key to the unconscious. Written some five

years after the discovery of the Surrealist method, it reenacts this historic event and expresses Breton's desire for a decisive breakthrough.

HORIZONTAL METAPHOR

Whereas the vertical bonds are predominately metaphoric, horizontally the Surrealist image employs metaphor and metonymy in approximately equal proportions. This difference undoubtedly reflects the need for strict parallelism in the first instance and flexibility in the second. It should be emphasized that these principles govern only the relations between $A'-B'$ and $A''-A''$. They do not exist at the conscious level. As before, metaphor revolves around physical, functional, and characteristic similarity. Thus, in the expression "pneus pattes de velours" ("tires velvet paws") the terms are paired according to functional similarity.[54] Automobile tires and cat's paws are both means of locomotion. On the contrary, Breton's gratuitous assemblage: "LE PREMIER JOURNAL BLANC / DU HASARD" ("THE FIRST BLANK NEWSPAPER / OF CHANCE") exploits characteristic similarity (MS, p. 343). Apparently unrelated, the blank pages and objective chance are linked in fact by the concept of absence. The lack of newsprint or photographs in the first instance corresponds to the absence of laws in the second. Both phenomena are impervious to analysis and interpretation. On the other hand, Lautréamont's phrase "le rubis du champagne" ("the champagne's ruby"), cited in the First Manifesto, depends on similarity of color for its effect (MS, p. 339).[55] An analogous process is at work in another assemblage by Breton: "Un éclat de rire de saphir dans l'île de Célan" ("A burst of saphire / laughter on the island of Ceylon") (MS, p. 341). Here the jewel and the sound have a similar sparkling quality, the burst of laughter conjuring up images of broken glass ("éclats de verre") in particular.

A similar explanation would seem to account for another of Breton's images, "la rosée à tête de chatte" ("the cat-headed dew"), which is also cited in the manifesto (MS, p. 339).[56] "Amalgamation of dew and the head of a cat," Matthews declares, "clearly lies outside the bounds of practical possibility and has no model in the world of physical reality. . . . The reasoning mind declines to venture beyond the limits of the physical universe. Conversely, by luring us outside those very limits, [the phrase] stimulates imaginative response."[57] When this image is compared to the preceding images, for instance, a common pattern begins to emerge. In retrospect all three phrases are structured around equations, or rather partial equations according to Breton's instructions. In

each case the preposition involved abdicates its spatiotemporal function and serves essentially as a copula. Like the champagne and the laughter, therefore, which resemble precious stones, the sparkling dew resembles the gleaming eye of a cat. This interpretation is reinforced, moreover, by the existence of a plausible intermediary: the cat's-eye stone or *oeil-de-chat*. The drops of dew probably reminded the poet first of jewels, then of cat's-eyes (which have a dew-like sparkle and shape), and finally of actual feline eyes. The final transition to "tête de chatte" was simply the result of a natural metonymic progression from contained to container.

The expression "mamelles de verre" ("breasts of glass"), versions of which appear in numerous Surrealist works, offers an interesting example of horizontal metaphor involving multiple similarity. To experience its full impact, instead of treating it as a harmless trope, one must imagine a woman whose breasts are actually made of glass. The key to this fascinating image lies in turn in the complex network of resemblances that exists at the analogical level. Once again it is necessary to invoke a verbal mechanism to reveal the secret affinities joining the two terms together. Proceeding via vertical metonymy, one perceives that the substance glass is easily replaced by its homonym, which designates a drinking glass (un verre à boire). Because both words sound exactly the same, the verbal bridge leads naturally from one to the other. In this case, since the context requires a rounded shape, one thinks automatically of a goblet or a wineglass. Thus, the comparison between breast and glass is founded partly on physical similarity. In addition both objects turn out to have a common function. Just as the purpose of breasts is to hold milk, the glass serves to hold various liquids. In other words, each object is commonly conceived as a container. Finally, breast and glass share a number of other characteristics. From the fact that they are paired with each other one would expect the woman's breasts to be smooth, cold, and hard. While these qualities appealed to some of the Surrealists, who considered them highly erotic, others found the new Eve less attractive. Several individuals attributed the qualities to the woman herself and concluded that she was an automaton rather than a human being. Thus, she was often depicted as passionless, calculating, and virtually indestructable.

Although this chapter concentrates on individual examples, multiple images are the rule rather than the exception in Surrealist poetry. Indeed, some works contain cascades of images that overwhelm the reader in successive waves. From time to time, moreover, one metaphor will engender a whole se-

ries of other metaphors that develop and amplify the initial equation. Extended metaphors have been studied by Michael Riffaterre in particular, who has emphasized their interlocking structure.[58] More commonly, an initial term will be paired with successive terms to produce a series of comparisons. Whereas the secondary elements are interrelated, like the primary elements, the latter have little in common. Thus, Pablo Neruda describes a rainstorm as follows: "Rodando a goterones, / cae el agua, / como una espada en gotas, / como un desgarrador río de vidrio, / cae mordiendo" ("Rolling in big raindrops, / the water falls, / like a sword in drops, / like a tearing river of glass, / it falls biting").[59]

As the reader quickly perceives, this is no ordinary rain. It pierces like a sword, flows like a river, and bites like a wild animal. While the first and third metaphors attribute specific properties to the rain, the second emphasizes its quantity. In order to refine the basic equation rain = river, Neruda added two qualitative epithets: "desgarrador" and "de vidrio." Although the second epithet merely stresses the physical resemblance between the two objects, the first changes the whole picture. Instead of flowing smoothly, the imaginary river threatens to destroy everything in its path. This change of focus directs our attention back to the other two metaphors, which share the same seme. All three objects are depicted as agents of destruction. Since rivers do not normally act this way, it is probably best to speak of characteristic rather than functional similarity. This is the principle that links the sword, the river, and the teeth to the rain. In addition it links each of the objects to each other. Despite their obvious differences, which are substantial, they all belong to the same paradigm.

This example sheds some light on a related image created by Vicente Aleixandre. Serving as the title of a book of poems, *Espadas como labios* (*Swords Like Lips*) repeats two of the previous motifs but alters the context in which they occur. Morris speculates that the image may have been suggested by a sentence in Aragon's *Les Aventures de Télémaque*: "Projectile du prodige, je pars poignard et j'arrive baiser" ("A prodigious projectile, I depart a dagger and arrive a kiss").[60] But while Aragon insisted on the difference between these two objects, Aleixandre was attracted by their apparent similarity. The question that naturally arises is how to explain what seems to be a peculiar choice. On the one hand, there is no denying the title's potency, for it evokes the telltale shudder that is the sign of success. On the other, it is not particularly easy to see why it should elicit this reaction. If one tries to visualize the image, for instance, the result is ludicrous.

Imagine the Three Musketeers defending the Queen's honor with pillows in the shape of lips! Everything is wrong with this picture; nothing works as it should. The swords' dominant semes are smothered by those associated with the lips, which are powerless in turn to resist the armed assault. If we want to understand the dynamics that underlie this image, we will have to look elsewhere.

One possibility would be to conclude that the simile belongs to the same paradigm as Neruda's three metaphors. Viewed in this light, the primary relationship would actually be between swords and teeth. Since teeth are normally concealed by lips, nothing could be simpler than for one to replace the other. The presence of lips in the title could simply represent metonymic displacement. According to this interpretation, the real equation would stress the swords' ability to inflict damage via functional similarity. Although it is impossible to disprove this thesis, which at least provides a workable model, it is not entirely satisfactory. For one thing, since swords are usually more dangerous than teeth, the comparison should proceed in the opposite direction. For another, lips and teeth differ greatly with regard to their symbolic possibilities. Finally and most important, the explanation fails to account for the title's evocative power.

These and other considerations force us to reevaluate the relationship between the two objects in the title. The principle that joins them together, one eventually realizes, is not functional similarity but rather functional dissimilarity. As Jakobson notes, antithesis is an important metaphoric principle. By definition likeness presupposes difference and vice versa. In contrast to swords, therefore, which are used for killing, lips serve to bestow kisses. Whereas the former represent instruments of death, the latter are viewed as instruments of love. In retrospect, Aleixandre's title appears to derive most of its force from the violation of categories long held to be sacrosanct. It not only fails to preserve the traditional boundary between these two domains but actually seeks to destroy it. On the one hand, as Riffaterre has demonstrated elsewhere, this phenomenon illustrates the radical nature of the Surrealist revolution.[61] By substituting an equivalence for polar oppositions such as punishment/reward, hate/love, and killing/reviving, the title attacks the foundations of meaning itself. On the other hand, it violates a long-standing taboo that forbids the erotic from mixing with objects associated with death. By combining Eros and Thanatos, therefore, the title threatens to undermine the foundations of society as well.

Although the eroticization of death is frowned on in our society, it surfaces from time to time in certain motifs such as the vampire and the femme

fatale. Whereas the latter seduces her victims before she kills them, the former delivers a fatal bite to the neck disguised as a kiss. Although both motifs were largely exhausted by the turn of the century, Aleixandre found a way to revive them. His solution, conscious or not, was to reverse the metaphor to recreate its original effect. Observing that vampires had lips like swords, he reversed the terms and added an erotic element. To be sure, lips can be used for speaking as well as for kissing. *Espadas como labios* could conceivably describe a mighty warrior, someone who prefers to let his sword do his talking for him. And yet the swords' erotic role is what provides the title with its punch. Like the lips of the femmes fatales before them, they are fascinating but also deadly. That the swords may also have a phallic identity is reinforced by their juxtaposition with the sexually ambiguous lips. Nevertheless, their sexuality is subtle rather than strident, implicit rather than overt. The dominant image that emerges is that of a passionate kiss, not a sexual embrace. Despite the swords' seductiveness, moreover, their promise of sensual bliss is misleading. Ultimately, they will serve not to inflame their victims' passions but to deliver the kiss of death.

HORIZONTAL METONYMY

Although horizontal metonymy may assume various forms, like horizontal metaphor, it ordinarily exploits physical or functional contiguity. Less commonly, one finds metonyms that are structured around relations involving categoricity, temporality, or causality. Categorical contiguity, for instance, involves a relationship between genus and species, between specific example and abstract concept. This is the principle that links rose to flower, diamond to gem, and the poet to the rest of humanity. Either term is capable of generating the other. Temporal contiguity, as its name implies, pairs elements that belong to the same time sequence. Since this link is relatively nonspecific, it can be difficult to identify. By contrast, the images in the following phrase, taken from *Les Champs magnétiques*, are joined by cause and effect: "[L']Enfant . . . barricade sa fenêtre de ses cils."[62] From the context it is clear that the possessive pronouns refer to the infant, but the function of the preposition "de" is problematic. If we interpret it to mean *avec*, as seems likely, we obtain the following analogical translation: "[The] child . . . barricades his window with his eyelashes." In other words, he blocks out the light coming through the window by closing his eyes. The sentence not only describes an action but the result of that action as well.

Although causal relations are often straightforward, as in the previous ex-
ample, they can also be difficult to detect. In some works cause and effect are
indistinguishable from one another. In others, there is no obvious agent to at-
tribute the effects to. Consider this Surrealist haiku by Octavio Paz, which
thrives on ambiguity: "El día abre la mano / Tres nubes / Y estas pocas pal-
abras."[63] In the absence of punctuation the poem can be interpreted in at least
two ways. It is impossible to tell whether the verb *abrir* governs all three ob-
jects or whether it is restricted to the first line. Assuming that the first two
verses end in invisible commas, the objects would constitute a series: "The day
opens its hand, / Three clouds, / And these few words." With a little thought
this statement can be reformulated at the analogical level. The first light of day
reveals three clouds and the poem we are reading. In other words, the dawn is
linked to the last two objects by causal contiguity. Assuming that the first verse
ends with an invisible colon (or a period), the revelatory function would be
transferred from the daylight to its metaphoric hand. Harking back to
Homer's rosy-fingered dawn, the latter continues the Classical personification
and adds a wrinkle of its own. In Paz's poem the hand opens to reveal that it
is holding the clouds and the poetic words in its palm. The cause-and-effect
relation still exists in the second reading; it has merely been displaced.

In most cases, however, metonymic objects are defined in terms of their
immediate surroundings or their function. The first situation describes one of
Breton's titles: *Le Revolver à cheveux blancs* (*The White-Haired Revolver*), which
appears at first glance to be totally gratuitous. Balakian associates the revolver
with the ultimate act of protest proposed in the Second Manifesto: shooting
into a crowd at random.[64] On reflection the title can also be seen to juxtapose
a penis and pubic hair at the symbolic level according to the principle of phys-
ical contiguity. Based on the color of his hair, one can even begin to construct
a portrait of the man in question, who is obviously elderly. Similarly, Lautréa-
mont's celebrated image of an umbrella and a sewing machine lying on a
dissecting table proves to be surprisingly coherent. On the one hand, in view
of their immediate context the first two objects may be interpreted as surgi-
cal instruments. That they have a medical function is indicated by their
presence on the dissecting table. On the other hand, these objects also serve as
sexual symbols—whence the eerie power of Lautréamont's simile. Seen in
this perspective, as Breton himself realized, the umbrella represents a man, the
sewing machine a woman, and the table a bed.[65] At the unconscious level,
therefore, the image depicts an erotic encounter. The same principle governs

many of de Chirico's paintings in which towers are juxtaposed with arcades to create a sexual universe.

Like the other relations we have examined, horizontal metonymy frequently challenges the reader or viewer to identify the elusive link between the two terms. Describing what appears initially to be a realistic landscape, for example, García Lorca suddenly introduces a startling image: "Por la luna nadaba un pez" ("A fish swam through the moon").[66] As is often the case in Surrealist compositions, the reader is confronted with several possible interpretations. Indeed, one discovers before long that the image can even be interpreted mimetically. Since the scene turns out to include a pond, the fish could conceivably be swimming through the moon's reflection in the water. If one assumes that the drama takes place in the sky, it becomes necessary to treat the fish as a metaphor. At this point we need to draw up a list of objects that can be juxtaposed with the moon. To be eligible each one must combine vertical similarity with horizontal contiguity. Proceeding on the assumption that a celestial object is involved, one discerns two lines of attack. On the one hand, the object may actually resemble a fish, in which case it may be an airplane or—since the poem dates from 1930—even a dirigible. On the other, the object may simply occupy the same position in the sky as the fish, in which case it may be a cloud. Whichever explanation one adopts, the object should be imagined as passing in front of the moon rather than through it.

Like Magritte, who saw an egg instead of a bird, Salvador Dalí incorporated a number of visionary experiences into his art. Since these assumed the form of hallucinations, they could be appropriated directly with relatively little effort. While the medium differed from the first stage to the second, the mode of expression—visual representation—remained essentially the same. One of the artist's more memorable experiences occurred in 1932. "A l'heure du coucher," he recalled, "je vois le clavier bleuâtre, très luisant, d'un piano dont la perspective m'offre en raccourci une série décroissante de petites auréoles jaunes et phosphorescentes entourant le visage de Lénine. Cette image se produit au moment d'entrer dans le lit, avant que la lumière soit éteinte" ("At bedtime, I saw the bluish keyboard, very shiny, of a piano whose foreshortened perspective presented a decreasing series of little yellow phosphorescent halos surrounding Lenin's face. This image occurred as I was getting into bed, before the light had been extinguished").[67]

Shortly thereafter Dalí portrayed this scene in a painting entitled *Hallucination partielle: six images de Lénine sur un piano*. Reproduced in *Le Surréalisme*

au Service de la Révolution in May 1933, it depicts not only the mysterious keyboard but the entire piano. Seated opposite the instrument, an elderly man contemplates the phosphorescent images of Lenin, while a woman appears to be crying in the background. Although the picture poses numerous questions, the most important concern Lenin's role in the painting. Why, one wonders, did Dalí choose to depict this particular character. Why is his head surrounded by a burst of light? Why are there half a dozen luminous images instead of only one? Above all, why is the Russian leader juxtaposed with a grand piano? The answers to the first two questions are relatively easy to divine. That the Surrealists included Lenin in their pantheon of revolutionary heros, along with Freud, Lautréamont, Sade, and others, is well known. Thus, the fact that Lenin's portrait is accompanied by a halo would seem to reflect the feelings of veneration that he aroused in them. Viewed from this angle, the images resemble a series of Russian icons.

By contrast, the answers to the last two questions are to be found at the analogical, or possibly the unconscious, level. They are mimetic only to the extent that they exploit vertical metaphor based on physical similarity. However, the objects on which the piano and the luminous images are modeled are anything but easy to discern. Only after lengthy investigation does the nature of Dalí's symbolism finally become clear. Eventually one perceives that the piano's keyboard represents an altar and that the phosphorescent halos represent votive candles. This is why there are so many of them, evenly spaced, extending the length (or the width) of the instrument. In addition, this explains why the room is so dimly lit. In reality (and at this point the term loses all semblance of meaning), the scene takes place in a church or other suitable building. In reality, what we are actually witnessing is Lenin's funeral. This is why the lady in the background is crying. Like the elderly man, whose face we cannot see, she is one of the mourners. Besides serving as an altar to Lenin, moreover, the piano also serves as his coffin. The reason its lid is raised to such an absurd height is to allow the mourners to catch one last glimpse of their idol. Since Dalí was not able (or did not wish) to depict the corpse itself, he superimposed Lenin's likeness on each of the candles.

Like the preceding objects, Paul Eluard's verse: "Sur la plage la mer a laissé ses oreilles" ("The sea has left its ears on the beach") relies on physical contiguity, but unlike them it exploits functional contiguity too.[68] While the immediate analogy conjures up the image of seashells lying on the beach, at a deeper level it juxtaposes uterine symbols and others associated with birth.

Symbolically, the situation recalls Botticelli's *Birth of Venus* in which the ocean gives birth to the goddess via a gigantic scallop shell. In addition to the mimetic progression leading from ear to shell to uterus, a metonymic relation exists between the ear and the uterus. Apart from the question of physical resemblance, which is considerable, in Classical antiquity pregnant women were commonly said to possess an "eared womb." And traditionally children who asked where babies came from were told they were born through the ear. In Eluard's poem, therefore, the sea is represented as an inexhaustible source of life. As the implicit pun on *mer* ("sea") and *mère* ("mother") makes clear, it is fecundity personified.

The same preoccupation with function can also be seen in the man cut in half by the window, discussed previously, where Surrealism is defined as the ability to reveal the unconscious. It is also evident in a striking phrase taken from *Les Champs magnétiques*: "Le lac qu'on traverse avec un parapluie" ("The lake one crosses with an umbrella").[69] In order to fly across the lake like Mary Poppins all we need is an umbrella. Or perhaps the umbrella is meant to be inverted and used as a kind of boat. In either case, the image is perfectly coherent at the analogical level. By definition an umbrella's function is to prevent its owner from getting wet. Just as it serves to repel rain on the one hand, it serves to repel the lake on the other. Viewed symbolically, the image reflects an unconscious desire for limitless mobility.

As has become abundantly evident during the preceding analysis, neither element of a polar image possesses an absolute identity. Each term derives its ultimate meaning from the other according to a complex dialectic involving multiple contexts and levels of interpretation. "Rompant d'aventure le fil de la pensée discursive," Breton observed, the Surrealist image "part soudain en fusée illuminant une vie de relations autrement féconde" ("Breaking the thread of discursive thought, it suddenly takes off like a signal flare illuminating a whole new network of relations").[70] As Arnheim remarks, the relations between the two universes joined together by metaphor are "a revealing characteristic of an author's literary style."[71] More important, by analyzing the relations within each of the images in a poem or a painting, one can begin to grasp the nature of the creative endeavor in question. To complete the task, one would need to apply the model sketched out in this chapter to the bonds between the polar images themselves in a composition. Since these external links conform to the same laws of metaphor and metonymy, they can be analyzed according to the same method.

The preceding method combines a generative approach to literature and art with a functional theory of imagery. These are its principal virtues. Except in cases involving objective chance, there are no accidental images in Surrealism. Every image has a purpose and fits into a larger pattern. Indeed, Jakobson's analysis of metaphor and metonymy and Freud's theory of dreams make this conclusion inescapable. By insisting on the inevitable coherence of any symbolic process, the former confirms the latter's observations regarding the logic of the unconscious. According to Jakobson himself, Freud's concepts of displacement and condensation depend on contiguity, while those of identification and symbolism exploit similarity. Jacques Lacan has modified Jakobson's conclusion by pairing the metaphoric and metonymic axes with condensation and displacement, respectively.[72] For our immediate purposes, it makes little difference which theorist is correct. What matters is that Surrealist imagery must conform to the rules governing both the linguistic and the psychological models. Whereas Freud's conclusions are particularly valuable at the level of the macrostructures, Jakobson's method is ideally suited to the microstructures. Combined with each other, they permit the reader or viewer to trace the development of a work as methodically as an archaeologist, unearthing unconscious stratagems and predilections step-by-step. In the last analysis, as the next chapter will demonstrate, the rewards are twofold. Not only can one reconstruct the composition from the point of view of its creator, but the process itself provides precious insight into the workings of the imagination.

7 AN EXTRAORDINARY VOYAGE

J. V. Foix and Joan Miró

From the very beginning the Surrealists were fascinated by the possibilities of the polar image, which opened up vast domains for creative exploration. By 1926, when Louis Aragon published *Le Paysan de Paris* (*The Parisian Peasant*), its ascendancy was so well established that he could equate the Surrealist image with the movement itself. Underlining the obsessive attraction it held for him and his colleagues, Aragon even went so far as to compare it to heroin or opium. "Le vice appelé *Surréalisme*," he wrote, "est l'emploi déréglé et passionnel du stupéfiant *image*" ("The vice known as *Surrealism* consists of the passionate and reckless use of the narcotic *image*").[1] Echoing Rimbaud on the one hand and parodying legal documents on the other, he portrayed the Surrealists as so many drug addicts. Just as certain narcotics are prized for the visions they induce, he added that "chaque image à chaque coup vous force à réviser tout l'Univers" ("each image in turn forces you to revise the whole Universe"). Whereas Breton had celebrated the image's despotic hold on artists and writers in the First Manifesto, which he compared to hashish and opium, Aragon expanded its sphere of influence to include the entire universe.[2] More than anything, the Surrealists believed the image possessed the power to alter our view of the world around us.

As C. B. Morris explains, the Surrealist project involved a two-pronged attack on reality. What the Surrealists were fortunate enough to witness and recreate was "a new arrangement of reality . . . [that] they redisposed in new

patterns and illuminated in a new light."[3] Although this program was espoused by the avant-garde in general, beginning with the Cubists, it was especially pronounced in Surrealism. Following the trail blazed by the Surrealist image, Breton and his colleagues hoped to effect a *rapprochement* between the real world and the world of dream in which each was to be reinterpreted in terms of the other. Envisaging a reciprocal relationship between reality and surreality, they strove to establish a common meeting ground. Surrealism not only possessed a narcotic effect, they realized before long, but it resembled various types of insanity as well. While opinions differed as to the condition it most resembled, Dalí concluded that it could be compared most fruitfully with paranoia. Like the latter, he asserted, Surrealism "consisteix a organitzar la realitat de maner a fer-la servir per el control d'una construcció imaginativa" ("consists in organizing reality so that it serves to control an imaginary creation").[4] Taking a leaf from Rimbaud's book, who taught himself to see a mosque in place of a factory, Dalí boasted that he had recently imagined a woman who was simultaneously a horse. By accustoming himself to voluntary hallucination he was able to reshape reality according to his unconscious desires. This experience, which foreshadowed the invention of his paranoiac-critical method, testified to the triumph of the pleasure principle over the reality principle.

In addition, as the same text confirms, the Surrealists did not regard reality simply as a point of departure but actively sought to undermine its foundations. To this end they enthusiastically welcomed "tot el que . . . pugui ruinar la realitat, aquesta realitat cada vegada més sotmesa, més baixament sotmesa a la realitat violenta del nostre esperit" ("anything that . . . might destroy reality, that reality which is becoming more and more submissive to the violent reality of our minds"). In theory, Dalí continued, with a little more practice he could probably generate a whole string of hallucinations. This would have disastrous consequences not only for traditional aesthetics but for the way we view the world around us. For one thing, because meaning would be continually deferred, no single image (or polar image) could presume to tell the truth. Representation as we conceive of it would cease to exist. For another thing, multiple hallucinations would threaten our image of reality itself, suggesting that our perceptions are the product of similar activity. Anticipating Jacques Derrida by more than thirty years, Dalí attacked the Western notion of a logocentric universe and denounced the metaphysics of presence.

For the Surrealists, therefore, reality was at best an illusion and at its worst a cruel deception. Conceived as an intellectual and emotional construct, it

was located at the intersection of language and experience. Not only was reality felt to be purely subjective, but it was believed to be largely imaginary. Maxime Alexandre was simply repeating a common refrain when he declared: "Il n'y a évidemment d'autre réalité que les images poétiques" ("There is clearly no other reality besides poetic images").[5] Aragon expressed a similar opinion during a lecture at the Residencia de Estudiantes in Madrid on April 18, 1925. Addressing a group that included many future Surrealists, he insisted on the fictitious nature of reality, which derived its ultimate authority from language. "Mes mots, Messieurs, sont ma réalité," he announced. "Chaque objet, la lumière, et vous-mêmes, vos corps, seul le nom que je donne à ce glissant aspect de l'idée l'éveille en moi" ("My words, gentlemen, are my reality. Each object, the light, yourselves, your bodies—only the name I give to this slippery aspect of the idea awakens it within me").[6] Again, many years before Jacques Lacan examined the subject, the Surrealists were aware of the slippage that exists between signifier and signified. Above all, as Herbert Marcuse so nicely puts it, they strove "to break the power of facts over the word," to divorce representation and meaning from the demands of bourgeois reality.[7]

How the Surrealists implemented this ambitious program forms the subject of the last two chapters, which are concerned with literary analysis. We will demonstrate some of the strategies they devised to tap the unconscious and deconstruct reality, which met with great success. In addition we will expand our discussion of the Surrealist image to encompass the whole poem. Of necessity the previous chapter was restricted to the individual image (or polar image) in order to analyze what happens at the most basic level. Now that the fundamental principles have become evident, we are free to explore larger structures. In an effort to illuminate some common mechanisms, each of the remaining chapters concentrates on a single text. In contrast to the previous chapters, which survey large amounts of material, they attempt to elucidate individual compositions. As the reader will discover, the first work recounts an extraordinary voyage and the second an extraordinary experience. Although the compositions are quite different, each in its own way is a minor masterpiece. As we try to disentangle the various semantic strands, each of the texts will be subjected to a different critical approach. The present chapter draws on Jakobson's discussion of metaphor and metonymy, which I have found to be extremely useful. The final chapter employs a methodology developed by Michael Riffaterre that has proven equally fruitful. The advantages that each of these models presents will become apparent as we progress.

J. V. FOIX AND THE SURREALIST ADVENTURE

Although the Catalan poet J. V. Foix repeatedly rejected the epithet "Surrealist," preferring to describe himself as an "investigador en poesia," most of his work is indistinguishable from that generated by the French movement.[8] If it is true that a person is known by the company he keeps, Foix's association with figures such as Salvador Dalí and Joan Miró speaks for itself. His interest in Surrealism was not limited to painting, moreover, but extended to literary texts written both in French and Catalan. Not only was Foix familiar with the latest experiments emanating from Paris, but he played an active role in reviews such as *L'Amic de les Arts* that served as a forum for the Surrealist movement in Catalonia. To this should be added Foix's habit of composing his works early in the morning, while the dreams of the night before were still fresh in his mind. Not surprisingly, a number of critics have noted the title of one of his poems, which nicely summarizes his poetic program. "ÉS QUAN DORMO QUE HI VEIG CLAR" ("I ONLY SEE CLEARLY WHILE I AM SLEEPING"), Foix exclaims, proclaiming his commitment to the Surrealist process, if not to the movement itself.[9]

While Foix's work remained faithful to Surrealist principles throughout his career, one can detect several stages in his development. As much as anything, the evolution of Foix's aesthetics is illustrated by his response to the art of Joan Miró over the years. Indeed references to Miró's paintings and drawings form a constant theme in his writings. Beginning in March 1918, when he published a drawing by the young artist in *Trossos*, Foix demonstrated his admiration for Miró's accomplishments on numerous occasions.[10] During the 1930s the two men even collaborated on a ballet (which was never produced), and as late as 1975 Miró contributed a series of engravings to a slim volume of Foix's poetry. Entitled *Quatre colors aparien el mon . . .* , the latter features a dialogue between the poet and his illustrator concerning the merits of various colors. For the purposes of charting Foix's aesthetic evolution, however, three texts are especially valuable. Entitled "A Joan Miró," the first one appeared in October 1918 and reveals the poet's innately Surrealist sensibility. Since Surrealism itself had not yet been invented, it belongs to Foix's avant-garde period and reflects his interest in the Dada movement.[11] The second text, which dates from 1928, represents the full flowering of Surrealism in Foix's poetry. Conceived as a poetic appreciation of the artist's work, it is simply titled "Presentació de Joan Miró." The third poem is dedicated to Miró and dated April 10, 1973. Entitled "Feiem estella de les branques mortes" ("We Reduce Dead Branches to Chips"), it celebrates

their mutual renovation of modern aesthetics, like the first poem, but tends to be more allegorical. Although Foix's dedication to Surrealist practice is still evident, it has become less intense and more overtly lyrical.[12]

This chapter focuses on the second composition, which appeared in *L'Amic de les Arts* on June 30, 1928. Following its initial publication, Foix incorporated it into *KRTU* a few years later, together with two other art critical pieces. Not only does this text illustrate the author's mature style, but it poses some interesting questions about the relationship of function to form. Equally important is the problem it poses for the critic who seeks to categorize Foix's thought according to traditional interpretive conventions. If one analyzes the composition as an example of art criticism, for instance, it is all too easy to ignore its poetic merit. And yet while Foix was certainly addressing the question of Miró's art, his remarks were dictated by his experience as a poet. Among other things this explains the composition's numerous eccentricities, which emphasize its aesthetic value. Although Foix manages to communicate his opinion of Miró's paintings and drawings, this process is interrupted by a series of formal devices that subvert the text's critical premises. The fact that it is written in prose rather than in lines of verse in no way detracts from its poetic status. The reader soon realizes that he or she is confronted with an established genre, the prose poem, and invokes the appropriate conventions. If one analyzes the work as an example of poetry, on the other hand, it is all too easy to lose sight of its critical function. Although the text's conclusions are masked by its stylistic features, what it has to say about Miró's art is clearly important.

The best course, therefore, is to consider both functions at the same time. In examining the various images and structures that give the composition its poetic identity it is wise to remember that it represents a work of criticism as well. In this respect "Presentació de Joan Miró" conforms to the rules that govern a second genre, known as "critical poetry." By 1928, the Surrealists had been experimenting with their own version, which they baptized *poésie synthétique*, for approximately ten years. Taking their cue from Apollinaire, who experimented with the genre as early as 1905, they insisted on the poetic value of the critical act. Despite the text's critical function, it had to be able to exist independently as poetry. The verbal composition was conceived not only as an act of homage but as a formal equivalent to the painting(s) in question. The best response to a work of art was not the critical essay, which reduced it to a series of abstract concepts, but another work of art in a different medium.

That Foix was keenly aware of the genre's conventions can be seen from his choice of title. This is not a discussion of Miró's art but rather a work in which the latter is *presented* to us. Despite the obvious differences that existed between Foix's aesthetics and the painter's, he sought to translate Miró's plastic achievements into poetic terms. To some extent his task was facilitated by the fact that they both subscribed to Surrealism. However, it remained to bridge the enormous stylistic gap that separated them and to overcome the barriers separating art and literature. As the following text demonstrates, Foix managed to solve both these problems.

I was surprised to discover, in mid April 1928, that the outlet of the Sant Gervasi tunnel was obstructed by the presence of a group of ladies dressed in green, with matching hats and shoes, in the style of the 1890's. I was also surprised that each one of them displayed a life-sized lithograph of *La Gioconda*, which they contemplated with undecipherable gestures. ("Mona Lisa! Mona Lisa!," objected a municipal railway inspector. "No, La Gioconda! La Gioconda!," I replied desperately. We nearly came to blows.)

The inspector looked like a pretty tough customer. He wore an excessive moustache that closely resembled typographical "moustaches." ("I know you: in 1918 I saw your portrait on the Dalmau Gallery's walls, on Portaferrissa Street. Joaquim Folguera assured me at the time that you were the husband of a woman who always dressed in green. You are an imposter. You cannot be each of these ladies' husband—they already number 30, 38, 49, 97, 100 . . . —and you have grown a moustache like Joan Miró's. You are neither an inspector nor Mr. Miró. However, my God!, suppose you were the painter Miró and were married to each of these ladies? But Mr. Miró shaved his moustache off sometime ago. If you weren't wearing that moustache, I would say you were Mr. Miró. You are wearing neither an 1898 style moustache nor a moustache in the style of 1928; you are not clean shaven, inspector; you are not each of these ladies' husband. You are Mr. Miró, that's for sure, Mr. Joan Miró, the painter Joan Miró. How are you, Miró? How are you doing? Please excuse me, and each of your wives as well; why have you grown so many moustaches all over your face, for no apparent reason? In order to make a copy of yourself for each of your wives?)

Composed of two cars, the Sarrià train passed on the other side of the tunnel without stopping. I continued my dialogue by myself when I perceived that Mr. Miró was sitting beside me, asleep in an eternal dream. While I was trying to awaken him, his head disappeared mysteriously through the window in the form of a phosphorescent ovule; from the decapitated trunk issued a flight of birds in a column, and an enormous gelatinous hand fell into my lap, like the mediumistic materialization of M. A. Cassanyes' hand.

When I thought I had arrived at the temporary La Ronda station, I observed the presence of thousands of phosphorescent ovules which ascended and descended along the shore of an unknown sea and which floated restlessly in the atmosphere. I was about to crush some between my hands and give birth to the beautiful unpublished worlds whose seeds they bear, if my arms had not been the fallen branches of a dead stump that projected a strangled shadow on the landscape.

This marvelously evocative text bears all the hallmarks of the Surrealist adventure. Foix's version of reality leaves plenty of room for contradictions and logical inconsistencies. No sooner does the narrator relay one piece of information than we learn he is mistaken. In addition, causal relations are suspended in favor of random juxtaposition. Events succeed each other without any apparent connection as the reader glimpses one mysterious episode after another. Objects suddenly metamorphose into other objects for no particular rhyme or reason. Enigmatic characters engage in strange rituals whose purpose is unknown. If Foix's tribute to Miró can be said to be governed by a single principle, surely that principle is the logic of dream. Conceived as a *récit de rêve*, it illustrates the workings of the unconscious. The hallucinatory quality of the text itself is typical of Foix's work. What gives his compositions their Surreal atmosphere is not his choice of elements, which tends to be realistic, but the unusual manner in which they are combined.

In one respect the present text differs from most of Foix's creations. Whereas the Catalan author often includes disturbing elements in his poetry, which recur with surprising regularity, "Presentació de Joan Miró" reflects a different state of mind. Unlike many of his works, it is a very funny text. Although our response has undoubtedly been conditioned by the Theater of the Absurd, the spectacle of the narrator's confusion is inherently humorous. The comparison that comes to mind is not with Kafka but with Charlie Chaplin's little tramp who, seeking to go about his business, is beset by one amusing difficulty after another. The source of Foix's mirth, moreover, is not difficult to discover. While Miró's art passed through no fewer than eighteen stages during his lifetime, in each case it retained the joyous quality that we have come to associate with his work.[13] From the beginning his paintings displayed the love of bright colors and the sense of humor that quickly became his trademark. Although the hues in the present text are relatively muted, Foix succeeds in reproducing Miró's whimsical humor and much of his visual appeal. By this

time, however, the two men had developed artistic vocabularies that had little in common. Whereas Miró had turned to abstraction in order to approximate the dream state, Foix achieved the same effect through a kind of distorted realism. The principal challenge, therefore, was to find a way of representing abstract form without sacrificing the text's penchant for concrete details.

One of the things that makes Foix's composition so interesting is the intrusion of the marvelous, which constantly undermines its banality. In attempting to take a short train trip, the narrator, whom we are free to identify with Foix, is frustrated by a series of irrational events. What better symbol of law and order than a train station, with its rows of clocks and precise timetables? And yet the carefully regulated universe with which he is familiar dissolves before his very eyes as one incredible experience leads to another. In keeping with common Surrealist practice Foix creates a realistic frame for his story. Despite its obviously fantastic character he situates it precisely in space and time. The events he is about to recount, he proclaims, took place in Barcelona in mid April 1928. One of the functions of the Sant Gervasi tunnel, evoked at the beginning, is thus to provide a recognizable setting. As much as anything the discrepancy between the tale and its frame, which is mirrored by that between the narrator and the events he witnesses, emphasizes the role of the marvelous. It also leads to an interesting paradox whereby the logical, objective narrator reports events that are clearly impossible, thus lending them credence. Although he claims to be surprised by the first encounter, he accepts the subsequent adventures without a murmur.

That the initial setting is a train station is indicated more clearly in the original version, which specifically evokes the "túnel de l'estació de Sant Gervasi."[14] Part of the municipal railway system, the station is situated in the suburb of Sant Gervasi on the northwestern edge of Barcelona. One must pass through this area to reach the funicular leading to the Tibidabo amusement park. Judging from the text itself, the narrator is waiting for a train to the neighboring suburb of Sarrià, which was once a separate town. Foix was born and raised in Sarrià and continued to live there for many years. Expecting to return home, he ends up in the temporary station of "La Ronda" instead. Exactly where this station was located is difficult to say, since it does not appear on current railway maps. Despite the author's attempt to trace a fairly precise itinerary, which reinforces the story's realistic frame, it makes little difference whether he travels in one direction or the other. For one thing, his destination is clearly imaginary. It represents a state of mind rather than a

particular geographical location. For another, the story is derailed before Foix can reach his ostensible destination. Descending the train at La Ronda, he succumbs to mysterious forces before he can resume his journey.

The text itself is divided into four episodes, two of which take place in the Sant Gervasi station and two during the subsequent voyage. Arriving at the station, Foix discovers that the tunnel connecting it with the rest of the railway has been blocked by a large group of women. Although he uses the word "sortida," they appear to be obstructing the tunnel's entrance rather than its exit. As long as the women refuse to budge no train will be able to leave the station. As Foix watches, their number swells to one hundred and continues to increase. While it is impossible to be certain, they seem to be emerging from the tunnel itself, which is overflowing with women dressed in green. Why they have decided to block this particular tunnel is never made clear. That they are engaged in some sort of demonstration, however, quickly becomes evident. Indeed the fact that the women are all wearing the same uniform proclaims their devotion to a common cause. Unfortunately, since their gestures are undecipherable, the cause itself is difficult to ascertain. Why are they carrying reproductions of the *Mona Lisa,* one wonders, and why do Foix and the inspector nearly come to blows?

The answer to the first question requires us to investigate the historical context in which the poem was conceived. The fact that all the demonstrators are women, for example, strongly suggests that they are early feminists. A potent force at the turn of the century, the suffragette movement was constantly in the news as women demanded the right to a series of male prerogatives. But why, one wonders, do feminists appear in this poem? Where do they come from, and what purpose do they serve? The presence of the suffragettes, it seems in retrospect, was occasioned not by a recent demonstration but by the death of their most famous leader two weeks earlier. A militant champion of women's rights for many years, Emmeline Pankhurst lived to see British women granted full franchise shortly before her death on June 14, 1928. At the time the poem was conceived, therefore, the publicity surrounding her demise provided Foix with his initial image. This explains why his suffragettes wear costumes dating from the end of the nineteenth century. Like the characters themselves, the costumes were probably suggested by newspaper photographs documenting Pankhurst's colorful career, which began about 1890. It also explains why they are all carrying pictures, since the suffragettes often adopted posters or sashes emblazoned

with slogans. In the present context, the image of the *Mona Lisa* would seem to symbolize universal womanhood. Gathered together under the banner of Leonardo's heroine, Foix's characters are protesting against inequities that have plagued women for centuries.

The answer to the second question is closely related to the first. Like everything else in the text the dispute between Foix and the inspector is seriously over- (or under-) determined. At one level, to be sure, it is simply intended as a joke. Ever since Leonardo painted the picture admirers have been arguing whether it should be called *La Gioconda* or *Mona Lisa.* The idea that the two men are taking advantage of the demonstration to continue the argument is decidedly humorous. It is hard to decide which is more inappropriate: their lack of response to the women's demands, which are not even acknowledged, or the passion with which they defend their respective positions. Since the argument occurs in a political context, one seeks to account for it at that level as well. A trip to the encyclopedia provides the necessary information. Leonardo's portrait depicts the wife of Francesco del Giocondo, whose given names were Mona and Lisa.

Seen in this perspective the heated debate would seem to concern the name, not of the painting but of the painting's subject. Whereas the inspector calls her by her first name(s), Foix insists that she should be addressed as "La Gioconda." Although his appellation is certainly more respectful, it is not entirely satisfactory from a feminist point of view. Not only does it define the woman in terms of her husband, it calls attention to her sex. Nevertheless, it is a distinct improvement over the inspector's choice and avoids alluding to her marital status. The idea of subjecting such a well-known painting to feminist scrutiny also adds to the humor of the situation. A third possibility also exists that is perfectly compatible with the other two. At yet another level the dispute may focus not on the names themselves but on what they can be made to signify. By a happy coincidence, *La Gioconda* can also be translated as *The Joyful Woman.* Indeed one wonders whether her enigmatic smile may not be due to Leonardo's love of wordplay. By contrast, the possibilities offered by *Mona Lisa* are much less flattering. Like the Italian expression, the Catalan equivalent is frankly insulting. In the first instance the title may be rendered as "shabby Mona," while in the second it becomes "homely monkey" ("mona llisa"). At the level of the signifieds, therefore, the two men would seem to be arguing about the woman's physical appearance. Whichever interpretation one adopts, Foix appears to be defending her honor against his adversary's churl-

ish insinuations. Whether we can determine his attitude toward feminism from these remarks remains to be seen.

At this point it is helpful to consider the demonstration itself. Why, one wonders, have the women chosen a train station for the site of their protest? Why are they blocking the tunnel so the trains cannot leave? It is always possible, of course, that their actions have no explanation. Their presence at the Sant Gervasi depot could simply reflect the author's fondness for surprising juxtapositions. However, the implications of such a gesture are difficult to escape. By creating a ridiculous demonstration, the author would be amusing himself at the feminists' expense. Although the scene is certainly humorous, this interpretation clashes with our analysis of the dispute between Foix and the inspector. A more satisfactory explanation is provided by the observation that Foix employs Freudian symbolism in much of his work. Indeed, this is one of the more prominent characteristics of his Surrealist style.

We scarcely need the father of modern psychiatry's help, however, to recognize that the tunnel resembles the female sexual apparatus and the train its male counterpart. Alfred Hitchcock would employ the same symbolism many years later in *North by Northwest*. This explains what the women are doing at the Sant Gervasi station. Responding to the author's cues, they have come in search of a vaginal symbol. Having begun the poem with a feminist theme, Foix decided to place it in an allegorical context. Unexpectedly, the text's symbolic setting turns out to be more important than its physical setting. It also allows Foix to make an amusing suggestion regarding feminist methodology. In this respect the initial scene recalls Freud's discussion of the role of wish fulfillment in dreams. In both instances we are confronted not with reality but with virtual images that simulate reality. Like the characters who populate our dreams, Foix's women are engaged in hypothetical actions. Harking back to Aristophanes' play *Lysistrata*, Foix suggests that women should withhold their sexual favors. Until that fateful day arrives, the "train" will not be allowed to enter the "tunnel" until men have learned to treat them as equals. The demonstrators' protest is directed not at the railroad, therefore, but at their male oppressors.

The second episode focuses on the railway inspector with whom Foix has been arguing. It is just as well they do not come to blows, for the inspector appears to be big and burly. Already apparent in the previous scene, his macho character is symbolized by his "bigoti excessiu" ("excessive moustache") that curls upward like a typographical bracket. His flamboyant moustache is the

badge not only of his profession but his masculinity. Taken together, these facts leave little doubt that the inspector represents an authority figure. As often happens in dreams, one fully expects to see him browbeat the innocent Foix and perhaps haul him off to jail. Whereas the inspector succeeds in intimidating Foix initially, the situation suddenly changes when the latter thinks he recognizes him. At this point the narrator and the inspector exchange roles, and the authority figure is forced to submit to interrogation. Ironically, Foix assumes the role of inspector and levels a whole series of accusations at his former adversary.

In order to understand the relationship of this episode to the rest of the text it is necessary to establish the inspector's identity. More precisely, we need to identify some of the associations he had for Foix and, if possible, to specify his function in the second scene. Why is it, for example, that one encounters the inspector at this point in the story? Where exactly does he come from and what is he doing here? To be sure, since the setting is a railway station his presence is not entirely illogical. And yet why does Foix choose to expose us to this particular character instead of another? Interestingly, the answers to these questions all focus on the inspector's distinguishing trait: his generous facial hair. As we will discover, the inspector's moustache is not only his badge of authority but his raison d' être. Without it he would literally cease to exist.

Discussing an earlier poem by Foix, C. B. Morris sheds valuable light on the inspector's enigmatic origins.[15] In a text entitled "Damunt el cel d'octubre . . ." ("Above the October Sky . . ."), which dates from the early 1920s, the poet wrote: "Cobrim-nos de pèl i pintem-nos bigotis i celles espessos" ("Let us cover ourselves with hair and paint thick moustaches and eyebrows on ourselves!").[16] Morris astutely deduces that this exclamation perpetuates a joke invented by Marcel Duchamp, which was repeated by García Lorca and others. In March 1920, the French artist published a scandalous portrait of the *Mona Lisa* wearing a mustache. Appearing in the Dada periodical *391*, it was accompanied by the obscene title *LHOOQ* ("Elle a chaud au cul"): "She has a hot ass." Judging from their response, Duchamp's iconoclastic gesture made quite an impression on Foix and his friends. In addition to confirming Morris' hypothesis concerning the previous poem, the present text demonstrates that the altered painting held great appeal for Foix in general. It also provides the missing link we have been seeking. What connects the first scene with the second scene, one realizes, is not their common setting but the Duchampian intertext previously described. Although certain allusions retain

their private character, despite our best efforts to penetrate their façade, the origins of the poem itself are clear. The initial image of the feminists generated not only the Sant Gervasi Tunnel but the pictures of the *Mona Lisa* they are carrying. Drawing on Duchamp's readymade portrait, the pictures generated the inspector's moustache, which in turn generated the inspector himself. Contrary to the laws of nature, the inspector's birth was preceded by the creation of his most distinctive attribute.

For the moustache to function effectively in the poem, however, Foix needed to find a receptive context. Like a bacterium in a Petri dish, the image needed the right medium to prosper. In this instance the right medium turned out to be painting. By 1928, moustache-shaped forms had come to play a significant role in Miró's iconography, where they interacted with a variety of other shapes (see Figure 7.1). In some paintings they were associated with masculine subjects, whose masculinity they in fact helped to define. In others they were freed from their representational chains and enlisted in the cause of abstraction. The important thing from Foix's point of view was that moustaches were associated with Miró's art. The convergence of these two intertexts, whose roles were vastly different, was highly fortuitous. Although the reference to Duchamp was buried beneath subsequent layers of meaning, the allusion to Miró was nearer the surface. If the former was largely implicit, for the latter to function it had to be relatively accessible.

Occurring early in the poem, the intersection of these two lines of thought furnished Foix with an aesthetic strategy. In addition, it provided a partial blueprint for the remainder of the work. Like André Breton, who published *Le Surréalisme et la peinture* the same year, Foix adopted a thematic approach to his material. Like the leader of Surrealism, who devoted part of his study to Miró, he drew on the artist's iconography.[17] That Breton's book appeared four months before Foix's text may or may not be significant. The fact that both men evoke the moustache shapes in Miró's paintings could be attributable to influence or it could be a simple coincidence. What matters here is that Foix decided to incorporate images taken from Miró's art into his text. His decision to proceed thematically explains the absence of logical transitions in the poem.

Anyone who takes the trouble to compare Foix's works with Miró's cannot fail to notice that they share several of the same motifs. Although it would be interesting to speculate about possible influence, this subject exceeds the scope of the present study. For our purposes, what matters is that the two men

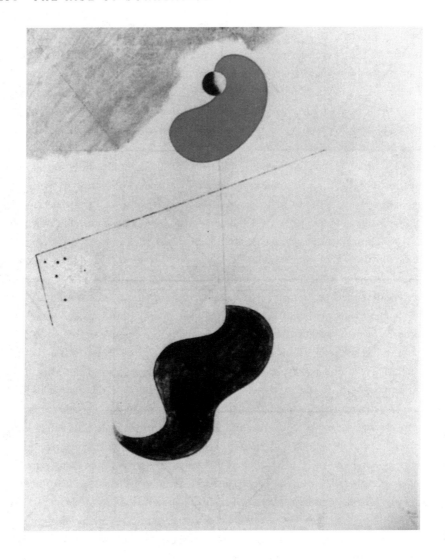

FIGURE 7.1 Joan Miró, *The Catalan*

were attracted to several of the same images. Like Miró, moreover, Foix had amassed his own collection of motifs, which he drew on repeatedly in his works. Thanks to the overlap already described, he could comment on Miró's paintings while preserving the integrity of his own poetry. Rather than

adopting a foreign lexicon, he could use his customary vocabulary. To be sure, the presence of identical motifs in both men's works does not mean they attached the same significance to them. Each image's meaning was grounded in the personal experience of the individual who evoked it.

The moustache motif is a case in point. Although the presence of this motif in Miró's art may owe something to Foix, one of its sources was undoubtedly the artist's father. Not only did the latter possess a luxurious moustache, as at least one photograph attests, he influenced his son in numerous ways.[18] Whereas the motif is surrounded by positive associations in Miró's paintings, it evokes a whole range of responses in Foix's works. Associated with Dada slapstick in "Damunt el cel d'octubre . . . ," it acquires sinister overtones in one of the pieces in *KRTU*, examined in the previous chapter, in which it becomes a source of fear.[19] In general, Foix's moustaches lack the domestic qualities of the painted versions, whose presence is somehow reassuring. Although the origins of this motif in his own work are obscure, one suspects that they go back to his own father. Indeed this would account for the inspector's intimidating manner. As Freud demonstrated long ago, the ultimate authority figure in Western society is the father. If this hypothesis is correct, the dispute between Foix and the inspector would also represent the underlying Oedipal conflict between father and son. At this level their onomastic rivalry would symbolize the struggle for possession of the mother.

As noted, the recognition scene early in the second episode quickly puts an end to the dispute. Assuming the dominant role, Foix begins to interrogate the inspector and eventually accuses him of engaging in deception. Unexpectedly (and most improbably) he remembers having seen the inspector's portrait ten years before during an exhibition at the Dalmau Gallery. Although Foix immediately changes the subject, the reference is to Miró's very first exhibition that took place at this gallery from February 16 to March 3, 1918. Consisting of sixty-four paintings and drawings covering the period 1914–1917, it included portraits, still lifes, and landscapes. For the first time, the inspector is deliberately linked to Miró. Not only does he share the artist's love of moustaches, but he is the subject of one of his works. The implications of this discovery are twofold. On the one hand, it reinforces the story's realistic foundation by providing the inspector with a concrete identity. Miró's portrait is ample proof that he exists. On the other hand, it suggests that Foix's character was modeled on a specific individual. The only surviving portrait that fits the description is a drawing of a burly individual wearing a thick overcoat, who

may be Foix's inspector.[20] Unfortunately, because the drawing is untitled, we do not know his name.

As if Miró's portrait were not enough to convince the reader of the inspector's existence, Foix invokes Joaquim Folguera's testimony as well. A prominent member of the avant-garde who died at a tragically early age, Folguera published Foix's very first poem in his journal *La Revista*. While his statement that the inspector's wife always wore green promises to clarify matters initially, in fact it only confuses them further. Above all it serves to introduce an ingenious series of non sequiturs. Invoking one Surrealist syllogism after another, the narrator deduces that the inspector is a triple imposter. For one thing, he cannot possibly be married to all the women dressed in green at the station. For another, despite his moustache, he is obviously not Joan Miró. Needless to say, these statements contain the seeds of numerous contradictions. The fact that the inspector is not the women's real husband, for example, also implies that he is not the subject of Miró's drawing. However, if he is not the subject of Miró's picture, who is? And in that case how was Foix able to recognize the inspector in the first place?

It makes no difference that the inspector has never made any of the claims for which he is being denounced. Before he has a chance to question the narrator's peculiar logic the latter plays his trump card. Unbeknownst to the inspector, Miró has shaved off his moustache and has thus rendered the inspector's disguise completely useless. If the inspector weren't wearing a moustache, Foix declares, he would have succeeded in passing for the painter. By this time the reader has become thoroughly entangled in the poem's logical conundrums. The inspector's moustache serves not only as a badge of authority but a source of confusion. At this point it is useless to object that Miró never wore a moustache. Nor is there much point in trying to understand how Foix determines that the inspector's railway credentials are phony. The reader succumbs to the text's relentless flow just as the inspector succumbs to the narrator's persistent questioning.

The second episode ends precisely as it began—with another recognition scene. As he is admonishing the inspector, Foix suddenly realizes he is talking to Joan Miró after all. This discovery completely invalidates his previous conclusions. The triumph of truth over falsehood in the earlier scene is shown to be false itself as a new version of the truth emerges. Since Foix's logic is rigid and all-encompassing, his multiple denunciations are suddenly transformed into confirmations. If the inspector is actually Miró, Foix reasons, he must be

married to the women dressed in green. Each development necessarily implies the other. Against every expectation, therefore, Miró turns out to be a polygamist. To protect himself from accusations of chauvinism, however, he has married a group of feminists. For all we know, he may be leading the demonstration in the station.

One wonders in any case what Miró is doing in the uniform of a railway inspector. Perhaps this is one more instance of his fascination with themes stemming from his childhood. Or perhaps he is simply moonlighting to supplement his meager earnings as an artist. Not only does Miró turn out to have a moustache, but on closer inspection Foix discovers that his face is covered with moustaches. How could he possibly have overlooked such a distinctive trait? The answer of course is that prior to his identification with Miró the inspector had only one moustache. According to the logic of multiplicity, the others were generated subsequently by his polygamous inclinations. As Foix explains, Miró has a moustache for each one of his wives. More than anything the artist has become the victim of numerical contamination. Foix liked the image so much that he returned to it many years later in *L'estrella d'En Perris* (1963). Among the characters who populate this collection of poems one encounters a familiar face belonging to "el faroner, de mil bigotis" ("the lighthouse keeper with a thousand moustaches").[21]

Obviously embarrassed, Foix apologizes first to Miró and then to his impressive harem. To compensate for his inexplicable obtuseness he pronounces the painter's name over and over. Despite his efforts to persuade us that the inspector is really Miró, a few lingering doubts persist. In view of his recent faux pas how do we know he can be trusted? In addition, if the inspector is actually Miró, why isn't he clean-shaven? Could he be wearing a false moustache, at least initially, as a disguise? Certainly this describes L'Homme-Que-Ven-Coco ("The-Man-Who-Sells-Coconuts"), who appears a few pages later in *KRTU* (see Chapter 6).[22] Or is the inspector really Miró's father, whose formidable moustache has been noted? This would certainly explain his uncanny resemblance to the artist. Foix may also be referring to a self-portrait that Miró included in his 1918 exhibition.[23] For some reason the subjects of his early paintings and drawings tend to resemble each other. With few exceptions they all have puffy cheeks and round faces. What differentiates Miró's portrait from that of the inspector, therefore, is primarily the latter's moustache.

While the reader's doubts are understandable, at some point he or she is forced to take the narrator's word that the inspector is really Miró. Once again

one succumbs to the flow of the narrative, which identifies the artist as the subject of the third episode. As the dream logic intensifies it becomes increasingly difficult to sort out the facts. Although the tunnel is blocked by the feminists, Foix can see the train to Sarrià as it passes by on the other side. Since the train would have had to come through the Sant Gervasi station first, one wonders exactly how it got there. It seems unlikely that the feminists would have allowed it to pass. Has the engineer somehow managed to avoid the station? Whatever the explanation, the situation seems hopeless. To catch the train he has been waiting for Foix would have to perform miracles. In the first place, he would have to persuade the women in green to let him through. In the second place, he would have to persuade the engineer to stop. Just as it looks like Foix has missed his train, he finds himself on board after all. Not only have we no idea how he got there, but he does not seem to know himself. Nor for some reason does he realize that Miró is sitting beside him.

Finally recognizing the artist, who has fallen asleep in the meanwhile, Foix attempts to waken him from his "son etern" ("eternal dream"). On the one hand, this expression evokes Miró's commitment to Surrealist principles, which are conceived as eternal guideposts. On the other hand, it alludes to his refusal to distinguish between waking and sleeping states in his art. The fact that he draws his inspiration from the unconscious makes him an eternal dreamer. This explains why Foix is unable to rouse his companion: it is impossible to separate him from the source of his inspiration. Instead of interrupting Miró's unconscious activities he only succeeds in increasing them. Like a bottle of champagne that is suddenly uncorked, Miró's dreams overflow all over the compartment as his head flies out the window. Transformed into a phosphorescent ovule, the latter object is followed by a flock of birds issuing from the decapitated trunk and by an enormous hand that falls into Foix's lap. Like the narrator, the reader stares in amazement as each one of these events transpires. There appears to be no limit to Miró's imagination once one enters the realm of the marvelous.

The same thing may be said of Foix as well, whose debt to the Surrealist movement is especially evident in this passage. As Breton was to insist the following year, Surrealism derives much of its effect from isolation and estrangement. "La surréalité," he noted, "sera d'ailleurs fonction de notre volonté de dépaysement complet de tout" ("Surreality will be a function of our willingness to divorce every object completely from its surroundings").[24] The successful text is therefore one that totally disorients the reader.

In accordance with Breton's instructions, Foix inserts each image into an inappropriate context. Not only do they have nothing to do with trains, but they have nothing to do with each other. In addition, he even employs one of the objects recommended in the French text: a disembodied hand separated from its arm. Although Foix's objects are clearly imaginary, like the episode itself, the author insists on describing each one in detail. Not only is the hand large and gelatinous, for instance, but the birds emerge in a column, and the ovule glows in the dark. Despite their immateriality these images are surprisingly concrete. The latter characteristic, which seems paradoxical on the surface, may well stem from their function in the poem. Like the inspector's moustache, they are actually motifs taken from Miró's paintings and drawings.

Ovules, birds, and disembodied hands, one soon discovers, constitute an important part of the artist's vocabulary. Although their iconological significance varies from one work to the next, they provide Miró's artistic production with much of its coherence. Often associated with freedom, the bird motif was one of the painter's earliest symbols. Somewhat more recent, the hand motif (Figure 7.2) was well established by 1928 as an indicator of human presence. Although Foix's description is highly whimsical, it is also surprisingly accurate. As he declares, the large, white, puffy hands that appear in Miró's paintings seem to belong to a family of ghosts. One translator speaks of "ectoplasmic" hands, which captures both the medium's role in producing them and their ethereal appearance.[25] It should be added that a similar image was widespread in Foix's own work as well. Like the moustache motif, decapitated heads and severed hands are found in poem after poem. Since the remaining motifs are absent from his work, however, the thematic congruence is only partial here. Although the narrator associates the gelatinous hand with Magí A. Cassanyes rather than with Miró, this is obviously a joke. Like Foix, Cassanyes was associated with L'Amic de les Arts and participated in the Surrealist adventure in Catalonia.

The final episode begins with Foix's unexpected arrival at the La Ronda train station, where he disembarks. As one eventually discovers, he has little choice but to get off since this is the end of the line. Although his geographical location is not immediately evident, several clues point to the southernmost station. Situated at the top of the Ramblas, where the Ronda Universitat meets the Plaça de Catalunya, it is known today simply as "Catalunya." Instead of taking the train to Sarrià, therefore, Foix has chosen

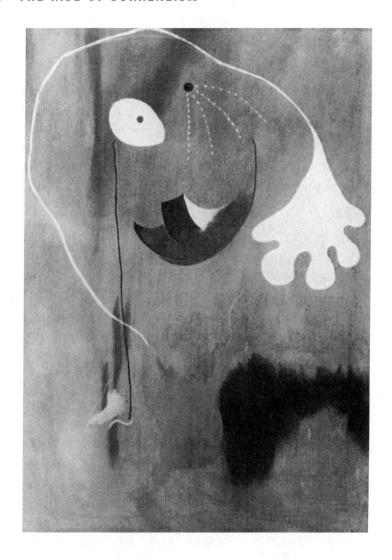

FIGURE 7.2 Joan Miró, *The Circus*

to travel in the opposite direction. This explains how he was able to leave the Sant Gervasi station with no apparent difficulty. Rather than run the feminist gauntlet, and risk irritating all his wives, he opted to make a strategic retreat. Instead of flagging down the train to Sarrià, which had already passed the station, he took the next train to La Ronda.

Although these reasons suffice to account for Foix's behavior, he may also have been influenced by Miró. Whereas the poet tended to gravitate toward one end of the municipal railway, the painter spent a great deal of time at the opposite end. Although they were engaged in similar endeavors, their daily lives were completely polarized. As we have seen, Foix's existence revolved about his hometown of Sarrià. Miró, on the other hand, shared a studio with E. C. Ricart at the other end of town. Situated in the Carrer de Sant Pere més Baix, where Foix must have visited him on numerous occasions, it was a ten-minute walk from the Catalunya station. All this suggests that Miró was headed toward his atelier when Foix encountered him at the beginning of the poem. Since the tunnel to Sarrià was blocked by the demonstration, he undoubtedly invited his friend to accompany him. If worse came to worse, he probably added, Foix could always spend the night in his studio. By 1928, to be sure, Miró had moved to Paris and visited Barcelona only infrequently. Like the earlier reference to the Dalmau Gallery, therefore, the imaginary train trip is motivated primarily by memory. On the one hand, Foix's journey retraces the route he used to take on his way to visit Miró. On the other, it leads back to the period when the two men were developing their distinctive aesthetics. From this it is clear that the journey extends back in time as well as forward in space. Foix's voyage is not only horizontal but vertical as well.

The fact that the train crosses Barcelona on the way to the Plaça de Catalunya allows us to visualize the journey in considerable detail. It means that the setting is thoroughly urban. The story takes place not in a sparsely settled region but in the center of a metropolitan area. It also means that the entire trip takes place underground rather than on the surface. Because Barcelona is so densely populated the municipal railway runs through an underground tunnel between the Sant Gervasi and the Catalunya stations. This situation provides a perfect setting for the events in the third episode. As one amazing image after the other emerges from Miró's decapitated body, the tunnel comes to represent the artist's unconscious. In addition, the situation explains why Miró's head is transformed into not just any object but one that is phosphorescent. Whereas the train's interior is lighted, the tunnel itself is dark. If the object were not phosphorescent, we would cease to see it once it flies out the window. As much as anything this event appeals to the reader's visual imagination. We are plainly meant to visualize each of the episodes in the poem.

Although these details are extremely important, by their very nature they can take us only so far. The conclusion itself transcends the realistic frame that

seeks to contain it. As one soon discovers, Foix's destination is both the Plaça de Catalunya and somewhere else. Emerging from the station's entrance, he finds himself not in the center of Barcelona but at the seashore. To further compound the reader's confusion, the sea itself seems totally unfamiliar. Although the final episode treats at least three different subjects, it focuses primarily on the mysterious ovules that float restlessly in the air. That these are all descendants of the single ovule in the episode seems relatively certain. Like the women in green and Miró's moustaches, they owe their existence to the theme of multiplication that extends throughout the poem. The fact that they are all phosphorescent may indicate that the scene takes place at dusk. Indeed, since they dance up and down instead of remaining stationary they would seem to be modeled on fireflies.

Before discussing the ovules themselves it is instructive to examine their original source. In seeking to understand their function we need to analyze the initial metamorphosis on the train. Fortunately, despite its apparent gratuitousness, this act can be explained satisfactorily. Although it appears to be unmotivated, it actually represents two separate lines of development. Whereas one of these involves the poem's symbolic dimension, the other reflects its aesthetic concerns. Like the birds and the ectoplasmic hand, one learns, the ovule is taken from Miró's iconography. A relatively recent motif, it occurs in various contexts in which it serves as a positive marker. Were it not for two circular forms, for example, *The Birth of the World* (1925) would be a very somber painting. Freed from their earthly tethers, which are symbolized by the murky background, two gaily painted balloons rise toward the top of the canvas.

However, the objects evoked by Foix are not balloons or beach balls but rather ovules. Their purpose is not to amuse but to enable their species to reproduce itself. In contrast to the forms in *The Birth of the World*, which in retrospect can be seen to depict spermatozoa, the objects in Foix's text are eggs. Through a process akin to cloning, the original egg—itself a product of metamorphosis—has been multiplied a thousandfold. In this context it is highly significant that the first ovule is associated with Miró's head. Much more is at stake here than mere physical similarity. Like Athena who sprang fully formed from Zeus's cranium, the myriad ovules bear witness to their creator's extraordinary mental powers. More precisely, since we are dealing with reproductive metaphors, they symbolize the fecundity of Miró's inspiration. Judging from appearances, the latter is virtually inexhaustible. Indeed, the presence of the ovules is foreshadowed by another event that stresses the sem-

inal quality of the artist's inspiration. If the flight of birds issuing from his de-
capitated torso resembles champagne flowing from a bottle, it just as surely
resembles an ejaculation. This explains why the hand that falls into Foix's lap
turns out to be "gelatinous." As Michael Riffaterre notes, "Most Western lit-
eratures compare inspiration to an outflow, sometimes seminal, and if painful,
of sweat and tears and blood."[26]

The equation between inspiration and sexuality accounts for the presence
of Foix's narrator at the seashore. In the light of the preceding discussion he
has come in search of the ovules. Viewed in this perspective, his nostalgic train
trip acquires all the markings of a religious pilgrimage. Foix has come to par-
ticipate in the creation of "bells mons inèdits" ("beautiful unpublished
worlds"). That the author speaks of "giving birth" at this point leads to an in-
teresting observation. As in Apollinaire's play *Les Mamelles de Tirésias*, a
symmetrical reversal of sexual roles occurs in the poem. Because the women
have gone on strike and refuse to engage in procreation, this task is entrusted
to the men. Although the text appears to be unstructured, its beginning and
end are symmetrical. Why the men have chosen the seashore for their repro-
ductive feat is not immediately evident. What is it about this location that
explains their presence? To understand the connection between the ovules
and the sea one needs to grasp the latter's symbolic role. Conversely, to com-
prehend the sea's symbolism its relation to the ovules needs to be made clear.
Reviewing the various possibilities, one eventually perceives that Classical
mythology provides the hermeneutic key. As in the myth of Aphrodite, who
was born from the foaming waves, the sea is a symbol of fertility. The fact that
it is associated with birth, therefore, explains why it is juxtaposed with the
ovules. Each is linked to the other through the principle of metonymy.

The concluding scene, which features yet another instance of metamor-
phosis, is remarkably inconclusive. As Foix is about to crush some of the ovules
between his hands he succumbs to a strange paralysis. Before he can facilitate
the creation of new worlds he is transformed into a dead tree. All that remains
of his attempt to liberate Miró's inspiration is the constricted shadow he casts
across the landscape. Not only is the hapless reader deprived of a sense of clo-
sure, he or she is faced with yet another enigma to decipher. Expecting to
witness a miraculous birth, one observes Foix's objectification and disintegration
instead. In its own way, of course, the narrator's transformation is as miraculous
as anything one could imagine. In contrast to the events associated with the
ovules, however, it is traversed by no fewer than three negative markers.

Whereas the ovules contain the promise of beauty and creation, the tree's branches are lying on the ground, the tree itself is dead, and its shadow resembles a hangman's noose.

From this description it is clear that the final scene is organized around a central binary opposition. Juxtaposing the forces of birth with those of death and dissolution, Foix comments on aesthetics and inspiration alike. Unlike Miró, whose art testifies to his incredible fertility, he concludes that his own work is essentially sterile. Compared to the painter, Foix implies, his inspiration is infinitely inferior. The reason he was prevented from crushing the ovules, therefore, is that he is incapable of sharing Miró's vision. Although the poem's subject is clearly painting, to some extent it is also concerned with writing. From the problem of naming, which is evoked at the beginning, to the "unpublished" worlds at the end the relation of the author to his work is a constant concern. In addition to its artistic commentary, therefore, the text contains a meditation on the writer's craft. Inevitably, Foix's discussion of Miró's creativity expands to include his own creative experience, which explains why the poem ends as it does. Serving as symbols of castration, the stump and the strangled shadow proclaim Foix's creative impotence. In the last analysis, to be sure, his impotence is largely symbolic. In the first place, like the poem itself it is conceived as an act of homage directed toward the painter. Seen from this point of view, Foix's confession reflects a traditional rhetorical strategy. Bowing low before his master, he magnifies the latter's importance by exaggerating his own defects. In the second place, for someone who supposedly has no talent Foix has written a very fine poem. Despite his final disclaimers the composition itself proves that he is Miró's equal. A remarkable tribute by a remarkable poet, it testifies to the power of his own inspiration as well.

8 THE HOUR OF THE SPHINX

André Breton and Joan Miró

Le chat rêve et ronronne dans la lutherie brune. Il scrute le fond de l'ébène et de biais lape à distance le tout vif acajou. C'est l'heure où le sphinx de la garance détend par milliers sa trompe autour de la fontaine de Vaucluse et où partout la femme n'est plus qu'un calice débordant de voyelles en liaison avec le magnolia illimitable de la nuit.

(The cat is dreaming and purring in the brown stringed-instrument trade. It scrutinizes the depth of the ebony and from a distance laps the living mahogany obliquely. It is the hour when the madderwort sphinx loosens by the thousands her horn around the fountain of Vaucluse and when woman everywhere is no longer anything but a chalice overflowing with vowels in connection with the illimitable magnolia of the night).[1]

In 1958, André Breton wrote twenty-two poems inspired by a brilliant series of gouaches that Joan Miró had created nearly twenty years earlier. Collected the following year in *Constellations*, each poem was juxtaposed with the appropriate painting in a mathematical progression based on skill and chance, intention and accident.[2] If, as Anna Balakian states, "Breton's *Constellations* is a cosmic venture in which man joins nature through his manipulation of language," the same may be said of Miró's paintings in which birds, women, and

stars offer a privileged view of the universe. This is particularly true of "Femme et oiseau" ("Woman and Bird"), the eighth poem in the series, whose title unites two of the artist's favorite motifs (see Chapter 7).[3] Throughout the volume verbal language complements visual language in an elaborate pas de deux. That Breton's intention was not simply to evoke Miró's art or to reproduce relevant themes may be seen from the term he chose to describe his creations: "proses parallèles." As such they represent independent meditations on subjects suggested by the paintings without any attempt to follow the path taken by the artist. Stressing the profound originality of Breton's undertaking, J. H. Matthews describes this reciprocal relationship as follows: "The image before his eyes liberates images within, and it is the latter that he seeks to capture, in acknowledgement of the former's evocative quality."[4]

According to Philippe Audoin, each text takes its point of departure from one of three sources: the painting's title, its general tonality, or one or more graphic elements.[5] This explains why the title "Femme et oiseau" makes no sense—it is entirely incidental. The poet does refer to a woman toward the end, but she is only one of several characters who are equally important. Not only is the bird nowhere to be found, but there is no indication that it will ever appear. Although Breton appropriates Miró's title for his poem, as he did throughout the book, it was clearly not the source of his inspiration. Continuing our inquiry in a similar vein, we can also rule out tonality as a potential source. Whereas the poem possesses a remarkable sensuality, which its leisurely rhythms and sonorous vowels accentuate, the painting (Figure 8.1) is a sprightly composition whose bright patches of color and curved lines appear to be in constant motion.

This leaves the plastic configurations, which seem to lie at the root of the poem. Although Miró's characters are not always easy to identify, for our purposes it makes little difference. What matters are Breton's personal reactions to the picture, which seems to depict two women facing each other while two smaller creatures float between them. The woman on the right, one of whose breasts is evident, is carrying another animal on her shoulder. The woman on the left, recognizable from her triangular skirt, narrow waist, and long hair, is even more exceptional than her companion. Standing with her head thrown back, a mouth full of razor-sharp teeth, and a darting tongue, she seems about to swallow the fish-shaped creature before her. Below the latter the second creature—undoubtedly the bird of the title—is about to fly into her mouth. As elsewhere in Miró's art, which parallels Picasso's use of the same motif, the voracious orifice is suggestive of Freud's *vagina dentata*.[6]

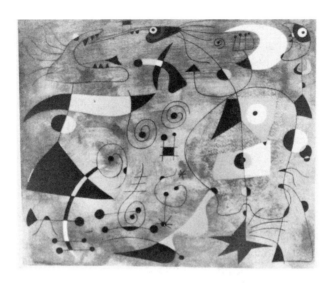

FIGURE 8.1 Joan Miró, *Woman and Bird*

Gradually one begins to understand how the painting is related to the poem. If the woman's torso is distinctly feminine, her ferocious expression and triangular teeth are markedly feline. In other words, as Breton clearly realized, the figure is that of a catwoman, whom we see devouring first a fish and then a bird. The entire poem derives from this seminal recognition scene. Once he chose his point of departure the poet turned his back on the rest of the painting, which is to say that its intertextual role is negligible. What interested Breton was the unexpected presence of the catwoman whose dual nature was well known to him. To understand her appeal one has only to transpose elements to see that she is a variant of the *sphinx* whose eerie shadow, like the minotaur's, is one of the hallmarks of Surrealism. Like the latter, the sphinx represents the union of intellectual and physical power.[7] The fact that both creatures mediate between the human and the animal makes them perfect vehicles for the *merveilleux* in which, as Breton tells us, "se peint toujours l'irrémediable inquiétude humaine" ("irremediable human anxiety is always depicted").[8]

In his *Semiotics of Poetry* Michael Riffaterre argues that every poem results from "the transformation of . . . a minimal and literal sentence into a longer, complex, and nonliteral periphrasis."[9] If Riffaterre is right, that a poem is generated by a single phrase or "matrix," then the origins of Breton's "Femme et

oiseau" are to be found in a statement such as "The sphinx is half cat and half woman." Structurally this sentence may be rendered as cat→sphinx←woman, where the sphinx's central position is dictated by its role as mediator in the human/animal dichotomy. Not only does the poem employ the same tripartite structure, it preserves the substantive nodes of the matrix and observes the same sequence. Seen in this perspective, Breton's strategy is relatively simple. Enumerating each element of the matrix, from cat to sphinx to woman, he pauses long enough for each image to generate a series of associations that he weaves together to form the poem.

Utilizing conscious and unconscious impulses, this process is more complicated than it sounds. As critics have long noted, "A work can only be read in connection with or against other texts, which provide a grid through which it is read and [comprehended]."[10] The same strictures govern its creation as well. Among the numerous forces traversing a text, Riffaterre focuses on a primary intertext that he calls a "hypogram." Consisting of a "pre-existing word group," the hypogram may be a quotation, a thematic configuration, a set of literary conventions, or a cliché. Situated midway between the matrix and the text, it distorts the former and produces the latter through conversion and expansion. With "Femme et oiseau," as elsewhere in Breton's works, the hypogram seems to be a poem by Baudelaire, in this case "Les Chats" ("The Cats"). More precisely, as we will discover, it includes a whole complex in *Les Fleurs du mal* centered on this poem:

> Fervent lovers and austere scholars
> Both adore cats, in their mature years,
> Powerful and soft, the pride of the house,
> Which like them are chilly and like them sedentary.
>
> Friends of knowledge and of voluptuousness
> They seek silence and the horror of the shadows;
> Erebus would have used them for funereal coursers,
> If they could bend their proudness to servility.
>
> While dreaming they assume the noble attitudes
> Of great sphinxes lounging in the depths of solitude,
> Which seem to submerge themselves in an endless dream;
>
> Their fertile loins are filled with magic sparks,
> And golden particles, similar to fine sand,
> Vaguely star their mystic pupils.[11]

As Riffaterre predicts, a number of Baudelaire's words and concepts are embedded in Breton's text, where they testify to its origins. One thing is immediately evident. What originally attracted him to "Les Chats" was the equation between cat and sphinx specified in the primitive sentence. This poem was the source of the sensuous language in "Femme et oiseau" and its languorous rhythms, which approximate Baudelaire's alexandrines. In tracing the evolution of Breton's imagery and ideas, we will see that many poetic features derive directly from the hypogram. Others were generated at the level of the text according to the principles of metaphor and metonymy identified by Roman Jakobson (see Chapter 6).

The first sentence of "Femme et oiseau," which is also the first line, illustrates Breton's method perfectly. Its alliterative play and twelve careful syllables underline the poet's debt to the author of "Les Chats." The initial portrait of the cat, who is dreaming and purring, is entirely conventional. Baudelaire not only evokes the animal's penchant for sleep but stresses its endless capacity for revery ("an endless dream") that marks it as an avatar of the Poet. Although none of his cats actually purrs, this is a metonymic characteristic that needs no justification. It is part of the baggage associated with the concept "cat." What is startling here is not the animal so much as its setting—a dusky music shop. If *lutherie* normally designates the stringed-instrument trade, here it is used metonymically to indicate the place where the instruments are made and sold. The next sentence corroborates this interpretation and develops it in more detail. Similarly, the fact that "brune" refers to twilight—on the model of "à la brune"—is confirmed by subsequent events in the poem.

But why does Breton choose this location? Why this time of day? To find the answer one must return to Baudelaire who associates cats with shadows (v. 6) and who makes Erebus, Lord of Darkness, their master (v. 7). Clearly in touch with demonic forces, they function as intermediaries between mankind and the unknown. Breton replaces Baudelaire's demonic forces by those of the unconscious, but otherwise the animal's poetic vocation remains the same. The music shop itself has several possible sources. Looking at Miró's painting again, for instance, one finds several shapes suggesting key signatures and musical notes. Moreover there may well be a metonymic link between the cat and the instruments, whose strings are probably made of catgut. However, the most likely explanation is metaphoric, exploiting similarity rather than contiguity. Baudelaire devotes

the first half of a two-part poem entitled "Le Chat" to celebrating the latter's delicate "voice" that he first compares to a verse of poetry. Continuing in the same vein, he exclaims:

> No, there is no other bow that
> Wounds my heart, perfect instrument,
> And causes its vibrating string
> To sing more royally
> Than your voice, mysterious cat[12]

Surely this explains why Breton's cat is in a music shop. The evolution of the image appears to be the following: from meow to voice the progression is metaphoric, based on functional similarity; from voice to violin bow it is also metaphoric, based on similar cause and effect. Thereafter the bow leads metonymically to the violin, which leads in turn to another metonym: the lutherie. In both cases the relationship is that of part to whole. If there is a common thread to the entire chain of events, it is musicality in its various forms. Once one begins to understand the poem's intricate background and its complexity of allusion, the seemingly banal first line comes alive. Radiating in every direction, from Baudelaire to Breton to the reader and back again, it is filled with virtual images operating at several levels. The image of the "lutherie brune" is especially resonant. Not only is the lute a traditional symbol of lyric poetry, as the *Petit Robert* dictionary insists, but the adjective *brune* conjures up visions of Jeanne Duval who appears in yet another poem entitled "Le Chat." Here the "corps electrique" ("electric body") of Baudelaire's cat suggests that of his mulatto mistress. Thus, at one point he exclaims:

> I am reminded of my woman . . .
> And, from her head to her feet,
> A subtle tune, a dangerous perfume
> Bathe her dusky body.[13]

Stated implicitly at the beginning, the themes of poetry and womanhood will gradually assume major proportions in the poem. From the fact that the shop is dark we know it must be past closing time. The shopkeeper has turned off the lights and has gone home, leaving his cat in the store until morning. This means that the initial scene takes place in total silence, broken only by the animal's purring, and that the shop is entirely empty. This too is charac-

teristic of Baudelaire's cats, who "seek silence and the horror of the shadows" ("Les Chats"). For Breton then, as for Baudelaire, the cat serves as an emblem of the poet's solitude.

The second sentence evokes the animal's curiosity—a metonymic trait ignored by Baudelaire but exploited here to good effect. By providing not one but two examples, the poet increases the verisimilitude of his portrait and injects a certain humor into the poem. Without moving from its comfortable spot, the cat peers curiously at one of the nearby instruments, then begins to lick it. Both gestures are typical, both are convincing. The first clause, "Il scrute le fond de l'ébène," depicts the animal peering through the strings at the ebony fingerboard. Next the cat extends its tongue as far as it can to lick the instrument's body, which is made of mahogany. The two prepositional phrases "de biais" and "à distance" stress the exploratory nature of this gesture. Once we realize that it is the instrument's body that is "tout vif," we can visualize what has occurred. During its investigation the cat has brushed against the strings whose reverberations are amplified by the soundbox, causing it to "come alive." Magnified by the stillness of the music shop, this sound announces a change of scene and the introduction of a new character.

The transition from cat to catwoman in the poem is surprisingly smooth. "C'est l'heure où," as Susan Harris Smith remarks, prepares the reader for the supernatural events to follow including the relaxation of the sphinx's suffocating coils around the fountain.[14] She also notes that this is the central action of the poem, corresponding to the sphinx's central position in the narrative sequence. The sphinx herself has been subject to considerable ambivalence historically.[15] In the first place, no less an authority than Lévi-Strauss assures us that she is a female monster who attacks and rapes young men, "the personification of a female being with an inversion of the sign."[16] We know from the Oedipus myth that she kills her victims when she is finished with them, which is confirmed by the etymology of her name: "the strangling one."[17] In the second place, as Baudelaire reminds us, the sphinx is also associated with the feminine condition. As such, one critic declares, she stresses "the incomprehensibility of beautiful women and, at the same time, their animality."[18] In the third place, being the supreme embodiment of the enigma, the sphinx keeps watch over the ultimate meaning that must remain forever beyond the understanding of mankind.[19] She is the guardian of the cosmic mysteries and the key to the riddle of the universe.

This explains Breton's fascination with the sphinx, whom he knew from previous encounters and who is best personified by the heroine of *Nadja*. If, as we have seen, the cat is the emblem of the Poet, the sphinx is the emblem of Woman whom Breton celebrates in all her diversity from *femme fatale* to *femme énigme*. This is the subject of the third sentence in which the poet explores woman's dual nature. In her first aspect, presented at the beginning, the sphinx represents the emasculating, devouring female.[20] As in the accompanying painting by Miró, her razor-sharp teeth evoke a "Freudian metaphor of psychosexual castration fear"—namely, the *vagina dentata*.[21] The word "garance," moreover, designates both the madderwort plant and a red dye made from its roots. Taken metaphorically, the term suggests that the creature is stained red with the blood of her victims. Used metonymically, it indicates that she is stained red from eating the plant itself like the birds and animals that feed on it. Since, as Smith observes, the consumption of madder was an ancient remedy for the absence of menstruation, Breton implies that the sphinx is sterile, which makes her especially threatening. While either path is enough to account for the presence of the red dye, the image also seems to be associated with *Nadja*. Among several intertextual glimpses of this work in "Femme et oiseau," we recall that Nadja's first address in Paris was the Hotel Sphinx, situated on the Boulevard Magenta. Like the color itself, the street was named after a town in Italy where an extremely bloody battle took place. Thus, the conjunction of sphinx and blood represents a constant in Breton's work.

The following section presents several difficulties. What is the sphinx doing in the department of Vaucluse, for instance, and how has she acquired a hunting horn wrapped around a fountain? That the author introduces a musical instrument at this point is understandable, for it may be traced back to the music shop described at the beginning. But why has he chosen a horn instead of a violin or a guitar, which would be more in keeping with the "lutherie"? To answer this question we need to sift through the multifarious meanings of *trompe* that range from Eustachian tube to aspirator and squinch (an architectural term). The explanation seems to be that the word is taken from an alternate version of the sphinx—whose name also designates a large velvety moth. Bearing a prominent death's head on its back, which confirms the sphinx's reputation as a *femme fatale*, the creature extends its "proboscis" in anticipation of the magnolia blossoms in the last line.

This word is also associated with a previous complex centered on "garance" in connection with the female reproductive system. For the fact that the sphinx is sterile suggests that she is suffering from blockage of her *trompes de Fallope* ("Fallopian tubes"). Integrating the term into his musical context, Breton created a fantastic brass horn with unusual flexibility. Like an elephant's trunk (*trompe d'éléphant*), it is capable of curling around objects and exerting pressure. This is consistent with the image of the hunting horn in particular, which has a circular shape. The idea of constriction—and its subsequent relaxation—is provided by the sphinx's reputation as a strangler. Whether the author was familiar with the creature's etymology or whether he was thinking of its derivative "sphincter" does not really matter. From *corps* to *cor* ("body" to "horn"), the sphinx retains her ability to squeeze her prey to death.

Coupled with a singular subject "sa trompe," the plural intensifier "par milliers" is troublesome until one attempts to visualize the scene. Despite our first impression, the reference is not to thousands of horns (or tubes or trunks), but to a single horn twisted into thousands of coils. Curled around the fountain in a stupendous death grip, the sphinx represents a terrifying adversary. The fountain in "Femme et oiseau" presents relatively few problems. Smith argues convincingly that it is situated in the Vaucluse region because Petrarch tried to escape his obsession with Laura by taking refuge in the town of Fontaine-de-Vaucluse. Thus, "Laura is the predator, the awful devouring beast, the compelling but destructive beauty that paralyzed the poet's mind."[22] Freed from her constrictive presence but inspired by her memory, the poet composed some of his more enduring works. An interesting parallel exists between the role of Petrarch's muse and that of Nadja who exerted a similar influence on Breton. Eventually committed to "the Vaucluse asylum," she gave him a radically new perspective on the world.

The fountain of Vaucluse consists of an artesian spring situated near Avignon, which serves as the origin of the Sorgue River. From *source* to source its symbolism in the poem is clear. Like Laura and Nadja, the fountain represents a source of poetic inspiration according to an age-old formula equating the two. What matters here is its juxtaposition with the sphinx—a configuration that occurs elsewhere in Breton's work. As far back as *Les Champs magnétiques*, for example, we read that "L'antiquité est une fontaine nacrée par places, mais la gorge des sphinx a verdi" ("Antiquity is a fountain that is lustrous in places, but the sphinxes' throats have turned

green").[23] Whereas the earlier statement deplores the loss of Classical wisdom, personified by the bronze sphinxes, in "Femme et oiseau" the situation is just the opposite. The sphinx becomes the source not only of inspiration but of a cosmic consciousness in which the difference between subject and object ceases to exist. The path to this final *point suprême* is indicated by the sphinx who as the source of ultimate wisdom plays an analogous role to that of the fountain. This explains why the two images are juxtaposed: each is a transform of the other. They are opposite sides of the same coin. In releasing her grasp on the poetic fountain, the sphinx releases the forces of the unconscious that are reflected in the cosmic enigma.

The poem itself is situated on the threshold between day and night, between the forces of repression and those of liberation. In passing from one realm to the other, Breton introduces the reader to the third term of the matrix and his Surrealist vision of Woman. The contrast between her and the sphinx is instructive. If one is cruel and destructive, the other is loving and creative. If one symbolizes suffocation and sterility, the other stands for freedom and fertility. Recalling the etymology of "sphincter," one may regard the sphinx as a classic anal retentive personality. Her successor, who gives birth to poetry at the end, is clearly vaginal expulsive. As such she represents the triumph of the life force over the destructive instinct, of Eros over Thanatos. To the extent that she combines the poetic with the enigmatic—poetry as enigma, enigma as poetry—she resolves two of the major themes in the poem and mediates between the cat and the sphinx. Among the homonyms and words used in more than one sense or context in *Constellations*, whose role is discussed by Balakian, "calice" is a product of a twofold metaphorical process.[24] A traditional symbol of purity, whose origins go back to the Holy Grail, the chalice is above all a receptacle for sacramental wine. As a receptacle, moreover, with a distinctly uterine form, it also functions as a sexual symbol. These facts lead us to discover a triple metaphorical bond between "femme" and "calice" based on the following semes: purity, holiness, and femaleness. From this one may deduce that the woman in question is a virgin priestess and that her mission is a sacred one.

An additional metaphorical link exists between the chalice and the fountain based on functional similarity. Both are containers that serve as sources of liquid. That this connection is deliberate is evident from the adjective "débordant," which stresses the fluidity of the vowels issuing from the priestess' mouth. These sounds function in turn on several levels. For one thing,

there is an implicit metonymic link between the stream of vowels and the references to poetry earlier in the poem. Clearly this is the moment of poetic utterance we have been waiting for. For another thing, there is an implicit metaphorical link to the wine of the Eucharist that is being poured from the chalice. Not only is the poetry divine, but it partakes of immortality. Finally, the fact that the woman utters sounds rather than words suggests a third (metaphorical) interpretation. Caught in the throes of sexual passion, she is moaning incoherently. The intensity of her experience is indicated by the term "débordant" which suggests that it is uncontrollable and by the fact that she has lost the power of speech. That she utters *vowels* is particularly significant, for there is an extensive tradition linking the sequence AEIOU to the sounds of love-making.[25] In "Femme et oiseau," poetic delirium and sexual ecstasy merge into one.

So far so good, but how are we to reconcile the priestess's sexual activity with the fact that she is a virgin? Aren't these characteristics totally at variance with one another? To understand what is happening it is helpful to consider Valéry's poem "La Pythie" ("The Pythoness"), which features an identical conclusion.[26] Like the Pythian oracle, of whom she seems to be a reincarnation, Breton's woman builds up to an orgasmic climax in which sexual release coincides with divine inspiration, birth, and poetic creation. Like Valéry's tragic heroine she is a virgin priestess of Apollo who is possessed by the god in the course of her divine office. The fact that she is a pythoness is especially intriguing and confirms the intertextual role of the earlier poem. What relates La Pythie to the sphinx—besides their enigmatic heritage—is their common association with serpents. For the former, seated on her tripod, the python is the emblem of the god's power. For the latter, coiled around the fountain, the python is a powerful form to be emulated.

Coupled with "la femme," the adverb "partout" ("everywhere") is initially confusing. Is the subject of this section one woman or many women? In the context of the previous discussion we can affirm that both statements are true. The subject is simultaneously singular and plural. What this means is that Breton's priestess is divided into countless images of herself according to a kaleidoscopic process. She is subjected to replication, expansion, and universalization until she becomes synonymous with Woman. Seen in this light, the section suggests that all women become priestesses of Apollo as soon as night falls. Like the cat, whose sexuality is emphasized by Baudelaire, she is a creature of night attuned to the mysterious forces that surround us. Poised on the

threshold of existence, she is ideally suited to serve as man's interpreter. Following the appearance of the priestess(es), Breton activates the second meaning of *calice* which is linked retroactively (and metaphorically) to "la femme." In passing from chalice to calyx (Latin for cup) he explores the word's etymology and continues the associations developed earlier. As the external envelope of a flower, the calyx encloses the latter's reproductive organs and thus stresses Woman's sexual capacity.

By itself the calyx is enough to generate the final image of the flowering magnolia tree through metonymic association. The latter is also connected to two other exotic trees, ebony and mahogany, which are evoked near the beginning. Together they contribute to the poem's sensuality and create a tropical ambience. The fact that the magnolia is in bloom reveals that it is a warm spring evening. Like the woman-chalice overflowing with sounds, it exudes a heavy perfume that permeates the night air. As much as anything the fragrant tree illustrates the twin themes of connection ("en liaison") and expansion ("illimitable") with which the poem ends.[27] Just as the magnolia's perfume expands to fill the garden, uniting everything in it, the priestess is multiplied infinitely and absorbed into the cosmic night. This is the event for which Breton has been preparing us: her ultimate apotheosis and fusion with the universe. Clearly Woman's power is a function of her permeability, of her ability to open herself to external forces. On another level the magnolia serves as a metaphor for night itself whose descent brings the poem to a close.

The conclusion combines three separate images in a metaphoric *tour de force*. Interestingly, although these follow the progression "femme"→"magnolia"←"nuit," their structural order is the reverse. Thus, in the phrase "le magnolia illimitable de la nuit" night functions as the tenor and the magnolia as the vehicle. Once the image is translated into visual terms, one realizes what is involved. Spanning the heavens from horizon to horizon, countless stars fill the sky with an unearthly radiance. Like a profusion of magnolia blossoms attracted to a gigantic tree, they shimmer seductively in the night. The image is not only beautiful, it is majestic. Among other things, it recalls the conclusion of the *Divine Comedy* where Dante beholds the Celestial Rose and perceives the unity of all creation. But if each of the blossoms represents a star, it just as surely represents a woman. This is the sense of "en liaison" at the metaphoric level. Each woman-calyx is *attached* to the magnolia tree, which means that each is actually a flower. Ultimately of course she is also a star, but this metaphoric transfer is too distant for the reader to perceive. Instead

Woman's position in the universe is rendered by her identification with the cosmic magnolia tree. Our last glimpse of the poem is peculiarly Surrealistic. Stretching toward infinity, a giant magnolia towers above us whose blossoms have been transformed into myriads of women.

The latter object illustrates two fundamental processes in *Constellations* that Balakian has drawn to our attention.[28] Since these also serve as themes, the work finally becomes its own subject, an example of auto-illustrative poetry. The first process/theme revolves about the notion of containment—both containing and being contained—that Breton regarded as a universal structural characteristic. Here as elsewhere the play of "l'un dans l'autre" ("the one in the other") stems from a belief in the basic interdependence of all things. Aside from obvious containers such as the fountain, the chalice, and the calyx, images of syntactic containment abound in which "de" ("of") often substitutes for "dans" ("in"). In some respects the poem resembles a series of Chinese boxes, each of which is nestled inside another. The first example, that of the cat in the room, is perfectly straightforward. The second involves the madder, one of numerous clinging plants in *Constellations* that Balakian identifies with the image of the embrace. Not only is the sphinx covered with red dye, but she is enclosed by the plant itself.

So far the images of containment exist side by side. Beginning with the fountain, they become more and more comprehensive, describing wider and wider circles as they spiral outward. We know that the latter is contained by the horn whose innumerable coils are wrapped around it like a python. The fountain, the horn, and the sphinx are embraced in turn by the Vaucluse region, which possesses its own geographic identity. Finally the field of action is enlarged to include "partout"—presumably the entire world—which encompasses the Vaucluse itself. Following the central fountain episode, "Femme et oiseau" includes two more examples of specific containment: the vowels contained by the *femme-calice* and the magnolia contained by the night. Despite its localized disguise, the last line opens at the very end to encompass the entire poem. Beyond the confines of the *lutherie*, beyond the Vaucluse itself, the magnolia night gathers the world and everything in it in a lasting embrace.

The second process/theme is that of metamorphosis, which informs the poem from beginning to end. Believing it to be the central mechanism of nature, Breton cultivates metamorphic imagery in an effort to duplicate this basic principle. In a sense metamorphosis is another form of containment.

Exemplified by the "trompe" and the "calice," which assume a multitude of forms, it inscribes one meaning inside another to create a transformational poetics. Above all, metamorphosis is personified by the hybrid sphinx, who alternates between cat and woman and who acquires a prehensile appendage. So too the *femme-calice* becomes many women and fluctuates between chalice and calyx before losing herself in the magnolia. The latter image, as we have noted, involves a double transformation as the night sky becomes a magnolia tree bedecked with ecstatic women. The principle of metamorphosis extends even into the poem's surface structures which may be schematized as follows:

cat → purring (shop) + cat → [vibrations] (shop) + sphinx → [water] (Vaucluse) + woman → vowels (everywhere) + chalice → [wine] (everywhere) + magnolia → [perfume] (night)

It quickly becomes apparent that the first line serves as a paradigm for each of the succeeding sections according to the principle of structural equivalence. This means that each of the six segments is related to the others analogically, that each presents its own version of the initial event. With two exceptions, the setting changes from scene to scene. The action that begins in the music shop is completed in the fragrant night after passing through the Vaucluse and the world beyond. Each episode features a being or an object that is the source of something else, leading one critic to conclude that the poem's subject is the creative act.[29] The cat emits a purring sound, then causes the strings to vibrate. The sphinx relaxes its grip on the fountain, allowing water to well up. In half the cases it is a question of something intangible that is emitted by the subject itself. The magnolia's perfume and the woman's vowels are simply an extension of the cat's purring. In theory each of the six structures is autonomous, reflecting its companions while remaining separate from them. In practice no sharp line of demarcation exists. Like other features of the poem they possess a basic instability that subjects them to perpetual metamorphosis. The purring cat becomes the sphinx lounging in front of the fountain who is transformed into the babbling woman. The latter assumes the guise of a sacred chalice, reappears as herself, and vanishes into the magnolia night. And vice versa. The continual exchange of identities defeats all attempts to isolate the constituent parts. Metamorphosis goes hand in hand with indeterminacy.

These difficulties not withstanding, certain evolutionary patterns can be identified in the poem that help to understand it. From a metrical standpoint

it is significant that the third sentence is three times as long as the second, which is twice as long as the first. Rhythmically, the poem constitutes an arithmetical progression (1 × 2 × 3), which accounts for the increasing momentum underlying the play of poetic forms. Against this rhythm "Femme et oiseau" follows two separate but complementary paths. Conceived in a moment of poetic solitude, documented in the first line, it eventually arrives at a point of total identification with the cosmos. As such it mediates between the two extremes and suggests that one is inevitably the product of the other. The second course extends from the initial meditative moment to the final burst of inspiration—indeed revelation—that concludes the poem. This path is entirely traditional and consists of the invocation of an internal Muse followed by the unveiling of unconscious processes.

It remains to consider the poem's narrative focus, which varies from section to section and is intimately linked to Breton's mission. From a relatively narrow focus in the first line, centered on the cat in the middle of the shop, the field of vision narrows even further to encompass the animal's head as it licks a single instrument. Thereafter it expands in concentric waves to include the sphinx, the Vaucluse, and finally the universe. This series of events is far from accidental and reflects a fundamental concern with the creative process extending throughout "Femme et oiseau." In particular the movement from constriction to relaxation duplicates that of the sphinx who in slackening her hold on the fountain and permits the poem to be born. The entire work is thus constructed around the image of birth, which, like the poem itself, radiates out from its center. Viewed in this perspective, the central action is identical to that of the poet who observes the same sequence of concentration and relaxation in the course of the creative act. But if the sphinx figures the poet, she also provides a glimpse of the reader. Confronted by the poetic text, the latter must focus intently on the signs before him or her in order to puzzle out their meaning. Only then can one relax and allow the poem to engulf one like the boundless magnolia of the night.

9 CODA

In view of Surrealism's unprecedented success, Anna Balakian argues that it constitutes "the major poetic and artistic current of the 20th century."[1] Of the dozens of movements that have vied for this honor since the turn of the century, Surrealism has proven to be the most durable and the most influential. The Italian Futurist movement endured for more than thirty years but eventually self-destructed. The history of the Dada movement, despite its international appeal, has been sporadic at best. Although abstraction has enjoyed a huge success, it has been limited almost entirely to art and music. Surrealism's most serious rival is (or was) probably Cubism, which had a tremendous impact on both literature, music, and painting. Another leading contender is Expressionism, however one chooses to define it, which also influenced a broad spectrum of aesthetic creations. Yet the fact remains that Surrealism has been the only movement to span the greater part of this century and enjoy widespread popularity. For these and other reasons, Charles Russell concludes that "the Surrealist movement represented the most extensive development of the avant-garde venture."[2] In retrospect, as I have attempted to show, it appears to have been a logical development of the movements and intellectual currents that preceded it. In charting some of the developments that paved the way for Surrealism, we have seen how Breton and his friends exploited earlier discoveries by Apollinaire, Giorgio de Chirico, and the Dadaists and were inspired by concepts such as the fourth dimension, *coincidentia oppositorum*, and the unconscious. What transformed Surrealism from an obscure Dadaist splinter group into a major movement

was its pervasive eclecticism as much as its programmatic guidelines. Welded together to form a coherent doctrine, these and other principles enabled the Surrealists to create "a utopic vision of society, life, and art."[3]

In the pursuit of this vision, each text or artwork was conceived as a sort of quest, as a venture of discovery that would expand the Surrealists' knowledge of life and of themselves. As Peter Nicholls notes, the relationship between the two goals was perceived to be dynamic and interdependent. "Surrealism's hope," he writes, "is that our interaction with the world may bring us back to a full sense of ourselves by disclosing the ways in which reality is shaped by and responds to our desires."[4] Borrowing a term from Claude Lévi-Strauss's repertory, Jacqueline Chénieux-Gendron describes Surrealist activity as a kind of *bricolage*.[5] Like someone attempting to effect a household repair, Breton and his colleagues used materials that were at hand: primarily words and images. As we have seen, Surrealism attempted to expand the ability of language to evoke irrational states and improbable events, consistently striving to transcend the linguistic status quo. By stretching language to its limits and beyond, the Surrealists transformed it into an instrument for exploring the human psyche. Like the Dada movement, from which it gradually emerged, Surrealism aimed not only to redefine language but to reconceptualize its basic function. Henceforth, words were to be viewed as independent entities rather than static objects. "Les mots . . . ont fini de jouer," Breton explained; "les mots font l'amour" ("Words . . . have finished playing silly games. Words have discovered how to make love").[6] For this reason, Nicholls remarks, Surrealist texts are open, expectant, and indeterminate. They constitute "a waiting upon signs rather than an ordered deployment of them to produce an end known in advance."[7] This describes Surrealist art as well, which, like de Chirico's paintings, waits for the viewer to activate their unconscious associations.

Although the Surrealists were fascinated by the endless ways in which words could combine to create their own reality, they were fascinated even more by imagery, which escaped the inevitable constraints imposed by a linguistic framework. One of the things that appealed to them was the image's dazzling immediacy, which dovetailed with their emphasis on "glorification of the convulsive intensity of the moment."[8] Another was the image's uncanny ability to mediate not only between the conscious and the unconscious but between consciousness and the phenomenal world. "C'est à de Chirico," Breton declared in 1922, "que nous devons la révélation des symboles qui

président à notre vie instinctive" ("We owe the revelation of symbols that preside over our instinctive life to de Chirico").[9] The creation of Surrealist objects permitted the Surrealists to experiment with reified versions of the image and to traverse the frontier separating art from life. Whereas Dadaists like Marius de Zayas and Francis Picabia focused on functional analogies, the Surrealists, in Nicholls's words, "strip[ped] objects of their mask of functionality to reveal the human investment within."[10] What interested them was not what an object looked like or how it performed but what it could tell them about themselves. The demise of the object as a world entire in itself was finally completed.

As the Surrealists insisted repeatedly, Surrealism intended above all to improve the quality of life. Although its accomplishments were largely aesthetic, it aimed to revolutionize the manner in which we view existence, both subjective and objective. With this end in mind it offered solutions to a whole series of problematic relationships. One of the problems Surrealism addressed was the relation between the individual and the unconscious. By devising methods to gain access to this secret domain, it gave new meaning to the ancient Greek maxim "Know thyself." At the same time, Surrealism strove to redefine the relation between each person and the physical world. Whereas the quest for the supreme point required one to reconceive reality in terms of unity rather than difference, the doctrines of objective chance and the marvelous called attention to its exceptional beauty. In addition, the Surrealists were determined to alter the relation between the individual and society as well as that between man and woman. Consistent with the movement's eclectic origins, they experienced no difficulty in combining Freud with the alchemist Fulcanelli and Eros with Karl Marx. Their goal was to transform the process of seeing, thinking, and feeling in order to arrive at complete liberation. Ultimately, Surrealism attempted to effect a total revolution in the way we perceive the universe and ourselves.

NOTES

CHAPTER ONE
INTRODUCTION

1. For a thoughtful analysis of this situation see Jean Weisgerber, "Les Avant-Gardes devant la réalité et le réalisme," *Comparatistica*, Vol. I (1989), pp. 103–15.

2. Peter Nicholls, *Modernisms: A Literary Guide* (Berkeley: University of California Press, 1995), p. 280.

3. James Thrall Soby, *Giorgio de Chirico* (New York: Museum of Modern Art, 1955), p. 160.

4. André Breton, *Le Surréalisme et la peinture* (1928) (Paris: Gallimard, 1965), p. 16.

5. Marjorie Perloff, *The Futurist Moment: Avant-Garde, Avant Guerre, and the Language of Rupture* (Chicago: University of Chicago Press, 1986), p. 36.

CHAPTER TWO
PROBING THE FOURTH DIMENSION

1. For a groundbreaking study of the role of X rays in modern art, see Linda Henderson, "X-Rays and the Quest for Invisible Reality in the Art of Kupka, Duchamp, and the Cubists," *Art Journal*, Vol. XLVII (Winter 1988), pp. 323–40.

2. Although this chapter concentrates on the first third of the twentieth century, the fourth dimension has continued to play an important role in the avant-garde ever since. See, for example, Renée Riese Hubert, "The Four Dimensional Book," *Word and Image Interactions*, ed. Martin Heusser et al. (Basel: Wiese, 1993), pp. 85–95.

3. Linda Dalrymple Henderson, *The Fourth Dimension and Non-Euclidean Geometry in Modern Art* (Princeton: Princeton University Press, 1983), p. 339.

4. See ibid., p. 346–50.

5. These possibilities are explored in considerable detail in *Modernism and the Fourth Dimension*, ed. Linda Henderson et al. (University Park: Penn State University Press, forthcoming).

6. Guillaume Apollinaire, *Méditations esthétiques: les peintres cubistes* in *Oeuvres en prose complètes*, ed. Pierre Caizergues and Michel Décaudin (Paris: Gallimard/Pléiade, 1991), Vol. II, pp. 10–12. Cited in the text hereafter as PC.

7. See the examples cited in Guillaume Apollinaire, *Méditations esthétiques: les peintres cubistes*, ed. L. C. Breunig and J.-Cl. Chevalier (Paris: Hermann, 1965), p. 103, and D. Valeton, *Lexicologie, l'espace et le temps d'après un texte critique d'Apollinaire sur la peinture moderne* (Paris: Nizet, 1973).

8. See, for example, Albert Gleizes and Jean Metzinger, *Du cubisme* (Paris: Figuière, 1912), p. 36. Although Apollinaire was later to equate the fourth Dimension with "la représentation du mouvement," his remarks were concerned not with the artist's displacement but with the difficulty of depicting objects in motion. See his recently discovered letter to an unknown critic in *Oeuvres en prose complètes*, Vol. II, p. 870.

9. Mabel Dodge, "Speculations," *Camera Work*, special issue, June 1913, p. 9.

10. Etienne-Alain Hubert, "Une Dédicace à Tristan Derême," *Revue des Lettres Modernes*, Nos. 450–455 (1976), special issue *Guillaume Apollinaire 13*, pp. 138–39.

11. Henderson, *The Fourth Dimension and Non-Euclidean Geometry in Modern Art*, p. 60.

12. Guillaume Apollinaire, "La Peinture nouvelle: notes d'art," *Les Soirées de Paris*, No. 3 (April 1912), pp. 89–92.

13. Henderson, *The Fourth Dimension and Non-Euclidean Geometry in Modern Art*, pp. 3–43.

14. André Lhote, "Cubism and the Modern Artistic Sensibility," *The Athenaeum*, No. 4664 (September 19, 1919), pp. 919–20.

15. Cited by Ramón Gómez de la Serna, "In memoriam" in *Páginas escogidas e inéditas* by Silverio Lanza (Madrid: Biblioteca Nueva, 1918), pp. 4–5. These remarks probably appeared in *Prometeo*, edited by Gómez de la Serna, which ceased publication in 1912, the year of Lanza's death.

16. Alfred Jarry, "Commentaire pour servir à la construction pratique de la machine à explorer le temps," *Mercure de France*, No. 110 (February 1899), pp. 387–96. Reprinted in Alfred Jarry, *Oeuvres complètes*, ed. Michel Arrivé (Paris: Gallimard/Pléiade, 1972), Vol. I, pp. 735–43.

17. Marcel Proust, *A la recherche du temps perdu*, ed. Pierre Clarac and André Ferré (Paris: Gallimard/Pléiade, 1954), Vol. I, p. 61.

18. See Henderson, *The Fourth Dimension and Non-Euclidean Geometry in Modern Art*, pp. 103–109.

19. Despite Apollinaire's attempt to acknowledge the influence of mathematics on the Cubists, one critic took him to task for not going into more detail. See Paul Fechter, *Der Expressionismus* (Munich: Piper, 1914), p. 34.

20. Frank Jewett Mather, Jr., "The New Painting and the Musical Fallacy," *The Nation*, Vol. XCIX, No. 2576 (November 12, 1914), p. 589.

21. Jean Metzinger, "Note sur la peinture," *Pan* (October–November 1910), pp. 649–51.

22. Guillaume Apollinaire, "L'Esprit nouveau et les poètes," *Mercure de France,* Vol. CXXX, No. 491 (December 1, 1918), p. 396. Reprinted in Apollinaire, *Oeuvres en prose complètes,* Vol. II, p. 954.

23. Guillaume Apollinaire, "Du sujet dans la peinture moderne," *Les Soirées de Paris,* No. 1 (February 1912), p. 4.

24. Friedrich Nietzsche, *Sämtliche Werke,* ed. Giorgio Colli and Mazzino Montinari (Berlin: de Gruyter, 1980), pp. 123–24.

25. Max Weber, "The Fourth Dimension from a Plastic Point of View," *Camera Work,* No. 31 (July 1910), p. 25.

26. See Willard Bohn, "La Quatrième Dimension chez Apollinaire," *Revue des Lettres Modernes,* Nos. 530–536 (1978), special issue *Guillaume Apollinaire 14,* pp. 96–97.

27. Henderson, *The Fourth Dimension,* p. 169, n. 16. For a more extensive account of Weber's role in New York see pp. 167–82.

28. Letter from Marius de Zayas to Alfred Stieglitz dated October 28, 1910. Alfred Stieglitz Archive, Collection of American Literature, Beinecke Rare Book and Manuscript Library, Yale University.

29. For a study of the relations between Apollinaire and the New York avant-garde see Willard Bohn, *Apollinaire and the International Avant-Garde* (Albany: State University of New York Press, 1997).

30. Weber may have been inspired by an article published in connection with a contest sponsored by *Scientific American.* In "The Fourth Dimension Simply Explained" Edward H. Cutler wrote: "The word 'fourth dimension' is more readily explained than defined. All more or less clearly conceive of space as extending indefinitely or infinitely in every direction" (*Scientific American,* Vol. CI, No. 2, July 10, 1909, p. 27).

31. For example, Philip Courtenay, "Einstein and Art" in *Einstein: The First Hundred Years,* ed. Maurice Goldsmith et al. (Oxford: Pergamon, 1980), p. 148. See also Carola Gidion-Welcher, *Die neue Realität bei Guillaume Apollinaire* (Bern-Bümplitz: Benteli, 1945), p. 10.

32. Minkowski's lecture was published the following year as "Espace et temps," *Annales Scientifiques de l'Ecole Normale Supérieure,* 3rd series, Vol. XXVI (1909), pp. 499–517.

33. Guillaume Apollinaire, *Oeuvres poétiques,* ed. Marcel Adéma and Michel Décaudin (Paris: Gallimard/Pléiade, 1965), pp. 183–85.

34. Guillaume Apollinaire, *Oeuvres en prose,* ed. Michel Décaudin (Paris: Gallimard/Pléiade, 1977), Vol. I, p. 1151.

35. Guillaume Apollinaire, "Les Peintres de Venise," *Paris-Journal,* May 23, 1914. Reprinted in Apollinaire, *Oeuvres en prose complètes,* Vol. II, p. 720.

36. In a recently discovered document, which probably dates from 1913, Apollinaire quotes Picasso as follows: "Le rythme en quelque sorte mécanique qui détruit les proportions de toutes les oeuvres grecques m'a toujours extrêmement déplu." See "Propos de Pablo Picasso" in *Oeuvres en prose complètes,* Vol. II, pp. 876–77.

37. William Carlos Williams, Letter to the Editor, *Little Review,* Vol. VIII, No. 7 (Autumn 1922), p. 59.

38. Marjorie Perloff, *The Poetics of Indeterminacy: Rimbaud to Cage* (Princeton: Princeton University Press, 1981), p. 110. For a penetrating analysis of *Spring and All* itself, see pp. 108–54.

39. William Carlos Williams, *The Collected Poems*, ed. A. Walton Litz and Christopher MacGowan (New York: New Directions, 1986), Vol. I, p. 225.

40. Amado Nervo, "La cuarta dimensión," *Obras completas*, Vol. II (Madrid: Aguilar, 1962), pp. 907–11. Nervo's concept of the fourth dimension is examined in more detail in Willard Bohn, "Writing the Fourth Dimension" in *Modernism and the Fourth Dimension*, ed. Henderson et al. (University Park: Penn State University, forthcoming).

41. Guillaume Apollinaire, reply to a questionnaire, published in *La Vie* in June 1914. Reprinted in Apollinaire, *Oeuvres en prose complètes*, Vol. II, p. 984.

42. Maurice Raynal, "Qu'est-ce que . . . le 'Cubisme'?" *Comoedia Illustré*, December 20, 1913. Reprinted in translation in Edward F. Fry, *Cubism* (New York: McGraw-Hill, 1966), pp. 129–30.

43. Hutchins Hapgood, "A Paris Painter," *Globe and Commercial Advertiser*, February 20, 1913, p. 8. Reprinted in *Camera Work*, Nos. 42–43 (April–July 1913), pp. 49–50.

44. Henderson, *The Fourth Dimension and Non-Euclidean Geometry in Modern Art*, p. 78.

45. Lhote, "Cubism and the Modern Artistic Sensibility," p. 920.

46. Alan J. Friedman and Carol C. Donley, *Einstein as Myth and Muse* (Cambridge: Cambridge University Press, 1985), p. 10.

47. See Henderson, *The Fourth Dimension and Non-Euclidean Geometry in Modern Art*, pp. 346–49.

48. André Breton, *Le Surréalisme et la peinture* (New York: Brentano's, 1945), p. 152.

49. Henderson, *The Fourth Dimension and Non-Euclidean Geometry in Modern Art*, p. 346.

50. Ibid., p. 345.

CHAPTER THREE
THE DEMISE OF THE OBJECT

1. José Pierre, *Le Futurisme et la dadaïsme* (Lausanne: Rencontre, 1967), p. 69.

2. This activity is documented in detail in Francis M. Naumann, *New York Dada 1915–23* (New York: Abrams, 1994).

3. See William Innes Homer, *Alfred Stieglitz and the American Avant-Garde* (Boston: New York Graphic Society, 1977), p. 52.

4. See, for example, "Marius de Zayas: A Master of Ironical Caricature," *Current Literature* (March 1908), pp. 281–83, which includes quotes from other articles about him and some sample caricatures. Other early caricatures are reproduced in Douglas Hyland, *Marius de Zayas: Conjuror of Souls* (Lawrence, Kans.: Spencer Museum of Art, 1981).

5. Catherine Turrill, "Marius de Zayas," *Avant-Garde Painting and Sculpture in America 1910–25*, ed. William Innes Homer (Wilmington, Del.: Delaware Art Museum, 1975), p. 62. A notable exception to this view is expressed in an article by Craig R. Bailey, which surveys de Zayas's art in the context of European achievements: "The Art of Marius de Zayas," *Arts Magazine* (September 1978), pp. 136–44.

6. William Agee, "New York Dada 1910–1930," *The Avant-Garde*, ed. Thomas B. Hess and John Ashberry (London: Collier-Macmillan, 1968), p. 108. This work corresponds to the 1968 issue of *Art News Annual*.

7. André Breton, *Anthologie de l'humour noir* in Breton, *Oeuvres complètes*, ed. Marguerite Bonnet et al. (Paris: Gallimard/Pléiade, 1992), Vol. II, p. 1077.

8. Letter from Alfred Stieglitz to Arther B. Carles dated April 11, 1913, Alfred Stieglitz Archive, Collection of American Literature, Beinecke Rare Book and Manuscript Library, Yale University. The projected gallery—called "L'Ourse"—opened in Paris toward the end of the year but closed before long for unknown reasons. See William A. Camfield, *Francis Picabia* (New York: Solomon R. Guggenheim Museum, 1970), p. 22, n. 25.

9. Anonymous, "Drawings by Marius de Zayas," *American Art News*, Vol. XI, No. 28 (April 26, 1913), p. 2. The internal quotation is from de Zayas's preface to his 1913 exhibition at "291."

10. William A. Camfield, *Francis Picabia: His Art, Life, and Times* (Princeton: Princeton University Press, 1979), p. 53.

11. Agee, "New York Dada 1910–1930," p. 108.

12. Dorothy Norman, *Alfred Stieglitz: An American Seer* (New York: Random House, 1973), pp. 122–23. For the entire document see Marius de Zayas, *How, When, and Why Modern Art Came to New York*, ed. Francis Naumann (Cambridge, Mass.: MIT Press, 1966). Unfortunately, de Zayas gives 1914 as the date of his soul-catcher experience, which is clearly impossible. *L'Accoucheur d'idées* appeared in *Camera Work*, No. 39 (July 1912), p. 55.

13. Marius de Zayas, "Caricature: Absolute and Relative," reprinted in *Camera Work*, No. 46 (April 1914), p. 20.

14. Marius de Zayas, "The New Art in Paris," *The Forum*, Vol. XLV, No. 2 (February 1911), pp. 180–88. Reprinted in *Camera Work*, Nos. 34–35 (April–July 1911), pp. 29–34.

15. Marius de Zayas, "Pablo Picasso," ibid., pp. 65–67. An illustrated, slightly expanded version appeared in Spanish in a magazine edited by de Zayas's father: "Pablo Picasso," *América: Revista Mensual Illustrada* (New York), Vol. VI (May 1911), pp. 363–65.

16. Marius de Zayas, "Caricature: Absolute and Relative," p. 20. The preface had been reprinted earlier as "Exhibition Marius de Zayas" in *Camera Work*, Nos. 42–43 (April–July 1913), pp. 20–22.

17. Cited in Norman, *Alfred Stieglitz: An American Seer*, pp. 109–10.

18. *Camera Work*, No. 46 (April 1914), plates I–III and V–X.

19. See Willard Bohn, "The Abstract Vision of Marius de Zayas," *The Art Bulletin*, Vol. LXII, No. 3 (September 1980), pp. 437–38.

20. For a study of the relations between de Zayas and Apollinaire see Willard Bohn, *Apollinaire and the International Avant-Garde* (Albany: State University of New York Press, 1997), pp. 48–56.

21. Guillaume Apollinaire, "Marius de Zayas," *Paris-Journal*, July 8, 1914. Reprinted in Guillaume Apollinaire, *Oeuvres en prose complètes*, ed. Pierre Caizergues and Michel Décaudin (Paris: Gallimard/Pléiade, 1991), Vol. II, pp. 812–813.

22. Writing to the poetess Jeanne-Yves Blanc from the front on October 18, 1915, Apollinaire offered the following commentary: "Quant au dessin de Zayas qui est intitulé

'Guillaume Apollinaire' la couverture vous enseigne que c'est une caricature. Le mot table ne ressemble pas du tout à une table et cependant il vous suggère l'idée d'une table. Comprenez-vous un peu de quelle essence est cette caricature . . . ?" ("As for the drawing by de Zayas entitled *Guillaume Apollinaire*, the review's cover explains that it is a caricature. The work 'table' does not resemble a table in any fashion, and yet it manages to suggest the idea of a table. Are you beginning to grasp the essence of this caricature . . . ?). Guillaume Apollinaire, *Lettres à sa marraine 1915–1918*, ed. Marcel Adéma (Paris: Gallimard, 1951), p. 36.

23. Paul B. Haviland, "Marius de Zayas—Material, Relative, and Absolute Caricatures," *Camera Work*, No. 46 (April 1914), p. 33.

24. Quoted in ibid., p. 34.

25. Marius de Zayas, "Photography," *Camera Work*, No. 41 (January 1913), p. 20 and "291" *Camera Work*, No. 47 (July 1914), p. 73, respectively. For a survey of de Zayas's writings through 1914, see Dickran Tashjian, *Skyscraper Primitives: Dada and the American Avant-Garde 1910–1925* (Middletown, Conn.: Wesleyan University Press, 1975), pp. 23–28.

26. Marius de Zayas, "Photography," p. 17.

27. Hyland has unearthed two additional caricatures from 1915 that are also in charcoal (*Marius de Zayas: Conjuror of Souls*, plates 31 and 33). However, a caricature of José Juan Tablada, which dates from the same period, was done in pen and ink. See the latter's *Obras*, ed. Héctor Valdés (Mexico: UNAM, 1971), Vol. I, p. 392.

28. *Camera Work*, No. 46 (April 1914), p. 51. Four earlier caricatures measure 28 × 22" ("Our Plates," *Camera Work*, No. 29 [January, 1910], p. 61.

29. Cf. Gabrielle Buffet-Picabia: "Il parlait de ses projets comme s'ils étaient déjà réalisés et si cela ne marchait pas tout seul, il était le premier à abandonner pour en inventer d'autres" ("He used to speak of his projects as they were already finished, and if there was any trouble, he was the first to abandon them for some other idea") (letter to the author).

30. Theodore Roosevelt, "A Layman's Views of an Art Exhibition," *The Outlook* (March 29, 1913), pp. 718–20. Reprinted in *1913 Armory Show 50th Anniversary Exhibition* (Utica, N.Y.: Munson-Williams-Proctor Institute and Henry Street Settlement, 1963) pp. 160–62.

31. Samuel Swift, writing in the New York *Sun*. Reprinted in *Camera Work*, Nos. 42–43 (April–July 1913), pp. 53–54.

32. William B. McCormick in ibid., pp. 51–52. In "The Art of Marius de Zayas," Bailey interprets the zigzag motif as a crown (p. 139).

33. De Zayas gave the original drawing to Stieglitz, who later gave it to the Metropolitan Museum of Art. A slightly smaller pencil and gouache version (18 × 14") is owned by the Musée de Peinture et de Sculpture in Grenoble, where it is incorrectly attributed to Picabia. Except for an inscription in the lower left corner reading "PICABIA"—probably a dedication—the portrait is identical to the version in the Metropolitan Museum of Art. It is reproduced in the *Gazette des Beaux-Arts*, Suppl. No. 163, February 1973.

34. For a photograph of Haviland see Homer, *Alfred Stieglitz and the American Avant-Garde*, p. 51

35. Hyland, *Marius de Zayas: Conjuror of Souls*, p. 114.

36. Francis Picabia, "Que fais-tu 291?," *Camera Work*, No. 47 (July 1914), p. 72.

37. Marius de Zayas, "In 1907, Stieglitz . . . ," *291*, Nos. 7–8 (September–October, 1915), p. 1.

38. Camfield, *Francis Picabia: His Art, Life, and Times*, pp. 80–81.

39. Ibid., pp. 77–80. Linda Henderson has argued that Picabia was also indebted to Marcel Duchamp's exploration of X rays and related equipment. See her "Francis Picabia, Radiometers, and X-rays in 1913," *The Art Bulletin*, Vol. LXXI, No. 1 (March 1989), pp. 122–23. For the role of X rays in modern art in general, see the same author's "X-Rays and the Quest for Invisible Reality in the Art of Kupka, Duchamp, and the Cubists," *Art Journal*, Vol. XLVII, No. 4 (Winter 1988), pp. 323–40.

40. Camfield, *Francis Picabia: His Art, Life and Times*, p. 45.

41. Francis Picabia, "Preface," *Picabia Exhibition*, New York, Little Gallery of the Photo-Secession, March 17–April 5, 1913.

42. Virginia Spate, *Orphism: The Evolution of Non-figurative Painting in Paris 1910–1914* (Oxford: Clarendon, 1979), p. 334.

43. Camfield, *Francis Picabia: His Art, Life, and Times*, p. 49.

44. Gaston Esnault, *Dictionnaire des argots* (Paris: Larousse, 1965), p. 574. See also *Harrap's French and English Dictionary of Slang and Colloquialisms* (London: Harrap, 1981).

45. See, for example, Marianne W. Martin, "The Ballet *Parade*: A Dialogue Between Cubism and Futurism," *Art Quarterly*, N.S., Vol. I, Nos. 1–2 (Spring 1978), pp. 85–111.

46. Henderson, "Francis Picabia, Radiometers, and X-Rays in 1913," pp. 112–23. Among other things, she speculates that "Npierkowska" may refer to N rays, which were thought to exist by some scientists.

47. This photograph is reproduced in Camfield, *Francis Picabia: His Art, Life, and Times*, illustration No. 6.

48. See ibid, p. 49 and Spate, *Orphism: The Evolution of Non-figurative Painting*, p. 381. An article published the next day describes the dance in detail and reveals that the judge dismissed the charges.

49. Camfield, *Francis Picabia: His Art, Life and Times*, pp. 44–45.

50. On May 27, 1915, Picabia's wife sent a telegram to "291" saying that he would be arriving on the liner *Espagne*. Alfred Stieglitz Archive, Yale University.

51. For a detailed analysis of these drawings see Camfield, *Francis Picabia: His Art, Life, and Times*, pp. 82–84, and William Innes Homer, "Picabia's *Jeune fille américaine dans l'état de nudité* and Her Friends," *The Art Bulletin*, Vol. LVII, No. 2 (March 1975), pp. 110–15.

52. Anonymous, "French Artists Spur on American Art," *New York Tribune*, October 24, 1915, pt. iv, p. 2. Cited in Camfield, *Francis Picabia: His Art, Life and Times*, p. 77.

53. Marius de Zayas, "New York did not see at first," *291*, Nos. 5–6 (July–August 1915), p. 6.

54. Homer, "Picabia's *Jeune fille américaine dans l'état de nudité* and Her Friends," pp. 111–15. Similarly, Elizabeth Hutton Turner asserts that Meyer is portrayed "as a catalyst for modernization analogous to a mass-produced interchangeable part" ("*La Jeune Fille*

Américaine and the Dadaist Impulse" in *Women in Dada: Essays on Sex, Gender, and Identity*, ed. Naomi Sawelson-Gorse [Cambridge, Mass.: MIT Press, 1999], p. 13).

55. For an analysis of this work see Willard Bohn, *The Aesthetics of Visual Poetry, 1914–1928* (Cambridge: Cambridge University Press, 1986), pp. 185–203.

56. Picabia never did learn to like the game. In a recently discovered novel he comments: "Voyez-vous, j'en suis arrivé à un point où la figure des femmes ne compte plus! Mais le corps magnifique de l'Américaine, qui joue au golf, danse, fait de la natation, conduit une voiture automobile, ne sait pas encore faire l'amour. C'est pourqoui elles ont inventé le flirt. L'Amour latin au contraire a tant d'expérience qu'il est presque professionel" ("You see, I have arrived at a point where a woman's face no longer matters. But the magnificent body of the American woman, who plays golf, dances, swims, drives a car, doesn't know how to make love. That's why they invented flirtation. The Latin lover, by contrast, has so much experience that he is almost a professional") *(Caravansérail* [Paris: Belfond, 1974], p. 71). Jules Laforgue used to say there were three sexes: men, women, and Englishwomen.

57. André Breton, "Francis Picabia," *Les Pas perdus* in *Oeuvres complètes* Vol. I, p. 281.

58. Camfield, *Francis Picabia: His Art, Life and Times*, pp. 81–82.

59. Breton, "Francis Picabia," *Les Pas perdus*, p. 283.

60. André Breton, "Introduction au discours sur le peu de réalité," *Oeuvres complètes*, Vol. II, p. 277.

61. See André Breton, "Objets surréalistes," *Oeuvres complètes*, Vol. II, pp. 1199–1202.

62. André Breton, "Crise de l'objet," *Le Surréalisme et la peinture* (Paris: Gallimard/Pléiade, 1965), p. 279.

CHAPTER FOUR
GIORGIO DE CHIRICO
AND THE SOLITUDE OF THE SIGN

1. André Breton, "Giorgio de Chirico," *Les Pas perdus* in Breton, *Oeuvres complètes*, ed. Marguerite Bonnet et al. (Paris: Gallimard/Pléiade, 1988), Vol. I, p. 251.

2. André Breton, "Alberto Savinio," *Anthologie de l'humour noir* in *Oeuvres complètes*, Vol. II, p. 1122. Breton's remarks apply to Alberto Savinio as well who, as the painter's brother, shared the same mythology and the same concerns.

3. Marianne W. Martin, "Reflections on De Chirico and *Arte Metafisica*," *The Art Bulletin*, Vol. LX, No. 2 (June 1978), p. 342.

4. Despite some serious omissions, most of his early works have been collected in *L'opera completa de De Chirico, 1908–1924*, ed. Maurizio Fagiolo dell'Arco (Milan: Rizzoli, 1984).

5. Giorgio de Chirico, "Sull'arte metafisica," *Valori Plastici*, Nos. 4–5 (April–May 1919), p. 17. Reprinted in Giorgio de Chirico, *Il meccanismo del pensiero: critica, polemica, autogiografia, 1911–1943*, ed. Maurizio Fagiolo (Turin: Einaudi, 1985), p. 86.

6. James Beck, "The Metaphysical de Chirico, and Otherwise," *Arts Magazine*, (September 1982), p. 85.

7. For a study of the mannequins as symbols of the creative artist see Willard Bohn, *Apollinaire and the Faceless Man: The Creation and Evolution of a Modern Motif* (Rutherford, N.J.: Fairleigh Dickinson University Press, 1991), pp. 96–131.

8. Another, more rudimentary drawing is reproduced in *Giorgio de Chirico, 1888–1978*, ed. Pia Vivarelli (Rome: De Luca, 1981), Vol. I, p. 87.

9. Breton, "Alberto Savinio," p. 1123.

10. Giorgio de Chirico, *Hebdomeros* (Paris: Flammarion, 1964), pp. 133–34. Hebdomeros himself is speaking.

11. Friedrich Nietzsche, *Jenseits von Gut and Böse*, *Werke*, ed. Karl Schlechta (Munich: Hanser, 1966), Vol. II, p. 754. The same text appears in *Ecce Homo*, "Warum ich so gute Bücher schreibe," section VI.

12. André Breton, *Le Surréalisme et la peinture* (Paris: Gallimard, 1928), pp. 35–36.

13. See Joseph C. Sloane, "Giorgio de Chirico and Italy," *Art Quarterly*, Vol. XXI, No. 1 (spring 1958), pp. 9–10. See also Bohn, *Apollinaire and the Faceless Man*, pp. 96–131.

14. "Zeusi l'esploratore," *Valori Plastici*, No. 1 (November 15, 1918), p. 10. Reprinted in de Chirico, *Il meccanismo del pensiero*, pp. 81–82.

15. Alberto Savinio, "Dammi l'anatema, cosa lasciva," *291*, No. 4 (June 1915), p. 4.

16. Alberto Savinio, "Drame de la ville méridienne," *La Voce*, March 31, 1916. Reprinted in *Metafisica*, ed. Massimo Carrà et al. (Milan: Mazzotta, 1968), pp. 256–59.

17. Maurizio Fagiolo dell'Arco, "De Chirico in Paris, 1911–1915," in *De Chirico*, pp. 22–29. For an Italian version of this essay, in slightly different form and profusely illustrated, see his *Giorgio de Chirico, Il tempo di Apollinaire, Paris 1911/1915* (Rome: De Luca, 1981).

18. Alberto Savinio, "Apollo," *Nuova enciclopedia* (Milan: Adelphi, 1977), pp. 49–51.

19. For a discussion of the Dionysos/Ariadne dichotomy see Bohn, *Apollinaire and the Faceless Man*, especially Chapter 5.

20. René Wellek and Austin Warren, *Theory of Literature*, 3rd ed. (New York: Harcourt, 1962), p. 85.

21. Marianne W. Martin, "On de Chirico's Theater," in *De Chirico*, pp. 81–100.

22. See, for example, Guillaume Apollinaire, "Musique nouvelle," *Paris-Journal*, May 24, 1914. Reprinted in Apollinaire, *Oeuvres en prose complètes*, Vol. II, pp. 723–26, and André Level, *Souvenirs d'un collectionneur* (Paris: Mazo, 1959), p. 36. Level also purchased two of de Chirico's paintings during his metaphysical period that he sold in 1927: "une grande tour" ("a great tower"), which resembled a monumental prison, and "une petite nature morte au pain en double croissant" ("a small still life with a small loaf of bread in the a form of a double croissant").

23. Nietzsche, *Die Geburt der Tragödie*, *Werke*, Vol. I, p. 25. Cited in the text hereafter as GT.

24. Giorgio de Chirico, untitled manuscript, *Il meccanismo del pensiero*, p. 13.

25. See note 14.

26. The cover and several pages are reproduced in Isabella Far de Chirico and Domenico Porzio, *Conoscere de Chirico* (Milan: Mondadori, 1979), p. 13. De Chirico's copy bears the following inscription, dated 1913: "meditatio mortis et somniarum magna semper poëtarum et philosophorum delectatio fuit" ("poets and philosophers have always delighted in the contemplation of death and important dreams").

27. Arthur Schopenhauer, "Versuch über das Geistersehn" *Parerga und Paralipomena, Sämtliche Werke* (Stuttgart: Cotta and Frankfurt: Insel, 1963), Vol. IV, pp. 278–79. Cited hereafter in the text as PP.

28. Nietzsche, *Ecce Homo, Werke*, Vol. II, p. 1108.

29. Friedrich Nietzsche, "Eternal Recurrence," tr. Anthony M. Ludovici, Vol. XVI of the *Complete Works* (New York: Gordon, 1974), pp. 237–56.

30. Nietzsche, *Ecce Homo*, p. 1111.

31. Giorgio de Chirico, "Arnoldo Böcklin," *Il Convegno*, No. 4 (May 1920), p. 51. Reprinted in de Chirico, *Il meccanismo del pensiero*, p. 169.

32. Giorgio de Chirico, untitled manuscript, *Il meccanismo del pensiero*, p. 22.

33. Salomon Reinach, *Manuel de philologie classique*, 2nd ed. (Paris: Hâchette, 1893), Vol. I, p. 272. Reinach was one of de Chirico's favorite authorities on classical antiquity.

34. See, for example, Joseph Fontenrose, *The Delphic Oracle* (Berkeley: University of California Press, 1978).

35. Marianne W. Martin, "Reflections on de Chirico and *Arte Metafisica*," p. 351.

36. Nietzsche, *Die Geburt der Tragödie*, p. 74. Nietzsche was probably thinking of Plato's *Ion* (533e) in which Socrates speaks ironically of poetic creation since it is not a conscious process.

37. James Thrall Soby, *Giorgio de Chirico* (New York: Museum of Modern Art, 1955), p. 32.

38. See especially the drawing entitled *Cavourian Enigma*, which offers a frontal view of this statue, in Fagiolo dell'Arco, "De Chirico in Paris," p. 33.

39. André Breton, *Perspective cavalière*, ed. Marguerite Bonnet (Paris: Gallimard, 1970), pp. 38–44. Breton also quotes extensively from an unknown manuscript by de Chirico (see pp. 19 and 45).

40. Stéphane Mallarmé, "Quant au livre," *Oeuvres complètes*, ed. Henri Mondor and G. Jean-Aubry (Paris: Gallimard/Pléiade, 1945), p. 381.

41. Sir William Smith, *Smaller Classical Dictionary*, rev. ed. (New York: Dutton, 1958), p. 111.

42. Nietzsche, *Götzen-Dämmerung, Werke*, Vol. II, p. 996.

43. Guillaume Apollinaire, "G. de Chirico," *Paris-Journal*, May 25, 1914. Reprinted in Apollinaire, *Oeuvres en prose complètes*, Vol. II, p. 729.

44. Salomon Reinach, *Apollo; histoire générale des arts plastiques professée à l'école du Louvre* (Paris: Hâchette, 1904), p. 71.

45. Maurizio Fagiolo dell'Arco, "De Chirico in Paris, 1911–1915," p. 26; *Giorgio de Chirico, Il tempo di Apollinaire*, p. 71.

46. Wieland Schmied, "Giorgio de Chirico," *Giorgio de Chirico* (Paris: Musée Marmottan, 1975), pp. 6–7.

47. Despite Apollinaire's, de Chirico's, and Savinio's assertions to the contrary, the silhouette cannot represent Apollinaire. Not only does it recur elsewhere (e.g., in *The Destiny of the Poet*, 1914), its associations are clearly negative. See the 1914 drawing mistitled *Portrait of Apollinaire* (Fagiolo dell'Arco, "De Chirico in Paris," p. 26), addressed to "Guy Romain," which depicts a menacing figure. This drawing actually has no title.

48. Eugenio La Rocca, "L'archeologia nell'opera di de Chirico," *Giorgio de Chirico, 1888–1978*, ed. Pia Vivarelli, Vol. I, pp. 33–34.

49. For some of Savinio's reactions to *Apollo* see the excerpts from his notebook quoted by Sergio Zoppi, *Al festino di Esopo* (Rome: Bulzoni, 1979), pp. 108–10.

50. Reinach, *Apollo*, p. 71.

51. Johann Joachim Winckelmann, *History of Ancient Art*, tr. G. Henry Lodge (New York: Ungar, 1968), Vol. I, pp. 215–16. Like the head of Apollo, this statue is reproduced in Willard Bohn, "Giorgio de Chirico and the Solitude of the Sign," *Gazette des Beaux-Arts*, Vol. CXVII, No. 1467 (April 1991), pp. 169–87.

52. Reinach, *Manuel de la philologie classique*, Vol. I, p. 360.

53. Letter from Giorgio de Chirico to Paul Guillaume dated January 29, 1925. Reproduced in *La pittura metafisica*, ed. Giuiliano Briganti et al. (Venice: Neri Pozza, 1979), p. 199.

54. Nietzsche, *Götzen-Dämmerung*, p. 996.

55. J. E. Cirlot, *Dictionary of Symbols*, tr. Jack Sage, 2nd ed. (New York: Philosophical Library, 1962), p. 295.

56. *L'opera completa di De Chirico*, p. 94, plate D 24.

57. Nietzsche, *Ecce Homo*, p. 1130.

58. Giorgio de Chirico, "Méditations d'un peintre," *Il meccanismo del pensiero*, p. 32.

59. See André Breton and Paul Eluard, *Dictionnaire abrégé du surréalisme* (1938) in *Oeuvres complètes*, Vol. II, p. 799.

60. René Magritte, *Ecrits complets*, ed. André Blavier (Paris: Flammarion, 1979), p. 562. See also pp. 565 and 568.

61. Magritte, *Ecrits complets*, p. 104.

CHAPTER FIVE
FROM SURREALSIM TO SURREALISM

1. Letter from Guillaume Apollinaire to Madeleine Pagès dated July 30, 1915. Reprinted in Apollinaire, *Oeuvres complètes*, ed. Michel Décaudin (Paris: Balland-Lecat, 1965–66), Vol. IV,. p. 493. As Michel Décaudin has demonstrated in "Le 'Changement de front' d'Apollinaire" (*Revue des Sciences Humaines*, n. s. No. 60 [October–December 1950], pp. 255–60), the roots of Apollinaire's "new aesthetic" actually extended back a great many years.

2. Guillaume Apollinaire, "Le 30ᵉ Salon des 'Indépendants,'" *Les Soirées de Paris*, No. 22 (March 15, 1914), p. 186. Reprinted in Guillaume Apollinaire, *Oeuvres en prose complètes*, ed. Pierre Caizergues and Michel Décaudin (Paris: Gallimard/Pléiade, 1991), Vol. II, p. 654.

3. Apollinaire's previous references to surprise as an aesthetic component of certain paintings were sporadic and unsystematic. See Guillaume Apollinaire, *Méditations esthétiques: les peintres cubistes* in his *Oeuvres en prose complètes*, Vol. II, pp. 22, 40–41, and 46.

4. Guillaume Apollinaire, reply to a questionnaire published in *La Vie* in June 1914. Reprinted in Apollinaire, *Oeuvres en prose complètes*, Vol, II, pp. 984–85.

5. Guillaume Apollinaire, "L'Esprit nouveau et les poètes," *Mercure de France*, Vol. CXXX, No. 491 (December 1, 1918), pp. 385–96. Reprinted in Apollinaire, *Oeuvres en prose complètes*, Vol. II, pp. 943–54. Cited in the text hereafter as EN.

6. See Margareth Wijk, *Guillaume Apollinaire et l'esprit nouveau* (Lund: CWK Gleerup, 1982).

7. Quoted in F. O. Matthiessen, *The Achievement of T. S. Eliot: An Essay on the Nature of Poetry*, 3rd ed. (Oxford: Oxford University Press, 1958), p. 17.

8. See Tristan Tzara, "Introduction," *L'Aventure Dada (1916–1922)* by Georges Hugnet (Paris: Galerie de l'Institut, 1957), p. 10.

9. Guillaume Apollinaire, "Surnaturalisme," *Les Soirées de Paris* No. 24 (May 15, 1914), p. 248. Signed "J. C." Apollinaire made essentially the same observation in *Les Peintres cubistes* (1913): "La vraisemblance n'a plus aucune importance, car tout est sacrifié par l'artiste aux vérités, aux nécessités d'une nature supérieure" ("Verisimilitude is no longer important, for the artist sacrifices everything to the demands of Truth, to the necessities of a superior order") (p. 9).

10. Apollinaire's anti-realistic critical stance dates back at least to 1908, when he attacked popular novelists for employing a "faux semblant de réalisme" ("phony realism") ("Romans," *La Phalange*, September 1908. Reprinted in *Oeuvres en prose complètes*, Vol. II, pp. 1132–33). Elsewhere the same year, in a text devoted to painting, he asserted that reality was relative ("Les Trois Vertus plastiques," *Catalogue de la III^e Exposition du 'Cercle de l'Art Moderne*,' Le Havre, June 1908. Reprinted in *Chroniques d'art 1902–1918*, ed. L. C. Breunig [Paris: Gallimard, 1960], p. 58).

11. Guillaume Apollinaire, *Les Mamelles de Tirésias* in *Oeuvres poétiques*, ed. Marcel Adéma and Michel Décaudin (Paris: Gallimard/Pléiade, 1965), pp. 865 and 869. Cited in the text hereafter as MT.

12. See Apollinaire's letter to Paul Dermée dated March 1917 in *Oeuvres complètes*, Vol. IV, p. 886. For the genesis of this term see L. C. Breunig, "Le Sur-réalisme," *Revue des Lettres Modernes*, Nos. 123–126 (1965), special issue *Guillaume Apollinaire 4*, pp. 25–27.

13. Guillaume Apollinaire, preface to *Parade, Programme des Ballets Russes* (Paris, 1917). Reprinted in Apollinaire, *Oeuvres en prose complètes*, Vol. II, p. 865.

14. Letter from Guillaume Apollinaire to André Breton dated March 12, 1916, *Oeuvres complètes (Paris: Balland-Lecat, 1965–66)*, Vol. IV, p. 876.

15. See note 4.

16. A similar opposition structures Reverdy's theory of the image, discussed in the final section, where the categories of *juste* and *loin* correspond to the notions true and false.

17. Apollinaire, preface to *Parade, Oeuvres en prose complètes*, Vol. II, p. 866. Cf. Ivan Goll's definition: "La transposition de la réalité dans un plan supérieur (artistique) con-

stitue le surréalisme" ("The transposition of reality to a higher (artistic) plane constitutes surrealism") ("Manifeste du surréalisme," *Surréalisme*, No. 1 [October 1924], n.p.).

18. Apollinaire was fond of this analogy, which he first employed in a lecture on François Rude in 1913. Praising the sculptor's originality and inventiveness, he remarked: "Quand l'homme voulut pour son utilité donner du mouvement aux choses inertes, il n'imita point les jambes mais créa la roue" ("When man wished to confer movement on inert objects for his own use, he did not imitate his legs but created the wheel") (*Oeuvres en prose complètes*, Vol. II, p. 525).

19. As so often, this statement has a lengthy history in Apollinaire's work. A similar observation occurs in "La Loi de renaissance," published in *La Démocratie Sociale* on July 7, 1912 (reprinted in *Oeuvres en prose complètes*, Vol. II, p. 964).

20. Anna Balakian, *Surrealism, the Road to the Absolute* (Chicago: University of Chicago Press, 1986), p. 84.

21. See, for instance, Adrianna M. Paliyenko, "Rereading Breton's Debt to Apollinaire," *Romance Quarterly*, Vol. XLII, No. 1 (Winter 1995), pp. 18–27; J. H. Matthews, *Surrealist Poetry in France* (Syracuse: Syracuse University Press, 1976), pp. 53–67, and *André Breton: Sketch for an Early Portrait* (Amsterdam and Philadelphia: Benjamins, 1986), pp. 33–50; Marguerite Bonnet, "Lettres d'Apollinaire à André Breton" and "Aux sources du surréalisme: place d'Apollinaire," *Revue des Lettres Modernes*, Nos. 104–107 (1964), special issue, *Guillaume Apollinaire 3*, pp. 13–37 and 38–74; and Anna Balakian, *Surrealism, the Road to the Absolute*, pp. 80–99, and "Breton in the Light of Apollinaire" in *About French Poetry from "Dada" to "Tel Quel"; Text and Theory*, ed. Mary Ann Caws (Detroit: Wayne State University Press, 1974), pp. 42–53.

22. André Breton, *Manifeste du surréalisme, Oeuvres complètes*, ed. Marguerite Bonnet et al. (Paris: Gallimard/Pléiade, 1988), Vol. I, p. 328. Cited in the text hereafter as MS. For an analysis of Breton's definition that focuses on its "weaknesses" see Robert Champigny, *Pour une esthétique de l'essai* (Paris: Minard, 1967), pp. 7–28. J. H. Matthews maintains that these qualities constitute the strong point of the definition (and the manifesto) since Breton rejects logic in favor of an artistic/intuitive approach (*Toward the Poetics of Surrealism*, pp. 68–83).

23. See Ignacio Soldevila-Durante, "Ramón Gómez de la Serna: *Superrealismo* and *Surrealismo*" in *The Surrealist Adventure in Spain*, ed. C. Brian Morris (Ottawa: Dovehouse, 1991), pp. 62–66.

24. See Bonnet, "Aux sources du surréalisme: place d'Apollinaire," p. 71.

25. Guillaume Apollinaire, "La Jolie Rousse," *Oeuvres poétiques*, p. 314.

26. André Breton, "Préface à la réimpression du manifeste," *Oeuvres complètes*, Vol. I, p. 401.

27. Balakian, "Breton in the Light of Apollinaire," p. 46.

28. Letter from Guillaume Apollinaire to Henri Martineau dated July 19, 1913, *Oeuvres complètes*, Vol. IV, p. 768.

29. See J. H. Matthews, *Surrealism, Insanity, and Poetry* (Syracuse: Syracuse University Press, 1982).

30. André Breton, "Prologomènes à une troisième manifeste du surréalisme or non," *Manifeste de surréalisme* (Paris: Gallimard, 1965), p. 170. The italics are Breton's.

31. Guillaume Apollinaire, "Le Cubisme et 'La Parade' " in Apollinaire, *Oeuvres complètes*, Vol. IV, p. 768.

32. Matthews, *André Breton: Sketch for an Early Portrait*, p. 36.

33. André Breton, reply to a questionnaire. Cited in M[ichel] D[écaudin], "Ventes, catalogues, etc.," *Que Vlo-Ve? Bulletin International des Etudes sur Apollinaire*, 2nd ser., No. 21 (January–March 1987), p. 20.

34. Jacques Rivière, "Reconnaissance à Dada," *Nouvelle Revue Française*, Vol. VII, No. 83 (August 1, 1920), p. 221. Michel Sanouillet, *Dada à Paris* (Paris: Pauvert, 1965), p. 204.

35. André Breton, "Pour Dada," *Nouvelle Revue Française*, Vol. VII, No. 83 (August 1, 1920). Reprinted in *Oeuvres complètes*, Vol. I., p. 239.

36. Sanouillet, *Dada à Paris*, p. 202, n. 6.

37. Bonnet, "Aux sources du surréalisme: place d'Apollinaire," p. 50.

38. See, for example, Jacques Rivière, "French Letters and the War," *Broom*, Vol. III, No. 1 (August 1922), pp. 21 and 25, and Matthew Josephson, "One Thousand and One Nights in a Bar-Room or the Irish Odysseus," *Broom*, Vol III, No. 2 (September 1922), p. 147.

39. Guillaume Apollinaire, "Les Collines," *Oeuvres poétiques*, p. 172.

40. Robert Champigny provides a detailed analysis of Reverdy's definition in *Le Genre poétique* (Monte Carlo: Regain, 1963).

41. André Breton, "Max Ernst," catalogue to his first Paris exhibition, Au Sans Pareil, May 3–June 3, 1921. Reprinted in *Oeuvres complètes*, pp. 245–46.

42. Citing Apollinaire's dictum "La surprise est le plus grand ressort nouveau" ("Surprise is the greatest new motive force"), Breton declared: "Le surréalisme, non seulement s'est rangé à cette opinion, mais s'en est fait une loi imprescriptible" ("Surrealism not only sided with that opinion but adopted it as an incontrovertible law") (*Entretiens 1913–1952* [Paris: Gallimard, 1952]), p. 242. Previously he remarked "La surprise commande, en effet, toute la notion du 'moderne' " ("Indeed, surprise governs the whole notion of 'modernity' ") (*Le Surréalisme et la peinture* [1928], rev. ed. 1965), pp. 221–22. And before that, in 1918, he observed: "Apollinaire prend à coeur de toujours combler ce Voeu d'imprévu qui signale le goût moderne" ("Apollinaire continually strives to satisfy the Demand for surprise that characterizes modern taste" ("Guillaume Apollinaire," *Oeuvres complètes*, p. 207).

43. Georges Duhamel, review of *Alcools, Mercure de France*, Vol. CIII, No. 294 (June 1913), pp. 800–801.

44. See Michel Décaudin, *Dossier d' "Alcools,"* rev. ed. (Geneva: Droz and Paris: Minard, 1965), pp. 73–81; 89.

CHAPTER SIX
THE SURREALIST IMAGE IN LITERATURE AND ART

1. Anna Balakian, *Surrealism: The Road to the Absolute* (Chicago: University of Chicago Press, 1986), p. 144.

2. André Breton, "Situation surréaliste de l'objet" in Breton, *Oeuvres complètes*, ed. Marguerite Bonnet et al. (Paris: Gallimard/Pléiade, 1992), Vol. II, p. 477.

3. Balakian, *Surrealism: The Road to the Absolute*, p. 144.

4. André Breton, "Le Message automatique," *Minotaure*, Nos. 3–4 December 1933), p. 63. Reprinted in Breton, *Oeuvres complètes*, Vol. II, p. 390.

5. J. H. Matthews, *The Imagery of Surrealism* (Syracuse: Syracuse University Press, 1977), p. 55.

6. Ibid., p. 212.

7. Balakian, *Surrealism: The Road to the Absolute*, pp. 190–91.

8. See René Wellek and Austin Warren, *Theory of Literature*, 3rd ed. (New York: Harcourt, Brace, Jovanovich, 1977), p. 186, and Ezra Pound, "A Few Don'ts by an Imagiste," *Poetry*, Vol. I, No. 6 (March 1913), pp. 200–201. Pound defined an image as "that which presents an intellectual and emotional complex in an instant of time."

9. Gerald Mead, *The Surrealist Image: A Stylistic Study* (Berne: Lang, 1978), p. 8.

10. André Breton, *Manifeste du surréalisme* in *Oeuvres complètes*, ed. Marguerite Bonnet et al. (Paris: Gallimard/Pléiade, 1988), pp. 321 and 324–25, respectively. Cited in the text hereafter as MS.

11. See, for example, André Breton, "Signe, ascendant" reprinted in *La Clé des champs* (Paris: UGE, 1973), p. 177, and *Manifeste du surréalisme*, pp. 324 and 337–38.

12. Rudolf Arnheim, *Toward a Psychology of Art: Collected Essays* (Berkeley: University of California Press, 1966), pp. 280–81.

13. Ibid., p. 279. For a stimulating discussion of this situation in Surrealist texts, see Michael Riffaterre, "Semantic Incompatibilities in Automatic Writing" in *Text Production*, tr. Terese Lyons (New York: Columbia University Press, 1983), pp. 221–39.

14. Matthews, *The Imagery of Surrealism*, p. 262.

15. Umberto Eco, *Semiotics and Philosophy of Language* (Bloomington: Indiana University Press, 1984), pp. 94–96.

16. Charles Baudelaire, "Le Vampire" in *Oeuvres complètes*, ed. Claude Pichois (Paris: Gallimard/Pléiade, 1975), Vol. I, p. 33.

17. For an extended discussion of these categories see Balakian, *Surrealism: The Road to the Absolute*, pp. 152–61.

18. Johnnie Gratton, "Poetics of the Surrealist Image," *Romanic Review*, Vol. LXIX, Nos. 1–2 (January–March, 1978), p. 112. See also Mead, *The Surrealist Image*, pp. 59–113, and Riffaterre, "Semantic Incompatibilities in Automatic Writing."

19. Mary Ann Caws, *André Breton* (New York: Twayne, 1971), p. 87.

20. Robert Champigny, "The S Device," *Dada/Surrealism*, No. 1 (1971), pp. 3–7.

21. Breton, "Signe ascendant," p. 176.

22. Ibid., p. 173.

23. André Breton, "Le Merveilleux contre le mystère," *Minotaure*, No. 9 (October 1936), p. 30. Reprinted in Breton, *La Clé des champs*, p. 13.

24. Louis Aragon, *Traité du style* (Paris: Gallimard, 1980), p. 190.

25. André Breton, "Fronton-Virage" in *La Clé des champs*, p. 13.

26. Breton, "Le Merveilleux contre le mystère," p. 11.

27. Anna Balakian, *André Breton: Magus of Surrealism* (New York: Oxford University Press, 1971), p. 73.

28. See J. Laplanche and J.-B. Pontalis, *The Language of Psychoanalysis*, tr. Donald Nicholson-Smith (New York: Norton 1973), p. 412.

29. André Breton, *Les Vases communicants* (Paris: Gallimard, 1955), p. 128.

30. Breton, "Signe ascendant," p. 177.

31. Balakian, *Surrealism: The Road to the Absolute*, p. 166.

32. See André Breton, "Le Cadavre exquis, son exhaltation" in *Le Surréalisme et la peinture*.

33. Matthews, *The Imagery of Surrealism*, p. 274.

34. Robert Desnos, *Corps et biens* (Paris: Gallimard, 1968), p. 36. Jean-François Lyotard analyzes this sentence in detail in *Discours, figure* (Paris: Klincksieck, 1971), pp. 288–89.

35. Laplanche and Pontalis, *The Language of Psychoanalysis*, pp. 326–27.

36. Sigmund Freud, *The Interpretation of Dreams*, tr. James Strachey (New York: Avon, 1965), p. 253.

37. Roman Jakobson, "Two Aspects of Language and Two Types of Aphasia" in Roman Jakobson and Morris Halle, *Fundamentals of Language*, 2nd ed. (The Hague: Mouton, 1971), pp. 69–96.

38. Cited in Arnheim, *Toward A Psychology of Art*, p. 266.

39. Jakobson, "Two Aspects of Language," p. 92.

40. Federico García Lorca, "Grito hacia Roma," *Obras completas*, ed. Arturo del Hoyo (Madrid: Aguilar, 1965), p. 520. Derek Harris also discusses this image in *Metal Butterflies and Poisonous Lights: The Language of Surrealism in Lorca, Alberti, Cernuda, and Aleixandre* (Arncroach, Scotland: La Sirena, 1998), p. 87.

41. José María Hinojosa, "Su corazón no era más que un espiga," *Poesía de la vanguardia española*, ed. Germán Gullón (Madrid: Taurus, 1981), p. 248.

42. Octavio Paz, "El pájaro," *Poemas (1935–1975)* (Barcelona: Seix Barral, 1979), pp. 49–50.

43. J. V. Foix, *Gertrudis*, ed. J. VallcorbaPlana, 2nd ed. (Barcelona, Quaderns Crema, 1983), p. 53.

44. J. V. Foix, *KRTU*, ed. J. VallcorbaPlana (Barcelona: Quaderns Crema, 1983), p. 109.

45. C. B. Morris, *Surrealism and Spain, 1920–1936* (Cambridge: Cambridge University Press, 1972), p. 54.

46. Rosamel del Valle, *Eva y la fuga* (Caracas: Monte Avila, 1970).

47. Anna Balakian, Introduction to Rosamel del Valle, *Eva the Fugitive*, tr. Anna Balakian (Berkeley: University of California Press, 1990), p. 18.

48. René Magritte, "Ligne de vie," *Ecrits complets*, ed. André Blavier (Paris: Flammarion, 1979), p. 110.

49. Luis Cernuda, "Cuerpo en pena," *Poesía completa*, ed. Derek Harris and Luis Maristany, 2nd ed. (Barcelona: Barral, 1977), pp. 86–87.

50. Rafael Alberti, "Los ángeles feos" *Poesías completas* (Buenos Aires: Losada, 1961), p. 292.

51. See Breton, *Oeuvres complètes*, Vol. I, pp. 467 and 1438, and Guillaume Apollinaire, *Oeuvres poétiques*, ed. Marcel Adéma and Michel Décaudin (Paris: Gallimard/Pléiade, 1965), p. 363. The latter poem includes the lines: "Ta langue / Le poisson rouge dans le bocal / De ta voix" ("Your tongue / The goldfish swimming in the fishbowl / Of your voice"), which Breton cited during his discussion of Surrealist images in "Signe ascendant" (p. 178).

52. André Breton, *Poisson soluble* in *Oeuvres complètes*, Vol. I, pp. 387–88.

53. Cf. the following description: "On sent qu'il est là le baromètre monstrueux, la lyre lampe à gaz des salles d'attente" ("One senses that it is there, the monstrous barometer, the gaslight lyre found in waiting rooms") (André Breton and Philippe Soupault, *Les Champs magnétiques* in Breton, *Oeuvres complètes*, Vol. I, p. 84). See also Riffaterre, "Semantic Incompatibilities in Automatic Writing," pp. 226–29.

54. Breton and Soupault, *Les Champs magnétiques*, p. 65.

55. Lyotard discusses this image in more detail in *Discours, figure*, p. 288.

56. André Breton, "Au regard des divinités," *Oeuvres complètes*, Vol. I, p. 172. Lyotard analyzes the image in detail in *Discours, figure*, pp. 289–90. Gérard Legrand offers another interpretaion in *André Breton en son temps* (Paris: Soleil Noir, 1976), pp. 94–95.

57. Matthews, *The Imagery of Surrealism*, p. 196.

58. Michael Riffaterre, "The Extended Metaphor in Surrealist Poetry" in *Text Production*, pp. 202–20.

59. Pablo Neruda, "Agua sexual," *Obras completas*, 2nd ed. (Buenos Aires: Losada, 1962), p. 215.

60. Morris, *Surrealism and Spain*, p. 59.

61. Riffaterre, "The Extended Metaphor in Surrealist Poetry," pp. 210–11.

62. Breton and Soupault, *Les Champs magnétiques*, p. 95.

63. Octavio Paz, "El día abre la mano . . . ," *Poemas (1935–1975)*, p. 133.

64. André Breton, *Second manifeste du surréalisme* in *Oeuvres complètes*, pp. 782–83. Balakian, *André Breton*, p. 132.

65. André Breton, *Les Vases communicants*, p. 67.

66. García Lorca, "Dos valses hacia la civilización," *Obras completas*, p. 528.

67. Salvador Dalí, *Le Mythe tragique de l'Angélus de Millet: interprétation "paranoiaque-critique"* (Paris: Pauvert, 1963), p. 101.

68. Paul Eluard, "Paul Klee," *Oeuvres complètes*, ed. Marcelle Dumas and Lucien Scheler (Paris: Gallimard/Pléiade, 1968), Vol. I, p. 182.

69. Breton and Soupault, *Les Champs magnétiques*, p. 84.

70. Breton, "Signe ascendant," p. 173.

71. Arnheim, *Toward a Psychology of Art*, p. 280.

72. Jacques Lacan, "L'Instance de la lettre dans l'inconscient ou la raison depuis Freud," *Ecrits* (Paris: Seuil, 1966), p. 511.

CHAPTER SEVEN
AN EXTRAORDINARY VOYAGE

1. Louis Aragon, *Le Paysan de Paris* (Paris: Gallimard, 1988), p. 82.

2. André Breton, *Manifeste du surréalisme*, *Oeuvres complètes*, ed. Marguerite Bonnet et al. (Paris: Gallimard/Pléiade, 1988), Vol. I, p. 337. Aragon's remarks were probably motivated by this passage which describes Surrealism as a "vice nouveau."

3. C. B. Morris, *Surrealism and Spain, 1920–1936* (Cambridge: Cambridge University Press, 1972), p. 146.

4. Salvador Dalí, "Posició moral del surrealisme," presented at the Ateneo de Barcelona on March 22, 1930. Reprinted in Morris, *Surrealism and Spain*, p. 234.

5. Maxime Alexandre, "Liberté, liberté cherie," *La Révolution Surréaliste*, No. 7 (June 1926), p. 31.

6. Louis Aragon, "Fragment d'une conférence," *La Révolution Surréaliste*, No. 4 (June 1925), p. 23.

7. Herbert Marcuse, *Reason and Revolution: Hegel and the Rise of Social Theory* (Boston: Beacon Press, 1960), p. x.

8. See, for example, J. V. Foix, "Algunes consideracions sobre la literatura i l'art actuals," *L'Amic de les Arts*, No. 20 (November 1927), p. 104. The phrase itself occurs in his preface to *Les irreals omegues* (1948), reprinted in J. V. Foix, *Obres completes* (Barcelona: Edicions 62, 1984), Vol. I, p. 119.

9. Foix, *Obres completes*, Vol. I, p. 169.

10. See, for example, his remarks in "Còpia d'una lletra transmesa a Na Madrona Puignau" and the section dedicated to Miró in *Gertrudis* (*Obres completes*, Vol. 2, pp. 87–88 and 16 respectively).

11. For a poem from this period that reflects the influence of literary cubism see Willard Bohn, *Modern Visual Poetry* (Newark, Del: University of Delaware Press, 2000) pp. 201–10.

12. Foix, *Obres completes*, Vol. I, pp. 280–81; Vol. II, pp. 65–66; Vol. I, pp. 307–08, respectively.

13. Jacques Dupin, *Joan Miró: Life and Work* (New York: Abrams, 1962).

14. J. V. Foix, *KRTU*, ed. J. VallcorbaPlana (Barcelona: Quaderns Crema, 1983), p. 88.

15. C. B. Morris, *Surrealism and Spain, 1920–1936* (Cambridge: Cambridge University Press, 1972), p. 53.

16. Foix, *Obres completes* (1979), Vol. II, p. 108.

17. André Breton, *Le Surréalisme et la peinture* (Paris: Nouvelle Revue Française, 1928), p. 64.

18. See, for example, Dupin, *Joan Miró*, p. 19.

19. Foix, *Obres completes* (1984), Vol. II, p. 170.

20. This drawing is reproduced in Dupin, *Joan Miró: Life and Work*, p. 55.

21. Foix, *Obres completes* (1984), Vol. II, p. 170.

22. Ibid., Vol. II, p. 71.

23. See Dupin, *Joan Miró*, p. 116.

24. André Breton, "Avis au lecteur pour La Femme 100 têtes de Max Ernst," *Point du jour* (Paris: Gallimard, 1970), p. 63.

25. Patricia J. Boehne, *J. V. Foix* (Boston: Twayne, 1980), p. 50.

26. Michael Riffaterre, *Semiotics of Poetry* (Bloomington: Indiana University Press, 1978), p. 162.

CHAPTER EIGHT
THE HOUR OF THE SPHINX

1. André Breton, "Femme et oiseau," *Signe ascendant* suivi de . . . *Constellations* (Paris: Gallimard, 1968, p. 143.

2. See in particular Anna Balakian, "From *Poisson Soluble* to *Constellations*: Breton's Trajectory for Surrealism," *Twentieth Century Literature*, Vol. XXI, No. 1 (February 1975), pp. 48–58, and two books by J. H. Matthews: *Languages of Surrealism* (Columbia: University of Missouri Press, 1986), pp. 79–101, and *The Imagery of Surrealism* (Syracuse: Syracuse University Press, 1977), pp. 247–54. Also two works by Georges Raillard: "Breton en regard de Miró: 'Constellations,'" *Littérature*, No. 17 (1975), pp. 3–13, and "Comment Breton s'approprie les *Constellations* de Miró," *Poésie et peinture du symbolisme au surréalisme en France et en Pologne*, ed. Elizbieta Grabska (Warsaw: University of Warsaw, 1973), pp. 171–82. See as well Renée Riese Hubert, *Surrealism and the Book* (Berkeley: University of California Press, 1988), pp. 130–38, and Richard Stammelman, " 'La Courbe sans fin du désir: les *Constellations* de Joan Miró et André Breton," *L'Herne*, No. 72, pp. 313–27.

3. Balakian, "From *Poisson Soluble* to *Constellations*," p. 53.

4. Matthews, *Languages of Surrealism*, p. 87.

5. Philippe Audoin, *Breton* (Paris: Gallimard, 1970), p. 224.

6. See Robert Rosenblum, "Picasso and the Anatomy of Eroticism" in *Studies in Erotic Art*, ed. Theodore Bowie and Cornelia V. Christenson (New York: Basic Books, 1970), pp. 337–50.

7. J. C. Cooper, *An Illustrated Encyclopaedia of Traditional Symbols* (London: Thames and Hudson, 1978), p. 156.

8. André Breton, *Manifeste du surréalisme, Oeuvres complètes*, ed. Marguerite Bonnet et al (Paris: Gallimard/Pléiade, 1988), Vol. I, p. 321.

9. Michael Riffaterre, *Semiotics of Poetry* (Bloomington: Indiana University Press, 1978), p. 19.

10. Jonathan Culler, *Structuralist Poetics* (Ithaca: Cornell, 1975), p. 139.

11. Charles Baudelaire, "Les Chats," *Oeuvres complètes*, ed. Claude Pichois (Paris: Gallimard/Plèiade, 1975), Vol. I, p. 66.

12. Ibid., pp. 50–51.

13. Ibid., p. 35.

14. Susan Harris Smith, "Breton's 'Femme et oiseau': An Interpretation," *Dada/Surrealism*, No. 6 (1976), p. 37.

15. See, for example, Yves Vadé, "Le Sphinx et la chimère," *Romantisme* (1977), No. 15, pp. 2–17, and No. 16, pp. 71–81, and Claude Maillard-Chary, "Les Visages du sphinx chez les surréalistes," *Mélusine*, No. 7 (1985), pp. 165–80.

16. Claude Lévi–Strauss, "The Structural Study of Myth," tr. Claire Jacobson, *European Literary Theory and Practice: From Existential Phenomenology to Structuralism*, ed. Vernon W. Gras (New York: Delta, 1973), p. 315, n. 6.

17. Sir William Smith, *Smaller Classical Dictionary*, rev. ed. (New York: Dutton, 1958), p. 275.

18. William Olmstead, "The Palimpsest of Memory: Recollection and Intertextuality in Baudelaire *Spleen II*," *Romanic Review*, Vol. LXXVII, No. 4 (November 1986), p. 366.

19. J. E. Cirlot, *Dictionary of Symbols*, tr. Jack Sage, 2nd ed. (New York: New York Philosophical Library, 1962).

20. Smith, "Breton's 'Femme et oiseau,' " p. 37.

21. See Rosenblum, "Picasso and the Anatomy of Eroticism," pp. 340–41.

22. Smith, "Breton's 'Femme et oiseau,' " p. 38.

23. André Breton and Philippe Soupault, *Les Champs magnétiques*, *Oeuvres complètes*, Vol. I, pp. 82–83.

24. Balakian, "From *Poisson Soluble* to *Constellation*," p. 55.

25. See, for instance, Scott Bates, *Petit Glossaire des mots libres d'Apollinaire* (Sewanee, Tenn.: Bates, 1975), p. 5.

26. Paul Valéry, "La Pythie," *Oeuvres,* ed. Jean Hytier (Paris: Gallimard/Pléiade, 1962), Vol. I, p. 173.

27. For the importance of connection in *Constellations* in general, see Balakian, "From *Poisson Soluble* to *Constellations*," p. 56.

28. Ibid., pp. 54–56.

29. Smith, "Breton's 'Femme et oiseau,' " p. 38.

CHAPTER NINE
CODA

1. Anna Balakian, "Surrealism," *The New Princeton Encyclopedia of Poetry and Poetics*, ed. Alex Preminger et al. (Princeton: Princeton University Press, 1993), pp. 1236–37.

2. Charles Russell, *Poets, Prophets, and Revolutionaries: The Literary Avant-Garde from Rimbaud through Postmodernism* (New York: Oxford University Press, 1985), p. 122.

3. Ibid., p. 121.

4. Peter Nicholls, *Modernisms: A Literary Guide* (Berkeley: University of California Press, 1995), p. 288.

5. Jacqueline Chénieux-Gendron, *Surrealism,* tr. Vivian Folkenflik (New York: Columbia University Press, 1990), p. 26.

6. André Breton, *Manifeste du surréalisme* in *Oeuvres complètes*, ed. Marguerite Bonnet et al (Paris: Gallimard/Pléiade, 1988), Vol. I, p. 328.

7. Nicholls, *Modernisms*, p. 289.

8. Russell, *Poets, Prophets, and Revolutionaries*, p. 148.

9. André Breton, "Caractères de l'évolution moderne et ce qui en participe," *Les Pas perdus* in *Oeuvres complètes*, Vol. I, p. 299.

10. Nicholls, *Modernisms*, p. 289.

BIBLIOGRAPHY

Agee, William. "New York Dada 1910–1930." *The Avant-Garde*. Ed. Thomas B. Hess and John Ashberry. London: Collier-Macmillan, 1968, pp. 105–13.

Alberti, Rafael. *Poesías completas*. Buenos Aires: Losada, 1961.

Alexandre, Maxime. "Liberté, liberté cherie." *La Révolution Surréaliste*, No. 7 (June 1926), p. 31.

Anonymous. "Drawings by Marius de Zayas." *American Art News*, Vol. XI, No. 28 (April 26, 1913), p. 2.

———. "French Artists Spur on American Art." *New York Tribune*, October 24, 1915, art IV, p. 2.

———. "Marius de Zayas: A Master of Ironical Caricature." *Current Literature*, March 1908, pp. 281–83.

Apollinaire, Guillaume. *Chroniques d'art 1902–1918*. Ed. L. C. Breunig. Paris: Gallimard, 1960.

———. "Du sujet dans la peinture moderne." *Les Soireés de Paris*, No. 1 (February 1912), pp. 1–4.

———. *Lettres à sa marraine 1915–1918*. Ed. Marcel Adéma. Paris: Gallimard, 1915.

———. *Méditations esthétiques: les peintres cubistes*. Ed. L. C. Breunig and J.-Cl. Chevalier. Paris: Hermann, 1965.

———. *Oeuvres complètes*. Ed. Michel Décaudin. 4 vols. Paris: Balland-Lecat, 1965–66.

———. *Oeuvres en prose complètes*. Ed. Michel Décaudin et al. Paris: Gallimard/Pléiade, 1977–1993. 3 vols.

———. *Oeuvres poétiques*. Ed. Marcel Adéma and Michel Décaudin. Paris: Gallimard/Pléiade, 1965.

———. "La Peinture nouvelle: notes d'art." *Les Soirées de Paris*, No. 3 (April 1912), pp. 89–92.

———. "Surnaturalisme." *Les Soirées de Paris*, No. 24 (May 15, 1914), p. 248. Signed "J. C."

Aragon, Louis. "Fragment d'une conférence." *La Révolution Surréaliste*, No. 4 (June 1925), pp. 23–25.

————. *Le Paysan de Paris*. Paris: Gallimard, 1988.

————. *Traité du style*. Paris: Gallimard, 1980.

Arnheim, Rudolf. *Toward a Psychology of Art: Collected Essays*. Berkeley: University of California Press, 1966.

Audoin, Philippe. *Breton*. Paris: Gallimard, 1970.

Bailey, Craig R. "The Art of Marius de Zayas." *Arts Magazine*, September 1978, pp. 136–44.

Balakian, Anna. *André Breton: Magus of Surrealism*. New York: Oxford University Press, 1971.

————. "Breton in the Light of Apollinaire." *About French Poetry from "Dada" to "Tel Quel": Text and Theory*. Ed. Mary Ann Caws. Detroit: Wayne State University Press, 1974, pp. 42–53.

————. "From *Poisson Soluble* to *Constellations*: Breton's Trajectory for Surrealism." *Twentieth Century Literature*, Vol. XXI, No. 1 (February 1975), pp. 48–58.

————. "Introduction." *Eva the Fugitive*. By Rosamel del Valle. Tr. Anna Balakian. Berkeley: University of California Press, 1990.

————. *Surrealism: The Road to the Absolute*. Rev. ed. Chicago: University of Chicago Press, 1986.

Bates, Scott. *Petit Glossaire des mots libres d'Apollinaire*. Sewanee, Tennessee: privately printed, 1975.

Baudelaire, Charles. *Oeuvres complètes*. Ed. Claude Pichois. Paris: Gallimard/Pléiade, 1975). Vol. I.

Beck, James. "The Metaphysical de Chirico, and Otherwise." *Arts Magazine*, September 1982, pp. 84–85.

Boehne, Patricia J. *J. V. Foix*. Boston: Twayne, 1980.

Bohn, Willard. "The Abstract Vision of Marius de Zayas," *The Art Bulletin*, Vol. LXII, No. 3 (September 1980), pp. 437–38.

————. *The Aesthetics of Visual Poetry, 1914–1928*. Cambridge: Cambridge University Press, 1986.

————. *Apollinaire and the Faceless Man: The Creation and Evolution of a Modern Motif*. Rutherford, N.J.: Fairleigh Dickinson University Press, 1991.

————. *Apollinaire and the International Avant-Garde*. Albany: State University Press of New York, 1997.

————. "Giorgio de Chirico and the Solitude of the Sign." *Gazette des Beaux-Arts*, Vol. CXVII, No. 1467 (April 1991), pp. 169–87.

————. "Metaphysics and Meaning: Apollinaire's Criticism of Giorgio de Chirico." *Arts Magazine*, March 1981, pp. 109–13.

————. *Modern Visual Poetry*. Newark, Del: University of Delaware Press, 2000.

————. "La Quatrième Dimension chez Apollinaire," *Revue des Lettres Modernes*, Nos. 530–536 (1978), special issue *Guillaume Apollinaire 14*, pp. 93–103.

————. "Writing the Fourth Dimension." *Modernism and the Fourth Dimension*. Ed. Linda Henderson et al. University Park: Penn State University Press, forthcoming.

Bonnet, Marguerite. "Aux sources du surréalisme: place d'Apollinaire." *Revue des Lettres Modernes*, Nos. 104–107 (1964), special issue *Guillaume Apollinaire 3*, pp. 38–74.

———. "Lettres d'Apollinaire à André Breton." *Revue des Lettres Modernes*, Nos. 104–107, special issue, *Guillaume Apollinaire 3*, pp. 13–37.

Breton, André. *La Clé des champs*. Paris: U. G. E., 1973.

———. *Entretiens 1913–1952*. Paris: Gallimard, 1952.

———. Letter in reply to a questionaire concerning the ten greatest geniuses. "Ventes, catalogues, etc." By M. D. *Que Vlo-Ve? Bulletin International des Etudes sur Apollinaire*, 2nd. ser., No. 21 (January–March 1987), p. 20.

———. *Oeuvres complètes*. Ed. Marguerite Bonnet et al. Paris: Gallimard/Pléiade, 1988–1992. 2 vols.

———. *Perspective cavalière*. Ed. Marguerite Bonnet. Paris: Gallimard, 1970.

———. *Signe ascendant* suivi de . . . *Constellations*. Paris: Gallimard, 1968.

———. *Le Surréalisme et la peinture*. Paris: Nouvelle Revue Française, 1928.

———. *Le Surréalisme et la peinture*. New York: Brentano's, 1945.

———. *Le Surréalisme et la peinture*. Paris: Gallimard, 1965.

———. *Les Vases communicants*. Paris: Gallimard, 1955.

Breunig, L. C. "Le sur-réalisme." *Revue des Lettres Modernes*, Nos. 123–126 (1965), special issue *Guillaume Apollinaire 4*, pp. 25–27.

Briganti, Giuliano et al., eds. *La pittura metafisica*. Venice: Neri Pozza, 1979.

Buffet-Picabia, Gabrielle. Telegram to "291" dated May 27, 1915. Alfred Stieglitz Archive, Collection of American Literature, Beinecke Rare Book and Manuscript Library, Yale University.

Camfield, William A. *Francis Picabia*. New York: Solomon R. Guggenheim Museum, 1970.

———. *Francis Picabia: His Art, Life, and Times*. Princeton: Princeton University Press, 1979.

Carrà, Massimo et al. *Metafisica*. Milan: Mazzotta, 1968.

Caws, Mary Ann. *André Breton*. New York: Twayne, 1971.

Cernuda, Luis. *Poesía completa*. Ed. Derek Harris and Luis Maristany. 2nd ed. Barcelona: Barral, 1977.

Champigny, Robert. *Le Genre poétique*. Monte Carlo: Regain, 1963.

———. *Pour une esthétique de l'essai*. Paris: Minard, 1967.

———. "The S Device." *Dada/Surrealism*, No. 1 (1971), pp. 3–7.

Chirico, Giorgio de. *Hebdomeros*. Paris: Flammarion, 1964.

———. *Il meccanismo del pensiero: critica, polemica, autobiografia, 1911–1943*. Ed. Maurizio Fagiolo. Turin: Einaudi, 1985.

———. *L'opera completa di De Chirico, 1908–1924*. Ed. Maurizio Fagiolo dell'Arco. Milan: Rizzoli, 1984.

Chirico, Isabella Far and Domenico Porzio. *Conoscere de Chirico*. Milan: Mondadori, 1979.

Cirlot, J. E. *Dictionary of Symbols*. Tr. Jack Sage. 2nd ed. New York: Philosophical Library, 1962.

Cooper, J. C. *An Illustrated Encyclopaedia of Traditional Symbols*. London: Thames and Hudson, 1978.

Courtenay, Philip. "Einstein and Art." *Einstein: The First Hundred Years*, ed. Maurice Goldsmith et al. Oxford: Pergamon, 1980, pp. 145–57.

Culler, Jonathan. *Structuralist Poetics*. Ithaca: Cornell, 1975.

Cutler, Edward H. "The Fourth Dimension Simply Explained." *Scientific American*, Vol. CI, No. 2 (July 10, 1909), p. 27.

Dalí, Salvador. *Le Mythe tragique de l'Angélus de Millet: interprétation "paranoiaque-critique."* Paris: Pauvert, 1963.

———. "Posició moral del surrealisme." *Hélix*, No. 10 March 1930, pp. 4–6.

Décaudin, Michel. "Autour du premier manifeste." *Quaderni del Novecento Francese*, No. 2 (1974), pp. 27–47.

———. "Le 'Changement de front' d'Apollinaire." *Revue des Sciences Humaines*, n. s. No. 60 (October–December 1950), pp. 255–60.

———. *Dossier d' "Alcools."* Rev. ed. Geneva: Droz; Paris: Minard, 1965.

Desnos, Robert. *Corps et biens*. Paris: Gallimard, 1968.

Dodge, Mabel. "Speculations." *Camera Work*, special issue, June 1913, p. 9.

Duhamel, Georges. Review of Guillaume Apollinaire, *Alcools*. *Mercure de France*, Vol. CIII, No. 294 (June 16, 1913), pp. 800–801.

Dupin, Jacques. *Joan Miró: Life and Work*. New York: Abrams, 1962.

Eco, Umberto. *Semiotics and the Philosophy of Language*. Bloomington: Indiana University Press, 1984.

Eluard, Paul. *Oeuvres complètes*. Ed. Marcelle Dumas and Lucien Scheler. Paris: Gallimard/Pléiade, 1968. 2 vols.

Esnault, Gaston. *Dictionnaire des argots*. Paris: Larousse, 1965.

Fagiolo dell'Arco, Maurizio. "De Chirico in Paris, 1911–1915." *De Chirico*. Ed. William Rubin et al. New York: Museum of Modern Art, 1982, pp. 11–34.

———. *Giorgio de Chirico: Il tempo di Apollinaire, Paris 1911/1915*. Rome: De Luca, 1981.

Fechter, Paul. *Der Expressionismus*. Munich: Piper, 1914.

Foix, J. V. "Algunes consideracions sobre la literatura i l'art actuals." *L'Amic de les Arts*, No. 20 (November 1927), pp. 104–106.

———. *Gertrudis*. Ed. J. VallcorbaPlana. 2nd ed. Barcelona: Quaderns Crema, 1983.

———. *KRTU*. Ed. J. VallcorbaPlana. Barcelona: Quaderns Crema, 1983.

———. *Obres completes*. 2 vols. Barcelona: Edicions 62, 1979.

———. *Obres completes*. 2nd ed. 2 vols. Barcelona: Edicions 62, 1984.

Fontenrose, Joseph. *The Delphic Oracle*. Berkeley: University of California Press, 1978.

Freud, Sigmund. *The Interpretation of Dreams*. Tr. James Strachey. New York: Avon, 1965.

Friedman, Alan J. and Carol C. Donley. *Einstein as Myth and Muse*. Cambridge: Cambridge University Press, 1985.

Fry, Edward F. *Cubism*. New York: McGraw-Hill, 1966.

García Lorca, Federico. *Obras completas*. Ed. Arturo del Hoyo. Madrid: Aguilar, 1965.

Giedion-Welcker, Carola. *Die neue Realität bei Guillaume Apollinaire*. Berne-Bümplitz: Benteli, 1945.

Gleizes, Albert and Jean Metzinger. *Du cubisme*. Paris: Figuière, 1912.

Goll, Ivan. "Manifeste du surrealisme." *Surréalisme*, No. 1 (October 1924), n. p.

Gómez de la Serna, Ramón. "In memoriam." *Páginas escogidas e inéditas*. By Silverio Lanza. Madrid: Biblioteca Nueva, 1918.

Gratton, Johnnie. "Poetics of the Surrealist Image." *Romanic Review*, Vol. LXIX, Nos. 1–2 (January–March 1978), pp. 103–14.

Hapgood, Hutchins. "A Paris Painter." Globe and Commercial *Advertiser*, February 20, 1913, p. 8. Reprinted in *Camera Work*, Nos. 42–43 (April–July 1913), pp. 49–50.

Harrap's French and English Dictionary of Slang and Colloquialisms. London: Harrap, 1981.

Harris, Derek. *Metal Butterflies and Poisonous Lights: The Language of Surrealism in Lorca, Alberti, Cernuda, and Aleixandre.* Arncroach, Scotland: La Sirena, 1998.

Haviland, Paul B. "Marius de Zayas—Material, Relative, and Absolute Caricatures." *Camera Work*, No. 46 (April 1914), pp. 33–34.

Henderson, Linda Dalrymple. *The Fourth Dimension and Non-Euclidean Geometry in Modern Art.* Princeton: Princeton University Press, 1983.

———. "Francis Picabia, Radiometers, and X-Rays in 1913." *The Art Bulletin*, Vol. LXXI, No. 1 (March 1989), pp. 114–23.

———. "X-Rays and the Quest for Invisible Reality in the Art of Kupka, Duchamp, and the Cubists." *Art Journal*, Vol. XLVII, No. 4 (Winter 1988), pp. 323–40.

Henderson, Linda, et al. *Modernism and the Fourth Dimension.* University Park: Penn State University Press, forthcoming.

Hinojosa, José María. "Su corazón no era más que un espiga." *Poesía de la vanguardia española.* Ed. Germán Gullón. Madrid: Taurus, pp. 247–48.

Homer, William Innes. *Alfred Stieglitz and the American Avant-Garde.* Boston: New York Graphic Society, 1977.

———. "Picabia's *Jeune fille américaine dans l'état de nudité* and Her Friends." *The Art Bulletin*, Vol. LVII, No. 1 (March 1975), pp. 110–15.

Hubert, Etienne-Alain. "Une Dédicace à Tristan Derême." *Revue des Lettres Modernes*, Nos. 450–455 (1976), special issue, *Guillaume Apollinaire 13*, pp. 138–39.

Hubert, Renée Riese. "The Four Dimensional Book," *Word and Image Interactions*, ed. Martin Heusser et al. (Basel: Wiese, 1993), pp. 85–95.

———. *Surréalism and the Book.* Berkeley: University of California Press, 1988.

Hugnet, Georges. *L'Aventure Dada (1916–1922).* Paris: Galerie de l'Institut, 1957.

Hyland, Douglas. *Marius de Zayas: Conjuror of Souls.* Lawrence, Kans.: Spencer Museum of Art, 1981.

Ilie, Paul. "The Term 'Surrealism' and Its Philological Imperative." *Romanic Review*, Vol. LXIX, Nos. 1–2 (January–March 1978), pp. 90–102.

Jakobson, Roman. "Two Aspects of Language and Two Types of Aphasia." *Fundamentals of Language*, By Roman Jakobson and Morris Halle. 2nd ed. The Hague: Mouton, 1971.

Jarry, Alfred. *Oeuvres complètes.* Ed. Michel Arrivé. Paris: Gallimard/Pléiade, 1972. Vol. I.

Josephson, Matthew. "One Thousand and One Nights in a Bar-Room or the Irish Odysseus." *Broom*, Vol. III, No. 2 (September 1922), pp. 146–50.

Lacan, Jacques. *Ecrits.* Paris: Seuil, 1966.

Laplanche, J. and J.-B. Pontalis. *The Language of Psychoanalysis.* Tr. Donald Nicholson-Smith. New York: Norton, 1973.

La Rocca, Eugenio. "L'archeologia nell'opera di de Chirico." *Giorgio de Chirico, 1888–1978.* Ed. Pia Vivarelli. Rome: De Luca, 1981. Vol. I, pp. 32–39.

Legrand, Gerard. *André Breton en son temps.* Paris: Soleil Noir, 1976.

Level, André. *Souvenirs d'un collectionneur.* Paris: Mazo, 1959.

Lévi-Strauss, Claude. "The Structural Study of Myth." Tr. Claire Jacobson. In *European Literary Theory and Practice: From Existential Phenomenology to Structuralism*. Ed. Vernon W. Gras. New York: Delta, 1973, pp. 289–316.

Lhote, André. "Cubism and the Modern Artistic Sensibility." *The Athenaeum,* No. 4664 (September 19, 1919), pp. 919–20.

Lista, Giovanni. *Futurisme: manifestes, documents, proclamations*. Lausanne: L'Age d'Homme, 1973.

Lyotard, Jean-François. *Discours, figure*. Paris: Klincksieck, 1971.

Magritte, René. *Ecrits complets*. Ed. André Blavier. Paris: Flammarion, 1979.

Maillard-Chary, Claude. "Les Visages du sphinx chez les surréalistes." *Mélusine*, No. 7 (1985), pp. 165–80.

Mallarmé, Stephane. *Oeuvres complètes*. Ed. Henri Mondor and G. Jean-Aubry. Paris: Gallimard/Pléiade, 1945.

Marcuse, Herbert. *Reason and Revolution: Hegel and the Rise of Social Theory*. Boston: Beacon Press, 1960.

Martin, Marianne W. "The Ballet *Parade*: A Dialogue Between Cubism and Futurism." *Art Quarterly*, n. s., Vol. I, Nos. 1–2 (Spring 1978), pp. 85–111.

———. "On de Chirico's Theater." *De Chirico*. Ed. William Rubin et al. New York: Museum of Modern Art, 1982, pp. 81–100.

———. "Reflections on De Chirico and *Arte Metafisica*," *The Art Bulletin*, Vol. LX, No. 2 (June 1978), pp. 342–53.

Mather, Frank Jewett, Jr. "The New Painting and the Musical Fallacy. *The Nation*, Vol. XCIX, No. 2576 (November 12, 1914), pp. 588–90.

Matthews, J. H. *André Breton: Sketch for an Early Portrait*. Amsterdam and Philadelphia: Benjamins, 1986.

———. *The Imagery of Surrealism*. Syracuse: Syracuse University Press, 1977.

———. *Languages of Surrealism*. Columbia: University of Missouri Press, 1986.

———. *Surrealism, Insanity, and Poetry*. Syracuse: Syracuse University Press, 1982.

———. *Surrealist Poetry in France*. Syracuse: Syracuse University Press, 1969.

———. *Toward the Poetics of Surrealism*. Syracuse: Syracuse University Press, 1976.

Matthiessen, F. O. *The Achievement of T. S. Eliot: An Essay on the Nature of Poetry*. 3rd ed. Oxford: Oxford University Press, 1958.

McCormick, William B. Review of Marius de Zayas's exhibition of abstract caricatures at "291." The New York *Press*. Reprinted in *Camera Work*, Nos. 42–43 (April–July 1913), pp. 51–52.

Mead, Gerald. *The Surrealist Image: A Stylistic Study*. Berne: Lang, 1978.

Metzinger, Jean. "Note sur la peinture." *Pan* (October–November 1910), pp. 649–51.

Minkowski, Hermann. "Espace et temps." *Annales Scientifiques de l'Ecole Normale Supérieure*, 3rd ser., Vol. XXVI (1909), pp. 499–517.

Morris, C. B. *Surrealism and Spain, 1920–1936*. Cambridge: Cambridge University Press, 1972.

Naumann, Francis M. *New York Dada 1915–23*. New York: Abrams, 1994.

Neruda, Pablo. *Obras completas*. 2nd ed. Buenos Aires: Losada, 1962.

Nervo, Amado. *Obras completas*. Madrid: Aguilar, 1962. 2 vols.

Nietzsche, Friedrich. "Eternal Recurrence." Tr. Anthony M. Ludovici. *Complete Works.* New York: Gordon, 1974, Vol. XVI, pp. 237–56.

———. *Sämtliche Werke.* Ed. Giorgio Colli and Mazzino Montinari. Berlin: de Gruyter, 1980.

———. *Werke.* Ed. Karl Schlechta. Munich: Hanser, 1966.

1913 Armory Show 50th Anniversary Exhibition. Utica, N.Y.: Munson-Williams-Proctor Institute and Henry Street Settlement, 1963.

Norman, Dorothy. *Alfred Stieglitz: An American Seer.* New York: Random House, 1973.

Olmstead, William. "The Palimpsest of Memory: Recollection and Intratextuality in Baudelaire *Spleen II.*" *Romanic Review,* Vol. LXXVII, No. 4 (November 1986), pp. 359–67.

Oster, Daniel. *Guillaume Apollinaire.* Paris: Seghers, 1975.

Paliyenko, Adrianna M. "Rereading Breton's Debt to Apollinaire." *Romance Quarterly,* Vol. XLII, No. 1 (Winter 1995), pp. 18–27.

Paz, Octavio. *Poemas, 1935–1975.* Barcelona: Seix Barral, 1979.

Perloff, Marjorie. *The Futurist Moment: Avant-Garde, Avant Guerre, and the Language of Rupture.* Chicago. University of Chicago Press, 1986.

———. *The Poetics of Indeterminacy: Rimbaud to Cage.* Princeton: Princeton University Press, 1981.

Picabia, Francis. *Caravansérail.* Paris: Belfond, 1974.

———. "Preface." *Picabia Exhibition.* New York: Little Gallery of the Photo-Secession, 1913.

———. "Que fais-tu 291?" *Camera Work,* No. 47 (July 1914), p. 72.

Pierre, José. *Le Futurisme et la dadaïsme.* Lausanne: Rencontre, 1967.

Pierssens, Michel. "Apollinaire, Picasso et la mort de la poésie." *Europe,* Nos. 492–493 (April–May 1970), pp. 178–90.

Proust, Marcel. *A la recherche du temps perdu.* Ed. Pierre Clarac and André Ferré. 3 vols. Paris: Gallimard/Pléiade, 1954.

Raillard, Georges. "Breton en regard de Miró: 'Constellations.'" *Littérature,* No. 17 (1975), pp. 3–13.

———. "Comment Breton s'approprie les *Constellations* de Miró." *Poésie et peinture du symbolisme au surréalisme en France et en Pologne.* Ed. Elzbieta Grabska. Warsaw: University of Warsaw, 1973, pp. 171–82.

Rapp, Marie. Letters to Alfred Stieglitz. Alfred Stieglitz Archive, Collection of American Literature, Beinecke Rare Book and Manuscript Library, Yale University.

Raynal, Maurice. "Qu'est-ce que . . . le 'Cubisme'?" *Comoedia Illustré,* December 20, 1913.

Reinach, Salomon. *Apollo: histoire générale des arts plastiques professée à l'école du Louvre.* Paris: Hachette, 1904.

———. *Manuel de philologie classique.* 2nd ed. Paris: Hachette, 1893. 2 vols.

Riffaterre, Michael. *Semiotics of Poetry.* Bloomington: Indiana University Press, 1978.

———. *Text Production.* Tr. Terese Lyons. New York: Columbia University Press, 1983.

Rivière, Jacques. "French Letters and the War." *Broom,* Vol. III, No. 1 (August 1922), pp. 18–28.

———. "Reconnaisance à Dada." *La Nouvelle Revue Francaise,* Vol. VII, No. 83 (August 1, 1920), pp. 216–37.

Roosevelt, Theodore. "A Layman's Views of an Art Exhibition." *The Outlook*, March 29, 1913, pp. 718–20.

Sanouillet, Michel. *Francis Picabia et "391."* Paris: Losfeld, 1966.

Savinio, Alberto. "Dammi l'anatema, cosa lasciva." *291*, No. 4 (June 1915), p. 4.

———. "Drame de la ville méridienne." *La Voce*, March 31, 1916.

———. *Nuova enciclopedia*. Milan: Adelphi, 1977.

Sawelson-Gorse, Naomi. Ed. *Women in Dada: Essays on Sex, Gender, and Identity*. Cambridge, Mass.: MIT Press, 1999.

Schmied, Wieland. "Giorgio de Chirico." *Giorgio de Chirico*. Paris: Musée Marmottan, 1975.

Schopenhauer, Arthur. *Sämtliche Werke*. 5 vols. Stuttgart: Cotta and Frankfort: Insel, 1960–65.

Sloane, Joseph C. "Giorgio de Chirico and Italy." *Art Quarterly*, Vol. XXI, No. 1 (Spring 1958), pp. 96–131.

Smith, Susan Harris. "Breton's 'Femme et oiseau': an Interpretation." *Dada/Surrealism*, No. 6 (1976), pp. 37–39.

Smith, Sir William. *Smaller Classical Dictionary*. Rev. ed. New York: Dutton, 1958.

Soby, James Thrall. *Giorgio de Chirico*. New York: Museum of Modern Art, 1955.

Soldevila-Durante, Ignacio. "Ramón Gómez de la Serna: *Superrealismo* and *Surrealismo*". *The Surrealist Adventure in Spain*. Ed. C. B. Morris. Ottawa: Dovehouse, 1991, pp. 62–79.

Spate, Virginia. *Orphism: The Evolution of Non-Figurative Painting in Paris 1910–1914*. Oxford: Clarendon, 1979.

Stammelman, Richard. " 'La Courbe sans fin du désir': les *Constellations* de Joan Miró et André Breton." *L'Herne*, No. 72. (Paris: l'Herne, 1998), pp. 313–27.

Stieglitz, Alfred. Letters to Arthur B. Carles and Marius de Zayas. Alfred Stieglitz Archive, Collection of American Literature, Beinecke Rare Book and Manuscript Library, Yale University.

Swift, Samuel. Review of Marius de Zayas's exhibition of abstract caricatures. *New York Sun*. Reprinted in *Camera Work*, Nos. 42–43 (April–July 1913), pp. 53–54.

Tashjian, Dickran. *Skyscraper Primitives: Dada and the American Avant-Garde, 1910–1925*. Middletown, Conn.: Wesleyan University Press, 1975.

Tournadre, Claude. "Apollinaire et les surréalistes aujourd'hui." *Quaderni del Novecento Francese*, No. 2 (1974), pp. 239–78.

Turner, Elizabeth Hutton. "*La Jeune Fille Américaine* and the Dadaist Impulse." *Women in Dada: Essays on Sex, Gender, and Identity*, ed. Naomi Sawelson-Gorse. Cambridge, Mass.: MIT Press, 1999, pp. 4–21.

Turrill, Catherine. "Marius de Zayas." *Avant-Garde Painting and Sculpture in America 1910–25*. Ed. William Innes Homer. Wilmington, Del.: Delaware Art Museum, 1975, p. 62.

Tzara, Tristan. "Introduction." *L'Aventure Dada (1916–1922)*. By Georges Hugnet. Paris: Galerie de l'Institut, 1957, pp. 7–11.

Vadé, Yves. "Le Sphinx et la chimère." *Romantisme*, Nos. 15 and 16 (1977), pp. 2–17 and 71–81, respectively.

Valéry, Paul. *Oeuvres*. Ed. Jean Hytier. 2 vols. Paris: Gallimard/Pléiade, 1962.

Valeton, D. *Lexicologie, l'espace et le temps d'après un texte critique d'Apollinaire sur la peinture moderne*. Paris: Nizet, 1973.

Valle, Rosamel del. *Eva the Fugitive*. Tr. Anna Balakian. Berkeley: University of California Press, 1991.

———. *Eva y la fuga*. Caracas: Monte Avila, 1970.

Vivarelli, Pia, ed. *Giorgio de Chirico, 1888–1978*. 2 vols. Rome: De Luca, 1981.

Weber, Max. "The Fourth Dimension from a Plastic Point of View." *Camera Work*, No. 31 (July 1910), p. 25.

Weisgerber, Jean. "Les Avant-Gardes devant la réalité et le réalisme." *Comparatistica*, Vol. I (1989), pp. 103–15.

Wellek, René and Austin Warren. *Theory of Literature*. 3rd ed. New York: Harcourt, 1962.

Wijk, Margareta. *Guillaume Apollinaire et l'esprit nouveau*. Lund: CWK Gleerup, 1982.

Williams, William Carlos. *The Collected Poems*. 2 vols. Ed. A. Walton Litz and Christopher MacGowan. New York: New Directions, 1986.

———. Letter to the Editor. *Little Review*, Vol. VIII, No. 7 (Autumn 1922), p. 59.

Winckelmann, Johann Joachim. *History of Ancient Art*. Tr. G. Henry Lodge. New York: Ungar, 1968.

Zayas, Marius de. *L'Accoucheur d'idées*. *Camera Work*, No. 39 (July 1912), p. 55.

———. *Alfred Stieglitz* (1914). *Gazette des Beaux-Arts*, Suppl. No. 163 (February 1973).

———. "Caricature: Absolute and Relative." *Camera Work*, No. 46 (April 1914), p. 20.

———. "Exhibition Marius de Zayas." *Camera Work*, Nos. 42–43 (April–July 1913), pp. 20–22.

———. *How, When, And Why Modern Art Came to New York*. Ed. Francis Naumann. Cambridge, Mass.: MIT Press, 1996.

———. "In 1907, Stieglitz . . ." *291*, Nos. 7–8 (September–October 1915), p. 1.

———. *José Juan Tablada. Obras*. By José Juan Tablada. Ed. Héctor Valdés. Mexico: UNAM, 1971, Vol. I, p. 392.

———. Letters to Alfred Stieglitz. Alfred Stieglitz Archive, Collection of American Literature, Beinecke Rare Book and Manuscript Library, Yale University.

———. "The New Art in Paris." *The Forum*, Vol. XLV, No. 2 (February 1911), pp. 180–88. Reprinted in *Camera Work*, Nos. 34–35 (April–July 1911), pp. 29–34.

———. "New York did not see at first." *291*, Nos. 5–6 (July–August 1915), p. 6.

———. "Our plates." *Camera Work*, No. 29 (January 1910), p. 61.

———. "Pablo Picasso." *Camera Work*, Nos. 34–35 (April–July 1911), pp. 65–67.

———. "Pablo Picasso." *América: Revista Mensual Ilustrada* (New York), Vol. VI (May 1911), pp. 363–65.

———. "Photography." *Camera Work*, No. 41 (January 1913), p. 20.

INDEX